ART SCHOOL

A COMPLETE
PAINTERS
COURSE

ART SCHOOL

A COMPLETE PAINTERS COURSE

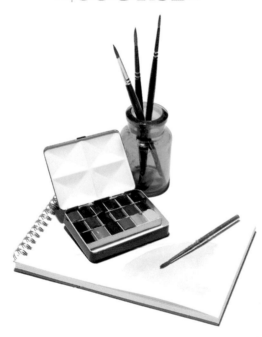

PATRICIA MONAHAN
PATRICIA SELIGMAN
WENDY CLOUSE

CHANCELLOR
PRESS

This 1999 edition published by Chancellor Press,
an imprint of Bounty Books, a division of the
Octopus Publishing Group Ltd,
2–4 Heron Quays, London E14 4JP

Monahan Patricia
Art School: A Complete Painters Course/Patricia Monahan.
Wendy Clouse. Patricia Seligman.
p. cm.
Includes bibliographical references and index

ISBN 0 75370 078 6

1. Painting Technique. I Clouse. Wendy. II Seligman Patricia, 1950- III Title.
ND1500.M653 1996
751.4–dc20

Printed in Hong Kong

Designed and edited by Sports Editions Ltd
3 Greenlea Park, Prince George's Road, London SW19 2JD

This material originally published as three separate titles:
Step by Step Art School Watercolour
Step by Step Art School Oils
Step by Step Art School Acrylics

Contents

WATERCOLOUR

OILS

ACRYLICS

General Introduction

Learning to paint is a rewarding and versatile skill which, once mastered, can be a source of endless pleasure and satisfaction. The Hamlyn Step-by-Step Painting Course explores three different media – watercolour, oils and acrylics – highlighting their individual characteristics and special effects. Beginners can either specialize in a particular technique, try out each medium until they find the one they like best, or work through all three sections and watch how the skills they acquire bring rich dividends.

Watercolour More tears of frustration have been shed over watercolour painting than any other medium, for it is both demanding and unpredictable in its results. But the rewards for perseverance are great – nothing can match its subtlety, brilliance and its pure transparent colours. In this book the section on watercolour, with its carefully graded step-by-step projects from simple use of single colour to wet-in-wet washes and more ambitious figures and landscapes, will help to produce an accomplished and attractive finished picture. Success depends upon skill and boldness with brush and paint, on manual dexterity and the co-ordination of hand and eye, on a few simple rules and lots of practice.

Oils Oils are undoubtedly the supreme painting medium, with their individual textures and exquisite colours. The Introduction begins with suggestions for choosing a subject and arranging the composition. This is followed by a guide to the astonishing range of artists' materials. Finally, there is a demonstration of those techniques which make oil painting such a beautiful medium. The gradual progression from the fundamentals of each technique to simple and then more complex projects takes the frustration out of the learning process and produces highly professional results. Both the beginner and the more experienced amateur will acquire sufficient knowledge to make paintings of which they will be proud.

Acrylics Acrylic is the youngest and perhaps most versatile of painting media. It simplifies the painting process for the beginner and yet provides a vast range of colour and complete flexibility of approach for the more advanced painter. The first chapter examines the medium – its history and development. This is followed by information about basic materials and choosing a subject and composition, and finally a variety of simple step-by-step demonstrations which thoroughly explore the possibilities of acrylic and colourfully illustrate the impressive range of results that can be achieved.

WATERCOLOUR

Chapter 1/Introduction

Watercolour has a fresh, glowing translucency which many artists, including beginners, find irresistible. It is a demanding, irritating but fascinating medium. It is also full of contradictions, for though undoubtedly a difficult medium to master, the basic techniques are really very simple. Most beginners fail because they do not understand the medium or the materials and therefore insist on treating watercolour as they would oil or poster colour. As a result their paper cockles, the wet paint runs and forms muddy puddles and, convinced of their own lack of ability, they give up.

We assume no knowledge of watercolour. In this chapter, for example, we look at some general topics – colour, composition and selecting a subject. In Chapter 2 we look at the materials and give you some pointers as to what you should buy. The remaining chapters start with an introduction to the concepts which underlie watercolour painting and the techniques which you will need to master if you are to become a proficient and confident watercolourist. Each topic is illustrated with simple exercises which you are encouraged to practise, for only by handling paint, putting brush to paper – and making mistakes – will you become familiar with the medium and

learn to handle paint with confidence. Make sure you have lots of paper to hand, preferably of various weights and qualities so that you get to know the way different surfaces affect and modify the behaviour of the paint.

Each chapter also contains a series of carefully structured projects which become increasingly ambitious as the book progresses and as your skills and confidence increase. The demonstrations in Chapter 3 are very simple indeed – the first one uses only one colour! There are two ways of using the book – you can either copy the paintings or you can find similar subjects and paint your own picture using the same techniques. A word of warning here. One of the attractions and pitfalls of watercolour is its unpredictability. The paint sometimes dries unevenly and wet colours bleed and run creating accidental effects which you will not be able to replicate, so your picture will never be an exact copy of the demonstration picture. However, by working through the project with the artist you will gain invaluable insights into his method of working, you will see how the techniques you have learned may be applied and learn how to overcome the limitations and exploit the randomness of the medium. In time you will develop your own unique approach.

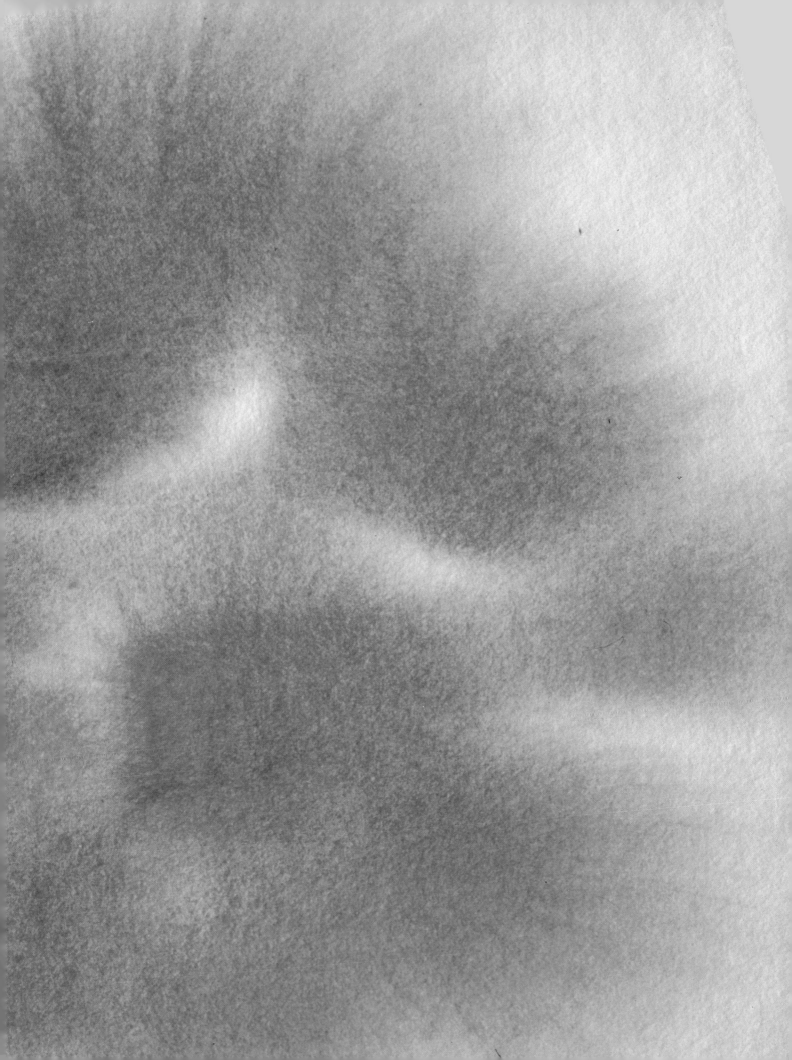

Introduction
COLOUR

Primary colours

These are colours that cannot be created by mixing other colours. For the artist the primary colours are red, yellow and blue. In theory every other colour can be obtained by mixing these colours in varying proportions.

Secondary colours

The secondary colours, green, orange and violet, are created by mixing two primary colours in equal proportions. It is difficult to create true secondaries using pigment primaries because they tend to contain traces of other colours. Thus cadmium yellow pale which contains a slight trace of red can be used to mix good oranges, but tends to dull greens. To achieve a good green use lemon yellow instead. Cobalt blue has a tendency towards yellow and dulls the blue-red mixture which produces violet. A better violet can be mixed from ultramarine and alizarin crimson which has a bluish tinge. On the right the secondaries have been produced by mixing primary pigments produced by the French company Pebeo.

Tertiary colours

Here we show tertiary colours which are produced by increasing the proportion of one of the primaries in the mixture. The tertiaries are red-orange; yellow-orange; yellow-green; blue-green; blue-violet; red-violet.

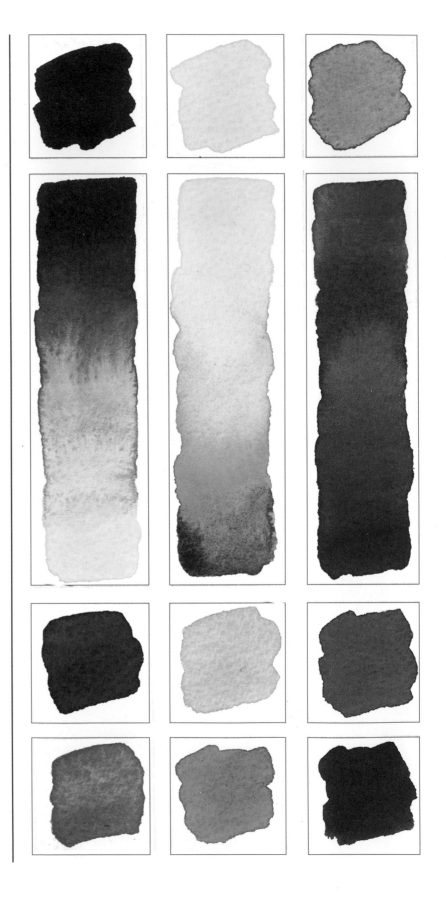

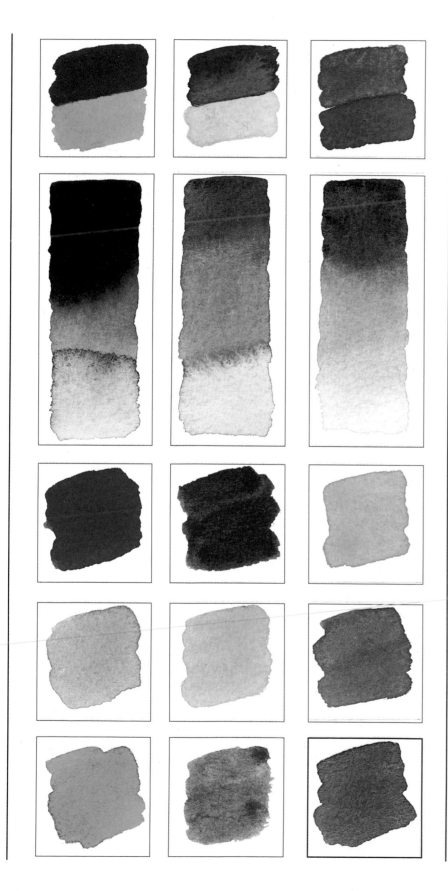

The complementaries

The complementaries are pairs of pure colour such as red and green, violet and yellow, blue and red. When placed side by side they enhance each other – red looks redder and green looks greener.

Neutral greys

The term 'pure' is used to describe a primary or any mixture of two primaries – the secondaries and tertiaries which we have looked at are all pure colours. If a third primary is introduced into the mixture a duller, less saturated colour is produced. This is a neutral grey – a grey with a colour-bias. Here the artist has created neutral greys by adding: red to green; yellow to violet; blue to orange.

Suggested palette

You can start painting in watercolour with a very modest selection of colours. Here we show you nine colours which together with ivory black are really all you need. As you progress you may find that you need additional colours. If you paint a lot of landscapes, for example, you may find that you need more greens – sap green might be a useful addition. However, you will find that most professional artists actually work with a very limited palette. The colours illustrated here are *(left to right, top to bottom):* cadmium red, alizarin crimson, cadmium yellow, yellow ochre, cobalt blue, Prussian blue, viridian green, burnt umber, Payne's grey.

CHOOSING A SUBJECT

A frequent cry from inexperienced painters is 'I don't know what to paint'. The answer is simple, paint whatever you see. It may be the view through the window, a 'landscape'; the clutter of coffee cups and biscuits, a 'still life'; or the questioner, a 'self-portrait' or 'figure study'! Lack of subject material is the thinnest of all excuses for not taking up your brush.

What you paint will depend on your interests, your circumstances and the type of image you want to produce. If you are particularly interested in vivid colour you will naturally gravitate to flower studies, if you find the complexities of tone more interesting you might concentrate on still life groups with simple arrangements of local colour. Those of you who live in the countryside, or visit regularly, will feature landscapes in your output. If you find your fellow human beings fascinating and you enjoy a challenge you may well concentrate on life studies and portraits.

In many ways still life is the simplest and most convenient subject of all. Unfortunately, many of us have been put off by memories of unrewarding school days spent slaving over a boring collection of broken crockery. But if you look around you, particularly in the kitchen, you will find an almost unending supply of material – bottles, jugs, pots and pans, bread, fruit and vegetables, the list goes on and on. But the special joy of still life is that you are in control – you select the shapes and colours that interest you, then you arrange and light them as you want. The group can be large or small and you can generally leave the set-up for several days. Still life is an infinitely fascinating source of inspiration, and a wonderful way of studying a particular theme such as

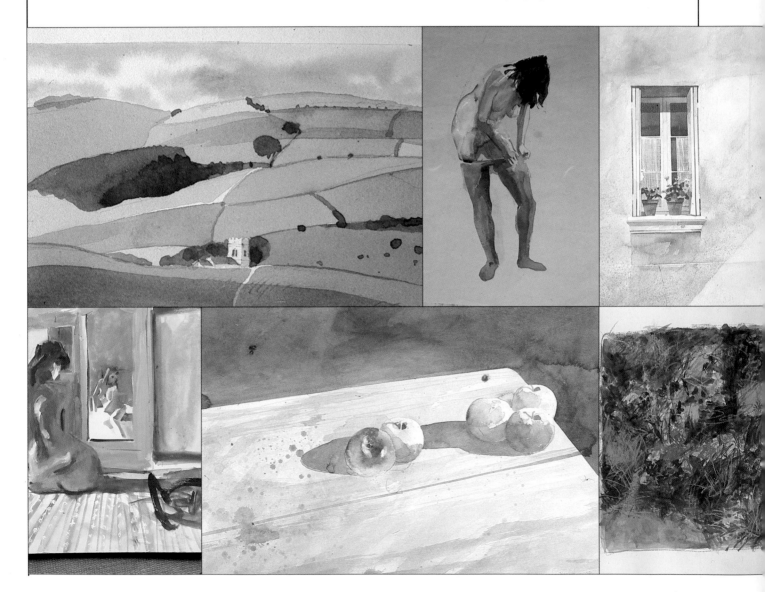

colour, shape, composition or tone.
When you take up painting you start to see the world in an entirely new way. You begin to see with the eyes of an artist and everything is potentially the subject of a painting.

The three main subject areas are landscape, still life and figure and portrait. Which you choose will depend on your interest and circumstances. Here we show a selection of images by different artists which will give you some idea of the range of subjects and approaches.

	1	2	3	4	5	6	
7		8	9	10		11	12

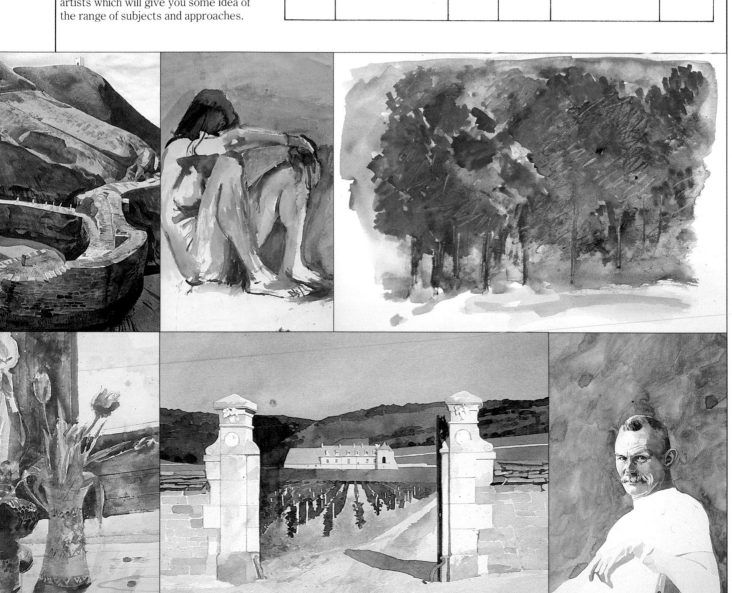

PLANNING THE PICTURE

The illustration above shows different arrangements of three apples on a table. The artist has considered not just the apples, which are the subject of the painting, but also the shapes made by the background space and the table. In many ways it is much easier to 'see' a composition if you don't 'see' the apples, if you see abstract shapes instead. The apples then become circles rather than spheres, the table becomes a rectangle, the space behind it an L-shape. The background is seen not as an empty, 'negative' space, but as a series of interlocking shapes of which the apples are a part.

A picture must be made. The raw material is there but as an artist you take that raw material and process it, and by editing, rejecting and sorting produce something which is original and uniquely your own. People tend to assume that the creative process starts when the artist puts brush to support, but a great many of the important decisions have already been made. This process of assembling and designing a picture is called composition. We also talk about the composition of a painting meaning the way the various elements are dispersed about the picture surface, the way the image is cropped by the edge of the support, and the rhythms and stresses within the picture.

There are lots of 'nevers' in painting, many of them formulae for 'good' and 'bad' composition, and like most of these rules they can be ignored if they don't suit you. They do, however, fulfil a useful function in that they force you to make a decision rather than leaving the composition to chance. In fact, many of them are quite sensible and, often, practical, but have been learned by rote and are sometimes applied with little understanding of the underlying reasons.

You can either compose the subject or the painting. With a still life or a figure painting, for example, you can decide where the subject should be, select the background and

colours, and arrange the lighting as you wish. The process is taken further when you start to work on the painting or drawing, for then you decide which part of the picture area the subject should occupy, how much of it should be included and how much emphasis should be given to the different elements.

If you are painting a landscape you have less control and a lot of decisions to make. For a start you have 360 degrees to choose from, but usually there will be one particular view which attracts you. Many beginners find landscape daunting because they do not know where to begin. You can make things a little easier by framing the scene – either with your hands or with a frame cut from card. This simple device isolates a section of the landscape and by holding the frame close to your eye you increase your field of vision, by holding it further away you isolate a smaller section of the landscape.

When you paint a picture you usually want to engage the attention of the viewer, and there are various devices for keeping the viewer's eye within the picture area. For example, in a figure study you would avoid having an important figure looking out of the picture as this would lead the eye away from the main part of the composition. Similarly, strong directional lines, such as an outstretched arm, would not normally point towards the edges of the picture. It is also sensible to avoid emphasizing the corners of the composition: imagine a circle or oval within your rectangle, touching it at the edges, and try to keep all the main activity within this area.

The shape and size of a painting is an important component of the composition of a picture. Most paintings are rectangular, a shape which relates to the walls on which our pictures hang, rather than our field of vision which is an ellipse. In most instances, therefore, your picture will be rectangular – should it be an upright rectangle known as 'portrait', or a horizontal rectangle which is called 'landscape'? The choice will depend on the subject and the way you want to treat it. For example, a broad sweeping

landscape with a wide horizon would obviously sit well within a landscape format, whilst a landscape which included a tall building or a high mountain peak would suggest a portrait format.

1 *Flower shop* by Ian Sidaway. Here the artist has opted for a landscape format. The line of the pavement and the awning give the composition a dominant horizontality which is balanced by the verticals of the shop front.

2 *Lighthouse* by Ian Sidaway. The artist draws attention to the striking shape and strong verticality of the lighthouse in two ways. He has chosen a portrait format which draws the eye upwards. He has also devoted more than half the picture area to the sky, which acts as a foil to the rest of the painting. The sky is not, however, a negative area, it is a bold important shape cut around, and drawing attention to, the outline of the lighthouse.

1

2

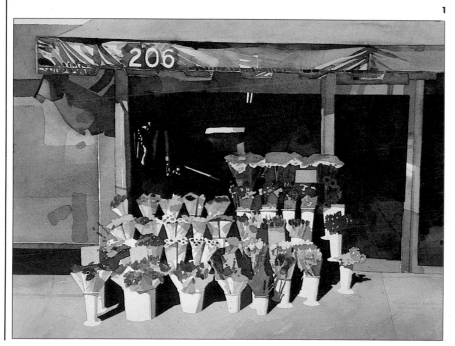

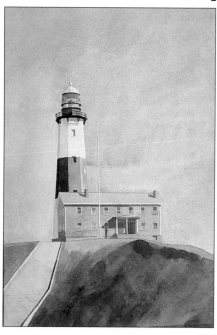

STARTING TO PAINT

Watercolour is an exciting, flexible and richly rewarding medium. It can be used for several purposes – for rapid sketchy notes, for finished paintings or for highly finished illustrations. It also responds well to different approaches so if your natural inclination is for bold splashy colour, you will enjoy it, but it can also be used in a tighter more controlled way. It is entirely up to you.

The projects in this book are carefully structured, simple and uncomplicated to start with, but becoming progressively more ambitious throughout the book. The artists have combined a controlled use of the medium with a willingness to incorporate accidental effects. When you have mastered the techniques and feel happy using the medium, you will be able to develop your own personal style. This book is intended to help you over the first hurdles and to encourage you to use the medium, it is not intended to impose a particular style. When you have worked your way through it your introduction to watercolour will only have begun, for there is no substitute for experience and you never stop learning.

One of the many myths which surround the art of watercolour is that it is fast, but the opposite is true. Watercolour washes use a great deal of water. Colour is built up by laying down one wash over another, but in order to achieve certain effects and prevent the painting from turning into a puddle of muddy colour, the painting must be allowed to dry between washes. This, of course, takes time, involving a lot of waiting round, and if you are out of doors you will probably resent the time spent twiddling your thumbs. One of the solutions is to work on several paintings at once. This may sound complicated but once you get into the habit it is quite easy. The three paintings of sweet peas on these pages were all completed at one sitting. The artist set up the still life, started working on one painting and once it became too wet, set it aside, and started on another, and then on to a third. By the time the third was unworkable the first was ready to be worked on again.

Watercolour is ideal for rapid, on-the-spot paintings. The paints are small and light, conveniently carried in a box which incorporates a palette and, sometimes, a waterbottle and reservoir. The paper is also light and easy to carry, whether it is in a block or stretched on a board. You do not necessarily need an easel, but if you take one it will be light and collapsible. To use your time most efficiently work on several studies at once, these need not be on separate sheets for you can paint several images on a single sheet – on these pages we show several examples of watercolour used in this way. The medium is ideal for studying transient effects such as the changing shapes of passing clouds, or the way that light changes with the weather. If your painting expedition is cut short by inclement weather you can make a rapid pencil sketch and touch in dabs of colour as an *aide memoire*. You can then take the sketch home and produce a painting at leisure.

The three studies of *Sweetpeas* by Sue Shorvon were painted at the same time, the artist moving from one painting to the next. This method of working allows each painting time to dry and avoids the painting becoming overworked.

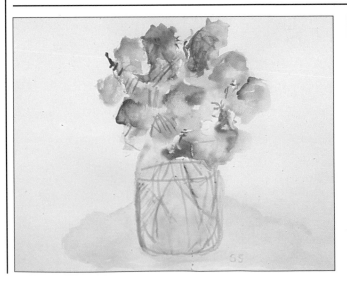

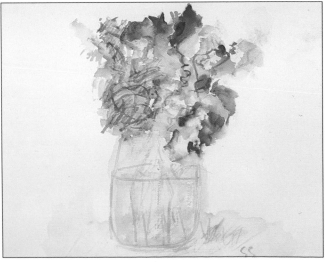

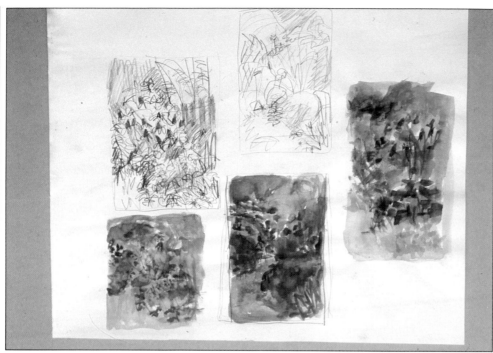

The sketches on the left are also by Sue Shorvon and were completed in a garden in Canada. Below, we see four studies of skies by Ronald Maddox. The artist worked quickly to capture the rapidly changing effects. The sketches of sand dunes are also by Ronald Maddox. Again they were painted on the spot and are part of a large collection to which he constantly refers for inspiration and for reference.

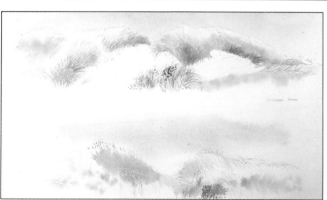

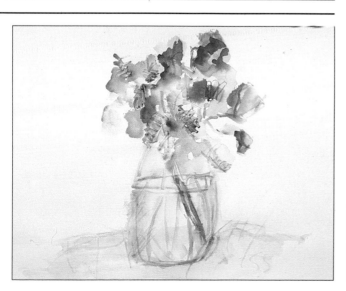

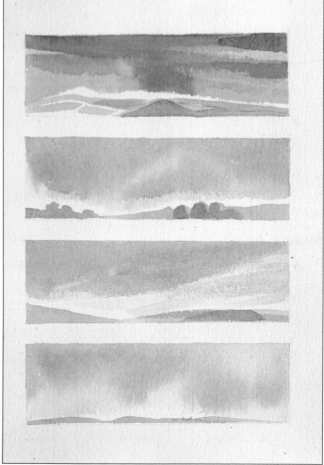

Chapter 2
Equipment

Watercolour is a thrilling and extremely flexible medium, with something to offer everyone. The extrovert can work boldly, enjoying the brinkmanship of working with fluid paint, while the meticulous can use a more controlled and minutely detailed technique. Unfortunately, watercolour has, over the years, acquired a mystique which leads the uninitiated to believe that the medium is not for them, assuming that only a trained, gifted or experienced painter could possibly cope with a medium so difficult and demanding. We set out to dispel those myths, and in this chapter tackle the first hurdle which you will have to overcome – purchasing your equipment.

The materials required for watercolour painting are simple: paints, paper, brushes and water. But that list belies the complexity of the subject. If you have already visited an art shop to buy paints you will be aware of the bewildering range of materials and the apparent impossibility of making a selection.

With watercolour more than any other medium you should buy the best you can afford – you will be getting extremely good value for money and the expenditure will be more than repaid by your pleasure in the result. The materials used for watercolour are a delight in themselves – small, exquisite and very desirable. The pans of paint, for example have a jewel-like quality, each with its own neatly printed paper band, under that a foil wrapping which peels off to reveal the glossy cubes of paint in their individual white plastic containers. The best brushes too are elegant objects, beautifully crafted from the finest materials with costly sable bristles and glossy, black lacquered handles. The paintboxes are ingenious master-pieces of economy and efficiency which combine paints, palettes, and often, waterbottles and reservoirs.

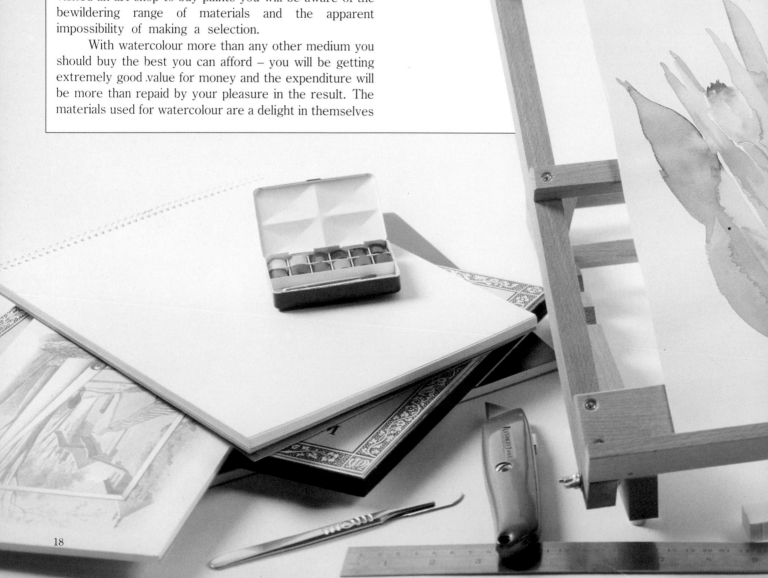

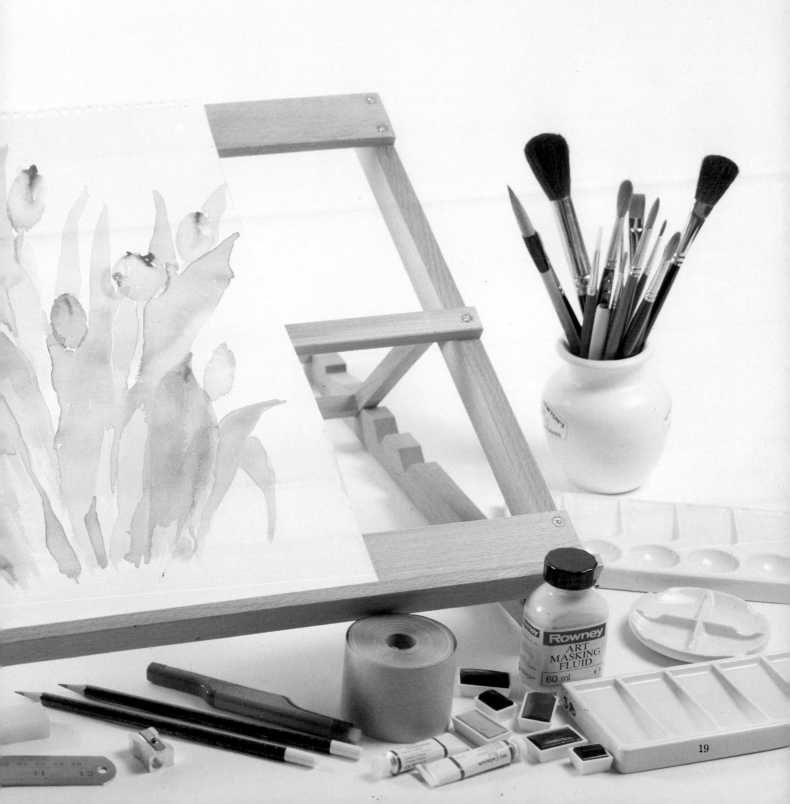

Equipment

SUPPORTS/PAPER

A 'support' is any surface which an artist uses for painting or drawing on – canvas, hardboard or even a wall can used as a support. The support for watercolour is paper which is cheap, available and portable.

The range of papers available is bewildering – they vary in colour, texture and the materials from which they are made. The best are expensive but worth the investment. The quality of the paper you use is important, for it plays a significant part in painting, affecting the way the paint is accepted. Generally the papers used for pure watercolour are white or only slightly tinted – this is because the paper itself will establish the lightest area of the painting, and the white of the support shows through the layers of transparent paint imparting a special brilliance to the colours.

Watercolour paper is sold in a range of weights which are expressed as pounds per ream (480 sheets) or grammes per square metre. Weights vary from 90 lb (185 gsm) for lightweight paper to 300 lb (640 gsm) for the heaviest. Most paper needs to be stretched – this prevents the wet paper from cockling. The heavier the paper the more readily it accepts water, so the heaviest papers – above 140 lb – need not be stretched unless they are going to be flooded with water.

Papers can be bought in spiral bound pads, blocks in which the paper is bound on all four sides and loose sheets. Pads are useful for sketching

especially if you don't use a lot of water. Separate sheets can be torn from the pad and stretched if necessary. The blocks are useful for working out of doors, the sheets are firmly attached and therefore do need to be stretched – and they do not blow about. If you look carefully you will find a small area where the sheets are not attached – remove them by slipping a blade in at this point and gently work it around the edge of the

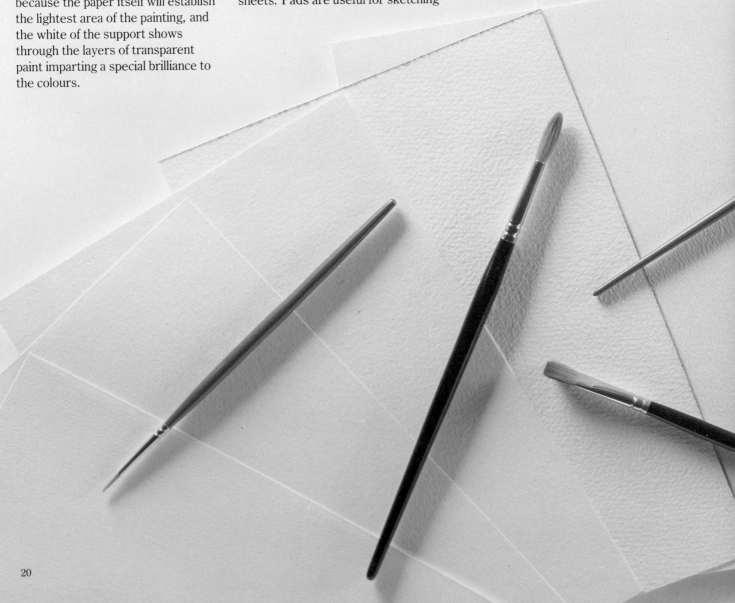

sheet. Do not use the sharp edge or you will cut the paper.

The Cotman paper used for most of the demonstrations in this book is a new paper developed for Winsor & Newton by Canson. It has two, different, Not surfaces and is available in two weights, 90 lb and 140 lb. It is a particularly good paper for the beginner as it is strong, offers a choice of surfaces and allows you to lift colour from areas very easily.

Here we show a selection of pads and blocks. The largest paper sizes are available only as loose sheets. The tiny watercolour box is a Bijou Box by Winsor & Newton. It contains 12 quarter pans of artist's quality paints and a sable brush pocket brush.

The papers shown on these pages are, from left to right: Bockingford 70 lb Not; Montval by Canson 90 lb Not; Cotman 140 lb Not; Arches 140 lb Rough; Arches 90 lb Not; Bockingford 140 lb Not; Arches Rough 300 lb; Saunders 90 lb H.P.; Watmough 140 lb H.P.; Watmough 140 lb; Rough Saunders 72 lb Rough.

PAPER TEXTURE

The type of surface a paper has is important. There are three basic finishes: Hot-Pressed (H.P.); Cold-Pressed or Not; and Rough. Hot-Pressed has the smoothest surface because during the manufacturing process it is rolled between hot metal rollers. Its smooth surface is ideal for drawings in pen or pencil. The paper has less tooth than other watecolour papers and some artists like the way paint responds to the slippery surface. However, it is not very absorbent and is difficult to use for wet, washy techniques. Its most important use is for tight, detailed work – illustrators often use H.P. papers.

Not paper, so-called because it is 'not' hot-pressed, has a medium textured surface. The Cotman paper used for many of the projects in this book has a Not surface, in fact, it has two Not surfaces.

Rough paper has a distinctly textured surface. Many artists like the way that paint responds to the irregular surface, sitting on the raised areas whilst the recesses remain white, giving washes a luminous sparkle. It is probably best to avoid Rough papers until you are more experienced.

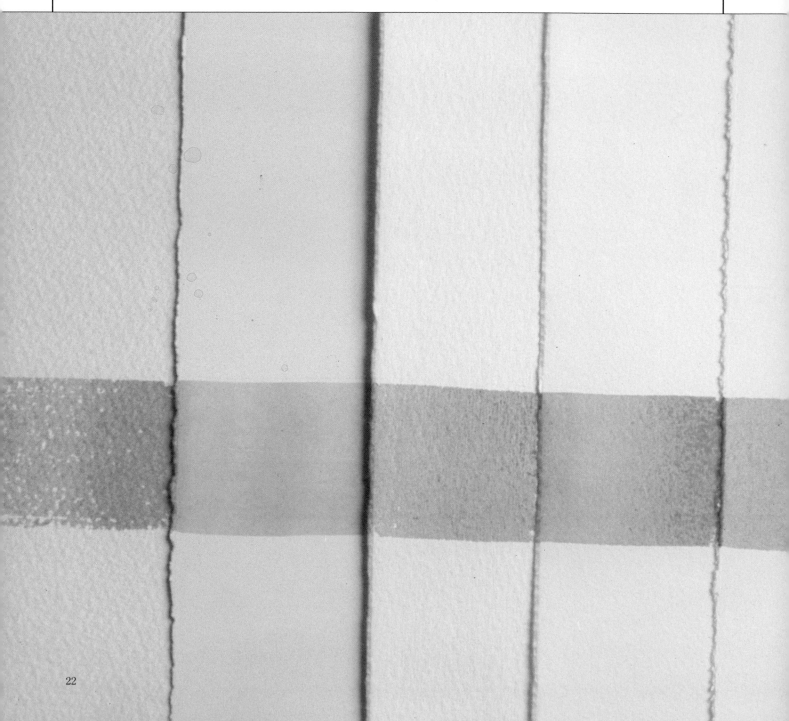

Paper is a subject which is apparently simple, but the more you go into it the more complex it becomes. To start with you will be safe enough if you buy any paper which says it is suitable for watercolour and stick to a Not surface. You should also get into the habit of stretching your papers, especially if you buy the lighter weights.

As you become more experienced you may experiment with different surfaces and weights and will soon discover what sort of surface you prefer. You will find that what one manufacturer describes as Not another calls H.P. You will also find that some papers are considerably more expensive than others. The most expensive papers are handmade and are really not for the beginner.

Here we have laid a band of watercolour across a selection of papers to show how the colour is received. *From left:* Green's pasteless board; Saunders 90lb H.P.; Arches 140lb Rough; Saunders 200lb Not; Arches 140lb Not; Arches 90lb Not; Bockingford 200lb Not; Saunder's Waterford 90lb; Cotman 140lb Not.

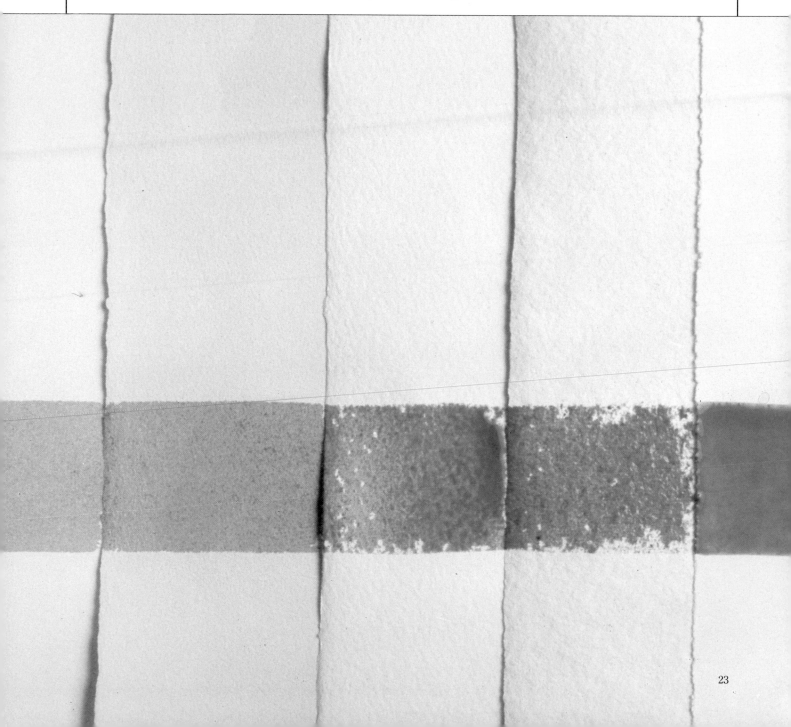

PAINTS

Watercolour paint consists of pigment bound with gum, a naturally occurring watersoluble substance. Gum arabic, the most common binding medium for watercolour is produced, by several species of North African and North American acacia trees. Gum tragacanth comes from a thorny shrub native to Greece and Turkey. The manufacturer mixes pigments with various components, such as gum and glycerin, in order to produce paints which will mix with water, and produce an even glaze of colour when diluted. The pigments come from many sources, some occur naturally, others are artificially produced.

Pigments are idiosyncratic – some, like viridian and alizarin crimson, are naturally transparent and therefore ideal for glazing. They also differ in their staining qualities, thus viridian is non-staining and is easily removed from paper while alizarin crimson will leave a mark. You can test the staining power of pigments by laying down patches of paint, allowing them to dry then washing off the colour under running water. You will find that some colours stain the paper quite strongly whilst others leave no mark at all. Colours also vary in their transparency, some colours like cerulean blue, oxide of chromium and Naples yellow are naturally opaque, and although the manufacturers try to overcome this by adding glycerin, you should use these colours with care if you are not to lose the translucency which is such an attractive quality of watercolour. Some pigments have a tendency to granulate when used in a wash – in fact some are so prone to this that they are not used in watercolour at all. Learning about pigments is not a purely academic exercise, for if you are aware of the way a particular colour behaves in certain circumstances, you will be able to use it in a more informed way – you will not, for example, obliterate a subtle passage by putting down too much of a particularly intense colour like viridian, or an opaque colour like yellow ochre. The more knowledge you have the more you can control the medium.

Watercolour is available in various forms: dry cakes, pans, half-pans, tubes, cakes and bottles of concentrated colour. You may already be familiar with the disks of dry colour often used in children's paint boxes. They contain very little glycerin so the colour is very concentrated. It is difficult to wet the paint so you must work the brush vigorously in order to lift the colour. If you do use paint in this form drop a little water onto each cake at the beginning of a session – this will soften the paint and make it easier to lift.

Pans and half-pans contain more glycerin and are semi-moist so it is easier to wet and lift the colour. Each cube of colour has its own container: pans measure 19×30mm and half-pans 19×15mm. The smallest boxes contain quarter pans – to replace these you will have to cut the larger pans to fit. Watercolours in pans are both economical and convenient. All the colours are available for immediate use, you take off colour as you need it and in exactly the quantities you need. With tube colours you must either decide which colours you are going to use and squeeze them out at the beginning or, alternatively, stop and squeeze out colour as you go along. You either waste paint or interrupt your work at intervals. Pan colours are particularly useful for sketching out of doors, where the nature of the subject and the working conditions mean that you need all your colours to hand, and you also want to keep your equipment to a minimum.

A disadvantage of pan colours is that once you have removed the wrapper you have no record of the colour. This can be confusing for dark colours look remarkably alike in solid form. You must therefore be very organized, laying out your paintbox in a particular way so that you know where each colour is. You should also make a colour chart, laying down a blob of each colour and labelling it – this will help you identify the colours when you are working and will also be useful when you want to replace the paints.

Tube colours contain even more glycerin than pan colours and are very soft. They are especially useful when you are working on a large scale and need to mix large quantities of wash –

Here we see a mixture of pans, half-pans and tubes. Pans will probably be more economical and useful, but you might need tubes for large washes – ultramarine or cobalt blue for skies for example.

PAINTS

it is easier to squeeze out colour and add water than to work up a pan and carry colour brushload by brushload to the palette.

The fourth form of watercolour is liquid and is sold in bottles. These colours are particularly vivid and are popular with graphic artists and some illustrators. They tend to be more fugitive than other forms of watercolour.

There are two grades of watercolour – artist's quality and student's quality. Student's quality colour is cheaper – usually all the colours are the same price – artist's quality are made from better pigments and this is reflected in the price. Artist's colours are coded by series which indicate the price

bracket. Some colours are extremely expensive so you should check the series number before you buy. Manufacturers aim their student's quality materials at beginners and the difference in price between these and the artist's quality certainly make them attractive. However, there is a lot to be said for starting with the best: artist's quality paints are better, and the colour is more intense and goes further.

Tubes of watercolour can be bought individually or in boxed sets. The boxes range from the tiny Bijou sketchers set shown below to large wooden chests of colour. The watercolour box fulfils several functions. Not only does it contain paints and possibly a brush, it

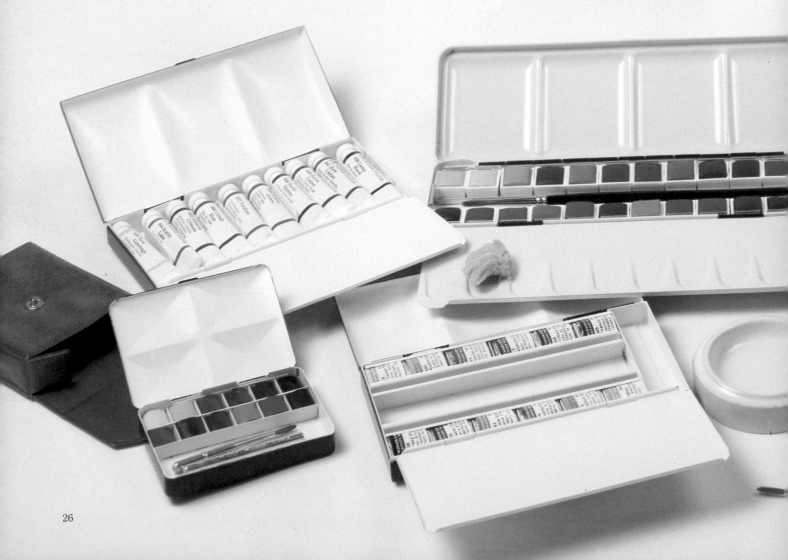

26

On the *left* we see a 'working' paintbox. Compare this with the pristine examples below!

Here we see a selection of watercolour boxes. They vary in the number and type of colours they contain – tubes, pans or half-pans. The smallest box contains quarter pans. The small ceramic saucer is for mixing washes.

protects the paints, preventing them from drying out and the lid functions as a palette for mixing colours. Some boxes have an extra leaf which folds out providing another mixing surface. You can buy an empty box and select your own colours – just a few to start with, adding others as necessary and as you can afford them.

You will also need separate palettes – these may be plastic or ceramic, but are usually white so that

you can see the colour of the wash. Plastic palettes with deep wells are ideal for mixing large washes. Alternatively you can use ceramic dishes often sold in nests of about five. Tile palettes are rectangular, usually ceramic, sometimes divided into five or six slanting divisions, or with a combination of circular and slant recesses. But ordinary household saucers and yogurt pots will do just as well. Many professional artists have very odd assortments of containers.

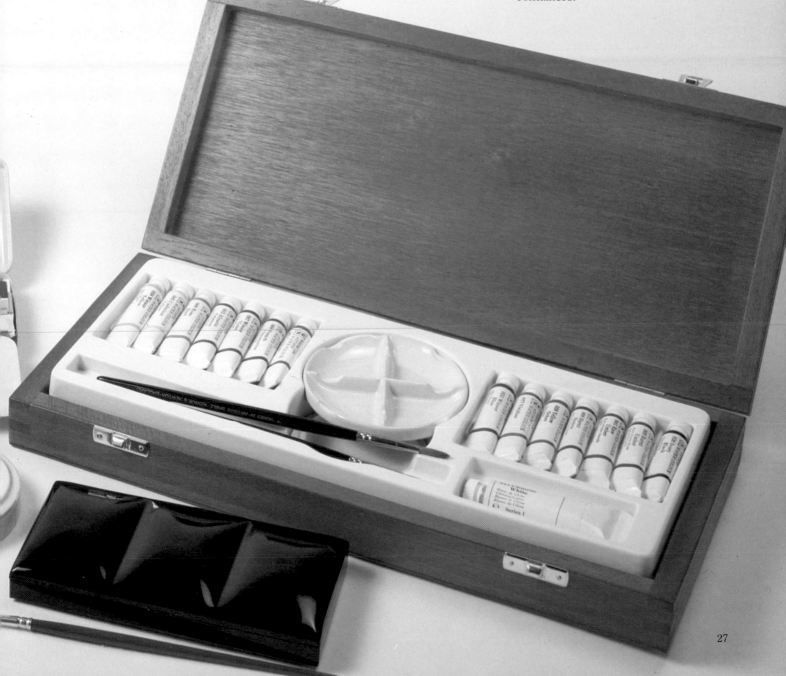

BRUSHES

You will need a small selection of brushes to start with, ideally a large flat brush to lay on washes, a medium sized brush for broad areas and a small brush for detailed work. The size and type of brush you use will depend on the type of painting, the size and your technique. A botanical illustrator, for example, might have a selection of very small sable brushes, whilst a painter with a freer, more gestural style might have a large selection of brushes, some not obviously appropriate for watercolour. Thus you will find brushes intended for DIY, toothbrushes and nailbrushes in many artists' collection.

Brushes are made from different materials, the most expensive being red sable made from the tail of the Siberian mink. They are extremely expensive especially in the larger sizes, but they are lovely to work with and properly cared for will last for a long time. Sable brushes have qualities which make them ideal for watercolour. They have a pleasing springiness, which makes for lively brushwork, yet they are responsive, allowing you to control the paint. The sable hairs have special qualities which allow the brush to absorb and hold paint, so that you can work with a loaded brush. With a less expensive

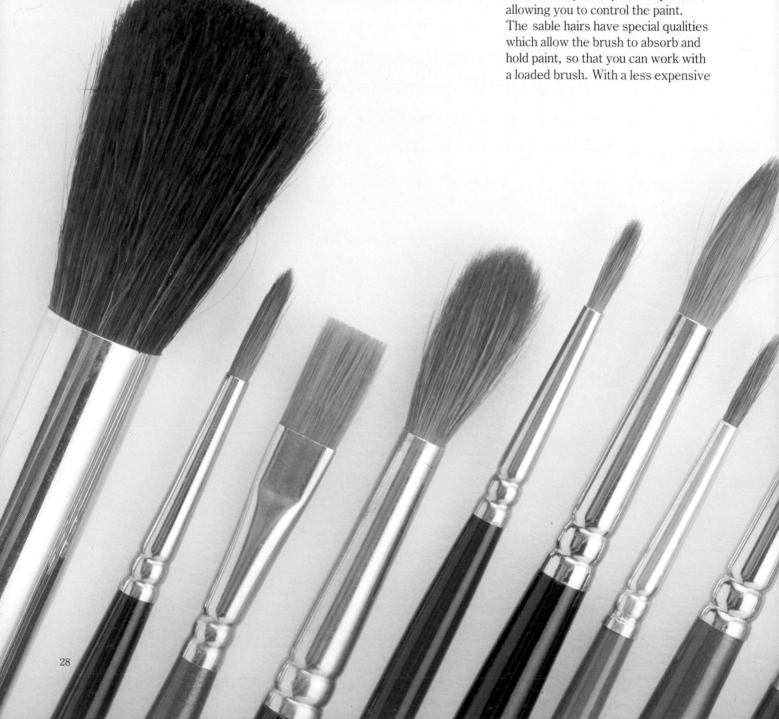

brush you would have to return to the wash several times, making a number of strokes where a sable would allow you to make one. Less expensive brushes are made from sable mixed with squirrel, ox hair or other fibres. The Sceptre range produced by Winsor & Newton are extremely good, though they are not cheap. Cheaper still are the brushes made without sable. Soft synthetic brushes are also used for watercolour, some of them are very good indeed.

Your brushes are expensive and should be looked after. Wash them thoroughly in water after use, gently reshape the bristles, or better still, flick them briskly and you will find that they resume their correct shape. Round brushes should come to a point and if you lose this they become difficult to use. Store brushes bristle end up in a jar. When you go out painting take your brushes in a container which will protect the bristles. Art suppliers sell tubes, but you can roll them up in card or a cloth, anything which will protect their bristles from damage. Never leave brushes standing on their hairs or bristles – in a jar of water for example. If you do the brush head will lose its shape and can become so distorted it is entirely unusable.

Here we show a selection of brushes suitable for watercolour. Unless otherwise indicated they are Winsor & Newton brushes. They are, from left to right:
series 14A, extra large, round wash brush, imitation squirrel;
series 7, number 3, sable;
Sceptre series 606, 6mm, mixed fibres including sable;
series 7, number 8, sable;
series 33, number 3, a cheaper sable;
series 16, number 8, sable;
series 35, number 3, ox and sable;
Sceptre, series 101, number 8 mixed fibres including sable;
series 33, number 8, sable;
Rowney, series 43, number 3 Kolinsky sable;
series 35, number 8, ox and sable;
Sceptre, series 101, number 2;
series 608, 8mm. sable;
Sceptre, series 202, number 3;
series 14B, large, domed wash brush, imitation squirrel hair.

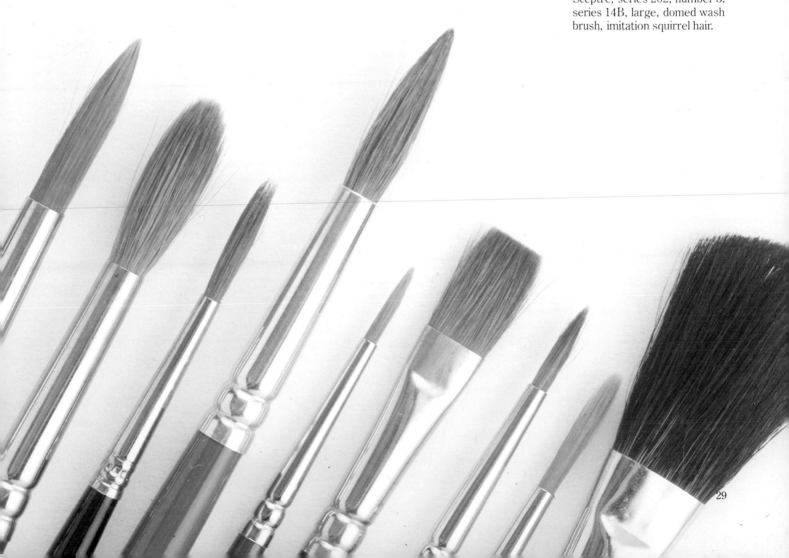

HANDLING WATERCOLOUR

How do you actually get the paint from the tube or pan to the support? Beginners sometimes get in a muddle because they squeeze paint onto a palette and then apply it directly to the support, or work directly from the pan to the support. If you do that you end up with a thick, opaque layer of paint rather than the thin washes which allow the white of the support to show through and give the medium such brilliance. Pan colours are semi-moist and get very soft and sticky if you work directly from the pan. And whichever form of watercolour you use you will get through it far too quickly. Using the paint correctly will give you a better and a more economical result.

The secret of watercolour is washes – these are solutions of paint and water. To prepare a wash with tube colour, squeeze a little colour into a saucer or one of the recesses of your palette, then dip your brush in a jar of water and work up the paint with the brush. Add more water until the colour is the right intensity – test it on a scrap of paper. Use your brush to add more water as required.

If you are using pan colour put a little water in a saucer or a recess in a palette. The paint must then be moistened with a wet brush and the brush used to work up the colour. When the brush is loaded with paint transfer it to the palette. Again, test the intensity of the colour and add more water or paint as required.

There are occasions when you will want to work directly from the unmixed paint or the pan, if for example you are working wet-in-wet and want to add more colour, or if you want to introduce intense, opaque colour for fine details. In general, though, you would dilute the colour first.

1 This is a working artist's paintbox. There are two tile palettes, a plastic palette with ten deep recesses and two saucers and a mixture of pans and half-pans. If you favour large brushes you should use pans – it is much easier to use a large brush on a large paint surface.

2 Here the paint is transferred to a dish in which there is a little water. Test the strength of the solution on a scrap of paper. Remember that watercolour looks much darker when wet than when it is dry.

1

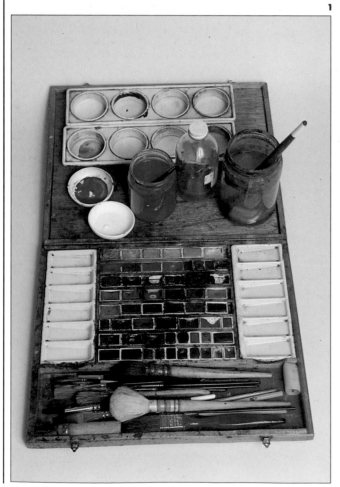

2

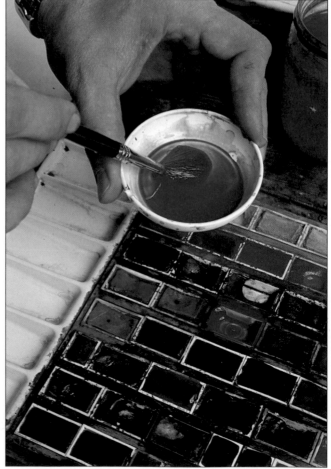

A great deal of water is used for paintings in watercolour and paper responds to water in different ways depending on how thick it is and how much size it contains. Nevertheless, most papers abosrb water causing them to stretch when wet, and then shrink as they dry. Unfortunately, they don't generally dry flat, but buckle and wrinkle. Many an aspiring watercolourist has started by painting on unstretched cartridge paper, and has ended up with a sadly wrinkled piece of paper covered in puddled colour. But even cartridge paper can be used for watercolour if it is first stretched. Stretching paper is very, very simple. And if you have a watercolour on which unstretched paper has cockled you can still flatten it. Simply follow the instructions here, but wet only the back of the paper and stretch the painting face down.

1 You will need: a sheet of watercolour paper; a drawing board or a similar flat surface; gummed tape; scissors or a scalpel; water and a sponge or a brush. Trim the paper so that it is slightly smaller than the board. Cut four strips of gummed paper – two to the length of the short side, two for the long side.

2 Lay the sheet of paper on the board. Here water is being squeezed onto the paper from a sponge.

3 Working quickly but gently to avoid damaging the paper surface, spread the water over the paper – it should be damp rather than soaking wet. If the paper is thin you only need to wet one side, if it is thicker you should wet both sides. If it is a really thick paper you may have to soak it in the bath for a minute or so, but be careful not to tear it when it is wet.

4 Wet the strips of gummed paper.

5 Use them to fix the paper to the board, making sure the paper is as flat as possible. You do not need to exert any pressure – the forces set up by the drying and contracting paper are quite enough to flatten it.

6 Don't worry if the paper looks bubbly when you leave it. Have faith, when you return it will be beautifully flat!

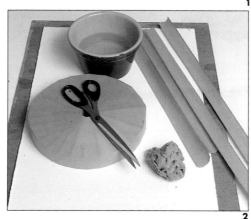

Chapter 3
Washes

Watercolour is entirely different from any medium you have used so far. First of all, it is transparent, the white of the paper giving it a special luminosity and brilliance which is unmatched in any other medium. Its transparency does, however, impose limitations which make it difficult for the beginner to handle watercolour without a little tuition. You cannot, for example, apply a light colour over a dark colour and in this chapter we look at the concept of 'working light to dark', which means that you lay down your lightest colours first and then build up the colour layer upon layer, adding the darkest tones last. To do this you must plan your approach carefully – you cannot suddenly decide to add a highlight at a late stage of the painting. Another important point to remember is that the only white available in a true watercolour technique is the white of the paper so this must be carefully guarded. In this chapter we look at ways in which you can create a range of tones, highlights and local whites without white paint.

Washes are the basis of all watercolour painting, for in a wash you see watercolour in its truest and most beautiful form. In a wash paint is diluted with lots of water and applied to the support in solution, so you will have to learn to control fluid paint and wet paper. There are all sorts of things you can do with a flat wash. First of all it allows you to cover large areas very quickly. Then if you allow the paint to dry you can apply another wash of the same colour and so build up the intensity of tone, or change the colour by applying another wash of an entirely different colour. Tones can also be built up by adding more colour, thus increasing the ratio of paint to water.

Working with wet paint and paper is thrilling, demanding and fun. The most successful watercolours are produced by artists who 'know' the medium, and can work with, and exploit, its unpredictability. In this chapter we lead you through the very first steps, explaining what you should do, but also explaining why. Make sure you have lots of paper and work your way through the exercises at the beginning of the chapter. Then try the three simple projects – copy them or find similar subjects of your own. Good luck!

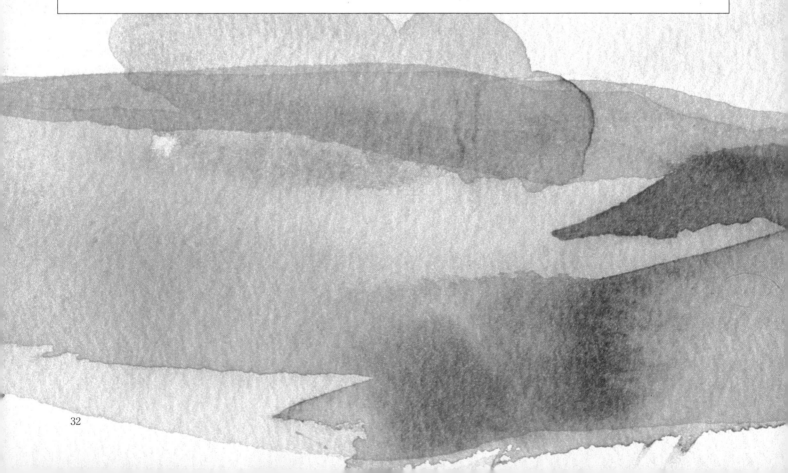

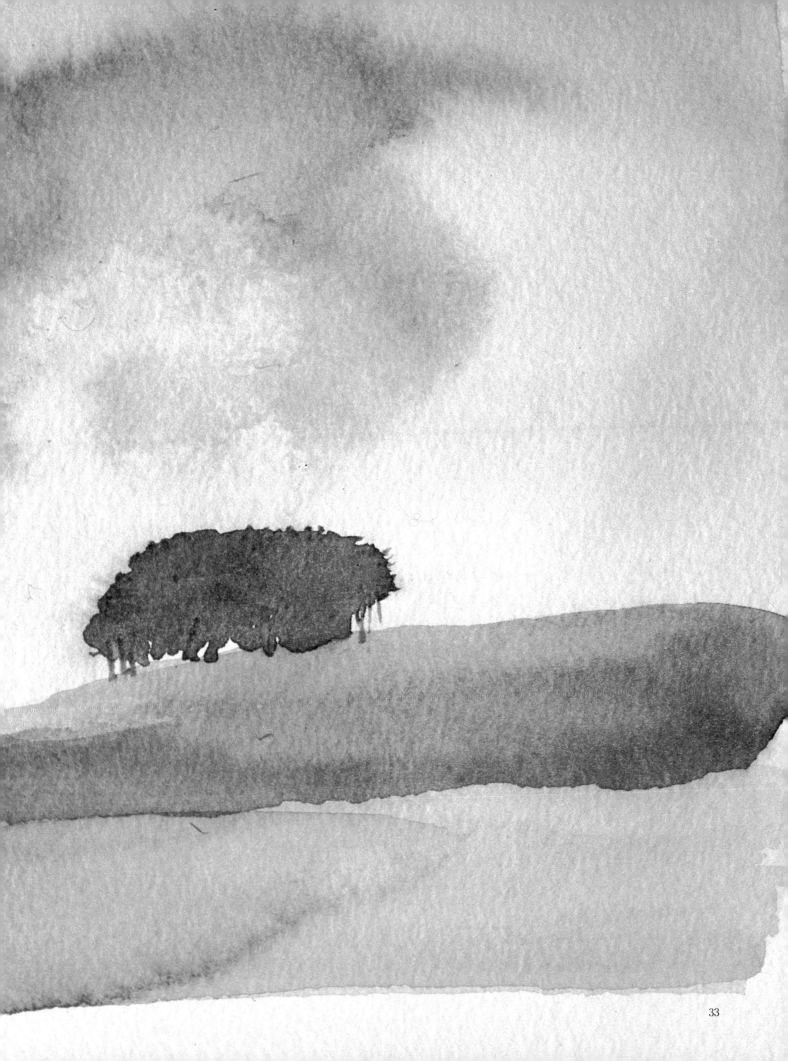

Techniques
LAYING A FLAT WASH

In a wash watercolour paint is diluted with considerable amounts of water and applied to the support in a very fluid state. The technique highlights both the attractions and difficulties of the medium. In a wash watercolour is revealed at its most transparent and subtle, but the quantities of water involved, the unpredictability of the reaction between paper and paint, and the uncertainties introduced by variables such as room temperature, add an edge of excitement whether the artist is an accomplished exponent or a struggling beginner.

You will need lots of clean water, at least two jars –

one for cleaning your brushes and the other for mixing paint. Clean your brushes between applications of colour, otherwise tiny amounts of paint will stray into your wash and spoil the purity of colour. Some pigments have particularly powerful staining qualities and a minute amount will contaminate an entire wash. You will need a palette or dishes to mix the wash in – their size will depend on the area you intend to cover. The recesses in the lid of your watercolour box may be adequate but a saucer will do if you need something larger. The secret of successful washes is to mix plenty of colour – otherwise you will run

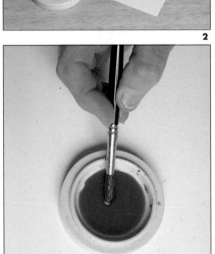

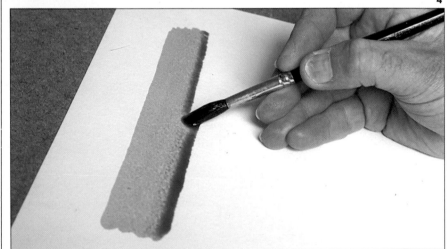

1 You will need paints, tube or pan, a palette, stretched paper, a brush, lots of water and a board of some sort.

2 Mix the paint and water in a dish. Use plenty of water and make sure that you have enough wash to cover the area.

3 Fix the paper to a board – the wet paint can then be controlled by tilting the board. Here the artist used Cotman 140 lb unstretched. Start by loading the brush with the dilute colour and lay a band of colour across the top of the tilted board.

4 Now, working in the opposite direction, lay a second band of colour making sure that you pick up the fluid paint along the base of the previous stroke. Here the artist lays a third band of colour – the tilted board has caused the stream of colour to gather along the bottom.

out half-way through and will have to stop to mix more. Not only will it be difficult to get just the right intensity of colour the second time, but whilst you are mixing it, your first application will have dried, leaving ripples and tidemarks.

You will need something to paint on – ideally you should stretch a sheet of good quality paper. Large quantities of water cause most unstretched papers to cockle – not only does this look unsightly, it causes the paint to puddle so that it is impossible to achieve a flat wash. Some heavy papers do not need stretching, but, just

to start with, you should stretch all your paper. Start by doing things by the book and you will avoid disappointment and make rapid progress.

Here we describe laying a wash with a brush, but you could also use a sponge, especially if you want to cover a large area. The method is otherwise the same. Make sure that you have lots of paper, and experiment with both techniques. Use different colours; this will help you become familiar with the colours in your box and with their peculiarities. Keep all your practice sheets, as you can use them to practise the techniques described later.

5

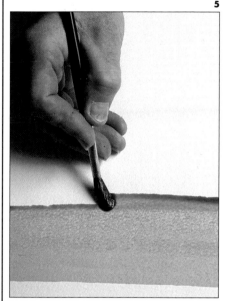

6

7

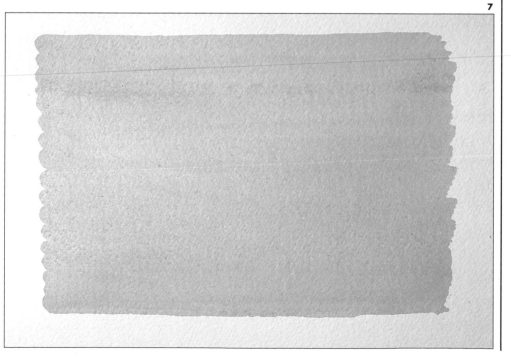

5 The secret of a good wash is to mix plenty of colour, work quickly, tilt the board and keep the front edge wet. Keep the brush loaded with colour to avoid running out of colour in the middle of a stroke. Reload, when necessary, at the end of a stroke.

6 When you have finished, use a dry brush to pick up the stream of fluid paint which has gathered along the bottom of the wash.

7 When the wash is dry the colour should be even in tone, though it will be lighter than when wet. If your wash is uneven, practise until you can get it right. You may never want to lay a completely flat wash but you will need this degree of control over the medium.

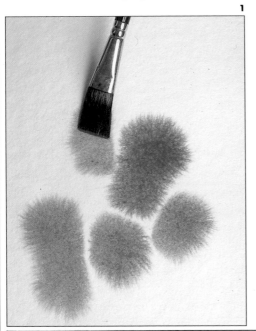

WET-IN-WET

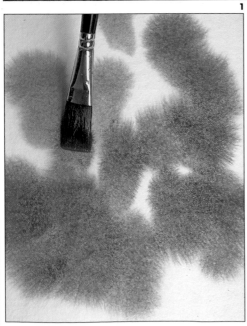

The term wet-in-wet describes the application of paint to a wet surface – this may be paper dampened with water, or paper on which there is already wet paint. You will have to master wet-in-wet techniques if you are to exploit watercolour to the full and, like the wash on the previous pages, the only way to learn about wet-in-wet techniques is to put paint to paper and experiment for yourself. You will soon find that watercolour is unpredictable and exciting, but the more you practise the more familiar it will become and the less alarming it will seem. To succeed you must be decisive and prepared to take risks – watercolour is definitely not a medium for the timid.

Wet-in-wet techniques have many uses. In the projects in this book, for example, the artist uses a very simple wet-in-wet technique to lay in skies. To do this, damp the paper, either with a large brush or a sponge. The paper should be damp rather than wet – the amount of water you need will depend on the type of paper, the room temperature and humidity. As you get more used to handling watercolour you will be able to judge exactly the amount of water required. Mix a solution of paint in a palette, load a large brush and touch the colour on to the

One colour on damp paper

1 Experiment first with a single colour. Dampen the paper with a large brush or a sponge. Mix a solution of colour – here the artist has used ultramarine – and lay the colour on to the damp paper with a large brush. Notice the way the colour spreads into the damp paper.

2 The colour continues to spread, but more slowly as the paper dries. When completely dry the colour will be paler and the edges softer than when wet. Practice with different papers and colours.

Two colours on damp paper

1 Now try the same exercise, but this time use two colours – here the artist has used ultramarine and vermilion. Mix solutions of the two colours and then dampen the paper as before with either a brush or a sponge. Use a brush to touch-in one colour, clean the brush and then dot in the other colour.

2 The paint will continue to bleed into damp paper – the amount will depend on the type of paper, how damp it is and the temperature and humidity of the room. The colour is paler than when wet, and the two colours have blended in places to create a third.

WATERCOLOUR

damp paper with the tip of the brush. You will see the colour being drawn off the brush and spreading over the paper. If you have not worked in this way before you will find the effect quite startling. The colour will continue to spread as long as the paper is damp, but more and more slowly as the paper dries. When dry the edges will be softer and the colour will look considerably lighter. Again, only with practice will you be able to look at the wet paint and know what the dry paint will look like.

Wet-in-wet techniques can also be used to blend colours. You can start by laying a flat wash of one colour

and drop a second one into it. Alternatively, you can mix solutions of two colours and drop one colour on to the damp paper, then clean the brush and do the same with the second colour. In both cases the colours will bleed into each other, creating a marbled effect with blurred edges at the margins of each colour. The final effect will depend on the dampness of the paper, the concentration of the washes, and the amount of colour solution used.

Wet-in-wet

1 Try this experiment. Lay a flat wash of colour – here the artist has used chrome yellow on a sheet of very heavy handmade paper. Then while the wash is still wet brush in two strokes of another colour – here the second is cadmium red.

2 The second colour spreads into the wash, the two colours blending to create orange. The mark of the brush enlarges, the edges blurring, but the broad form of the original mark is still discernible.

Wet-on-dry

1 Now using the same colours as above try this experiment. Lay a wash of the first colour, but this time allow it to dry completely – it must be absolutely dry. Now, using the second colour, lay two brush strokes on to the dry wash.

2 This time the colour does not spread and the integrity of the mark is maintained with crisp, clearly defined edges. This highlights yet another resource of the watercolour artist – the ability to create different types of edges – softly blurred edges using wet-in-wet techniques and crisp edges using wet-on-dry.

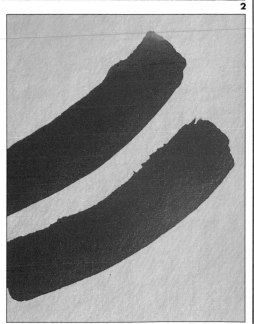

PAINTING WITHOUT WHITE PAINT

For the newcomer to pure watercolour the lack of a white paint presents both an intellectual and a practical problem, yet it is essential that this concept should be grasped if you are to use watercolours correctly. Those of you used to working in oil or poster colour will be quite stumped. How on earth are you to represent something white and how do you create lighter tones of a colour? The answer is twofold: paper and water. In true watercolour the white of the paper is the only white and your lightest colour. This means that you must plan your paintings carefully, allocating the whites at a very early stage and carefully guarding them. With many other media, white is created at a late stage by overpainting with white paint and you can make a last minute decision about where the whites should go. With watercolour, once you have lost a white area it is almost impossible to retrieve it. (There are certain exceptions which are discussed in Chapter 4).

But what about pale tones? To understand this you must remember two important things about watercolour. First, it is a transparent medium and, secondly, the support is white. The vehicle for carrying the paint to the paper is water and as you increase the proportion of water to paint so you increase the transparency of the paint. What you are really doing is increasing the extent to which the white paper is allowed to show through the paint layer.

We look at this concept more closely in the following pages when we discuss the ways in which you can create tones.

To understand watercolour you really must understand the implications of the lack of white. If you don't, you will constantly work yourself into corners from which you will find it difficult or impossible to extract yourself. You will start by making an area too dark, and in order to maintain the correct tonal relationships you will have to make the rest of the painting much darker than you had intended. Which brings us to the concept of working 'light to dark'. This describes the classical watercolour method in which the artist starts with a white sheet of paper onto which he lays very pale tones, making sure that the white areas are left untouched. The darker tones are built up as layers of colour, the darkest tones being added at the end.

The illustrations on these pages are intended to reinforce these concepts by demonstrating two different ways of creating whites. In the picture at the top of the facing page the pattern is created by painting around the shapes, leaving the white of the paper to show. But below, the pattern is created by laying down a strip of red paint and then using white gouache to paint the pattern. If you look at the strips below you will see that the final effect is much the same, but the approach required is entirely different.

BUILDING UP TONES BY OVERLAYING WASHES

In order to describe form you need to be able to create a range of tones – here we are looking at one of the ways of creating a range of tones with watercolour. If you were asked to create a blue tonal scale – a range of tones of a single colour, from lightest to darkest – how would you go about it? Your first reaction would probably be to reach for the white paint, and develop the scale by progressively adding more white to the blue. But there's the rub – you have no white! And because watercolour is transparent, it is not possible to overpaint and obliterate one colour with a lighter colour. The method of creating tonal variations which is illustrated on this page, exploits the transparency of watercolour by overlaying washes of the same colour. Start by laying a flat wash of your chosen colour. Allow the first wash to dry and then lay another wash over the first, leaving a strip of the original showing. As you can see, each additional layer of colour darkens the tone. See how many layers you can put down before the wash starts to break up. When you have finished you will have a tonal scale of the colour. Experiment with different colours and try different types of paper. You will find that the transparent colours give you a greater range of colours

1 Start by laying a flat wash of colour – you can use your sample washes. Make sure that you have enough colour to complete the exercise. Here the artist has used rose madder alizarin. Before progressing to the next stage allow the wash to dry.

2 When the first wash is dry, load a large brush with the same colour and start to lay a flat wash of colour over it. Use the same method as before, laying one band of colour under the next, working briskly from left to right, then right to left, keeping the front edge wet and picking up the stream of colour on each return stroke. Take the colour two-thirds of the way down.

3 Allow this second layer of colour to dry completely – if you don't, the overlaid wash will pick up the underlying colour and the flat, even tone will be disturbed. Load a brush with the same colour and lay the colour in exactly the same way as before, this time taking it down only one-third of the wash. Allow the colour to dry and you will see that you have achieved three tones of the same colour from a single solution of colour.

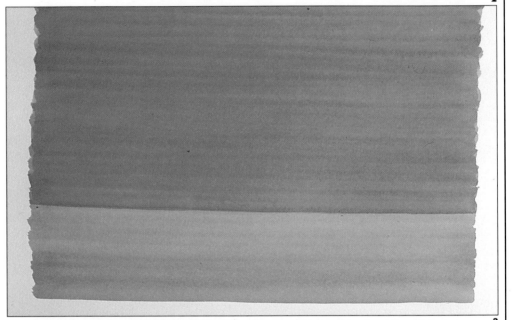

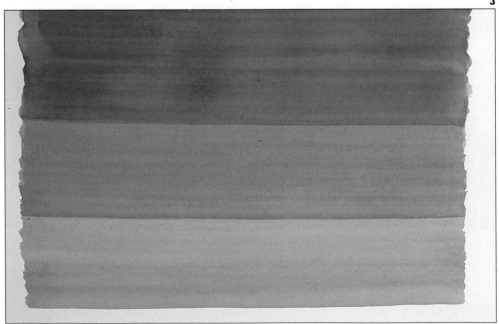

than the more opaque ones. You will also find that some papers can take more layers of colour than others, but eventually the wash will begin to break up. Make sure that each layer is completely dry before the next one is applied.

This technique of overlapping washes is very important in watercolour, and is exploited in the monochrome painting – the first project in this chapter. However, you will also overlap washes of different colours, each colour modifying the other to create a third colour, and all of them affected by the white of the paper which shines through the transparent paint layers.

1 To emphasize our point we have repeated the exercise with a different colour – ultramarine. Again we have started with a flat wash.

2 The first wash is allowed to dry completely and then a second wash of colour is laid over the first, taking it over two-thirds of the original wash.

3 A third layer of colour is laid over the other two, this time taking it down over the top third of the wash.

4 When the colour is dry you can see that again three different tones of the colour have been created by overlapping washes.

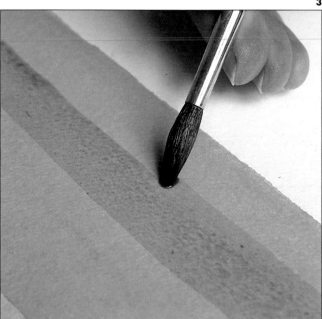

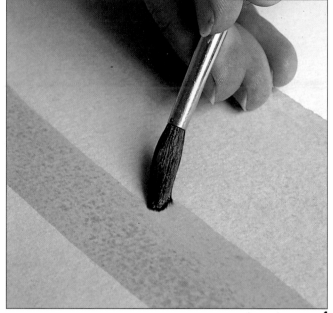

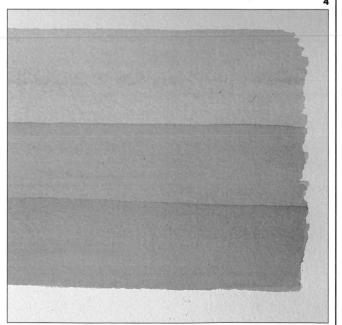

CREATING TONE BY DILUTING PAINT

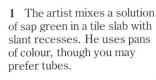

1 The artist mixes a solution of sap green in a tile slab with slant recesses. He uses pans of colour, though you may prefer tubes.

2 Below we see three bands of sap green. The artist mixed the darkest tone and laid the first band. He then added more water and laid the next band and so on.

On the previous pages we discussed the concept of painting light to dark and the building up of increasingly dark tones by overlapping washes of the same colour. So we now have a white – the white of the paper – and a limited range of tones created by overlaying washes. Here we look at another way of varying tone – this involves controlling the degree to which the paint is diluted. It is quite obvious, once you think about it, that the more the paint is diluted with water, the paler the colour will be. But if you are to use watercolour effectively and with confidence you need to know exactly how much water to

add to the paint, how a colour will look on a particular paper and what range of tones you can get from a particular colour. Here we suggest that you experiment with two greens: sap green which is rather transparent and oxide of chromium which is much more opaque. We have produced only three tones of each colour – when you have tried this simple exercise, see if you can create a continuous tonal scale by painting a square of the most intense shade of the colour you can get, then add a little water and paint another square beside the first. Continue until you have a shade so pale it barely tints the paper.

3 Here the artist has used exactly the same approach, but this time he uses oxide of chromium, a less transparent colour than sap green. This is particularly evident if you compare the middle bands of each sequence. Experiment with different colours – it will help you become familiar with the paints in your box. Each has special qualities, and it is very irritating to find that you have spoiled a subtle effect by using a colour which is too opaque or too strong.

You could darken your wash by adding more paint but it is easier to control and predict the effect of adding a certain amount of water.

3

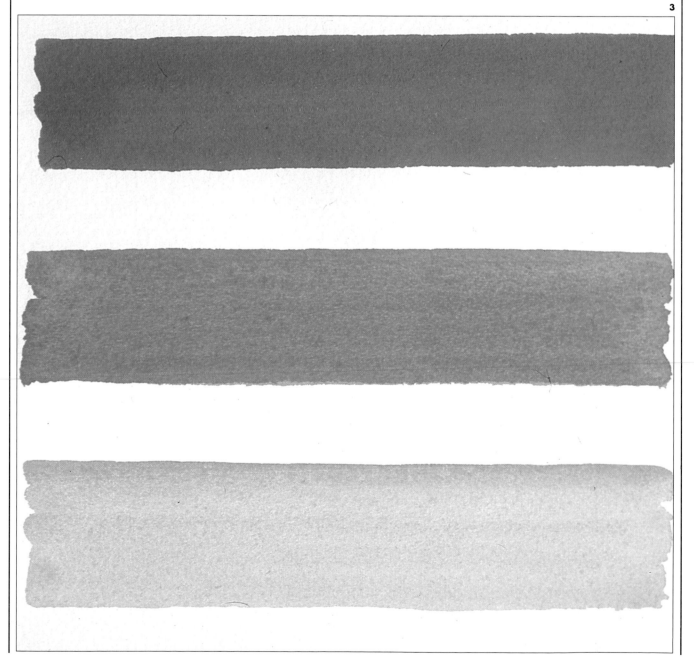

LAYING A GRADED WASH

Graded wash on dry paper

1 Mix a solution of colour and load a brush with this full-strength mixture. Lay a band of this colour across the top of the paper.

2 Lay several more strokes of the same full-strength colour as you would for a flat wash.

3 Dip the brush into water and lay a band of colour, picking up the wet front.

4 Continue in this way, gradually increasing the ratio of water to pigment to achieve a gradual lightening of the tone.

5 The finished wash dries lighter than it looked when wet and you must allow for this.

A graded wash is one in which the colour is dark at the top progressing through carefully controlled tonal gradations to the bottom of the wash, where it merges into the colour of the paper. Graded washes can be laid in one of two ways. In both cases you will need stretched paper which is fixed to a board. The board should be tilted at about 30 degrees. For the first method you mix a solution of colour, and with this full-strength mixture and a loaded brush lay a band of colour across the top of the sheet. Keep the board tilted so that the colour runs down. Dip the brush into clean water and then lay another band under the first,

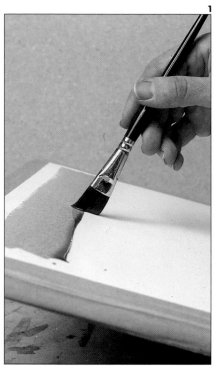

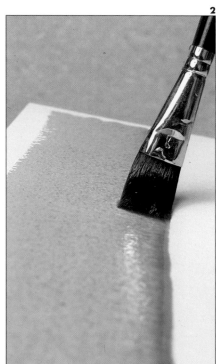

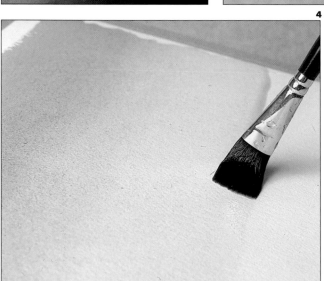

picking up the wet front. Continue in this way and you will find that the colour gradually becomes lighter in tone. You can achieve the same effect by adding water to the original wash before each stroke. You can also lay several bands of one strength before diluting the wash.

For the alternative technique you should damp the lower part of the paper where you want the pale colour to be. Mix the solution of colour as before and lay a band of paint across the top of the paper. Then working quickly take the colour down into the damp paper, where it will become paler.

Laying a wash into a wet area

1 Now try to achieve the same effect in a different way. Start by damping the **paper** with a sponge or water – blot off excess water.

2 Start with the full-strength solution in the same way, laying the colour with a loaded brush and picking up the wet edge of the wash.

3 Eventually you will take the colour down into the damp area and, as the paint solution meets the wet paper, it will become lighter in tone.

4 The final effect is much the same as that achieved using the previous technique. Nevertheless this method is useful when you want to establish a pale area in a particular part of a painting.

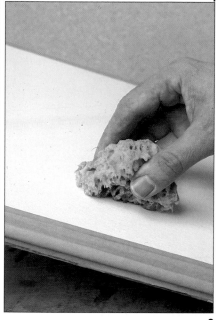

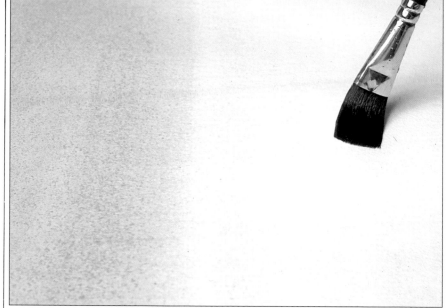

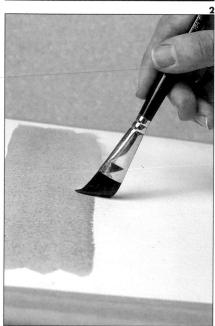

Rain Clouds 1
MONOCHROME

For this, your first watercolour painting, you will need only one colour, lamp black. The word monochrome is used to describe a drawing or painting in which only one colour is used. The exercise will give you practice in judging and mixing tones, laying and controlling wet paint and creating form and space with only one colour. It will also allow you to apply the knowledge you have gained by doing the exercises on the previous pages.

You may use either pan colour or tube colour. When mixing large quantities of a single colour it is probably easier and quicker to use a tube – you squeeze a little colour onto a palette and add water. With pan colour you have to pick up colour from the pan with a wet brush, take the loaded brush to the palette and add water. You may have to return to the pan several times in order to take up sufficient colour. However, the decision to use pan or tube colour is finally a question of personal preference. The type of ceramic palette with both slab and circular recesses is probably best for tube colour. The colour can be squeezed into the circular recess and water added when mixing small quantities, or larger amounts can be mixed in the slab recess.

Make sure that you mix plenty of colour – it is very irritating to run out half-way through a wash. If you do have to stop to mix more colour the wash will have started to dry by the time you return, creating ugly tide-marks when you wanted a smooth, even finish. This can sometimes be remedied by applying more water to the area and allowing it to dry thoroughly. The success of the remedy will depend on several factors: how dry the paint is, the type of paper and the staining power of the particular pigment. Only with experience will you be able to judge these accurately, but forewarned is forearmed, so we will try to alert you to the pitfalls which lie in wait for you. In most of the paintings in this book the artist has used Cotman paper, a new paper produced by Winsor & Newton Ltd which is particularly suited to the requirements of the beginner. One of its qualities is the ease with which colour can be lifted from its surface.

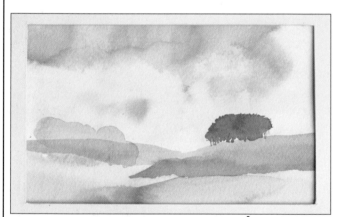

The subject of our first watercolour demonstration is a rolling landscape beneath a brooding sky. The painting evolves in a series of simple steps. Study the captions and pictures carefully and then have a go yourself. Good luck!

1 The artist used a sheet of unstretched 140 lb (300 gsm) Cotman paper 10¾ in × 14¾ in (22.5 cm × 37.5 cm). He used only one brush – a number 8 Kolinsky sable; a little piece of natural sponge; a jar of water; and a plastic palette.

The artist uses a sable brush loaded with water to dampen the paper. This is not as easy as it sounds for the amount of water on the paper is critical: too much and the colour will spread too rapidly and you will not be able to control it; too little and the paper will dry before you have run in the colour, creating tide-marks.

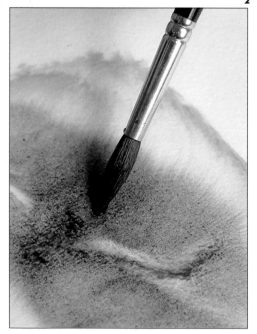

2 You must work quickly. The artist creates the sky using a wet-in-wet technique. He mixes a large quantity of colour in a plastic palette and, with a loaded brush, works across the damp paper touching in the colour with the tip of the brush. The colour spreads quickly across the paper, the variegated tones creating the impression of a cloudy sky.

3 The artist softens the edges of the wash by dabbing the wet paint with a small piece of damp sponge which lifts out some of the colour. When you first start working wet-in-wet the effect can be startling – everything is wet and apparently uncontrollable. Many things can go wrong – the paper can get too wet, there may be too much colour on the brush or your colour mixture can be too light or too dark. But there's no need to panic because as long as the paint is wet, there is hope. Here for example, the artist kept the edges soft by picking up excess colour from around the edges with a brush. He used the sponge to blot off colour to give greater transparency to the underside of the clouds.

4 Below we see just how effective and dramatic watercolour can be. We've actually done very little, but a great deal has been achieved by working with the paint and paper, and to a certain extent, by allowing the medium to dictate the outcome. Once familiar with the water, paint, paper and other materials, you can better handle the elements of risk and randomness inherent in the medium. With a few touches of the brush and by lightly controlling the wet paint, the artist has created an atmospheric sky. Notice the way in which the colour has been contained within the original wet area.

3

4

5 Here we have the artist working wet-on-dry in order to achieve crisp edges. It's important to make sure that the painting is absolutely dry before proceeding to this stage. The artist mixes a darker solution of lamp black and, using the same number 8 sable brush, lays down a swathe of colour to describe the distant hills. Notice how dark the colour looks and compare this with the tone in the final painting.

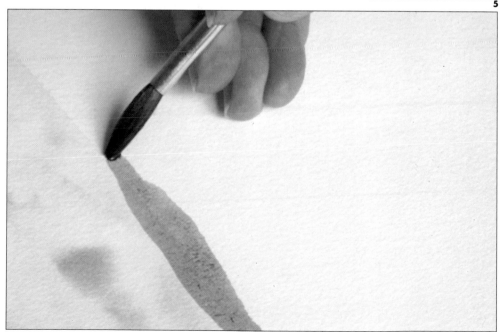

5

WATERCOLOUR

6 The artist adds more lamp black to his mixture and lays down a broad band of colour to describe the nearer hills. The darker tone creates the impression that these hills are nearer. This is the principle of aerial perspective, which states that objects in the distance are lighter in tone and less clearly defined than those closer to the observer. As you can see, with a few simple areas of a single colour the artist has already managed to create a sense of space and distance.

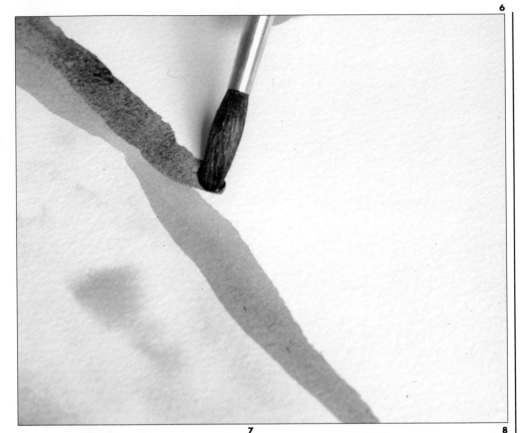

7 Next the artist uses a very light wash to establish the foreground. He works rapidly, keeping a wet edge to avoid streaking and takes the colour down the page. Where this wash overlaps the previous washes darker areas are created, adding interest to the middle distance.

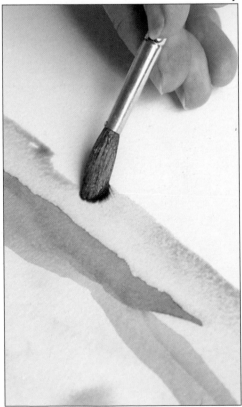

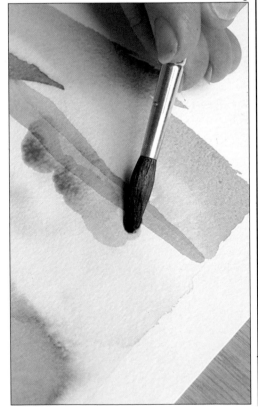

8 Using the same mixture and a loaded brush the artist now defines the clump of trees on the hillside. In this detail you can see quite clearly the transparent quality of watercolour and the effects created when one wash is overlapped by another.

9 A pool of deeper lamp black is laid down to describe the clump of trees which stands out starkly against the light sky. This feature adds interest and resonance to a painting in which most of the elements are very sketchily defined.

At this stage the artist stood back from the painting and viewed it from a distance to see if it was 'coming together'. He decided that a final wash was required in the foreground to establish this area and bring the whole painting into focus.

Here we show two versions of the final painting. In one we see the uneven edges of the paint areas, in the other we have dropped a mount over the painting. This has the effect of delimiting the boundaries of the picture, concentrating the viewer's attention. Cut yourself a mount to the correct size and use this to mask off the painting. Doing this at various stages as you work will allow you to 'see' the painting more clearly. Areas that are too dominant will jump out at you and those areas requiring more work will become apparent. While in these exercises the end product is less important than what you learn in the process of creating the painting, it is sometimes helpful for beginners to have their early works framed as they are able to see them as 'real' paintings. You will probably be pleasantly surprised to find that your picture is better than you thought... 'It's amazing the different a mount and frame makes.'

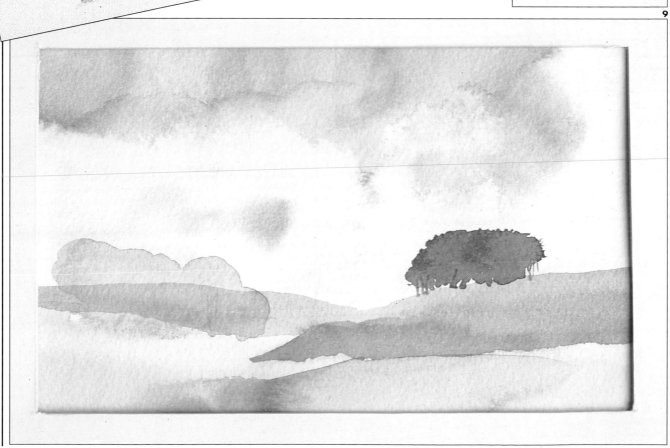

Lamp black

9

Rain Clouds 2
MONOCHROME WITH WASH

I hope that you will have been agreeably surprised by the range of tones and the variety of effects you were able to achieve with only one colour. It is a good idea, especially when you start painting, to limit your palette and concentrate on becoming familiar with the techniques and the possibilities of the medium. You will find that most experienced artists use a fairly limited range of colours. Certain basic colours crop up again and again in their work, but this basic palette may be supplemented by other colours introduced for particular purposes.

One of the special qualities of watercolour is its transparency. This means that the white of the paper glows through the layers of paint, giving it a special brilliance. It also means that you can overlay one colour with another, one modifying the other to create either a third colour or a darker tone. Here the artist demonstrates this quality by laying tints over the original monochrome painting. The effect is rather like that of a hand-coloured print. Try this yourself, but remember to make sure that the first washes of paint are completely dry before you start work. Otherwise the first washes will lift off and taint the top layers.

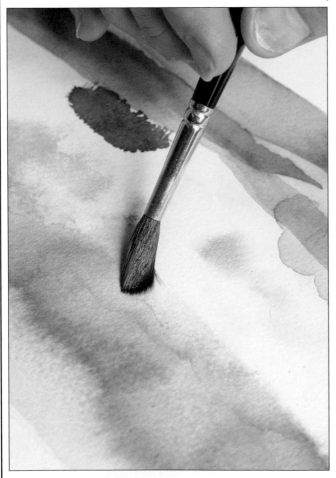

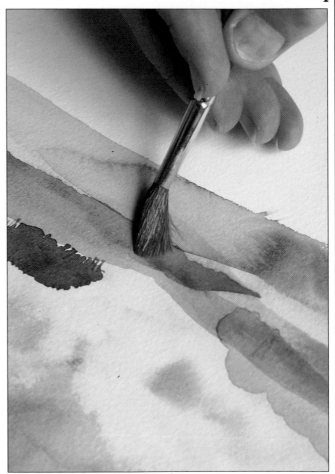

1 The artist used a number 8 sable brush and two colours – Winsor blue and yellow ochre. He mixed a quantity of Winsor blue wash in a ceramic dish. He used a number 8 brush and worked up the surface of the colour in the pan by going over it briskly with a wet brush.

The success of this exercise depends on speed and decisiveness. You must decide exactly where the colour will go before you start and make sure you have enough colour to complete the wash. The artist laid blue wash over the sky area with a loaded brush and you'll see that the tonal underpainting shows through the transparent colour.

2 Next the artist laid a wash of yellow ochre over the foreground. Again he mixed plenty of colour and worked quickly, the transparent wash adding a hint of colour to the foreground.

3 Here we have masked the painting again so that you can see it as a 'finished' object. Cut yourself a set of masks to fit the sizes that you work with. Drop them over your paintings to judge your work as it progresses.

Watercolour is unlike any other medium. Other water based points such as gouache, poster colour or acrylic are opaque, and the lightest tones are created by the addition of white, while darker tones are created by adding more of the same colour, or black. Working in watercolour is entirely different: you add more water to create a light tone – the thinner the wash the more the white of the paper will show through. The support – the painting surface – thus becomes extremely important, the texture and colour having a significant influence on the final image. In this painting, for example, the palest tones are in the sky just above the horizon where the white of the paper is overlaid by a subtle wash of Winsor blue.

Another way of creating dark tones is by overlaying several washes of colour as the artist has done in the middle distance. In most other media one colour will obliterate an underlying colour. Here, though, the ochre and monastral washes do not obliterate but rather modify the underlying tonal painting.

Lamp black *Yellow ochre* *Winsor blue*

3

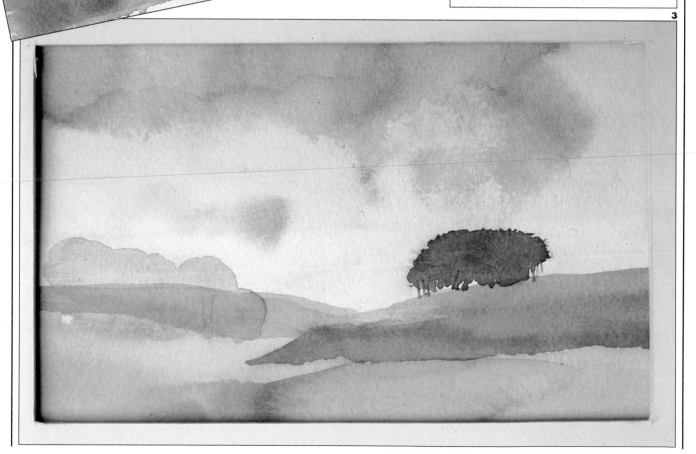

The Beach

GRADED WASH

<div style="writing-mode: vertical">WATERCOLOUR</div>

In this simple painting you will be applying a graded wash. This is a wash in which a colour grades from an intense shade, through gradual changes of tone to a very pale tone of the same colour. Here it is used to describe a clear, cloudless sky which shades to pale blue at the horizon – this is typical of a hot summer's day when the bright blue of the zenith is modified nearer the ground by heat hazes. This grading of colour helps to create a sense of space: the deepest blue is overhead, above the viewer, the paler colour is perceived as being further away.

Remember that there are two ways to lay a graded wash. You can damp the paper in the area you want to be palest and then take the colour down into that area. The other technique is to dilute the wash as you come down the paper, you can do this by dipping your brush into water and going directly to the paper. Alternatively, you can add a little more colour to your wash. Practise until you are confident that you can complete the wash without dithering – if you stop the wash will dry or will begin to run back. Laying a graded wash should take only seconds.

The painting is simple – a few bands of colour with details added in the foreground and in the distance, but it is, nevertheless, effective. Try and keep your painting simple so that you can concentrate on getting to know watercolour. When you are more familiar with the medium you can be more ambitious with your choice of subject.

1 The paper for this painting was Cotman 90 lb (185 gsm) and measured 10¾ in × 14¾ in (22.5 × 37.5 cm). The artist used two sable brushes, a number 3 and a number 8.

The artist mixed a solution of Winsor blue and Payne's grey. Tilting the board and using a number 8 sable brush loaded with colour and working left to right, the artist laid a broad band of colour across the top of the picture area. When he reached the edge he lifted his brush, picked up more colour, then made the return stroke, making sure that he picked up the 'wet edge'. He diluted the wash by adding more water, then loaded his brush with this paler colour and laid another band across the paper, continuing in this way to the bottom.

1

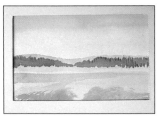

2

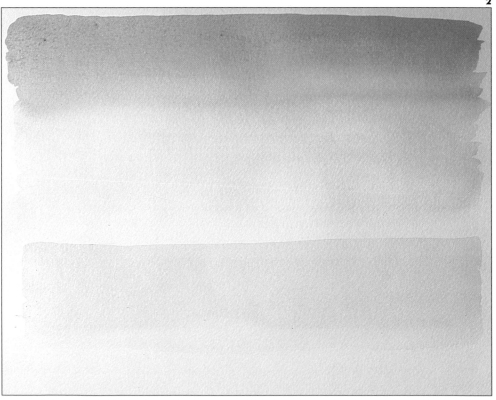

Here the artist has chosen a simple subject – a sandy beach backed by a strip of vegetation, and low hills.

2 The second wash of ochre and Payne's grey was laid down in the same way. Here you see the two areas of colour.

When laying any kind of wash it is important to work quickly and keep the board tilted, so that the swathes of colour blend evenly and do not run back into the wet area. The wash would not be smooth if that happened and you would end up with puddles of colour and tide-marks.

3 The graded washes were allowed to dry and, working wet on dry with a mixture of sap green and Payne's grey, the artist laid down the broad forms of the vegetation which borders the beach. Try to simplify your work as much as possible by concentrating on the broad forms rather than bothering with details.

It is important that you become familiar with watercolour and the way it reacts in different circumstances – only in this way will you gain confidence, allowing you to experiment and develop your own style.

4 In this detail the tip of the brush handle is being used to draw strands of colour out of the still-wet paint, effectively breaking up the smooth contours of the colour so that it suggests the spiky outlines of mixed vegetation.

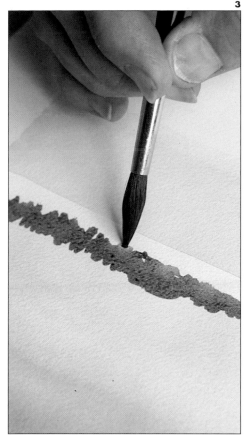
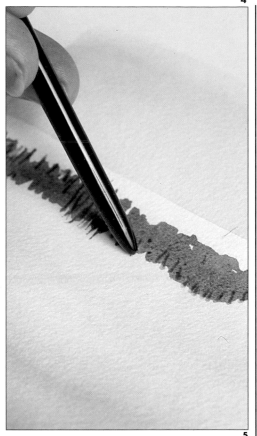

5 So far you have laid down only three areas of colour: two graded washes for the sky and sand and a band of wet-on-dry textured with the brush handle for the strip of vegetation. Yet, as you can see, the broad forms of a convincing landscape are already beginning to emerge. At this stage stand back from your painting and study it carefully to see which areas need more work. This is particularly important with watercolour, which is generally small scale and often painted on a flat surface. You tend to work close to the painting, either hunched over or even sitting down to it. This means that you do not tend to step back from the work at frequent intervals as you do with easel painting.

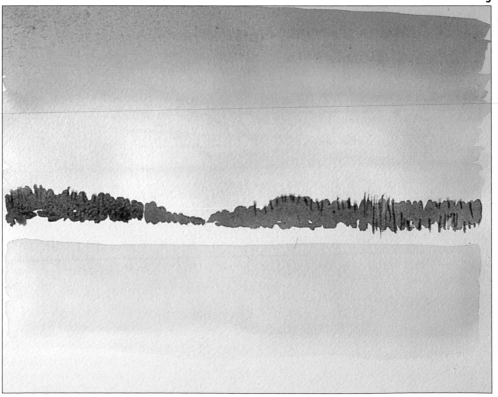

GRADED WASH/THE BEACH

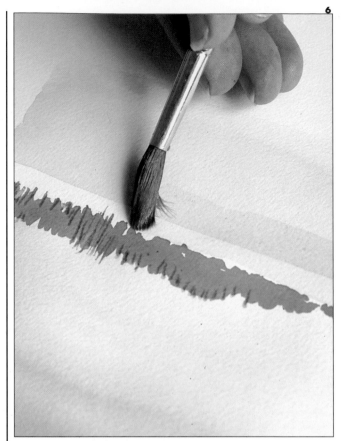

6 The artist decided to strengthen the middle distance by laying on a wash of yellow ochre mixed with a little Payne's grey and sap green – this detail shows very clearly the way overlapping washes help to build up the tone. Here a single band of colour creates a light ochre on the white paper and a darker ochre where it overlays the previous ochre wash.

7 The artist takes the ochre wash right down into the foreground area and, while the paint is still damp he paints the marram grass in the foreground using a smaller brush – a number 3 sable. Notice the way the colour spreads into the damp paper, creating soft lines. Compare this with the crisper lines created where the paint is applied to a dry surface.

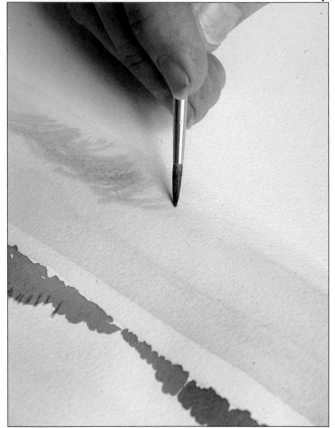

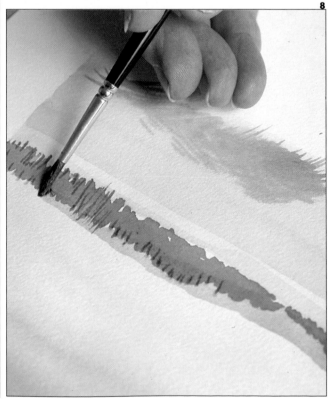

8 The hills along the horizon are painted with a wash of Payne's grey and Winsor blue applied with the smaller number 3 brush. The colour is applied wet-on-dry and dries with a crisp edge. Compare this with the softer quality of the marram grass which was painted on damp paper.

9 The artist completes the picture by mixing a little Payne's grey and ochre and laying a broad, wedge-shaped shadow across the beach. This simple wash of colour adds interest and form to a rather bland area.

In the demonstrations in this chapter we have introduced you to the basic techniques of watercolour – everything that follows merely elaborates or reinforces these first principles. Watercolour is a skill or craft which allows you to express yourself and visualize your ideas. To be a really good watercolourist you must obviously be able to draw and need a grasp of perspective, composition and the theory of colour. But these concerns are distinct from an understanding of the physical qualities of the medium, from the 'craft' of watercolour. So, while an ability to handle the paint well will not necessarily make you a good artist, it will help. In the same way you may be a great poet, but if you cannot write or type it will be difficult to record your thoughts and read them back. Watercolour is merely one of the means of expression available to the artist. When you are so familiar with the medium that it becomes second nature, you will be able to concentrate on what you are trying to express rather than on the mechanics of the process. Like learning to write, to ride a bicycle or to drive, the initial stages are tedious and you may be tempted to take short cuts, but the effort is worth the freedom that confidence and real skill give.

Payne's grey	*Yellow ochre*
Winsor blue	*Sap green*

9

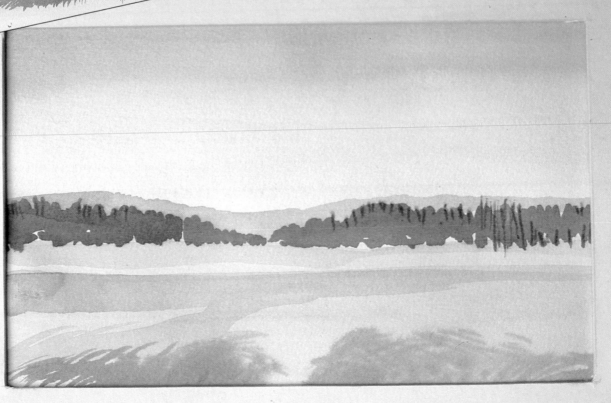

Chapter 4
Further techniques

Having mastered the wash you are now well on your way to success as a watercolourist. It is important that you should nurture your early enthusiasm for only that will carry you through the frustrations and setbacks. Here we take the techniques one stage further. Immediately you will be faced with the contrariness of watercolour, for having made great play of the lack of white and the restrictions this sets upon you – the inability to overpaint a colour with a lighter colour for example – we now contradict overselves. In the very first pages of this chapter we look at ways in which colour can be lifted from the paper whilst still wet – and even after the paint has dried. For many artists the process of laying on lots of fluid paint, blotting it out in places and dotting in more colour wet-in-wet, is an integral part of their technique.

Above all you must practise, for in watercolour there are no short cuts, no substitutes for personal experience. Only in this way will you get the skill and confidence which will allow you to move on from the first tentative stages to the process of discovery which allows you to make a medium your own. After all, you do not want to ape other people's work, but even if you do imitate their methods and techniques, they will become changed in the process, resulting in something unique and new.

We also look more closely at the brush, which is not just a means of getting paint to palette, water to palette and mixed colour to paper, but is also a draughting tool, a means of creating texture, gestural and descriptive marks; in short an important way of expressing yourself. As we have discussed in the chapter on materials, brushes come in a myriad of shapes, sizes, types and materials. Some artists work with a huge selection, others use no more than one or two. But every brush is capable of creating a whole range of marks, depending on the way it is held, the speed with which it is moved, the type of gesture, the amount of paint it holds and the type of paper. Do spend some time getting to know your brushes – they are an important part of the watercolourist's armoury.

57

Techniques
LIFTING COLOUR

In the previous chapter we talked about the lack of white in the watercolourist's palette and the limitations this imposed on the artist. As we said, the white of the paper then becomes the only white available, and pale colours are created by diluting the paint with water. It is obvious therefore that you must plan carefully to retain white and light areas, because they cannot be lightened by overpainting at a later stage. However, there are exceptions to every rule and artists are ingenious at overcoming the limitations of a particular medium.

Watercolour is a very fluid medium and takes a little while to dry. While the paint is still moist it is possible to lift the paint and thus lighten an area. The success of this process depends on several factors: how dry the paint is; the staining power of the paint; and the type of paper. As we have mentioned, different paints have different staining powers. The paints with high staining power are extremely difficult to lift once they are laid down. Winsor blue and alizarin crimson fall into this category and, under most circumstances, they will leave a stain on the paper. The paper's capacity to release colour depends on texture and the size used. The Cotman paper, which we have used

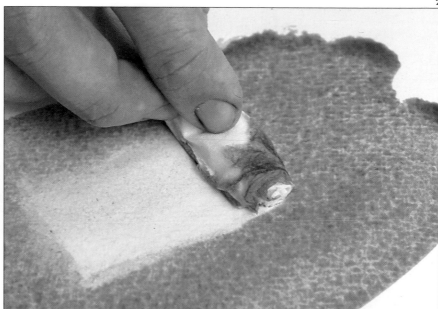

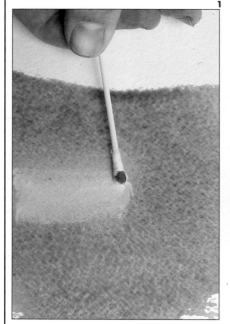

for many of the projects in this book, is particularly good for this purpose and you should try if possible to get some for these exercises.

Wet colour can be lifted from paper, usually with tissue, a brush or a soft cloth. This can be useful to correct mistakes or when you have flooded the paper and simply want to remove the excess. But it can also be used for more positive reasons, to create a light area for a particular purpose – clouds in a blue sky, ripples on water, or highlights on a vase, for example. In many ways it can be thought of as 'drawing back' into the paint.

Even when the painting is dry there are things that you can do – again, you may wish to correct a mistake or achieve a more positive aim. Here we illustrate the use of sandpaper or a blade to scrape off the surface of the paint – obviously this damages the paper surface. However, if you are interested in texture you may wish to incorporate this scuffed effect in your painting.

Now lay a flat wash and experiment with the following suggestions.

1 These cotton wool buds are extremely useful. The cotton wool absorbs the colour while the stick and the small size and neat shape of the bud gives considerable control. See how many patterns and shapes you can create.

2 Tissue paper is another useful absorbent material. Here a tightly rolled wad of tissue is used to lift colour from a still-wet wash.

3 A brush can be used to lift wet paint. Wash it thoroughly in clean water, then dry it by blotting it with cloth or tissue. Dab the brush into the colour and you will find that some of the paint is absorbed. Wipe the brush on tissue and repeat the process. If you want to lift a large area of colour you may need to rinse the brush in water at intervals.

4 A small sponge is an essential piece of equipment for the watercolourist. Sponge is an absorbent material, ideally suited for this purpose. It is particularly useful for lifting colour from large areas and for blotting sky washes to create cloud effects. Sponges are sold in art suppliers, but you will find it cheaper to buy one elsewhere and cut pieces from it as you need them. Use either natural or synthetic sponge.

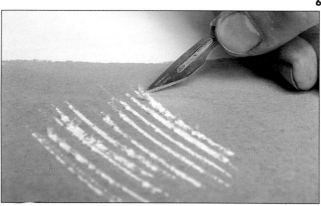

5 The examples on this page are all applied to dry or nearly dry paint surfaces. Here a fine sandpaper is used to lighten an area. The sandpaper should be handled lightly, but even so the surface of the paper will obviously be damaged. However, if your painting is dry and there is something you feel you must remove, this may be the only way.

6 Here a sharp blade is used to remove paint. Again, the paper surface is damaged, but the technique allows you to remove very small amounts of colour or create very fine details. It could also be used to introduce texture to an area.

7 This technique is known as a backwash, and it sometimes happens by mistake! The paint is almost dry and water is dropped on to the surface. Leave it for a few minutes and the colour will lift and separate, the colour particles tending to accumulate at the edge of the wet area. This technique is used to add texture to a painting, but it also shows that some colours *can* be lifted once they are dry.

LOOKING AT EDGES

Watercolour is a simple medium, based on a few principles but capable of almost infinite possibilities. Here I want to draw your attention to the different qualities of edges that can be achieved using wet-in-wet and wet-on-dry techniques. You may never have considered edges in isolation before, but they give you important clues to the visual world – at a distance, edges become blurred and ill-defined, while those close to you appear crisp and sharply defined. This allows you to imply distance in a painting and is exploited in aerial perspective. Crisp edges can also be used to suggest brightness. On a bright sunny day there will be a lot of contrast between the areas in full light and the shadows, which will be dark with clearly delineated outlines. So if you want to suggest brilliant sunshine introduce a few contrasty shadows.

The quality of edges is also important in the description of form. To describe a rounded object in certain light conditions you will need to create subtle changes of tone, one colour gradually blending into another. This effect can be achieved in several ways. You might, for example, use small dots of broken colour which blend in the eye, so that seen from close to the changes are far from subtle, but when seen from a distance the eye is deceived into reading them as a subtle gradation. You may decide to use a tighter, more meticulous technique,

blending the colours into one another so that there are no sudden changes of tone. In that case you would apply the paint wet-in-wet, allowing the colours to run into one another. To learn more about edges, and the way paint reacts under different conditions, we suggest you practise the exercises on these pages – no amount of reading can replace the experience of putting brush to paper.

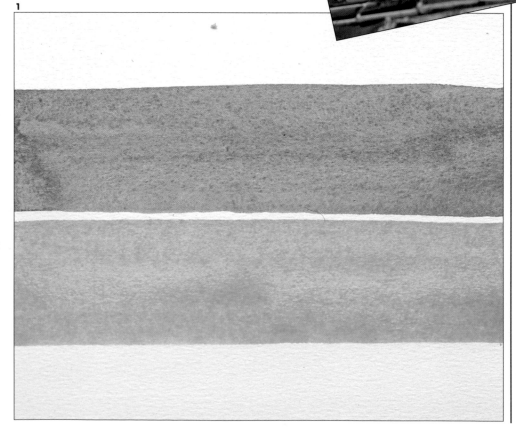

Collect jam jars and coffee jars – they make excellent water containers. As a watercolour painter you will soon find all sorts of alternative uses for household objects.

1 Lay two bands of colour side by side on to a dry sheet of paper, leaving a small gap between them. The colours used here are permanent mauve and prussian blue. Leave the paint to dry. The first point to notice is that the blocks of colour dry with a crisp edge – because they were applied wet-on-dry. The other point is that although they are laid fairly close together they have not run into one another. This can be exploited when you are painting in a hurry – out of doors for example. If you want to paint a sky and hills along the horizon and do not have time to let the sky dry first, you can lay in the sky and then, leaving a slight gap between the two, lay in the hills, filling the gap at a later date. The size of gap required will depend on the type of paper; on some papers paint bleeds more than on others – again, only experience will tell you which.

2

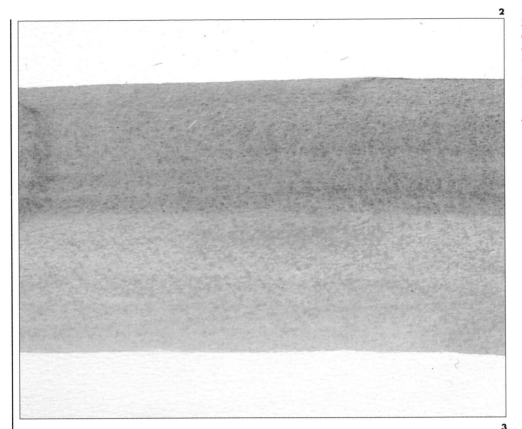

2 Next, using the same colours and working wet-on-dry, lay two bands, but this time allow them to just touch. Again leave it to dry. You will find that the colours merge into one another at the junction, creating a softer edge between the two colours. The wetter the paint, the more they will run into one another.

3

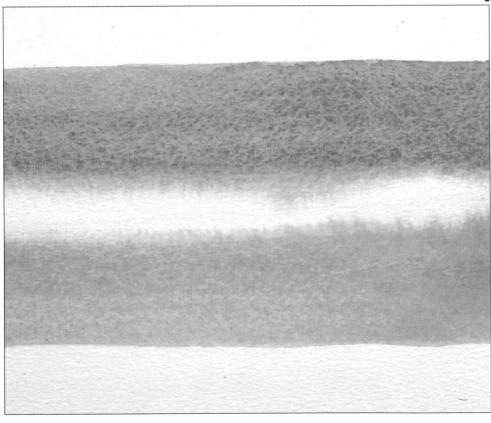

3 Finally damp some paper and lay two bands of colour onto it, leaving a reasonable gap between the two colours. As you see, the colours flow into the wet area, creating a soft edge – which should be compared with 1 and 2. Again, practise laying colours wet-in-wet varying the distance between them.

BRUSH MARKS

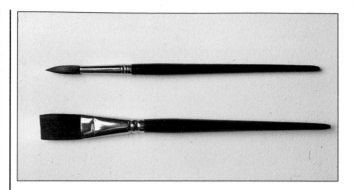

The brush is not just a means of getting paint on to the paper in the way that a decorator applies paint to the wall. For the artist, the brush is a means of expression, a subtle instrument to be exploited in just the same way as a flautist exploits his flute. The brush works in conjunction with the paint, the water and the paper, and you must be prepared to let these various elements do the work for you. So sometimes you will leave the brush on the paper for a moment and allow the colour to bleed off, rather than brushing it on. There are a great many different kinds of brushes and we have looked briefly at some of these in

Round number 9 Kolinsky sable

The marks were made as follows *(left to right, top to bottom)*:

Regular hatching marks, moving from the wrist.

Brisk vertical marks, again from the wrist.

Vigorous hatching, moving from the elbow.

Stippling, using the tip of the brush and moving from the elbow.

Rolling the brush.

A stippling movement, but applying pressure so that the ferrule is near to the paper surface.

Chapter 2. However, don't think that you need a huge selection – most of the paintings in this book were painted with just one or two at most. To start with, choose a couple of brushes and really get to know them. Start by holding the brush in different ways, close to the ferrule, part way up the handle, and at the very top of the handle. Each grip gives you a different range of movements and a range of marks. Except for close detailed work you will normally find that holding the brush in a fairly relaxed way will give you the best results. Now look at the range of movements that can be used. Depending on the scale of the work you can use wrist movements, movements from the elbow or, on really large works, movements from the shoulder. Experiment with all these gestures and try making a variety of long strokes and short strokes. Now do as we have here and take a flat brush and a round one of the same size, and see just how many different marks you can get from single brush. Use the tip of the brush, the centre, and the base near the ferrule. Make short stabbing strokes, long sweeping strokes, and rolling movements. Practise these marks and movements whenever you can, and you will acquire greater control over your brush.

Flat, ¾in ox hair
The marks were made as follows *(left to right, top to bottom):*
The flat of the brush, left to right gesture from the elbow, with a stiff wrist.
Stippling with the tip of the brush.
Stippling with the corner of the brush.
Brisk hatching marks from the wrist, changing direction.
Flat of the brush with a loose wrist.
Stabbing gesture with the side of the brush.

DRY BRUSH

Dry brush is a delicate technique which employs, as the name suggests, a brush which is only barely damp. The brush is dipped in the paint solution and surplus fluid is removed by squeezing the brush between thumb and forefinger – alternatively, the surplus can be blotted off on a piece of tissue. If you experiment with either of these techniques you will find that the fibres of the brush spread and become separated, and when applied to the paper surface create a light feathery effect. To create this effect in any other way you would have to use a very tiny brush and spend a great deal of time building up the delicate marks. Dry brush can be used for a variety of effects; in this book it has been used to describe grasses and shadows of grasses on a track. It could also be used to suggest wintry trees seen from a distance, the tiny twigs of a tree seen from close to, or feathers or fur. Practise dry brush techniques on a variety of papers and with different brushes. Also explore the range of marks that can be created with a stiffer brush than is usually used for watercolour.

1 Mix a quantity of the colour you intend to use, in a dish. Test the colour on a sheet of paper – if it is too pale, the technique will not show to advantage.

2 Now remove excess moisture from the brush by blotting it on tissue, or by pulling the bristles through your thumb and forefinger. This not only removes moisture, it also causes the fibres to separate into pointed groups.

3 Using the tip of the brush make a series of marks on a sheet of dry paper. You will find that the brush leaves not one but several marks.

4 Here the artist has built up a complex mesh of marks to show you how the technique might be used.

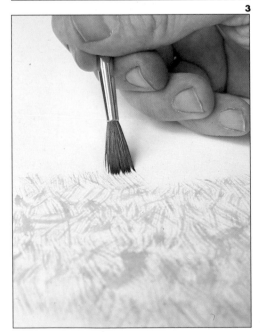

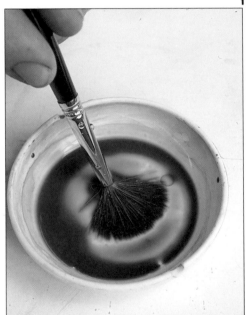

EXPLORING PAPER TEXTURE

In Chapter 2 we looked briefly at different types of watercolour paper and their qualities. Here we again look at paper and how you can get the most from it. For the beginner a Not surface will probably be most useful – its texture is smoother than Rough and rougher than H.P. The surface of the paper, whether smooth or textured, makes a great deal of difference to the painting. Look at the work of other artists and you will find that generally those who use a tightly rendered technique go for a smooth paper, whilst those who apply the paint rather freely like a more textured surface. Illustrators, for example, favour smooth papers as these allow them to render fine detail and are much easier to reproduce from – the pits and shadows on a textured paper are picked up by the camera in the reproduction process. The texture changes the feel of the paper, and this in turn affects the sort of gestures you make and the way you handle the brush. Textured paper has tooth, takes up a lot of paint and resists the brush. On a smooth paper, on the other hand, the brush slips over the surface with very little resistance.

Scumbling

1 This term, which is usually applied to oil painting, describes the application of paint so that coverage is uneven, allowing the support or underlying paint layers to show through. The result is broken colour. Here the artist takes up the colour on his brush, blots off the excess and applies the paint, brushing briskly.

2 Here you can see the uneven paint surface which allows the white of the paper to show through. The texture of the paper contributes to this effect – a smoother paper would produce a less broken effect.

Rolling

1 Here the artist has loaded a brush with paint and then rolled it over the paper surface.

2 As you can see the paint takes to the paper surface unevenly, catching on the high parts and leaving the recesses paint-free. The effect is heightened on this highly textured paper.

Country Track
DRY BRUSH

At this stage we have started introducing slightly more ambitious subjects and a few new techniques such as dry brush. However, the wet-in-wet washes and wet-on-dry washes which are the basis of all watercolour painting are still important but by now you should have gained confidence and competence. Nevertheless, every new painting will spring surprises on you, some pleasant and others instructive. Just when you think you've mastered the technique your paper begins to cockle, your watercolour puddles and runs back and your graded wash looks streaky. However, there are two points to remember. The first is that the finished painting is not the point. We all like to have attractive pictures to frame and show our friends but this is an achievement that must be earned rather than seized. The second is that your mistakes are often as instructive as your successes and if you are more concerned with what you learn on the way rather than the finished image you will not be afraid to admit defeat and abandon what is obviously a failure. The end is the attainment of the true skills, not an allegedly finished piece of incompetence.

The subject looks much more complicated than it actually is. It contains slightly more elements than we have introduced so far, but nevertheless if you think of the subject as an abstract composition it becomes a very simple collection of interlocking curved shapes. The track which curves away from the foreground through the middle distance and away to the horizon is the focal point of the painting, leading the eye into and over the picture surface. Simple shapes can be very satisfying and what appears elementary to the painter can look intriguing to the viewer. All representational images are abstract. The minute you start constructing a painting simplifications are made and that is part of the process of creativity – it's not a real landscape. Much of the art consists in persuading the viewer's eye to see more than you have put onto the paper.

This sketch was made on location using a very soft pencil. The path in the foreground leads the eye into the distance, a compositional device which creates a satisfying image.

1 The paper used here is 90 lb Cotman 10¾ in × 14¾ in (22.5 cm × 37.5 cm). The artist used only two brushes, a number 3 and a number 8 sable.

The artist wets the paper with a brush in preparation for laying in the wet-in-wet sky. The paper must be damp enough to allow the colour to flow but not so wet that it will pool. The amount of water required will depend on the type of paper and also the conditions in which you are working. If the room is very hot or if you are working outside on a hot day the paper will dry quickly. You must allow for this by using more water than you would otherwise. Here the artist applies small areas of mixed colour letting it flow into the damp paper.

2 The painting is left to dry and the colour gradually spreads over the paper surface creating a subtly modulated sky. Compare the lightened tone of the dried colour with that of the wet colour and allow for this effect when you lay in your own sky.

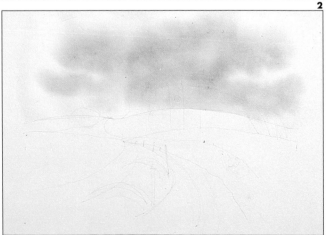

3 The artist now mixes a dilute mixture of sap green and yellow ochre. Test your colours on the edge of your painting. If your painting completely fills the sheet then use a piece of scrap paper but it must be the same as the paper you are using. Different textures and weights of paper can make astonishing differences to the final appearance of the colour.

The artist starts to block in the foreground using a number 8 brush loaded with colour. He works briskly so as to create a flat unmodulated wash. Then, while the paint is still wet, he reverses his brush and uses the tip to draw out strands of colour to suggest blades of grass overhanging the lane.

4 A very pale wash of sap green describes the softly-rounded slopes of the hills in the distance. The undulating contours in the right foreground are laid in with a flat wash of dilute raw umber. The raw umber is further diluted and a touch of Payne's grey is added. Using this mixture the artist lays down the verge with a single broad swathe of colour.

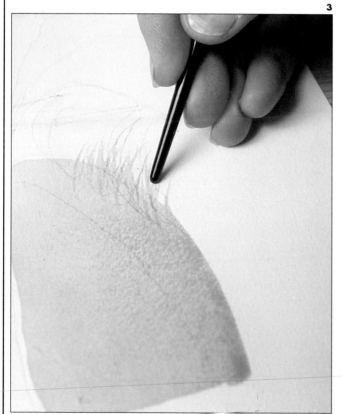

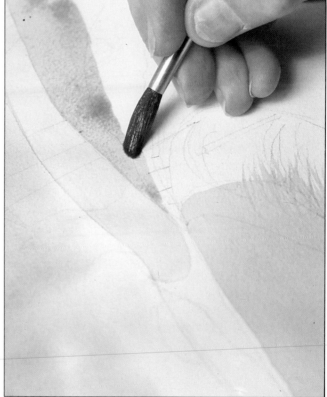

5 As you can see, the artist has simplified the subject and the painting is building up in broad areas. Many beginners fall into the trap of fiddling with details rather than seeing the images as large abstract forms. This is particularly important with watercolour which builds up one layer upon another; if the first layers are too fussy the subsequent layers will not 'tell'.

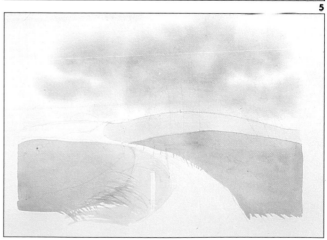

DRY BRUSH/COUNTRY TRACK

6 Watercolour is a flexible medium and by working wet-in-wet or wet-on-dry you can create entirely different effects and a great range of marks. Here the artist uses a mixture of raw umber and Payne's grey and with a number 3 brush draws in the spiky forms of the conifers crowning the hill. Once again, avoid the temptation to become distracted by details but rather consider the contribution that this element will make to the entire composition. You must constantly shift from the particular to the general, from the detail you are working on, to the way it affects the whole composition.

7 In the detail below the artist continues to develop the clump of conifers. While the first layer of green dries, he mixes a darker pine-tree green by adding more Payne's grey and a little sap green to the previous mixture.

Using the number 3 brush as a drawing instrument he describes the general forms. The broadly pyramidal shape is outlined by using a vertical stroke to describe the trunk and horizontal brushmarks applied with a rapid right to left swishing movement suggest the broad flat forms of the branches. The brush is a very flexible tool capable of making many different kinds of marks. Practise your brush strokes on a spare scrap of paper to develop fluid movements appropriate to the forms you want to describe.

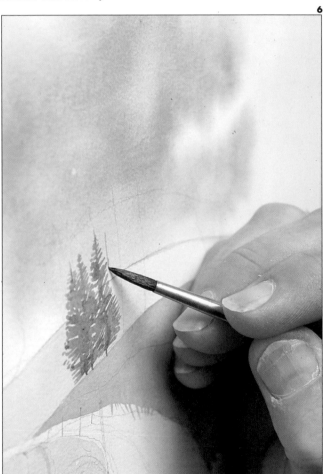

6

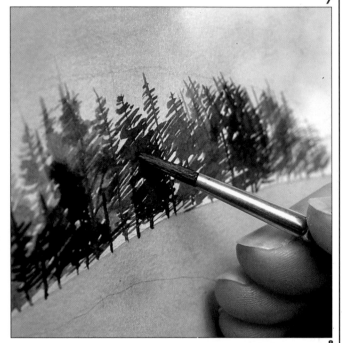

7

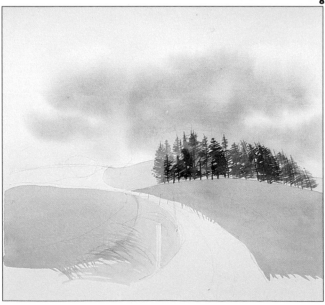

8

8 Review your progress at this stage. Stand back so that you can see your work from a distance. If you are working either from life, from a reference such as a photograph or directly from this book, you should continually compare your work with the subject. Try viewing the painting through half-closed eyes, this will help you concentrate on the essentials. Areas that are too light will become apparent and it will be easier to identify faults in the composition or drawing.

9 The clump of trees is now dry and the artist uses a dilute solution of Payne's grey to describe the drift of trees in the distance. On the right he has used the handle of the brush to break up the edge of the colour, suggesting the spiky silhouettes of conifers.

10 Sap green and Payne's grey is used for the vegetation which borders the path on the right. The artist uses the tip of the smaller brush to make a series of rapid marks, each one beginning broad then becoming thinner towards the end of the stroke. On the left he is using a drier brush to create the long tangly stems of the grasses.

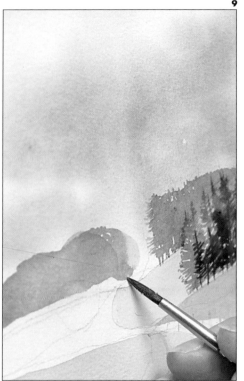

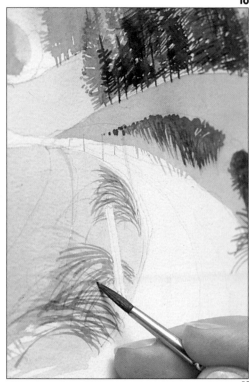

11 Working in the same way the artist adds more detail to the verges on either side of the path. He leaves this to dry, then a wash of raw umber toned down with a touch of Payne's grey is laid onto the area just below the horizon on the left. When the foreground is dry the artist strengthens it with light washes of Payne's grey, as on the right for example, and along the verge on the left. Finally a swathe of Payne's grey defines the high centre part of the rutted track.

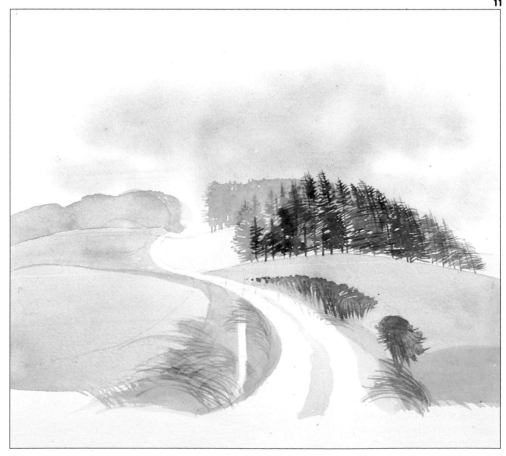

DRY BRUSH/COUNTRY TRACK

12 A Payne's grey-sap green mixture is used to add interest to the middle distance, the blobs of wet paint suggesting a clump of bushes. The transparency of the paint means that the underlying colours will show through, giving the Payne's grey a greenish tinge.

13 The artist works into the wet paint with the handle of his brush, drawing out the colour to break up the contours and suggest the twiggy outline of a bush. You could also do this with a fine brush but you would find that the bristles would pick up colour whereas the wooden handle of the brush merely moves it.

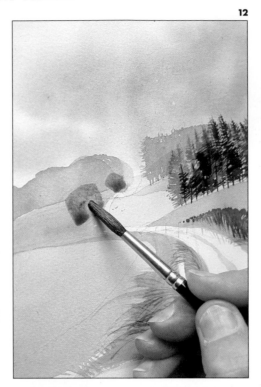

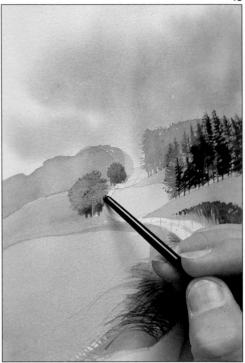

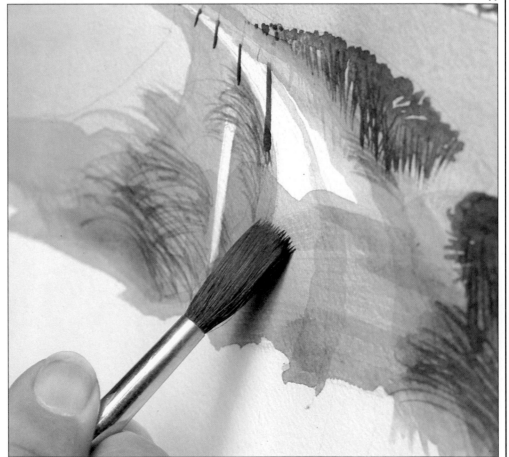

14 The artist continues to develop the foreground by laying a broad shadow of Payne's grey across the path and the adjacent vegetation. When this is dry he uses a dry brush technique to suggest the shadows cast by the tall grasses. A dry brush allows you to create very light, striated textures. You achieve the effect by removing most of the colour from your brush, either by squeezing the colour from the hairs between your fingers or by dabbing it on an absorbent surface such as tissue or kitchen roll. In both cases the hairs are spread in the manner seen here and the characteristic 'toothed' marks are created.

Detail
Here we see just how transparent watercolour can be. The background is clearly visible through the dark shrubs.

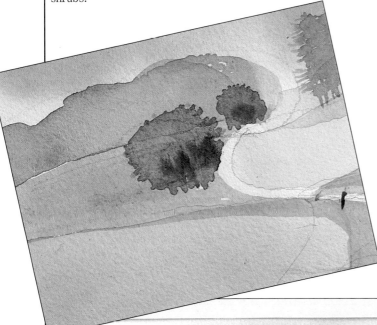

15 This painting is considerably more ambitious than those you have attempted so far. Nevertheless the techniques involved are simple wet-in-wet washes, wet-on-dry washes and a variety of marks which exploit the mark-making capabilities of the brush. It also illustrates the control and forethought which is required of the watercolour painter. You must decide where your lightest tones will appear and make sure that you keep them light. When you start it is better to err on the side of caution by laying down very light washes which can be overlaid and modified as the work progresses. Remember that you cannot make an area lighter – it can only be made darker. Remember too that watercolour is a transparent medium and you can paint details into an area and then dilute the effect by overlaying it with a light wash – the underpainting will still show through the subsequent glaze of colour.

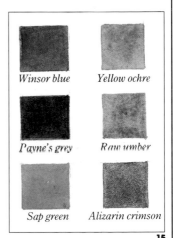

Winsor blue	*Yellow ochre*
Payne's grey	*Raw umber*
Sap green	*Alizarin crimson*

15

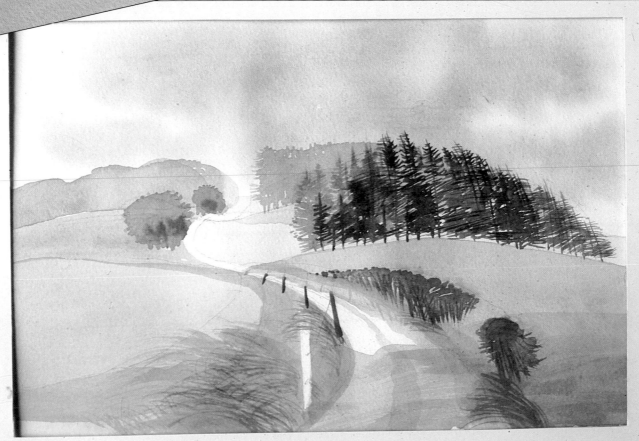

Mill in Winter

USING THE WHITE OF THE PAPER

One of the aspects of watercolour which many beginners find difficult to grasp is the concept of working light to dark. They also find it difficult to reconcile themselves to working with a medium that provides no white paint. The overriding characteristic of watercolour is its transparency which means that colour is built up as a series of transparent washes. White pigment is always opaque, so it covers any underlying colours. If white paint were mixed with watercolour, the watercolour would lose its translucency – it would in fact become gouache. So for all intents and purposes white paint is 'banned' from the palettes of pure watercolourists. At this stage it would be best if you could avoid the use of white. When you are more expert with the handling of pure watercolour you may well decide to mix your media and incorporate gouache, but that is really a more 'advanced' technique. Like most new concepts, once you understand and accept it, the principles of watercolour are not particularly difficult. But, especially if you have been used to a medium such as oil, gouache or poster colour, you will find it difficult to plan your work. The snow scene which we now demonstrate forces you to address this particular problem. The white snow is obviously the lightest part of the painting, so from the very beginning you must decide to avoid putting any colour in these areas. The shadows on the snow are the next lightest areas and these too must be reserved. Once a dark tone has been laid down, the only way it can be lightened is by physically removing it – with a tissue or sponge, for example. Particularly when you are new to watercolour it is probably best to build up your painting as a series of very light washes. Remember that in watercolour you can always get darker but you cannot (with certain exceptions) get lighter.

This snowcovered landscape will help you to understand one of the basic principles of watercolours – the paper is the only white you have to work with!

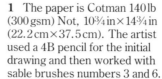

1 The paper is Cotman 140 lb (300 gsm) Not, 10¾ in × 14¾ in (22.2 cm × 37.5 cm). The artist used a 4B pencil for the initial drawing and then worked with sable brushes numbers 3 and 6.

He started by making a simple outline drawing of the subject. He did not put in too much detail, just enough information to tell him where the main elements of the composition were located. He uses very light pressure to avoid indentations in the paper surface.

2 The artist mixes a wash of Winsor blue and Payne's grey, making sure he has plenty of colour to complete the wash. Using a number 6 sable brush dipped in clean water he carefully 'paints in' the area of the sky, working along the horizon line up to and around the roofs of the tall gabled buildings. The area of the wash has been shaped by the water. In the detail below the artist is adding in the Winsor blue/Payne's grey mixture to the wet area.

3 The wet-in-wet technique is capable of almost infinite variety. You may be exclaiming, 'Not another Payne's grey/Winsor blue sky!' but if you examine the picture on the right you will see that the effect achieved is quite different. The artist laid down the colour by working across the painting from left to right then right to left. Near the horizon he has let horizontal strips of white paper show through the wash, creating a crisp cold mackeral sky.

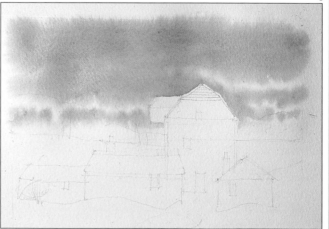

4 The artist mixes raw umber with a touch of Payne's grey and starts to block in the gabled end of the weatherboarded building. Stripes representing the boards were laid on in a slightly darker tone while the paper was still damp. The edges of these stripes are slightly softer than they would have been had the paper been completely dry.

5 The trees in the background are laid in very simply and directly with broad strokes of a burnt umber/ Payne's grey mixture. The buildings in the foreground are blocked in with a very dilute wash of burnt sienna.

6 The painting has progressed remarkably quickly for several reasons. The subject is simple and the snow on the ground and roofs makes the white of the paper a positive element in the composition. The white areas become more significant as you define other areas of the picture. Another factor in the speed with which the painting develops is the scale at which the artist is working. The artist tends to work on a fairly small scale especially when he is working from life. He does however work on a larger scale on other occasions, when the subject appears to demand it or when he has a particular commission to fulfill. You will soon find the scale you prefer to work on – you may even like to vary the scale quite often.

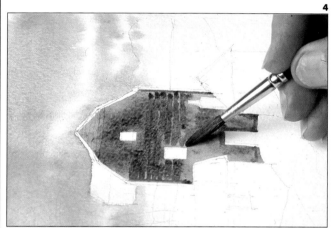

4

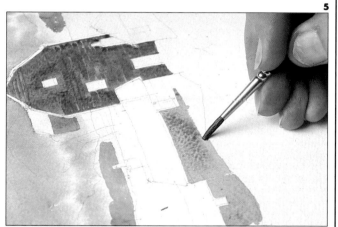

5

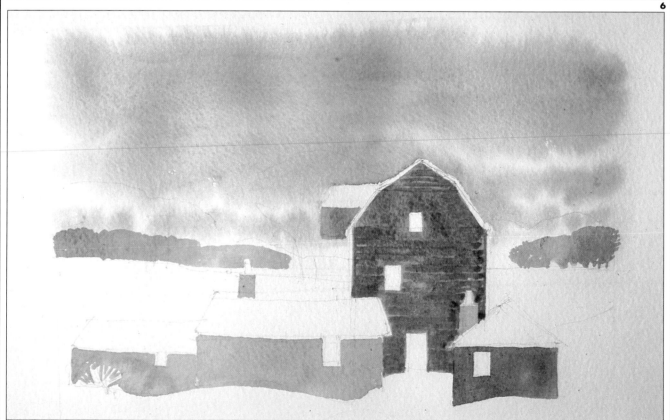

6

WATERCOLOUR

7 With a very pale tone of the burnt umber/Payne's grey wash, the artist lays in a band of colour along the horizon suggesting woods and coppices receding into the distance. Remember that pale colours and soft edges persuade the eye that the object is further away than a dark object with crisp edges. Now that the broad areas of the painting have been established the artist starts to add details. Below we see him putting in the glazed areas of the windows, using a mixture of burnt umber, Payne's grey and Winsor blue with the tip of a number 3 brush. Notice the way he has left the white of the paper to stand for the window frame and glazing bars.

8 A touch of cadmium red on the door adds a zest of colour. Payne's grey and burnt umber are used to draw in the skeletal forms of the wintry trees behind the house. The artist again uses a pale tone to place the group of trees in their correct position in space. Below, he uses the same mixture to draw the spiky outline of the small bush.

9 Snow is not white and flat, it is a reflective surface which picks up colour from its surroundings and in most instances the surface will be broken by humps and hollows which we see as subtle changes of tone. Here the artist uses a pale blue wash mixed from Winsor blue and Payne's grey to suggest the tones of the snow.

7

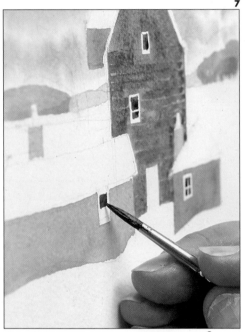

8

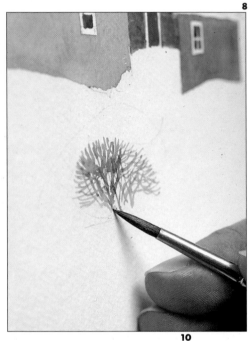

10 Here the artist lays a dark band of colour along the eaves of the roofs to describe the shadow cast by the overhang.

11 In this detail the artist adds interest and texture to the wash on the building. With a more concentrated mixture of the same burnt sienna he puts in dashed lines which very simply but precisely evoke the brick pattern.

9

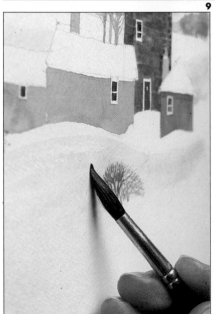

10

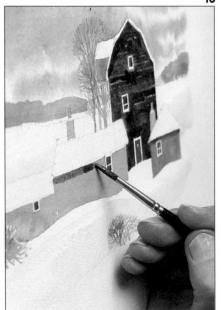

11

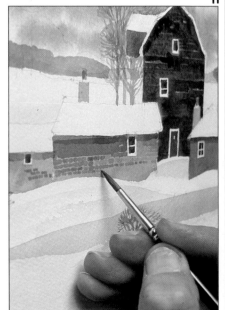

Detail
Watercolour is a flexible medium. Its transparency can be seen by the way in which the background shows through the skeletal forms of the tall trees. The soft modulations in the sky can be contrasted with the crisp edges of the blobs of colour which suggest the texture of the brickwork.

12 At this stage the artist carefully appraised the work so far. He decided he needed to define the various buildings because white on white is difficult to read. He chose to intensify the darker tones of the snow behind the roofs of the foreground buildings and removed any visual ambiguity. He also washed in some light directional shadows on the roofs where one shadow is cast by the chimney pot and where another is cast by the taller building.

This painting was created with a very limited palette but the effect is satisfying and convincing. It demonstrates in a very simple way the importance of the white paper in a watercolour painting – the white paper is the lightest tone you can achieve and must be carefully guarded when, as here, you require a pure white area. In almost any other medium white areas could be retrieved at a late stage by applying an opaque white pigment.

Winsor blue	*Burnt sienna*
Payne's grey	*Cadmium red*
	Burnt umber

12

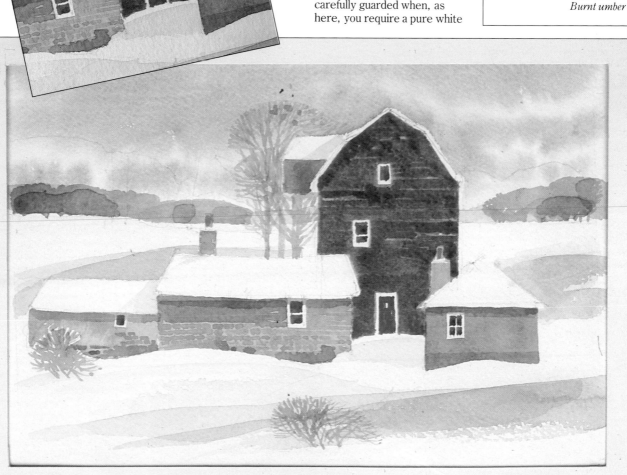

Child with Panda

MIXING FLESH TONES

In this book we have deliberately avoided subjects which appear difficult, for first and foremost we want you to learn to use and love watercolours. You can set yourself more ambitious projects when you are able to handle paint with enough confidence to really enjoy it. Portrait painting has always interested artists for it is one of the most challenging subjects, infinitely varied and full of expressive possibilities. We have chosen a portrait of a young child, an apparently difficult subject which the artist has treated simply and directly. You will find that watercolour is a particularly appropriate medium for describing the subtleties of flesh, especially the glowing translucency of youthful skin. Here the artist uses a series of pale washes, studying the child closely to get just the right colour. The

subject requires a direct approach for the colours must be fresh and lively. If skin tones are overworked they look dull and dead, not at all like real, living flesh. The artist uses a combination of wet-in-wet and wet-on-dry to create subtle blending of tones and crisp shadows.

One of the particularly striking aspects of this painting is the composition. The child and panda group occupy an unusually low position within the picture area, leaving a large empty space at the top of the painting. This creates a sense of balance and tension within the painting – the large, rather still background space providing a foil and a contrast for the small, busy area at the bottom. The large space around the group also draws attention to the youth and small size of the child.

Watercolour is ideal for capturing the freshness of a young child's skin tones.

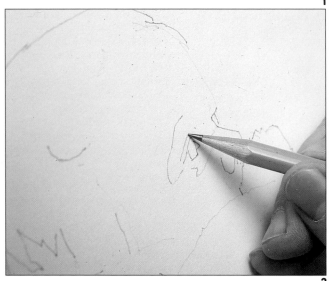

1 For this painting the artist stretched a sheet of Bockingford 140 lb (300 gsm), Not, watercolour paper, 30 in × 22 in (750 cm × 550 cm). The brushes were sable, numbers 8, 6 and 3.

The artist started with a very simple but detailed drawing using a 2B pencil. He had considered the subject carefully and knew exactly how he was going to approach it. He uses the pencil to define the outlines of the form and to delimit areas of tone.

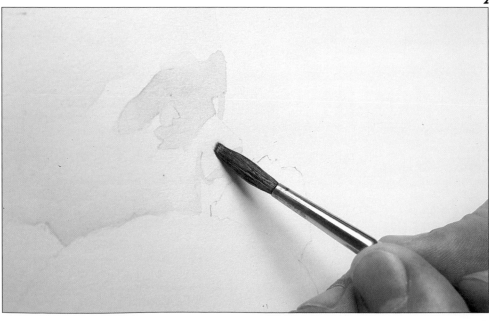

2 It is often difficult to identify areas of tone, especially when the subject is made up of very close tones. One way of identifying the tones is to study the subject carefully through half-closed eyes. The artist mixes a mid-tone from cadmium orange and brown madder alizarin, washing this into the area around the eye sockets and another touch of the same tone under the nose. These are usually the darkest tones on the face in normal lighting. The lightest tone is washed in with a dilute solution of cadmium orange. The same two tones are used to define the hands.

3 Next he starts to work on the hair by laying down a very pale wash of yellow ochre. Without allowing the paint to dry, he creates darker and more intense tones by adding more yellow ochre using a wet-in-wet technique rather than by introducing a new colour. Notice the way the pencil drawing helps him to identify the darker areas and the way in which he has simplified the subject.
There is a great temptation to regard hair as a mass of separate strands but from an artist's point of view it is a single object with a particular texture. For example, if you were painting a rope you would 'see' the whole rather than the fibres.

4 Below we can see the progress made so far.
The forms are beginning to build up very gradually as the artist lays down each subtly modulated wash. The subject requires sympathetic handling – crude brash colours would not be appropriate.
The artist's method of working is the classic watercolour technique. He establishes his lightest tones first, then gradually adding the mid and dark tones. Obviously the subject demands light colours but do remember that the colour will dry lighter than it appears when wet – but by now you are probably much better at making these judgments.

3

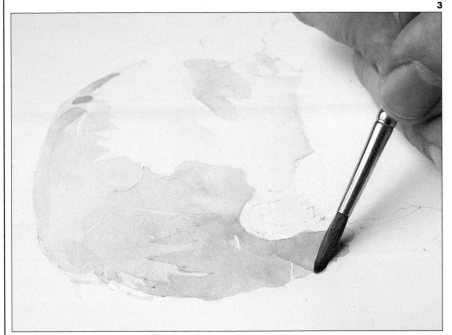

4

5

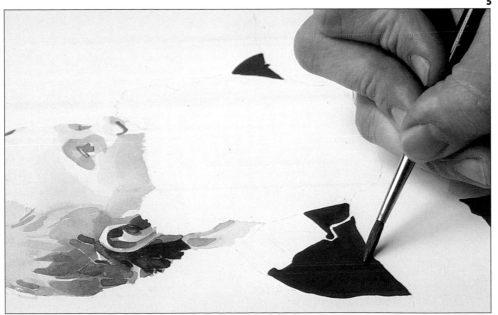

5 The artist continues working in this way, establishing the forms by laying in darker tones.
He uses sepia and yellow ochre for the darker tones where the back of the head is cast in shadow. The very darkest tones are created by adding Payne's grey to the previous mixture.
He develops the tones on the face with a warm shadow colour mixed from brown madder alizarin and chrome orange. The eyes are treated very simply by creating a dark colour from ivory black and Payne's grey. Pure black would look too heavy. The child's garments are laid in with a brown madder alizarin.

MIXING FLESH TONES/CHILD WITH PANDA

6 As we saw in the previous painting, white is a slightly difficult colour to render. In watercolour the whitest white you can get is the paper surface and the artist has deliberately kept this area of the painting clean. He uses a Payne's grey and yellow ochre wash to add tone, handling the colour very freely to describe the furry texture.

7 As a subject for the painter, eyes should not be any more of a problem than a pebble, flower or any other contained object. But they are difficult to handle because they have a special significance and are thought to reveal a subject's character. Our natural inclination is to draw them much larger than they are, this is shown in the way children draw the human face. Again, screw up your eyes and see the subject as an abstract pattern of lights and darks. Paint what you see, have the courage of your convictions and you will find that almost miraculously a convincing eye appears. Here the artist touches in the dark pupil in the centre of the iris.

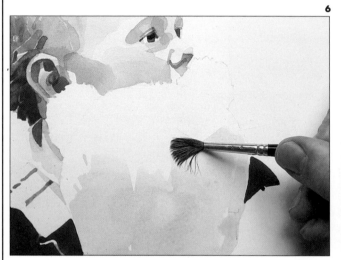

6

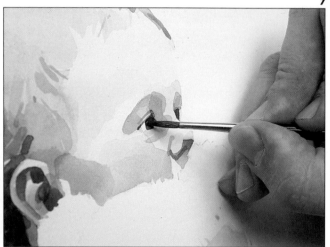

7

8 A rich juicy black is used to block in the dark furry texture of the panda's arms and legs. The flat black colour emphasizes the pattern-making qualities of the subject, adding another level of interest. Notice the sympathetic way the artist has handled the edges of the paint areas with the intermittently broken line capturing exactly the quality of the toy's fur.

8

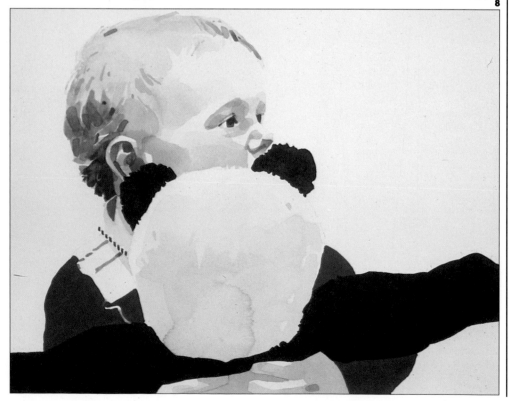

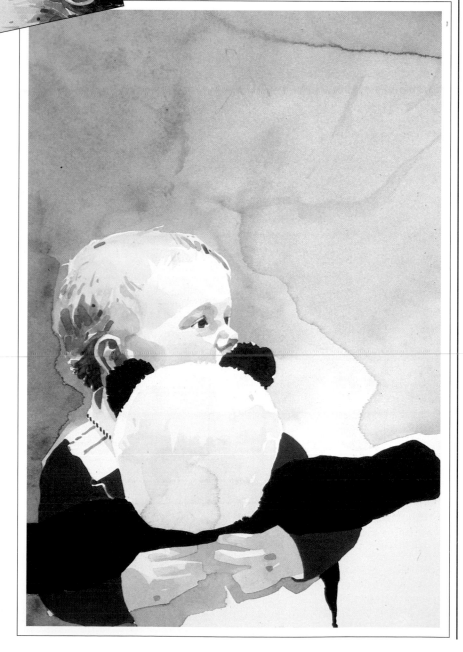

9 The painting is almost finished and the artist draws the whole thing together with a wash of Payne's grey which he scumbles into the background, working quickly and freely with a loaded brush. He works wet-on-dry and is not concerned with achieving a flat wash, because a textured finish breaks up the surface and adds interest to the painting.

Brown madder alizarin *Yellow ochre*

Payne's grey *Chrome organe*

Ivory black *Sepia*

10 The Payne's grey background is simple but adds considerable interest to the painting. The artist has made it darker on the left and lighter on the right. The fluid colour has puddled and run, eventually drying to a variegated finish of crisp ripples which suggest a marble or stone surface. The artist has applied the colour carefully around the contours of the body and head. This sharpens up the outline throwing the figure forward and creating very simply a sense of space. The choice of colour for the background is also important. Too bright a colour would overwhelm and dominate the subject. Too dull a colour would be unsympathetic to the freshness of the child's complexion. Payne's grey is a useful colour which can be mixed from ultramarine and black. Payne's grey nicely illustrates a problem for artists. The Payne's grey provided by one manufacturer is entirely different from that provided by another. The Payne's grey we used here is manufactured by Winsor & Newton and has a particularly useful bluish cast.

House by the Shore

WET ON DRY DETAILS

There are many ways to 'start' a watercolour. In almost all the examples shown in this book, the artist begins with a pencil drawing. The drawing serves several purposes including allowing the artist to see how the composition will work. If you are painting a bowl of flowers, for example, you can place the image at any size or position on the paper surface. Each combination of scale and location creates an entirely different composition. The pencil drawing also helps the artist organize his colour areas; thus, when he is laying down a blue wash for the sky, a light pencil line indicating the horizon will tell him where the colour should finish.

For beginners, deciding what to include and what to leave out is the first of many dilemmas. A simple homemade viewfinder can help. This is simply a sheet of card with a small rectangular window cut in it which is held to the eye to frame the subject. Hold the viewer close to your eye and it will frame off part of your surroundings. As you move it away from your eyes the field of vision will get smaller. As the different elements come into view your composition changes. Choosing which view you will use is the first step in the composition of the picture.

There are several subjects which strike fear into the heart of most people when they begin to paint. Any architectural subject is regarded as difficult because the artist has to cope with the perspective of a three-dimensional geometric shape. In a landscape painting, the soft lines of the contours blur the problems of perspective but as soon as a building is introduced it must be shown to stand squarely and convincingly in its own space. The architectural details such as windows, doors, bricks and roofing tiles also present problems, for there is a temptation to attempt too literal an interpretation when a few lines could be used to imply a texture or pattern. In this painting the artist has made things easy for you by avoiding these problems: the perspective difficulties are reduced by taking a square-on view of the house; and the architectural details are simplified by the use of representational rather than photographic effects.

1 The artist used a soft, 2B, pencil and three brushes – numbers 2, 6 and 8.

Here the artist uses a soft 2B pencil. It is important to use a light line and not to apply too much pressure. A dark pencil line will show through subsequent layers of paint and a heavy line will create indentations on the soft paper surface in which the paint will gather.

2 In this drawing we can see that the artist has made several decisions about the composition. He has chosen a simple straight-on view which avoids the perspective problems any other view would pose. About a third is allocated to the sky, the foreground occupies just under a third, while the house and the trees behind it occupy the remainder of the picture area. The house could have been higher up or lower down, it could have been larger but the artist has chosen to place it firmly in the picture area.

The artist has chosen a simple architectural subject and placed it in the centre of the picture area for maximum impact. Think carefully about the way you organise the elements of your painting, composition makes an important component to the final effect.

1

2

3 The artist started by wetting the paper in the sky area making sure that the paper was damp enough to allow the colour to flow without pooling or running back. With the wet brush he carefully traced the contours of the house and trees then, after mixing a wash of Payne's grey, he applied the colour using a number 8 Kolinsky sable. In this detail you can see him touching in the colour with the tip of his brush. Notice the way strands of colour bleed into the wet paper after the brush strokes have been made.

4 In this painting the artist has used the wet-in-wet technique from his previous paintings to create the sky. Here the effect achieved is quite different. By allowing the white of the paper to show through, he has suggested a billowing, moody and mobile sky. As we have said before, the techniques which the watercolourist needs to master are actually very few but the greater the skill and experience of the artist the more varied will be the range of effects he can achieve.

3

4

5

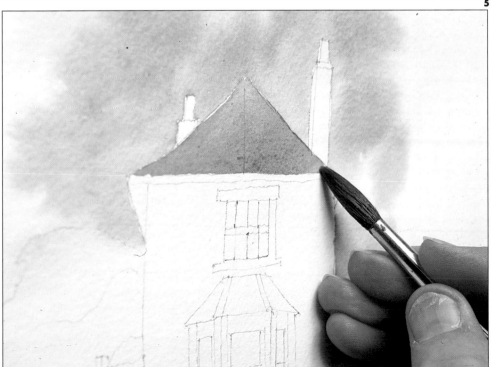

5 With a mixture of dilute burnt sienna the artist lays in flat areas of colour for the roof, the chimneypot and the brick columns between the windows. He works carefully using the same number 8 brush. Some of the details are small but by using the tip of the brush it is possible to create quite fine lines. He works wet-on-dry because he does not want the colour to spread. It is obviously important that the sky area should be dry before he proceeds to this stage for even if the paper were slightly damp the burnt sienna would seep into the Payne's grey.

6

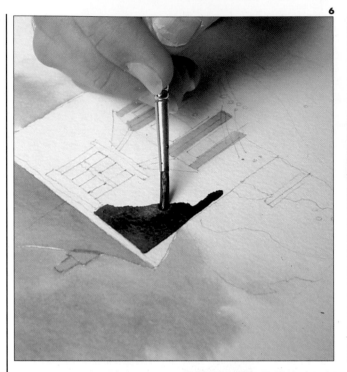

7

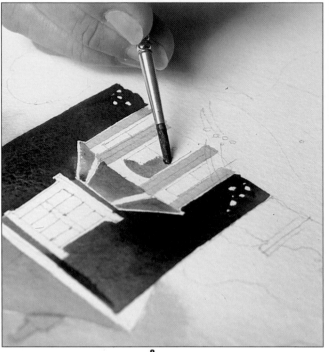

8

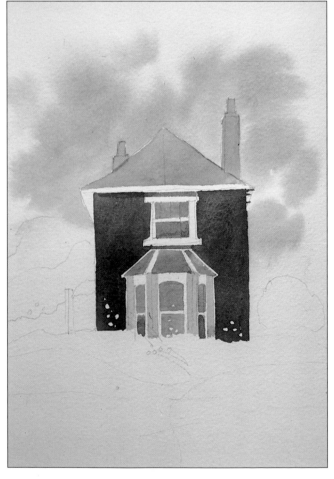

6 The dark tone of the house front is a mixture of Payne's grey and neutral tint. In the detail above, the artist applies this rich dark colour using a loaded number 3 brush. He works quickly starting from the top left-hand corner taking the paint down the page and keeping the painting edge wet, as he wants to create a fairly flat unmodulated area of colour.

7 In the detail above, the artist lays in a pale Payne's grey to describe the canopy over the bay window and the glazed areas of the windows. He works carefully with a number 6 brush making sure that he keeps the colour within the pencil lines since he wants to keep the window frames white and no paint must be allowed to stray into these areas.

8 On the left we can see the way in which the painting is developing. So far it has been treated as areas of flat untextured colour. The artist has simplified his subject as much as possible but nevertheless it is a convincing representation.

9

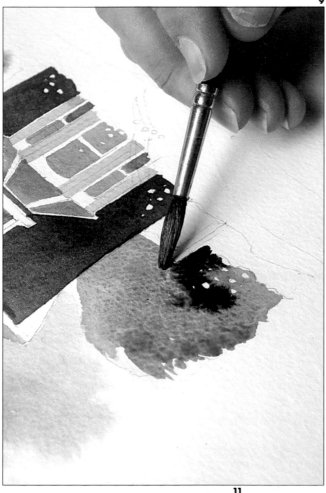

9 The artist now turns his attention to the canopy of trees in the background. With a mixture of sap green and Payne's grey, he blocks in the trees which stand behind the house. In this detail he bleeds Payne's grey into the still-wet paint to create a darker tone, carefully working round the white areas which he is reserving for the flower heads.

10 The tree on the right of the house is laid in using a wet-in-wet technique. The artist wets the area and then touches in Payne's grey so as to achieve a soft outline which contrasts with the crisp edge of the other clump of trees. A mixture of sap green and yellow ochre as a base colour for the hedge.

10

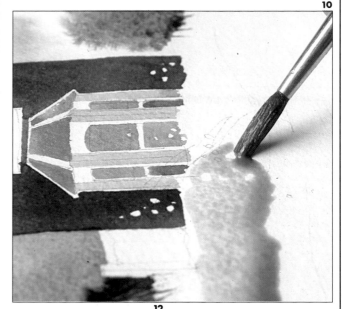

11

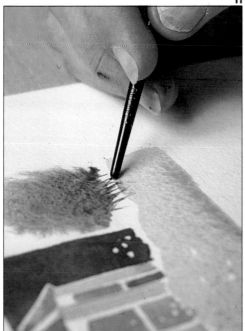

12

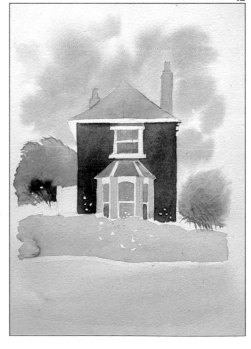

11 In this detail we see the artist pulling down wet paint from the Payne's grey. He uses the tip of the brush handle in order to create a crisp line which suggests the stems of tall ornamental grasses.

12 A very pale wash of the Payne's grey/yellow ochre mixture is laid into the foreground area and this is allowed to dry.

WATERCOLOUR

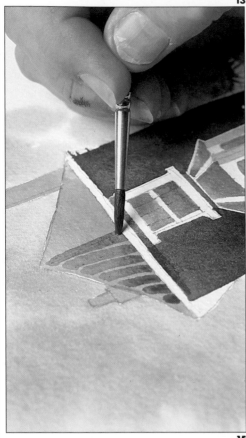

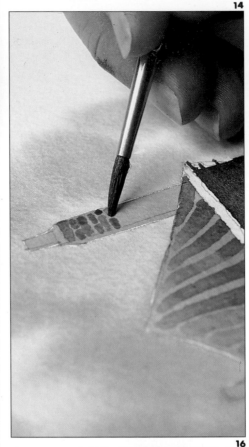

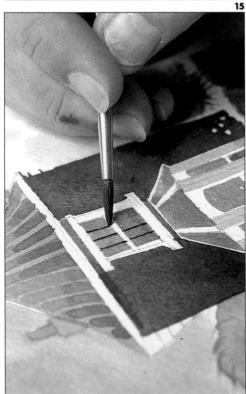

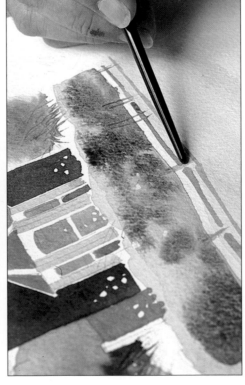

13 The artist wants to suggest the texture of the roof tiles. There is a great temptation to draw every single tile but the artist abstracts and simplifies what he sees and produces a shorthand representation of · reality. When faced with a subject such as this, ignore your ideas about tiles but study the subject intently, half-closing your eyes if necessary, and paint exactly what you see. In this case, the artist interprets the tiles as broad dark stripes which alternate with thin lines of a darker tone. In the detail above, he lays down stripes of a Payne's grey/burnt sienna mixture using a number 8 brush, overpainting the lighter tone with a darker tone. He is 'working from light to dark'.

14 In the detail left, the artist applies the same technique to create a brick pattern on the chimney. He allows the colour to blob at the end of each stroke, creating a darker brick.

15 In the detail far left, the artist draws in the glazing bars of the top window using Payne's grey. As you can see, he can create a very fine line using a number 3 brush.

16 A mixture of burnt sienna and Payne's grey was used for the dark shadows between the white boards of the wooden fence. Once an area is dry, there is no reason why it should not be made wet again. Here the artist wanted to create the texture of foliage in the hedge which runs in front of the house. With a damp brush, he wets the area then bleeds in a dark green mixed from Payne's grey and sap green. Again he uses the tip of the brush handle to draw down wet colour.

17 A few touches are added to complete the painting. A dark tone is laid on the shady side of the chimney and the same Payne's grey/burnt sienna mixture is used for the shadow it casts across the roof. Other details such as a light wash of Payne's grey on the guttering are added. The door on the left is painted with Payne's grey and Winsor blue and Payne's grey is used to create the dark areas in the windows. These suggest the space inside the house. The artist brings up the tone in the foreground by laying a wash of yellow ochre. Finally, a mixture of Payne's grey and burnt sienna is used to cast a shadow across the grassy foreground.

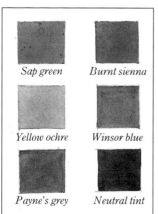

Detail
Here you can see the way in which the texture of the paper adds interest to an area of flat colour. The Payne's grey used for the front of the house is subtly modulated by the undulations in the paper surface. You can also see the way one colour is modified by a subsequent colour – in most cases the underlying colour shows through but when very dark tones are used, as in the darks within the windows, these completely obliterate the previous colours. This detail also shows you how free the initial drawing can be and how loosely the artist has followed the pencil line.

Sap green	*Burnt sienna*
Yellow ochre	*Winsor blue*
Payne's grey	*Neutral tint*

17

Chapter 5
Masking

Having started by persuading you that watercolour is really very difficult – we're now showing you little tricks of the trade which will make life a lot easier. By now you will have realized just how important the white of the paper is to the watercolourist and will undoubtedly have found how difficult it is to make sure that you retain your whites. You may have found the effort to make sure that you remember where the white areas are, and to ensure that you do not stray into them, very restricting. You may even have cheated and used white paint to rectify an apparently insoluble problem. Here we show you various ways of protecting the white of the paper. The first uses artist's masking fluid – a fluid which is applied to the painting with a brush or pen. It dries to a thin rubbery film, protecting the painting while you work, and allowing you to paint very freely. The mask is removed by gently rubbing it with your finger. It is very simple and allows you to handle projects which would otherwise seem entirely impossible – you'll wonder how you managed without it. There are other solutions to the problem too – wax can be used as a resist,

as can paper – each gives the finished image its own special quality.

In this chapter the projects are slightly more difficult and all use masking techniques to some extent. As before you are encouraged to work through the projects we show you here, though you may by now feel able to set up a similar project of your own. This is particularly the case with the study of anemones. Arrange a vase of flowers and set up a still life, thinking about the background and the lighting – you'll find that strong light emphasizes the tonal differences and may make the subject easier to tackle. Next think about your viewpoint – will you be looking down on the subject, up at it, or seeing it from straight on. Then decide whether you will be near the subject so that the image is seen in close-up, or will you view it from a distance, so that it looks smaller and you can see less detail. Will it fill the paper or will it be seen as part of the surroundings? You'll have done a lot of the work before you even put pencil or brush to paper – the time spent thinking is almost as important as the time spent painting.

Techniques
MASKING FLUID

We're back to the white of the paper, only this time we shall look at ways of reserving the white. As you will no doubt have found by now, keeping your white areas white and the light areas light takes a great deal of organization. In some cases, the subject is so complicated that maintaining the white areas becomes very tedious if not impossible, and certainly forces you to curtail your more expansive gestures. Masking fluid can be applied at an early stage – this seals off the white areas with a thin rubbery film. You can then work over the masked areas with great freedom, confident that the white areas will remain intact. The masks can be removed at the end or whenever suits you. But make sure that the mask is absolutely dry before you start applying paint over it, and also make sure that the paint is dry before you remove the mask at the end. Masking fluid is removed by rubbing gently with your fingers – it comes away as little rubbery crumbs, revealing the clean white paper beneath. But beware, if the paint is not dry you will immediately smudge your crisp white paper.

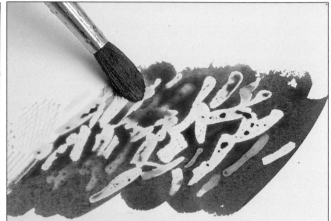

1 Masking fluid can be painted on to broad areas or it can be used in a much tighter way to define small details. DON'T use your best brush. DO clean your brush in water immediately after use – the rubbery fluid is almost impossible to remove from the hairs of a brush once it has dried.

2 Here masking fluid is being applied with a dip pen – having a stiff drawing point, it is much easier to control for fine details like stippling and delicate linear details.

3 Allow the masking fluid to dry before applying paint over it. You can test for this by touching it gently with your fingers. If you don't allow it to dry the mask will lift, mix with the paint, and your carefully masked areas will become confused.

4 You can work very freely over masking fluid, applying as many washes as you like, for example. Not only does masking fluid allow you to work very freely, it also, in many instances, allows you to work very quickly. BUT DO REMEMBER – allow the painting to dry before you remove the masking fluid.

5

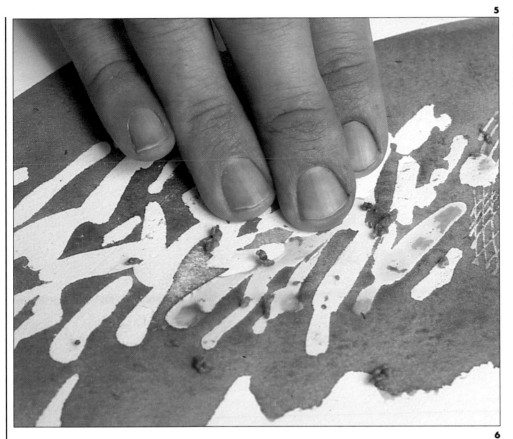

5 When the paint is completely dry you can remove the masking fluid. The method is very simple – just rub gently with the tips of your fingers. The mask will lift and come away from the paper as rubbery crumbs, revealing the pristine paper beneath.

6

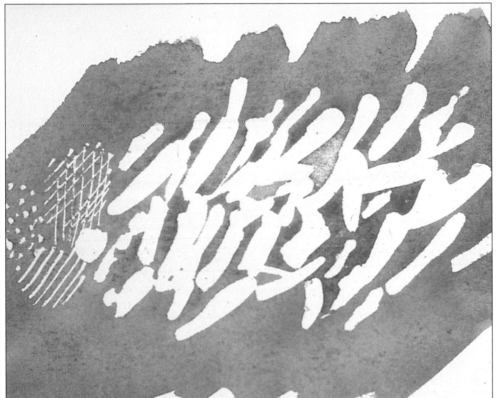

6 Areas that have been masked in this way have a special crisp quality, with very clearly defined edges. This is a quality which you may be looking for, though it will not necessarily suit all subjects. Here we have talked about masking white paper, but in the projects that follow you will find at least one instance where the artist has masked an area which has already been washed with a light colour. You will also find one instance where the artist decides to leave some of the mask, as he felt that it contributed to the final image.

WAX RESIST

Here we look at another way of reserving the white of the paper, or any colour. This time we are using a white wax candle. The intention, and the result, are different from the masking fluid method we looked at on the previous pages. This time we are exploiting the antipathy between wax and watercolour. The wax is laid down, then watercolour is applied over it. The waxy areas repel the water – or most of it, leaving them to show as white. The difference between wax resists and masking fluid is that the wax remains on the surface. It is also a much broader technique – a candle – or even a wax crayon is a much blunter drawing instrument than a brush or a pen. Some paint does stay on the waxy area, especially when the wax is applied over a large area. The water is shed by the wax, but some coagulates to form droplets which dry on top of the wax, adding another textural interest to the area. Wax resist tends to be used to add texture rather than for reserving white for details. Coloured candles and crayons can be used to add variety and texture to an area. Again, once the resist has been applied you can work with considerable freedom.

1 Here the artist uses a white wax candle, but you could use a wax crayon, even a coloured one depending on what effect you are trying to achieve.

2 Apply a wash of paint over the waxed surface and notice the way the water runs off – or forms droplets.

3 Here you see the effect when the paint is dry. A wax resist has a special textural quality which can add interest to a painting. Compare this with the masked areas on the previous page.

MASKING WITH PAPER

There may be occasions on which you want to reserve an area of white, but you don't want to use masking fluid – perhaps you haven't got time, or you haven't got any masking fluid to hand. A paper mask can be very useful – cheap, clean and quick to use – and has the added advantage that it gives you a choice of edges. By cutting the paper you create a crisp edge, by tearing it you create a softer edge. Different types of paper tear in different ways, depending on their thickness and strength. Experiment with papers and see just how many different effects you can achieve.

Torn paper mask

1 Tear a sheet of fairly thick paper and lay it on to the support. Fix it with bits of masking tape – you don't want the mask to shift as you work, or the paint will smear and destroy the effect.

2 Peel the mask back briskly. The edge which has been masked with torn paper has a pleasingly soft quality.

Cut paper mask

1 This time the paper mask is created by cutting rather than tearing – it is laid over the support as before. Apply the painting, working briskly.

2 Compare this with the type of edge produced by the torn paper mask.

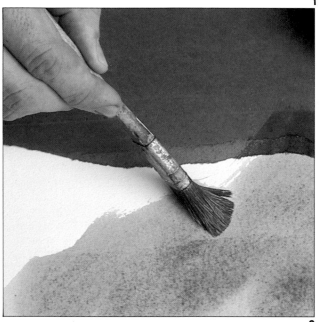

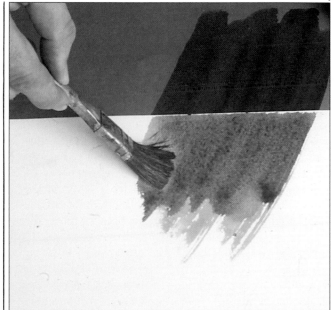

Summer Fields
MASKING FLUID WITH PEN

This subject is interesting in many ways. First of all the artist has taken an apparently daunting tangle of wayside weeds and grasses and produced a delightful painting which is not as complicated as it looks once the techniques he used are understood. What is probably more difficult for the beginner is the analysis of the subject into manageable areas, then the planning of the stages to prevent the painting from getting too dark too early. You will gain confidence by trying the exercise yourself then by finding a similar subject to apply what you have learnt.

Let's look at the composition. The artist has chosen a fairly high horizon but has placed the picture plane quite close to the viewer. We feel as though we are in a sunken lane viewing the landscape over a bank and through the wildflowers that grow so profusely on it.

The idea of the picture plane is interesting as well as helpful to the landscape painter. If you have ever tried to paint in the countryside you will be aware of that feeling of inadequacy as you try to decide where to begin – after all, you can stand on the spot and turn through all 360 degrees! As you turn, not only is a different 'picture' revealed but having chosen your 'view' you can also choose a wide-angled or a relatively narrow field of vision. The painting can include everything from the ground at your feet to the horizon. Think again about the viewfinder we discussed in the previous painting, because the picture plane is a similar idea. Imagine that instead of the viewfinder, you are holding up a vertical sheet of glass – this is the picture plane. Hold it as near to you or as far away as you like and what you see through the glass will be included in the picture. A more practical demonstration is to stand in front of a window. Start at the far side of the room – if you had a really long-handled brush you could trace off the details of the view. Now move nearer the window and see how the image changes until, when you are standing right next to the window, your picture plane includes the window sill outside.

1 The drawing was made with a 4B pencil on Cotman Not 140lb (300gsm), 10¾in ×14¾in (22.5cm×37.5cm).

The artist sketched in the broad outlines of the composition using a soft, 4B, pencil. He wanted to depict light coloured grasses, the white composite heads of cow parsley and delicate white flowers of the wayside weeds.

He uses masking fluid to protect the white of the paper, allowing him to work with greater freedom. In this detail he uses a pen to put in small blobs of masking fluid in the areas which will eventually be the cow parsley. In the bottom left-hand corner, vigorously applied slashed lines of masking fluid will represent the stems of grasses.

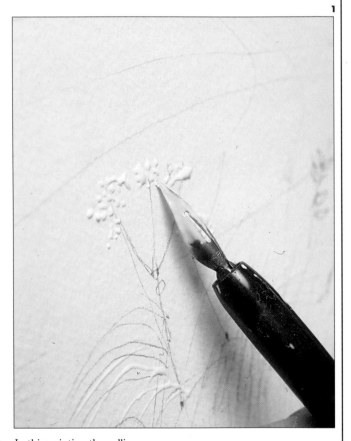

1

In this painting the rolling countryside provides a backdrop to the colourful wayside flowers. The subject is a rolling landscape with a bank of wild flowers and grasses occupying the foreground. The picture plane is close to the viewer, drawing us into the painting. By deciding what to include and what to leave out, what to emphasize and what to play down, the artist helps us to see a fairly common subject in a new way, through his eyes.

2 In this detail the artist uses the now familiar wet-in-wet technique to create the sky. In this case he has used a cobalt blue to create a more summery effect.

3 The artist wanted to create the sort of white fluffy clouds sometimes seen on a summer's day. To create this effect, he lifts out the wet colour by dabbing it with a small piece of natural sponge. This works particularly well on this Cotman paper for the colour lifts out cleanly and easily revealing the pure white paper.

4 With a mixture of cadmium lemon and cobalt blue, a flat wash is laid in the left foreground area. In this detail, the artist applies loose streaks of the same colour to suggest the tangle of weeds and grasses in the foreground.

5 The artist treats this not as an element of the landscape but as a simple area of colour. In his mind he has planned the way he intends to achieve his final effect. He uses a light wash at this stage so that he can build up the final tone from a series of similar light washes which will give the final painting a special depth and brilliance.

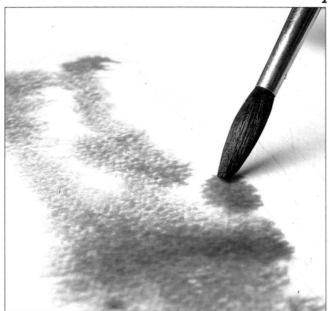

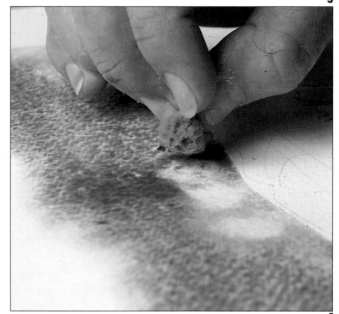

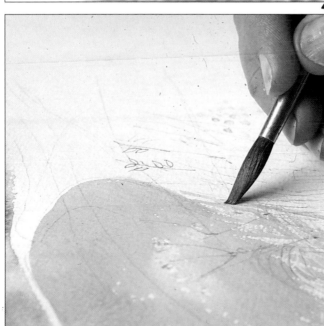

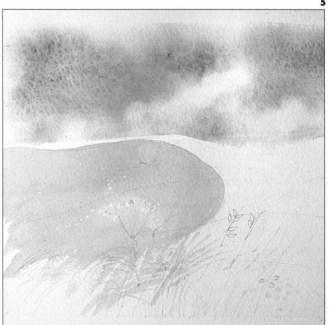

MASKING FLUID WITH PEN/SUMMER FIELDS

6 The field on the right is blocked in with a flat wash mixed from cadmium lemon and yellow ochre. This is laid in wet-on-dry. Again the artist starts by laying a light wash so that he can develop the tones and textures at a later stage. If it gets too dark too early on he limits the possibilities. In this detail, a mixture of sap green and raw umber is laid into the foreground area picking out the darker tones of the vegetation. The paint is wet and therefore looks darker than it will when dry. Notice the way the lines and dots of masking fluid stand out against the dark paint.

7 In the detail below, the artist adds more texture and detail to the foreground by using the handle of his brush to draw in the wet paint. He is moving paint which has already been applied to the surface rather than applying more paint.

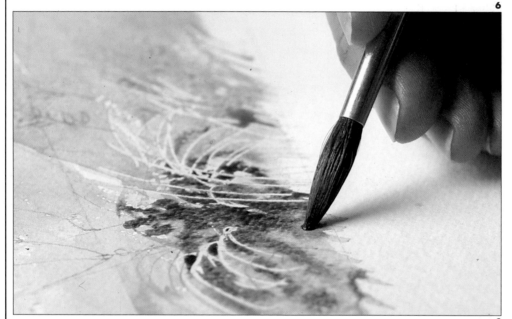

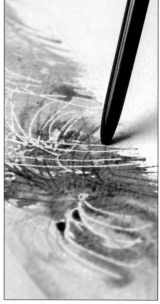

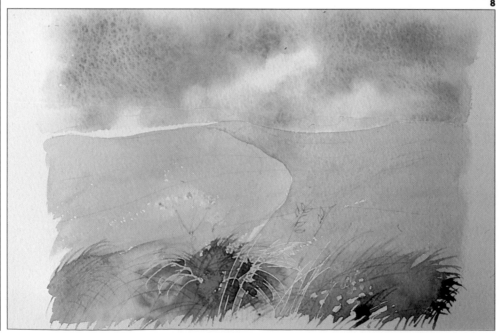

8 At this stage the artist stands back and takes a careful look at the painting. He has established all of the main elements of the composition and has started to develop the focal point of the picture – the bank of flowers and grasses in the foreground. He has applied only one layer of colour in this area but nevertheless it is beginning to read accurately. He has used a variety of techniques here, only one of them – masking – is new to you. The others, wet-on-dry, wet-in-wet and drawing into the paint with the tip of the brush are all familiar. This is a very good illustration of the way watercolour allows you to use simple techniques to good effect.

9 The band of trees which defines the horizon is laid in with a mixture of sap green and raw umber. The artist uses a loaded number 3 brush to lay in a sweeping band of colour. He then suggests the outline of the trees by going back over the paint while it is still wet and flicks at the edge of the paint area with the very tip of his brush.

10 The artist adds interest to the foreground area with a broad shadow which runs diagonally from left to right. This is laid in with a mixture of sap green and yellow ochre. At this stage the underlying layers are quite dry and this new wash of colour sits on top without disturbing them. If the first paint layers were not completely dry, this second layer of paint would pick it up and create a lighter area known as a 'backrun'. Below, the artist uses a pen to create linear detail. Because it is difficult to mix sufficient colour to allow the pen to be dipped in it, he applies the colour to the pen with a brush.

11 The artist works into the foreground with a dark sap green/raw umber mixture. He uses a number 3 brush to build up a delicate and complex web of stems and leaf shapes. Sometimes he paints the forms, sometimes the spaces between. A complex subject like this is best handled by 'seeing' it as a pattern of light and dark areas rather than small separate elements.

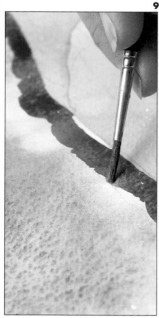

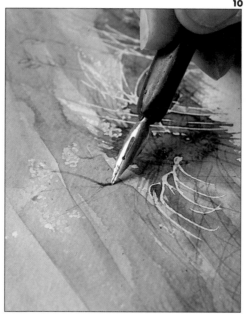

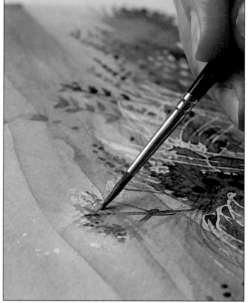

12 You can learn a lot by comparing this picture with the one at the bottom of the facing page, for they show you very clearly the way the painting is developing. As the artist increases the amount of detail in the foreground, that area of the picture becomes increasingly resolved, creating the illusion that it is very near to the viewer's eye. The background areas are by contrast thrown into the distance, suggesting recession towards the skyline. You can also see the way the artist increases the tonal contrast of the painting, adding darker areas in the foreground and a dark band of trees along the horizon.

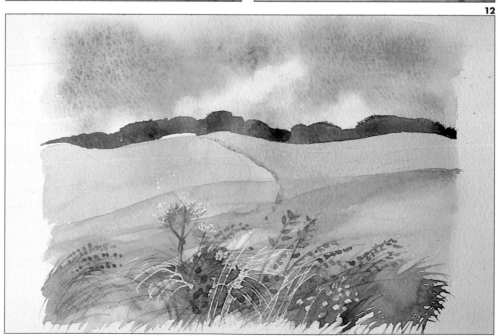

WATERCOLOUR

13 The artist removes the masking fluid by rubbing the masked areas very gently with his fingers. The rubbery film lifts off revealing the white paper underneath. Notice the crisp edges created by the masking fluid. Always make sure that your painting is dry before you start rubbing the mask off. If not, you will smear wet paint into the newly exposed white paper making a muck of all your efforts. Masking fluid is not only extremely useful, it is extraordinarily satisfying to remove and expose the pristine white of the paper beneath. This detail also shows the crisp edges achieved when wet paint is applied over dried paint – see the little touches of colour used to describe the leaflets.

14 The detail below illustrates yet again the complexity that can be achieved using very simple techniques. The artist hasn't actually painted any realistic details, he has merely interpreted the forms and found an equivalent mark. However, he has the advantage of being familiar with the medium and from experience knows which marks and techniques will allow him to create the effect he requires. He can see into the future in a way that a less experienced painter cannot. Nevertheless you should persevere, for the more paintings you do, the more you will add to your sum of knowledge and to your ability to predict the outcome of the techniques you use.

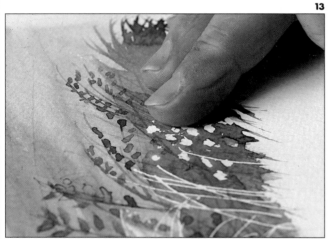

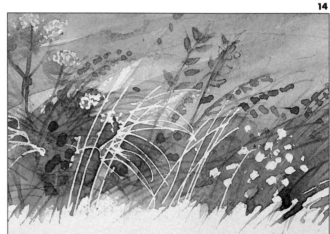

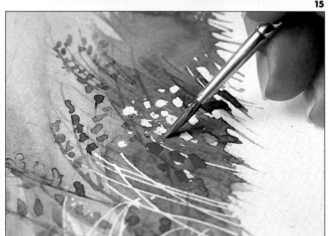

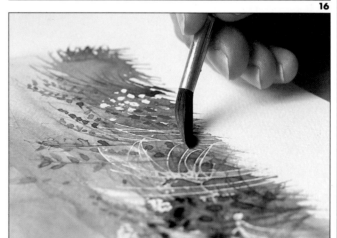

15 Here the artist adds a dash of colour with blobs of cadmium red standing for poppies. This small area of colour will have a disproportionate impact on the final painting. Red is a complimentary of green and this relationship means that when they are seen in combination, they enhance each other making the green look greener and the red look redder. Artists sometimes introduce touches of red into paintings of grass or foliage for just this reason. Look for this in paintings by great masters next time you visit a gallery or museum.

16 In this detail the artist lays a light wash over some of the masked areas so that they stand out as pale rather than white stems of grass. In this instance masking has allowed the artist to add a light tone at quite a late stage.

Detail
Watercolour is a seductive medium which gives pleasure on many levels. There is in all of us a child who likes messing around with water and paint. The materials too have a special quality. Everything about watercolour is neat and compact – from the boxes whose design has changed little in the last hundred years to the pans of colour like brightly coloured sweets. The images too can be enjoyed in their entirety as paintings, but the details are often as rewarding.

17 The artist completes the painting by adding further light washes across the fields suggesting the undulations of the ground.

The finished painting illustrates several points which we have discussed before. It shows you the freedom that masking fluid can give you. It also illustrates the way in which an apparently complex subject can be treated fairly simply and effectively. I suspect that when you first looked at this painting you thought 'that's far too difficult for me to do' but now I am sure you feel quite confident that you could cope with this, or with a similar subject. The other point we can learn from this painting has more to do with composition. Objects low down in the picture plane are perceived as being nearer to the viewer and the more detailed an object, the nearer it will be assumed to be.

And finally, if you establish the picture plane close to the viewer's eye and suggest a distant horizon, you will create a sense of space and recession within your painting. An effect which is particularly useful in landscape painting.

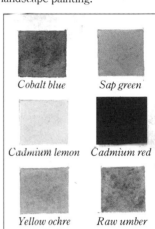

Cobalt blue	Sap green
Cadmium lemon	Cadmium red
Yellow ochre	Raw umber

17

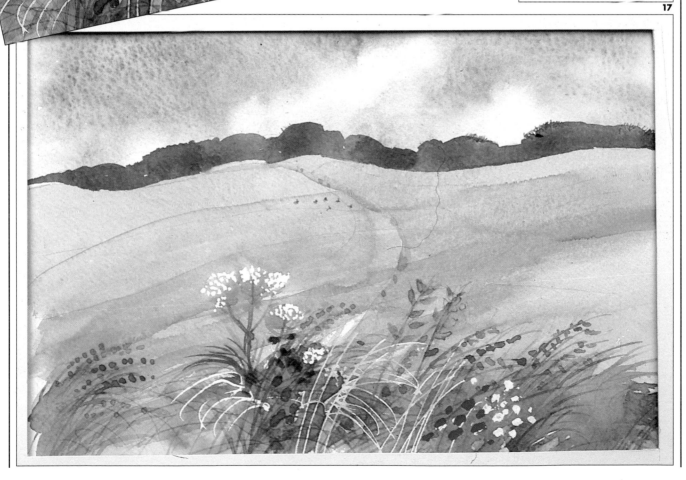

Sailing in the Bay
MASKING DETAILS

The paintings we are showing you are gradually becoming more complex in both the subjects and the techniques involved. The sea is high on the list of subjects considered difficult by beginners. One of the fascinations of the sea is the way it changes mood from a flat calm pond one day to a whipped-up froth of crashing waves and flying foam on another. The colour also changes, because a large body of water has a highly light-reflective surface and tends to mirror the colour of the sky above. Other factors come into the equation. The reflective qualities of the surface can be modified by the depth of the water, the amount of debris and plankton in suspension or whether the water is calm, broken by large rollers or covered in ripples. It also changes from minute to minute as clouds pass across the face of the sun and, just as you've mixed the right wash to depict a particular dark tone, the area is suddenly bright and sparkling. The only way to cope is to concentrate hard and paint what you see. By the time you have finished the painting everything will have changed so often that the final painting will be a summation of all that has occurred in that time.

Another particularly useful technique for the watercolourist working under changeable weather conditions is to work on two or three paintings at a time. The artist in this book used this method and so collected most of the material on which he based the paintings you have been studying. One of the many myths about watercolour is that it is a quick method of recording an image and it can indeed be used for very simple sketches and note-taking. But as you will now know, the process is slow since most watercolours are based on a series of very wet washes which usually need to be dry before the next wash can be applied. If you have two or three paintings on the go at once you can work on each in turn, ensuring that each is dry before you return to it. You can either paint exactly the same view – the differences between each attempt will be as interesting as the similarities. Or, alternatively, you can decide to paint three different views so that you return home with a variety of images.

Study this painting carefully and then work through it yourself. Once again the artist has made things easier for you by sorting out the method of working and by selecting and simplifying the image – nevertheless I hope it will give you the confidence to tackle a similar subject on your own.

Any view which includes a large expanse of water presents special problems – here the artist shows you how he captures the feeling of moving water and the sparkle of ripples.

1 The artist used the following: Cotman 140 lb (300 gsm), 10¾ in × 14¾ in (22.5 cm × 37.5 cm); a soft pencil (2B); several brushes – numbers 2, 6, 8 sables and a flat half-inch brush; masking fluid and a dip pen. He started with a simple outline drawing, indicating the broad masses of the hills and the areas where the water changes colour as it changes depth. Here the sky is dampened in preparation for the wet-in-wet wash.

2 The sky is laid in using a loaded brush and a mixture of Payne's grey and cobalt blue. Notice the way the artist introduces colour in some areas but not in others so as to achieve a variegated effect. It is important to work quickly at this stage as the sky must be completed in one go. There is usually no place for hard lines in a sky where the effect depends on soft blended edges.

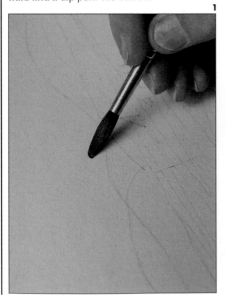

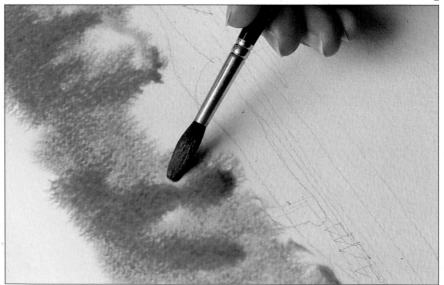

3 In the detail below, we see a wad of tissue being used to blot out the shape of billowing clouds just over the horizon. This must be done before the paint begins to dry and on this particular paper the technique is especially effective.

4 Here the artist uses a small number 3 brush to mask the white triangles of the sails. These are small but important elements of the final painting and a crisp edge is needed if the forms are to read against the blue of the sea. Clean the fluid from your brush immediately, otherwise the rubbery substance will gum the hairs together and once dry it is impossible to remove.

5 Here masking fluid is applied with a dip pen. He stipples in rows of small dots which will suggest the sparkle of reflected light glancing from the broken water. Here the pen is used to put down slightly larger dots suggesting the pebbles on the foreshore. The pen nib being rigid and precise is suitable for small details.

6 Here we see the effect of the finished sky with the body of the clouds now apparent. We can also see the yellow masking fluid used to reserve the white areas of the sails, the gulls, and the ripples breaking the surface of the sea.

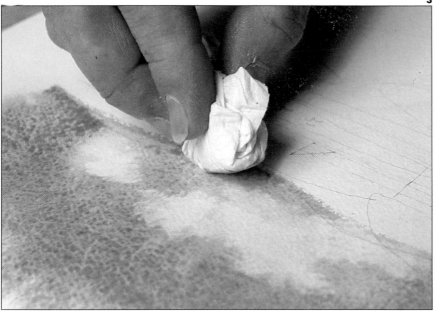

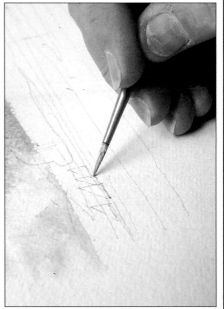

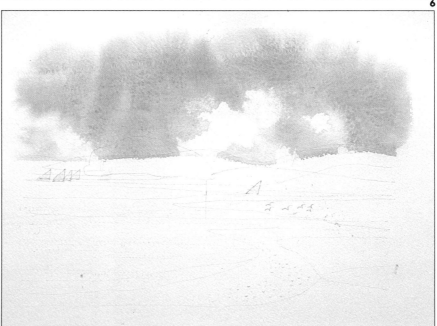

WATERCOLOUR

7 With a mixture of alizarin crimson and cobalt blue, the artist washes in the narrow band of the distant hills. Notice the way he has overlapped the edge of the sky, creating a third colour which can be read as shadows on the hills. Don't forget that watercolour is a transparent medium and that one wash can be overlapped with another to create a third colour.

8 Using a number 8 brush and a mixture of Payne's grey and cobalt blue, the artist starts to lay in the water. As you can see, his brush is fairly dry so that the wash breaks on the texture of the paper creating yet more sparkle. He is able to paint straight across the small sailing boat because the white sail is protected by the masking fluid. If you look carefully, you can see that some of the white in the sea area is actually masked while some of it is created by the dry brush technique.

9 The clump of trees on the distant shore is laid in with a rich mixture of Winsor green with a touch of cadmium scarlet. The artist uses the brush to push and pull the wet paint to the outline which will more realistically suggest the coppice. In this detail he uses the tip of the handle of the brush to draw down lines of wet paint which express the trunks of the trees.

10 Here the artist continues to work into the wooded area adding more detail and taking the vegetation down to the sea shore. Watercolour is an expressive and flexible medium which allows him to describe a fairly complex subject with only one colour. Obviously he has simplified the subject so that he sees the wood rather than the trees. He has varied the marks he makes, firstly by using a brush to lay down a pool of colour which describes the canopy of foliage. The brush is then used to push out the colour and break up the edge in a way that implies the individual trees within the wood. Finally he uses the tip of the brush to draw the trunks of the trees taking the lines of paint. In this way he paints not only the outside surface of the wood but also implies its depth and the space it occupies.

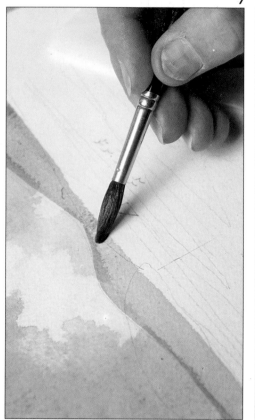

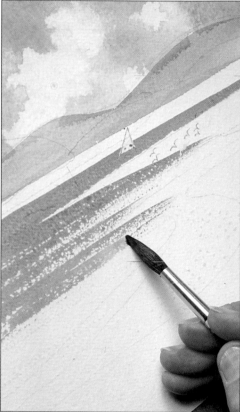

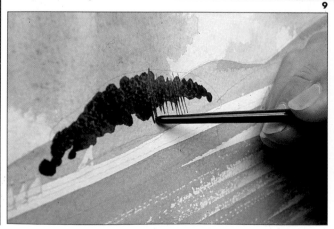

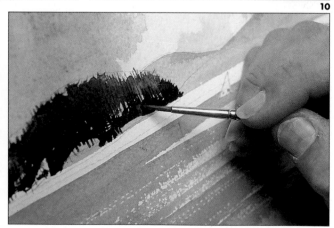

11 The artist uses a very pale wash of sap green as an underpainting for the coastline. The colour will be developed over this as a series of washes with areas of more detailed texture applied later.

12 In this detail, the artist lays a wash of the same sap green over the spit of land which juts into the sea. Once again we see the way in which the masking fluid allows him to work quickly and freely.
We can also see where a wash of green overlays the purple foothills creating a muted green on the far shore.

13 A wash of yellow ochre is sweeps round in a curve following the line of the beach. It is also laid over the pale green wash. When this is almost dry, the artist draws into it with more sap green and begins to establish the tussocks of marram grass. Here he uses the tip of a half-inch flat brush to touch in stems of grass with raw umber and a little sap green.

14 Here the artist uses the same brush but in an entirely different way. The brush is fairly dry and the colour is applied with broad sweeping strokes of the flat of the brush. The bristles of the brush separate, creating a striated effect. These are all examples of dry-brush work.

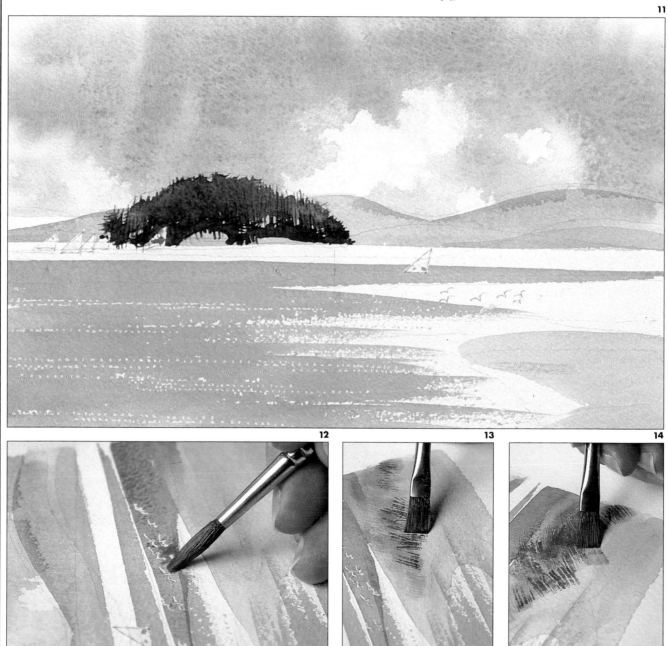

MASKING DETAILS/SAILING IN THE BAY

15 The artist continues to develop the painting laying washes of varying intensity across the sea. He adds details to the line of low hills which borders the far shore using touches of Payne's grey and sap green. Here he lays a pale blue wash into the shallow seas in the distance.

16 Here the artist uses a number 6 brush and with a mixture of sap green and yellow ochre adds more detail to the vegetation in the lower right-hand part of the picture. Be careful not to overwork this area.

17 When the paint is completely dry, the artist removes the masking fluid by rubbing it gently with his finger. The masking fluid forms small rubbery crumbs as it is rolled off to reveal the virgin white of the paper beneath. There are now two kinds of masking fluid – white and yellow. The yellow stained certain papers so a white version was brought out.

18 Here the artist uses a fine number 3 brush to suggest the hulls of the sailing boats. They are some distance from the viewer and it is important that they should be sketched in impressionistically rather than described in great detail.

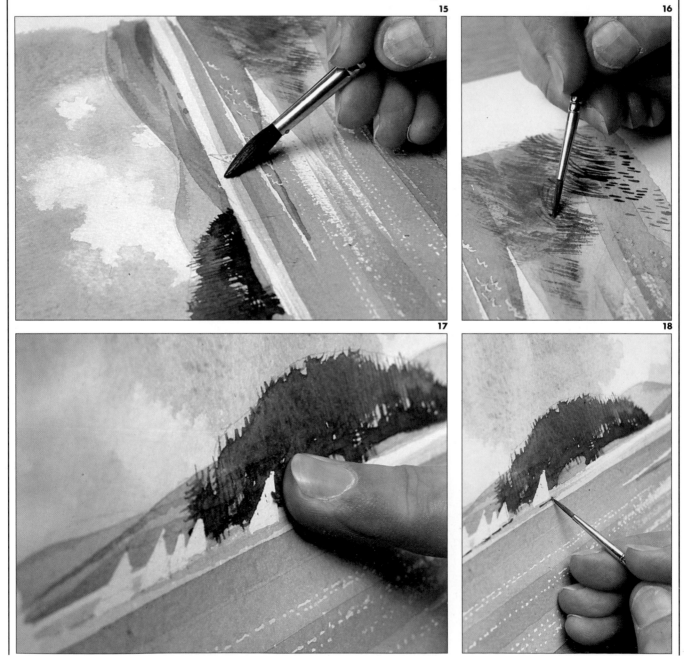

Detail
In this detail we see the way the artist has used masking fluid and a dry brush technique combined with the texture of the paper to suggest the sparkle of moving water. You can also see the way the crisp white shapes revealed by the masking fluid suggest very convincingly a flock of birds in flight and beyond that the white sail of a small boat.

19 The artist completes the painting by adding a splash of cadmium red for the sail of the leading boat. Notice the way the red sings against its complimentary green. It is interesting that such a small splash of colour draws the eye and, though small, is the focal point of the painting. Again the artist has used a simple compositional device to capture the viewer's attention. The eye is led along the curve of beach which sweeps from the foreground along the spit which projects into the sea. From there, it leaps across to the bright red sail and is brought up short by the line of hills which introduces a strong horizontal element into the painting. A revealing exercize for those of you interested in composition is to lay a piece of tracing-paper over a painting and to draw in the main compositional lines.

In this case it will consist of two main lines: a single sweeping curve from the right foreground to the point where the far shore is cut by the left border of the painting; and a horizontal line defined by the far shore.

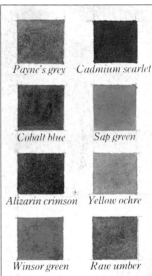

Payne's grey Cadmium scarlet

Cobalt blue Sap green

Alizarin crimson Yellow ochre

Winsor green Raw umber

19

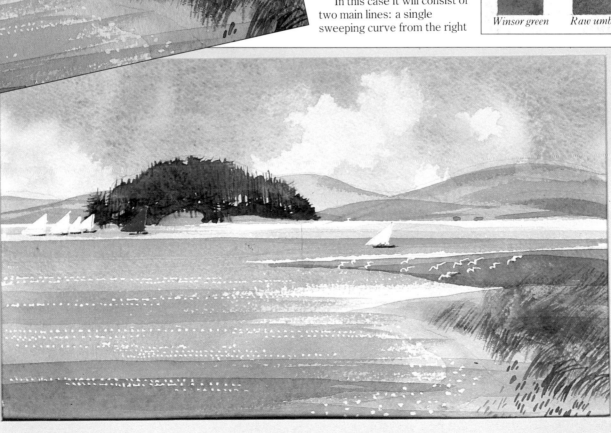

Town Gate
LINEAR PERSPECTIVE

The artist is surrounded by 'pictures' but some subjects are considered more stimulating or appropriate than others. Despite the fact that most of us live in towns or cities watercolour is nearly always associated with landscape painting while the urban scene is neglected. There are many possible explanations for this prejudice. For many of us painting is a leisure pastime and has become associated with country or seaside holidays. This is reinforced by the fact that many of the examples in our museums and galleries date from the great age of watercolour in the eighteenth and nineteenth centuries when topographical subjects predominated. Nevertheless, it is important to realize that the perfect subject for the painter is as elusive as the perfect picnic spot.

There are many reasons why you should paint subjects close to home. First of all there is the availability of subjects. Household objects such as cups and saucers, potted plants, fruit and vegetables, are always near to hand and an interesting still life is assembled in a matter of moments. Similarly the view from your own window is always there, changing with the time of day, with changes in the weather and the seasons. The time that would be spent journeying to the perfect piece of countryside can be spent painting!

In fact the city is a fascinating and challenging subject. The smooth rolling lines of the countryside are replaced by straight lines with the angular geometry of buildings creating an interesting conjunction of surfaces. Planes impinge on planes casting strong and complex shadows. Superimposed on this angular structure are the textures of manmade and quarried materials, of brick, stone and concrete. The greens and earths of the rural palette are supplemented by vivid primaries and the synthetic colours of paintwork and even clothing.

Some of you will be puzzled by the problems of perspective that the subject presents. Linear perspective is a device which can help you analyse, understand and depict what you are seeing. It is based on the fact that when viewed from a particular point, and assuming one eye is closed, parallel lines on the same plane always meet at a point which can be anywhere above or below the horizon. In this street scene the bases of the houses and the line of the eaves are in the same plane – the plane is represented by their facades. A line drawn through the line of the eaves and base of the facade meet at a point just to the left of the archway – this is called the vanishing point. Please don't worry about perspective at this stage, whole tomes have been written on the subject which is hedged about with ifs and buts, just draw what you see and if something looks wrong check that the perspective lines are correct.

In this study we look at an urban scene for the first time. The subject provides us with new challenges – we have to cope with the problem of perspective and use a much broader palette.

1 The artist used a sheet of unstretched Cotman paper, 90 lb (185 gsm), 10¾ in × 14¾ in (22.5 cm × 37.5 cm). The brushes were numbers 3, 6 and 8, and he also used a pen and masking fluid.

He started by making a simple outline drawing with a B pencil. The drawing is more detailed than those he has made so far as the construction of the intricate pattern of streets, houses, roofs and other architectural details needs to be resolved before the paint is applied. The subject lent itself to bright clear colours and a lot of contrast. He therefore establishes his darkest tones first, using black ink applied with a brush. To achieve a really strong black which will not bleed into subsequent colours, the artist has used black ink rather than paint. The darkest areas are the shadow on the inside of the ancient gateway and the shadows within the windows on the upper storeys of the nearby houses. Having established the darkest tone, the artist lays in the mid-tones which he creates by diluting the Indian ink with water.

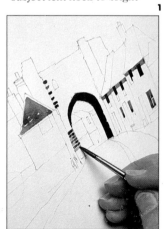

2 One of the important aspects of this painting is the way the perspective lines lead the eye into the centre of the painting where the town gate frames the view beyond. This must be firmly established in its position in space to avoid any visual ambiguity. So the artist uses a very pale black wash to describe this area. The paler tones contrast with the stronger tones nearer to the viewer and help to reinforce the sense of recession.

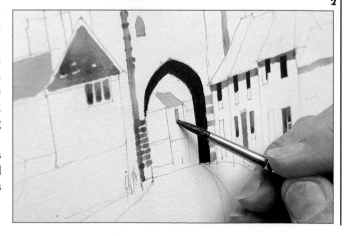

3 The sky is laid in using a wet-in-wet technique and a mixture of Payne's grey and Winsor blue. The artist works quickly and as you can see in the detail below, the wash is very wet at this stage.

4 The clump of small conifers on the left is laid in using a wet-in-wet technique. The colour is Winsor green. The paint is applied with the point of a number 3 sable brush using vigorous graphic marks which describe the skeletal structure of the trees. The outline blurs into the damp paper but here you see crisp details being created as the colour is taken into dry areas.

5 The artist begins to establish the foreground – the street and pavement – with a dilute wash of neutral tint. This area will receive several washes of colour before the painting is finished so it is important that this first wash is fairly pale.

6 So far we have seen masking fluid being used to mask the white of the paper. Here, however, the artist wanted to create a 'cobbled' effect on the pavement. To do this, he masks not the white paper but the first pale grey wash. Here we see him using a pen to stipple in blobs of masking fluid where the cobbles will appear.

3

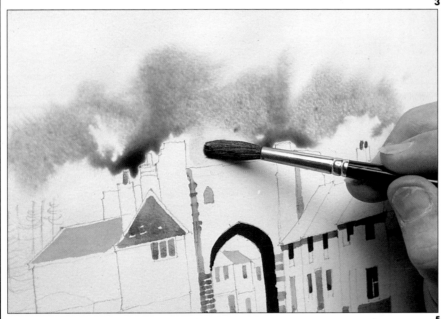

4

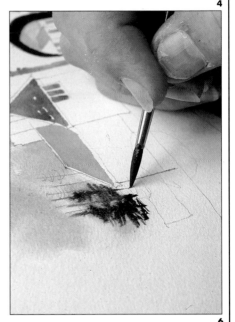

5

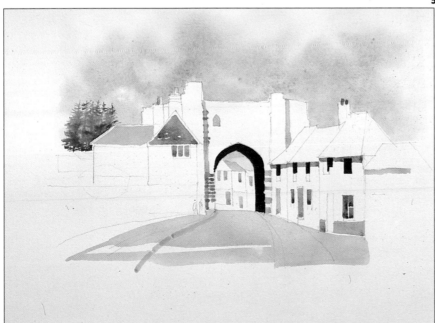

6

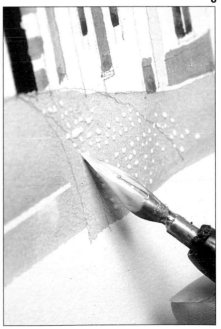

7 The artist starts to block in the simple geometric shapes of the buildings. He uses burnt sienna for the roofs, yellow ochre for one of the buildings, a diluted burnt sienna for some of the walls and burnt sienna mixed with Winsor green for the end of the house to the left of the gate. Here we see him using neutral tint for the façade of the nearest house.

8 The artist continues in this way, treating the areas of the buildings as flat areas of colour. At this point the reason for his control of the tone of his washes becomes apparent, for he now needs to lay in the textures and can do so using subtle colours. If he had allowed his first washes to become too dark, the subsequent detailing would have been very dark and crude. Here he uses stripes of neutral tint to describe the weather-boarded façade. On the lower wall, dashed and dotted marks describe the irregular masonry and on the tower he develops the texture of the stonework. He has already begun to build up a series of washes in the foreground, allowing each one to dry before the next is applied.

9 The masking fluid is removed and now we begin to see the point of the earlier masking as the cobbled effect is revealed. Here the artist lays a dark shadow over the foreground in order to give that area more impact. The colour is mixed from alizarin crimson, Winsor blue and burnt sienna.

7

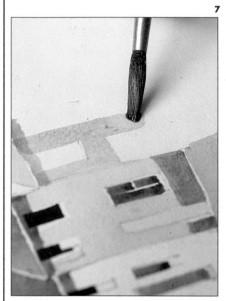

8

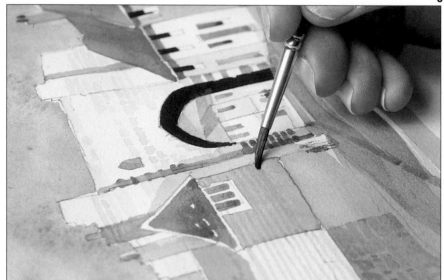

9

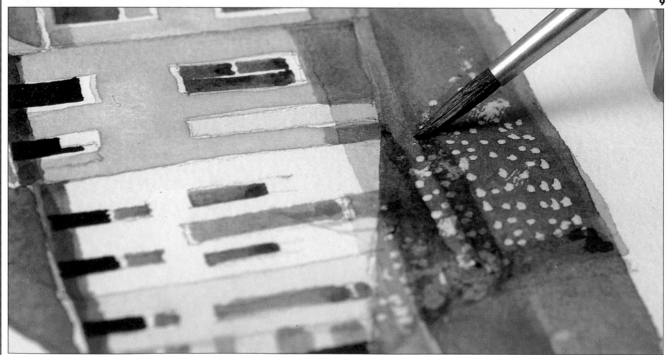

Detail
Here we see the simple and impressionistic way the artist has handled the townscape beyond the arch. There is sometimes a temptation to pay too much attention to the human figure when it is included in a painting such as this. But if the figures depicted here had been rendered more sharply than their surroundings, they would have leapt from the painting rather than harmoniously blending with their surroundings.

10 The picture is completed by working up the textures in the roofs and walls. Stripes of cadmium red with yellow ochre add interest to the rooftops. With the tip of his brush the artist puts in the slightest suggestion of groups of figures, these help to give a sense of scale to the painting.

Payne's grey *Burnt sienna*

Winsor blue *Yellow ochre*

Winsor green *Cadmium red*

Neutral tint *Alizarin crimson*

10

Anemones

MASKING LARGE AREAS

Still life provides the artist with an infinite source of inspiration and has exercized all the great artists at one time or another. The material is varied in terms of texture, shape, size and colour and wherever you are there will be elements around you to assemble into an intriguing still life study. A still life also has the advantage that you have control over it. The arrangement is what you choose it to be, the lighting can be adjusted according to your taste and, unlike a model, it won't want paying or feeding, suffer from cramp or boredom. As you can see, many 'artistic' considerations are really terribly pedestrian!

Anything can be the subject of a beautiful or expressive painting but some have a more obvious attraction than others. Flowers are an obviously seductive subject but one, however, fraught with difficulty – there is first the temptation to produce a 'pretty' and possibly unsatisfying image. It takes a stout heart to interpret a subject which is so obviously 'perfect'. But if you don't put something of yourself into the study you run the risk of merely copying, which no artist attempts and in which no amateur succeeds, if you want a photorealistic record, why not take a photograph?

Flowers are exciting subjects, especially for those of you who are colourists at heart. Watercolour is a particularly sympathetic medium given the vibrancy of its colours and the subtle blended effects that can be achieved: approach the subject as you would any other. See it as an integral and integrated part of the whole picture. Plan the composition, is it to be asymmetrical or symmetrical, is the image to fill the area or be placed within a large space? Make thumbnail sketches to help you consider the alternatives. When you have begun to form your ideas, sketch in the broad outlines making decisive rather than tentative marks. The pencil drawing is not an outline to be filled in as a child 'fills in' the colours in a painting book. It is to help you to 'elicit' the painting from the broad compositional structures you have identified.

Next examine the subject and decide where your lights and darks are to go. Studying the subject closely through half-closed eyes will exaggerate the tones. Then you can either build up the tones very carefully by laying down the lightest areas first or you can do as the artist has done here and begin by masking the lightest areas. The advantage of this technique is that you can work very freely without fear of getting too dark too quickly. At first you will have to think very carefully about where you put the masking fluid. Here the artist wants to retain white paper so that the colours of the petals can be laid on in a single wash of colour to which the white of the paper will contribute a brilliant sparkle.

When you have tackled this painting, try it again using the other approach. Lay down the palest tones first then build up the tones laying down the dark background last. Remember that you will have to cut the dark background colour around the flowers which will be very detailed. There is an example of a flower painting created in this way later in the book.

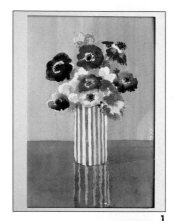

Here the artist used a vase of flowers as the basis of his painting. He has loosely interpreted the subject – simplifying the pattern on the vase and editing certain details. He did this to create a strong composition and also to provide an image which would be easier for you to follow.

1 The materials for this painting were 140 lb (300 gsm) Cotman paper, 10¾ in × 14¾ in (22.5 cm × 37.5 cm); a number 3 and a number 6 sable brush; and masking fluid.

With a soft 2B pencil, the artist draws in the broad outline of the petals, the dark circle of the stamens in the centre and the striped pattern of the vase. The drawing is very loose – avoid the temptation to make a tight, botanically correct drawing. All you want to do at this stage is map out colour areas.

2 There is no fussy detail in the finished drawing, but the artist has established the composition and has enough information to plan the way he will approach the painting. Notice the way the reflections of the striped vase are treated as a continuation of the real thing. Also consider the composition: the artist has placed the vase of flowers firmly in the centre of the picture area and the background is divided at approximately two-thirds of the way down the paper.

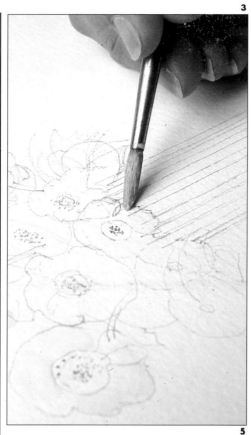

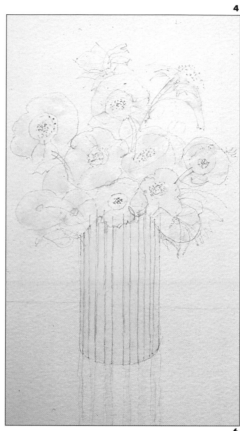

3 The masking fluid is applied to the flower heads. The artist uses an old sable brush and works freely but carefully. He uses the masking fluid to define the shape of each petal. What he is doing is preparing a sort of 'negative' of the subject, the areas he covers with masking fluid will be revealed as white paper at a later stage.

4 The vase is entirely masked and the masking fluid is also taken down into the reflections where it is used to reserve the areas which will eventually show as white against the dark table surface.

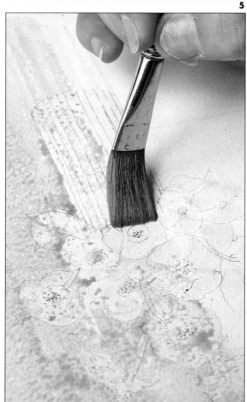

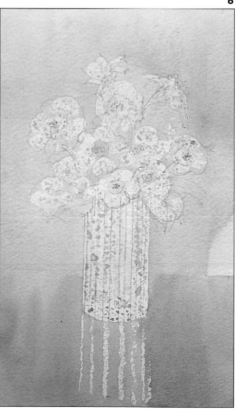

5 The artist has chosen a fairly simple background which provides a neutral foil to the vivid colours and strong pattern of the vase and flowers. This simplicity is an important component of the final image; the artist could have set the flowers against a more complex background – patterned wallpaper, a window or a clutter of other objects. This editing, whether in the selecting of the objects or in the selective drawing, is all part of the process of composing a picture. The artist lays a neutral grey wash over the whole area. The colour is mixed from yellow ochre, Payne's grey and Winsor blue and is laid on with a large flat brush, working quickly from top to bottom.

6 Here we see the masked forms of the vase of flowers as a negative image against the darker background.

7

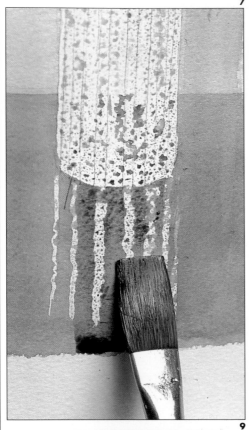

8

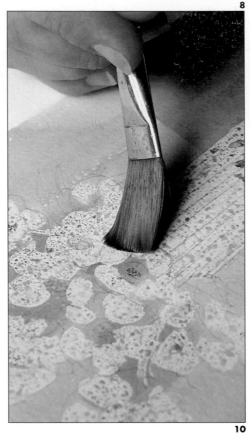

7 The first wash of colour is allowed to dry before a darker tone is applied to the area of the table top. The colour is created by adding more paint to the original wash. Here you can see the value of masking fluid, which allows you to work very freely in an area where there is a lot of pale, intricate detail. The artist can apply several layers of washes until he achieves just the right tone – imagine trying to work several washes around the lines of the reflection!

8 At this stage the artist studied the painting carefully and decided that another wash of colour was required to give the background more punch. He uses the same mixed grey applied with the broad, flat brush to the right hand side of the picture, making the painting darker on this side. Notice the way he has allowed the colour to streak, adding textural interest to an otherwise flat area.

9

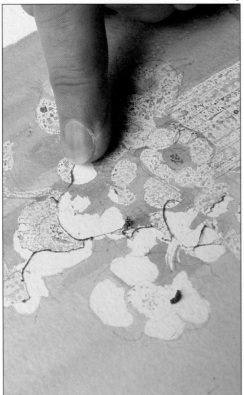

10

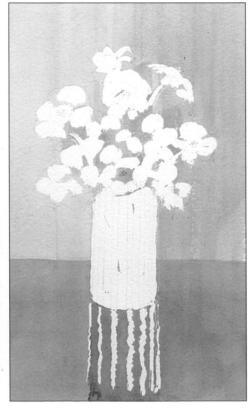

9 The artist removes the dried masking fluid by rubbing it gently with his forefinger. You only need to apply a little pressure since the rubbery film lifts quite easily from most papers. This masking fluid has a yellowish tinge which was found to leave a slight stain on some papers. A new white version is now on the market, though for your purposes either would do.

10 Here all the masking fluid has been removed and the image can be seen as white silhouette against the dark background – a sort of negative of the subject. Notice the special crisp quality of the edges created with masking fluid.

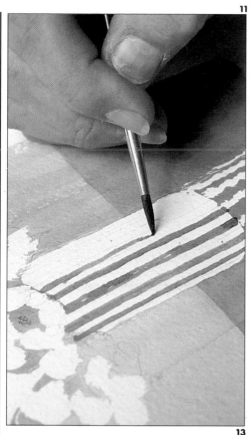

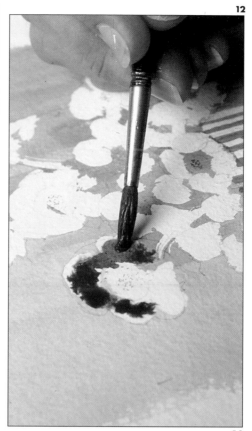

11 Using a number 3 Kolinsky sable and Payne's grey, the artist paints in the dark stripes on the vase making them slightly broader than they actually are. He felt that in the context of the composition broader stripes would have more impact than very fine stripes. As an artist you have considerably more freedom than a photographer – so do not feel that you must slavishly copy what you see. It's your picture and as long as the final painting has conviction and is successful (and only you can decide that) then you can include, discard or modify as you wish.

12 At last, twelve steps into the painting, we can start to introduce some real colour into the picture!
Here the artist has washed in magenta and now drops in a little cadmium scarlet.

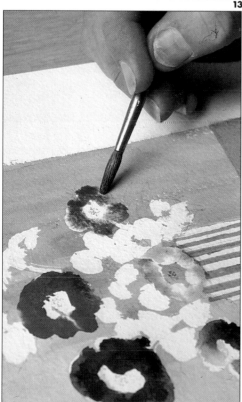

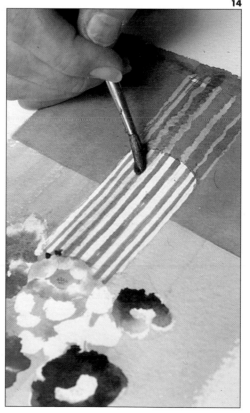

13 The flowers are painted in a range of rich colours: cadmium scarlet, magenta, cadmium yellow and Winsor blue. Using a wet-in-wet technique small touches of colour are introduced into the predominant colours, purple is touched into the cadmium scarlet and magenta flowers, for example. Here the artist uses a loaded brush and mauve paint to wash in the furthest flower.

14 At this stage a wash of Payne's grey was used to 'knock back' the white of the reflection. 'Knock back' is a useful term describing the process in which a too-dominant area is harmonized with its surroundings. The artist then uses a very pale wash of Payne's grey to lay a tone on the shadowed side of the vase. This heightens the roundness of the vase, which becomes darker on the side opposite the source of light.

MASKING LARGE AREAS/ANEMONES

15 The painting is rapidly coming together as colour is applied to each flower in turn. Very dilute cadmium scarlet and magenta are used for the pale flowers. Intense washes of the same colours are used to create darker flowerheads. The subtle blurring of the wet-in-wet technique creates a naturalistic blending of colours which contrasts with the crisp, masked outlines. Notice the free way in which the colour has been applied – yellow ochre washes over the white paper as well as over the grey background, in other places the colour does not fill the outline, leaving a white halo.

16 The dark cluster of stamens in the centre of each flower is stippled in with neutral tint – a warm grey.

17 Here we see a small piece of natural sponge being used to apply colour. The method is quick and achieves the soft, slightly blurred effect which the artist is seeking.

18 The artist continues in this way, washing in touches of colour and taking the colour from one area to another. This allows the picture to develop as a whole rather than one area taking precedence over another. He uses a number 3 brush and sap green paint for the leaves and flower stems treating them very sketchily.

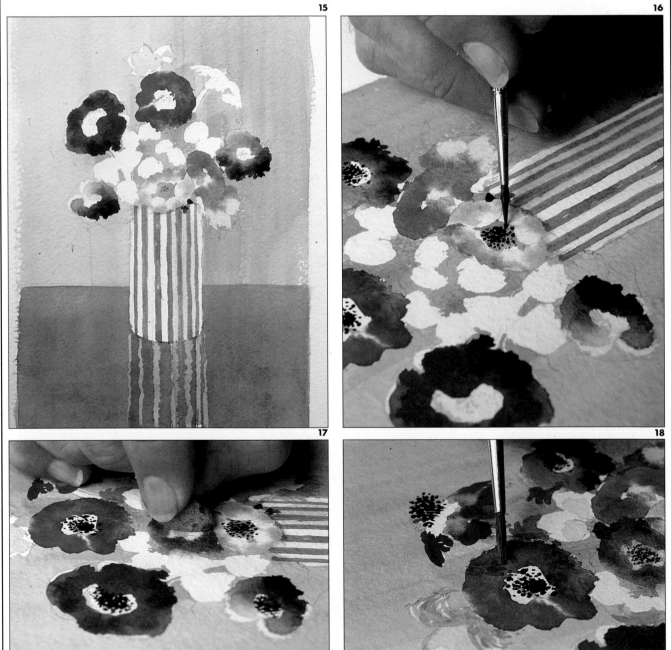

15

16

17

18

19 Flowers are an obvious and delightful subject for the painter: they are attractive, colourful and their forms are almost infinitely variable. However, a pitfall for the unwary is a tendency to become obsessive about detail, so that what is attempted is a scientifically accurate but sterile image. Here the artist has created a simple but elegant composition. The subject has been treated very freely by applying the paint with a loaded brush and dropping in touches of adjacent colours with a wet-in-wet technique. This is more sympathetic to the subject than a minutely accurate approach. Rather than applying colour in one area only, the artist developed the painting as a whole. Colours are affected by those that surround them and should not be judged in isolation or against a white background.

It is also true that all coloured objects reflect off one another so an object is rarely a single colour but contains traces of adjacent colours. If you paint an area in a single flat local colour the result will be unnatural.

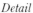

Detail
In this pleasing and realistic image, overlapping layers of transparent colour and subtly blended colours create a softly-focussed effect. Crisp accents of pure colour, touches of darker tones and the clearly defined white edges 'hold' the image so that some areas swim back into focus. The artist implies form rather than describing it.

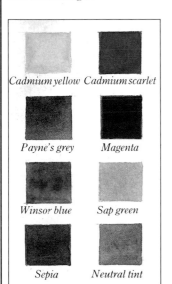

Cadmium yellow *Cadmium scarlet*

Payne's grey *Magenta*

Winsor blue *Sap green*

Sepia *Neutral tint*

19

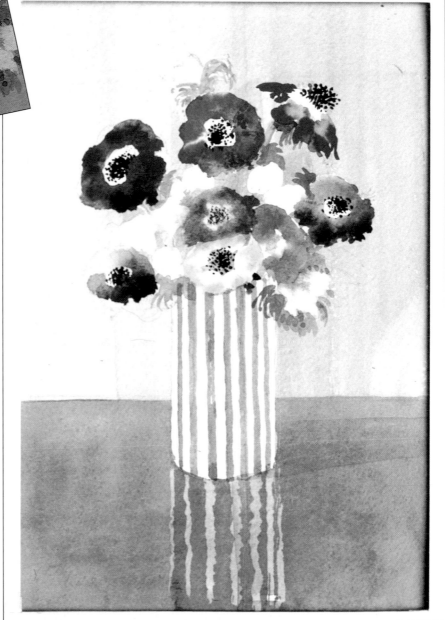

Chapter 6
Approaches

As we said in the introductory chapter there are all sorts of ways of approaching watercolour. In this book we have chosen a particular approach to help you over the initial hurdles, but we are not suggesting that this is the only way to use watercolour. Basically you need to be able to handle paint in order to make it work for you. You also need to improve your observing, recording and drawing skills. But once you have mastered the basic skills you can afford to indulge your personal passions whether they are for colour, texture or realistic representation – but you will continue to learn and improve your skills throughout your painting life. Here we start by looking at texture. Texture can be introduced into a painting for many reasons, to progress the image, to add interest, even to demonstrate your dexterity. Apart from anything else, texture is fun, just like noise is fun, and just as organized noise becomes

music so organized textures can become part of the abstract qualities of an image. Try the techniques we have shown here, but take them further. Experiment, make the techniques your own and discover others of your own. The bigger your repertoire the greater and the more ambitious the projects you can undertake. An enlarged vocabulary expands the means you have of expressing yourself, allows you to communicate complex ideas, and enables you to express yourself more quickly.

The projects here are a little more ambitious but well within your reach. Look at the paintings in detail. Try them for yourself or set up similar projects. The still life with shells is particularly interesting and if you have done the flower painting with masking fluid in the previous chapter you may like to try the flowers in this chapter using a entirely different wet-in-wet technique.

Techniques

TEXTURE

Texture is introduced into paintings for a variety of reasons. It can be used in a purely literal way, to describe foliage, cobblestones or a sandy beach, for example, but it can also be used for decorative purposes and to enliven the paint surface. In many paintings the subject matter is secondary to the artist's obvious enjoyment of paint, paper, and the paint surface. As you progress you will evolve ways of describing particular textures, some you will crib from other people, from books like this, or by studying the work of the masters of the medium, past and present. But you will also find your own ways of treating certain subjects, a personal shorthand for describing the visual world, and as long as you have a fresh and enquiring approach you will continue to add to this repertoire, developing new solutions to old problems, and modifying and developing old solutions.

The truth is, that the more you learn about watercolour the more there is to learn. By now you should be handling paint with authority, controlling wet washes, using various masking techniques and introducing simple textures using a dry brush. To succeed with watercolour you need to combine a bold, vigorous approach with an

awareness of the medium and a willingness to let it lead you now and then. The happy accident is an important part of all good watercolours, so you need to be alert and decisive, prepared to incorporate an unplanned effect which enhances the painting. Watercolour offers plenty of opportunity for the happy accident, but to provide fertile ground for these you must adopt an investigative and open-minded approach to the medium. The successful painting comes from a balance of control and the unexpected. The more competent you become the more confident you will be, and the happier you will be to let the

materials do some of the work. We have looked at some of the basic techniques and there are obvious ways of achieving particular special effects, but the possibilities are endless and you will be limited only by your own inventiveness.

The techniques described here are very simple. In the first four, texture is applied with different materials – a stencil brush, a small nailbrush and two sponges, one natural and one synthetic. Here we have used a single colour which has been dabbed on to demonstrate the possibilities of the marks – take these same textures

Stippling with a nail-brush
Dip the nailbrush in a paint solution and dab one end on to the paper surface with rapid stabbing movements.

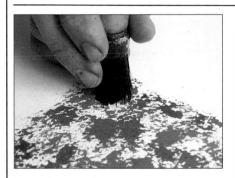

Stippling with a stencil brush
Here the artist dabs the paper with a stiff stencilling brush. The textures created by these two brushes are surprisingly different.

TEXTURE

further by introducing a second colour, or smearing the paint in some areas.

The other technique described here involves spattering paint on to the picture surface, and has a pleasingly unpredictable quality. In one of our projects it is used to create a pebbly effect on a beach but there are innumerable other applications. The paint can be applied with any sort of brush – here we use a decorating brush – and each will create a different effect depending on the stiffness of the bristles. Old toothbrushes are particularly effective. Mix a quantity of paint and dip the brush in the colour. Shake the brush to remove surplus colour – if it is too loaded the colour will drip. Hold the brush over the surface of the paper and draw a stiff instrument, such as a painting knife, through the bristles. This will create a fine spray which can be directed over the painting. The further away from the paper you hold the brush the larger the droplets will be.

Another way of introducing these 'accidental' effects is by flicking colour from a brush on to the paper – this introduces larger splashes which tend to be varied in size. Load your brush with colour and flick it briskly over the

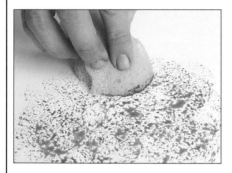

Stippling with a synthetic sponge

Cut a small piece of sponge from larger one and dip it in the paint solution. Now dab the paper surface with the sponge, to create a mottled effect.

Stippling with natural sponge

Cut a small piece of sponge as before, dip it in water and dab the paper repeatedly with it. The natural sponge has a more open texture, and this is reflected in the pattern it makes.

painting – this technique was used to introduce a variety of tones and textures into the Mediterranean beach scene in this chapter. You can also texture an area by flicking the paint surface with clean water. The water splashes on to the paint and the droplets of water soften and loosen the paint, causing the pigment particles to separate and flow towards the edges, creating lighter areas.

Once you have mastered these techniques and discovered new ones you will begin to incorporate them in your painting. In a tight, realistic painting a small textured area will stand out, making a strong statement. In a more loosely and impressionistically handled work the textures will balance each other and no one area will stand out. However, you can draw attention to an area and 'explain' it by making a few simple marks which sharpen it up and bring it into focus. You are providing a few visual clues – after all, painting is all illusion, a trick of the eye. Different artists have different aims. Some want to describe and interpret the world about them, sharing their unique vision with the viewer. Others want to entertain. Whatever your particular concern you should explore the medium, so that you can use it to produce the images you want.

Spattering on to dry paper

Load a stiff brush with paint, hold it over a sheet of dry paper and run a knife through the bristles. This will deposit a fine spray on the paper.

Spattering on to damp paper

Damp a section of your paper and then spatter on to it in the way described above. The result is a more softly mottled effect, the speckles blurring into one another.

On The Beach

WET-ON-DRY

The figure provides a subject which is infinitely challenging yet wonderfully expressive and it is for this reason that artists throughout the ages have never tired of depicting it. It is not necessary to have a deep knowledge of anatomy to be able to draw the figure well, though as you pursue the subject you will undoubtedly want to increase your knowledge, to look under the skin for explanations of what you can see from the outside. The knowledge gained at second hand from books or classes will never do more than supplement what you learn from your own personal observation. This is why we encourage you, firstly to work through the demonstrations we have shown you here, and then to find similar subjects to which you can apply what you have learnt. We are really trying to give you the basic skills so that you can develop on your own. We are giving you a 'push start' in the hope that you will continue under your own momentum.

There is no substitute for painting and drawing directly from the figure, but you do not need to go to the expense of hiring a model or even going to classes where a model is available. There are free models all around you, beginning with your friends and family who may be persuaded to 'sit' for you or whom you can draw surreptitiously. In parks and bars or as here on the beach, there are people to be drawn. You should get into the habit of carrying a sketchbook in which to make notes no matter

how cursory. It will surprise you how much information you will find in a sketch which seemed too thin to be useful. Watercolour is an excellent medium for this sort of notetaking although in this book we do not really discuss its qualities as a sketching medium.

The beach is a wonderful place to people-watch. You can make yourself comfortable in an unobtrusive position from which you can see much without being overlooked. It is important to make the marks recording what you see rather than concerning yourself with the finished image. The images are being imprinted on your mind as you work, in the same way that writing notes helps you to remember things even if you never read the note. Again the rule is to look, make notes, observe and to draw. The practice and the experience cannot be bought.

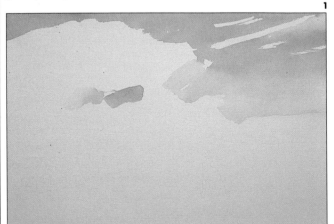

So far we have not really looked at the figure. Here the artist gives you a gentle introduction.

1 The paper for this painting is Bockingford 140lb (300gsm), Not, 15in×22in (37.5cm×55cm). The brushes were a large Dalon (number 18) and sables number 3 and number 8.

The artist mixes a solution of cobalt and ultramarine, and with a large brush (number 18) loaded with colour, washes in the sky, working wet-on-dry.

2 The artist treats the figures very simply, looking for the broad forms rather than the details.

Study the subject carefully through half-closed eyes. Try to reduce it to an abstract pattern of lights and darks and put down what you see, not what you 'know' to be there. The artist started with a light wash of brown madder alizarin and chrome orange. When this was dry he laid in the mid-tones with sepia and brown madder alizarin.

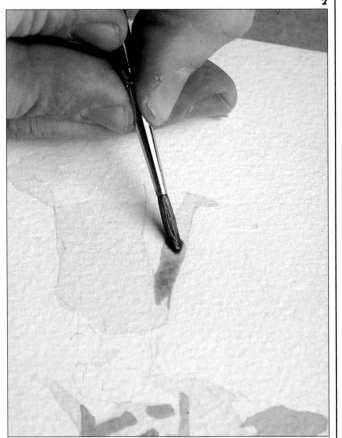

2

1

3 The sky was washed in briskly, using a big brush. The artist allows the white of the paper to show through in places to suggest white clouds in a brilliant summer sky. The wet-on-dry technique creates crisp edges. The figures have been established simply, but very effectively, using a light tone and a mid-tone.

4 The bright sunlight casts strong shadows and the painting has more contrast than some of the landscapes we have seen so far. The artist uses Payne's grey for the darkest skin tones then, while this is still wet, he drops in a mixture of brown madder alizarin and sepia to add warmth to the shadows. The sunlight reflected from the sand warms the shadows.

5 Having broadly established the figures, the artist drops in background features such as the beach umbrella. The various elements of the composition then begin to take their place in space. The umbrella is laid in with brown madder alizarin with a touch of Winsor red; cobalt and ultramarine; sap green; and Payne's grey for the dark parts. The artist paints these

details wet-on-dry with a number 3 brush.

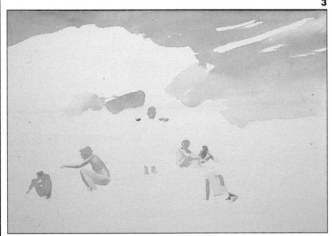

3

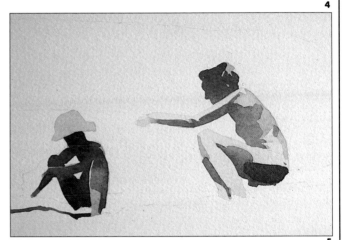

4

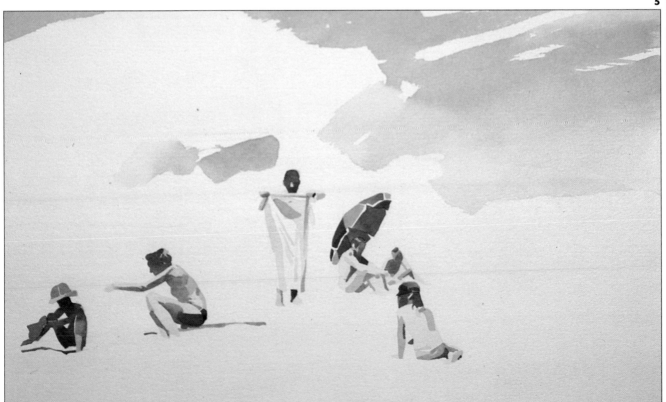

5

WET-ON-DRY / ON THE BEACH

6 In this detail we see the way the artist is building up the forms from discrete patches of colour. Seen close to, the painting has an abstract quality – it is divided into small elements of colour like a jigsaw puzzle. However, these resolve themselves into accurately described forms as soon as you increase the viewing distance.

7 The deep green foliage of the pine trees which form a backdrop to the beach is an excellent foil for the warm tones of the sand and flesh, and the occasional brilliant touches of local colour.
The green is mixed from sap green and Payne's grey and is washed in wet-on-dry with a large brush. A smaller brush is used to cut back around the contours of the figures.

8 The background is simple but descriptive. The artist has used the colour to block in large areas for the canopy of the trees, and has also used it to 'draw' the complex tracery of the tree trunks. A dilute wash of sap green is used to trace the silhouettes of the palm trees in the distance – these pale colours help to suggest that the trees are further away.

9 The beach is laid in with a series of overlaid washes mixed from yellow ochre and cadmium yellow. The colour is applied broadly in the open spaces, but around the figures the colour has to be applied more carefully with a number 3 brush.
The shadows beneath the figures are laid in with Payne's grey mixed with a little yellow ochre.

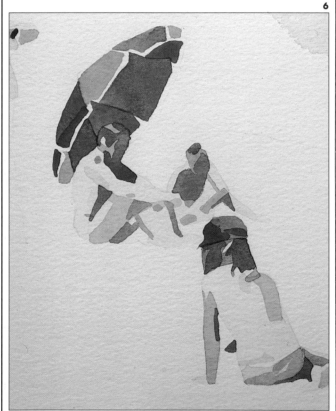

6

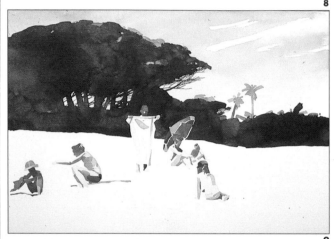

8

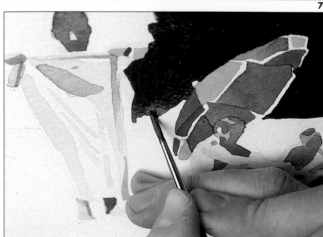

7

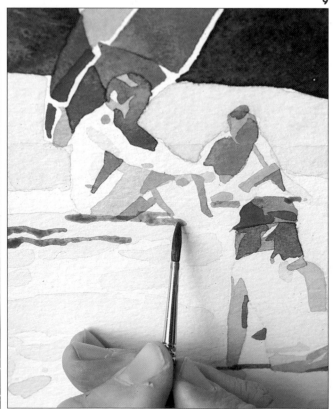

9

Detail
The crisp layers of fresh colour effectively create the warmth and brightness of a Mediterranean summer.

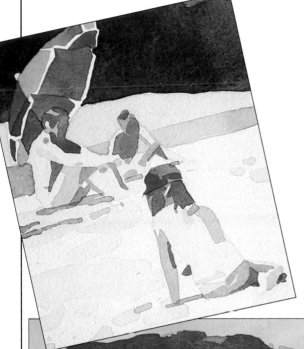

10 To complete the painting, the artist lays a slab of shadow across the beach – adding both compositional interest and form. The sweeping diagonal divides the rather plain rectangle of the beach into two more interesting geometric shapes. Payne's grey and ochre are spattered in the foreground; again it has a dual purpose, describing the pebbles on the beach and the uneven surface of the sand, as well as adding textural interest.

The subject could be considered complicated. Firstly, there are many different elements within the picture: people and their beach paraphenalia, the sandy beach and the background. The figures seen in this way are constantly moving and can adopt an apparently infinite range of poses. The answer is to be direct and decisive, drawing what you see, putting down only the essentials and risking making a mistake. Deal with the subject as a whole rather than becoming too concerned with one element. The artist has simplified the forms, but the painting is nevertheless an accurate and easily read representation of the scene.

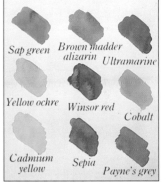

Sap green Brown madder alizarin Ultramarine

Yellow ochre Winsor red Cobalt

Cadmium yellow Sepia Payne's grey

10

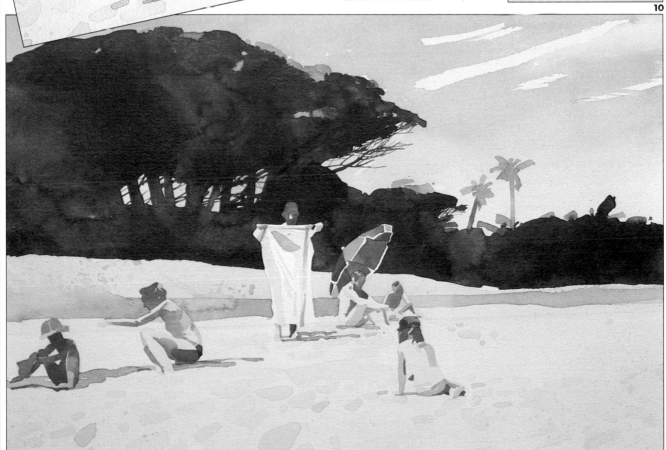

Boats – Low Tide
SPATTERING

This composition may appear more complex than some of those we have encountered, but when analysed, it consists of a few simple elements. The boats occupy the central area and, with the repeated curves of their hulls and their exhilarating colours, undoubtedly dominate the painting. Nevertheless the foreground is an important part of the composition, balancing the bright primary colours of the boats. These two visually busy areas are set against the more subtle colours and textures of the background. The textures in the foreground are built up gradually – so

be careful not to let this area get too dark too quickly, or subsequent layers of pattern and texture will not 'tell'. For this project the artist uses very simple techniques but the exciting results demonstrate the way that these basic techniques can be extended almost infinitely. The artist used pencil to apply small areas of texture to the cliff-face – this combining of media is often frowned upon but it is effective and does not compromise the essential qualities of watercolour – its freshness, spontaneity, and that luminosity which is unequalled in any other medium.

1 For this painting the artist used a sheet of 90lb Cotman paper with a Not surface. The paper measured 10⅜in×14¾ (22.5cm× 37.5cm). The brushes were a number 3, number 6 and number 8 sable. The artist also used a soft B pencil.

The first step is to make an outline drawing – for this the artist used a soft B pencil to block in the main elements of the subject. He made only sufficient marks to help him identify and organize the main colour areas but not enough to confuse the drawing. It is

important that the drawing is kept as simple as possible since watercolour depends for its effect on bright, clean colours. When he has blocked-in the main areas of the drawing the artist stipples in masking fluid to represent the shingle. The blobs of fluid are varied in size so that those nearer the viewer at the bottom of the page are larger and those further up the page – further from the viewer – are smaller. He also masks the circle of the sun and a flock of gulls swirling in front of the cliff-face.

These sketches were made on location – the artist was drawn to the simple curved shapes of

the hulls of the beached boats. He used these as the basis of this study of texture.

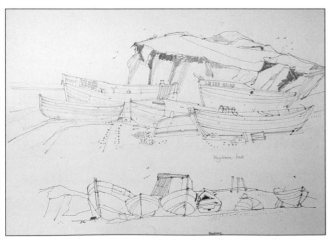

2 The sky is washed in with a pale blue – a dilute mixture of cobalt into which a little raw sienna and Payne's grey has been introduced to create a rather watery sky. This pale first wash will be overlain at a later stage with further washes to create a hazy effect. To achieve subtle effects such as this you must develop the tones gradually. If you allow the colour to get too dark at an

early stage you will limit your possibilities later. If, on the other hand, you are after dramatic effects, do not be afraid to make a bold statement.

3 The beach in the foreground is washed in with a mixture of raw umber into which the artist has introduced a little yellow ochre. Occupied areas of space are rarely the colour you believe them to be. A beach, for example, is expected to be a golden yellow but the colour of the sand or pebbles will depend on the geological structure of the coastline. The rocks which back the beach are not necessarily those which will supply the material of which the beach is made. Often the longshore currents move quantities of material down the coast, resulting in the shingle being comprised of material from an outcrop further up the coast. Other factors in the equation are the weather, the light and, as here, a covering of seaweed giving a green cast.

4 The first wash is allowed to dry then the artist adds more yellow ochre to the original mixture. This creates an olive green which is washed over the foreground, covering part of the original wash but leaving some parts exposed. Here the artist introduces Payne's grey plus a little lamp black into the wet wash to create a dramatic darker tone in the foreground.

5 One of the important elements in this painting is the texture of the shingle. He started by masking the larger pebbles, taking care to make sure those in the foreground are larger than those in the distance to aid the sense of recession. Dots of Payne's grey mixed with lamp black are being stippled in here to create another level of texture.

6 The beach can be seen to be a series of overlapping washes edged with deliberate undulations and not simply random shapes. Dark stipples of the Payne's grey/lamp black mixture extend in lines from the foreground into the background – creating a linear perspective and at the same time defining the bases of the troughs.

3

4

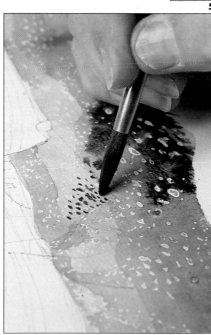

5

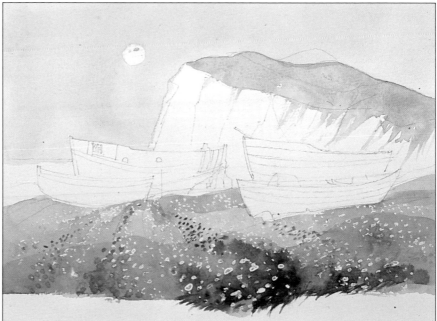

6

SPATTERING / BOATS – LOW TIDE

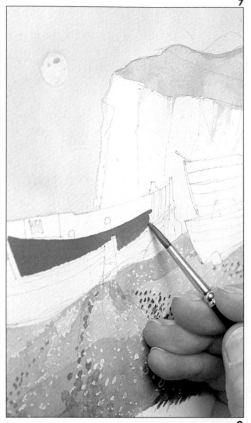

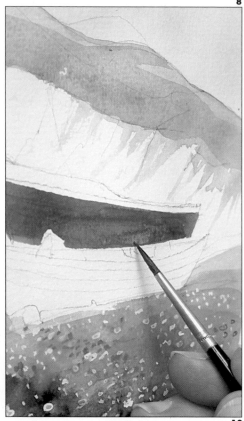

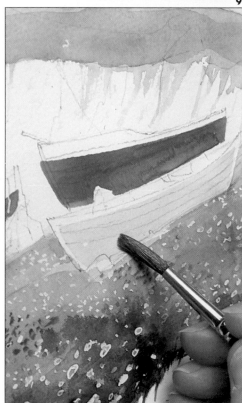

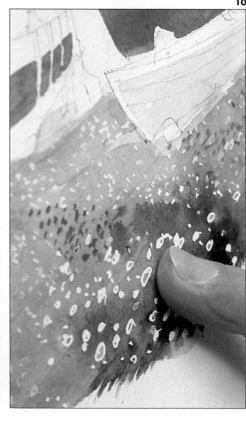

7 The vivid paintwork of the fishing boats provides the artist with a wonderful opportunity to use pure primaries – red, blue and yellow. Here he uses cadmium scarlet. The paint is laid on with a number 3 sable brush using a stroking movement to create a relatively smooth paint finish. The brushstrokes follow the line of the planks of the clinker-built hull so that any streaking in the paint will follow and help describe form.

8 For the second boat the artist uses cobalt blue, a particularly vivid blue. Study the painting carefully at this stage. You have established the colour of two of the boats but, despite the fact that you have probably matched the paintwork exactly, the effect is likely to be unconvincing. This is because the pure unmodified colours which you have used are actually 'the local colour' and not the colour you would see. At a later stage various tones of red and blue will help to define the form and create a more realistic image.

9 Here the artist uses a cadmium lemon to describe the local colour of the nearest boat. Notice the transparency of the yellow and compare it with the cadmium scarlet, which is a very opaque colour.

10 The artist mixes a large quantity of yellow ochre and, using a loaded number 8 brush, applies this colour across the foreground, working briskly to create vigorous gestural marks. In this detail, the artist removes some of the masking fluid by rubbing it very gently with his finger making sure that the paint is quite dry. He leaves some of the masking fluid because its creamy yellow makes a useful contribution to the texture of the shingle.

11 Here the artist creates a spattered effect in the foreground. The technique is very simple – he first mixes a quantity of raw umber and raw sienna in a large dish.
A toothbrush is dipped in the colour and held over the painting. The artist then takes a palette knife and runs it across the bristles, depositing a very fine spray of colour on the surface.

12 Payne's grey mixed with lamp black is used to develop the detailed structures of the boat such as the rudder, the keel, and the propellor.
Few brush strokes are used to describe the simplified shapes – it is the general forms that are required, not a lot of detail. Here the artist uses the tip of a number 3 brush to paint the blackened timbers propping up the boat.

13 At this stage we can review the progress of the painting once again, and it might be useful if you glanced back at picture number 6.
As you can see, the artist has laid a tonal wash across the top of the cliffs so that the clifftop can now be read as a hummocky area covered in grass. The sea has been washed in with a very pale wash of Payne's grey.

Cadmium yellow, with a little Payne's grey, has been washed over the original lemon yellow of the nearest boat. The shingle beach is richly textured and convincing but the rest of the painting needs a considerable amount of work before it will be complete.

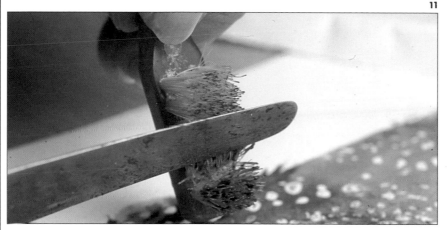

11

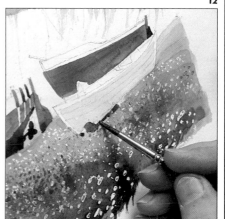

12

13

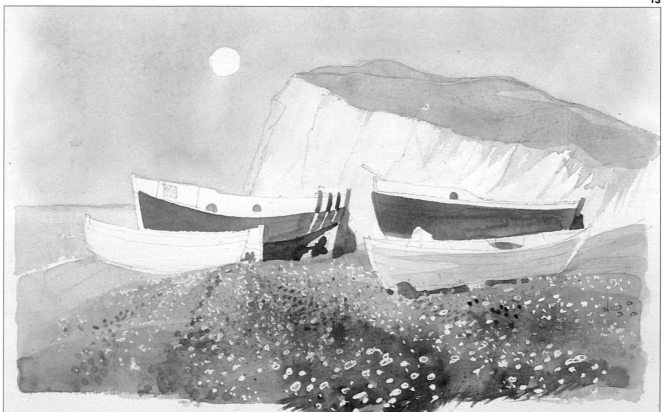

SPATTERING / BOATS – LOW TIDE

14 The artist continues to develop the details of the boats. A very pale wash of Payne's grey is used on the red boat to 'knock back' the bright red and suggest the way the boat curves along its length. The white boat is rendered with a wash of Payne's grey. Details are added over this with a strong Payne's grey tint applied wet-on-dry, creating the crisp lines of the timbers and other details. Here the artist uses the tip of a number 3 brush and lamp black to paint the lettering on the prow of the boat. He deliberately leaves the letters undefined since sharp edges would leap from the painting rather than taking their proper place in space. Details at that distance would not be clearly defined.

15 In this detail we see the artist using an ordinary lead pencil to sharpen up some of the detail on the boat. People often recoil from the notion of 'mixing media' but it can be useful. The pencil is appropriate because it has a very fine and rigid drawing point that can be handled with great accuracy and its sutble grey tones well with the watercolour.

16 The artist works into the cliffs with a pale Payne's grey, using the brush to create marks which suggest faceting and fissuring of the rock. When this is dry he applies more texture using a dry brush technique. The texture of the rock-face builds up as a series of thin and very pale applications of colour, some applied wet-in-wet, others applied wet-on-dry. When the artist was satisfied with this area of the painting he removed the masking fluid, revealing the gulls. Here you can see the way in which he has added more texture using a fairly blunt lead pencil.

17 The painting is completed by laying a light wash across the sky. The artist uses the original mixture of cobalt, raw sienna and Payne's grey in a very dilute solution. He drags the colour across the sky area to create the impression of thin veils of cloud which drift across the sun. The colour is laid on with a fairly dry number 8 brush as he wants to create streaks of thin colour rather than a wet wash which might lift the underlying colour.

The artist has created a pleasing composition which relies for its impact on the simplicity of the forms, the contrast between the strongly textured foreground and textures of the sea, sky and chalky cliffs, and finally on the vivid complementary colours which dominate the centre of the painting.

Detail
In this detail you can see just how richly textural watercolour can be. These effects are created optically, for the paint surface is entirely flat – contrast this with oil painting where it is possible to build up thick encrustations of paint which extend the surface of the painting to almost three-dimensional proportions.

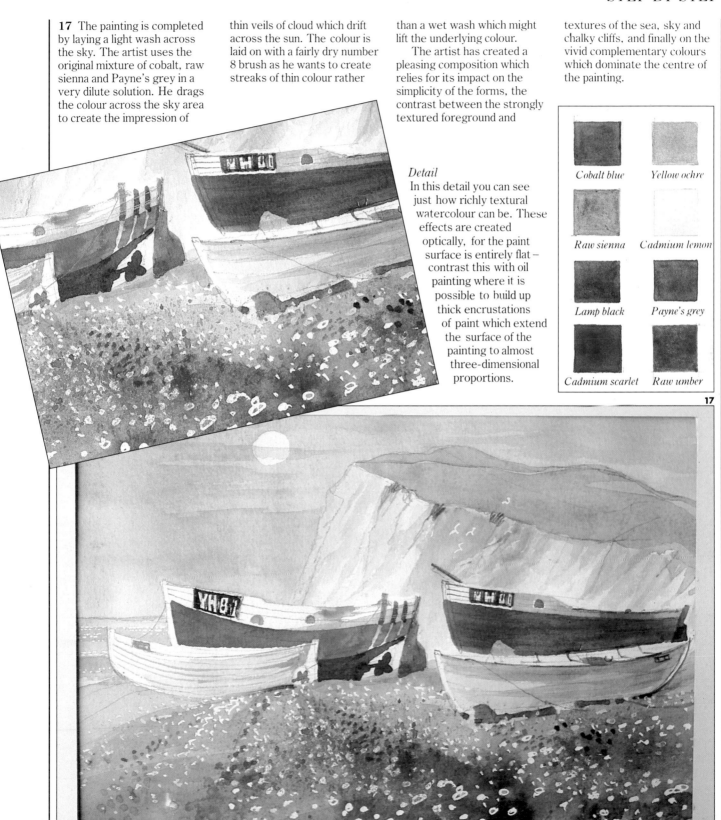

Cobalt blue Yellow ochre

Raw sienna Cadmium lemon

Lamp black Payne's grey

Cadmium scarlet Raw umber

17

Still Life – Shells

WAX RESIST

Objets trouvés provide the artist with a never-ending source of inspiration and the sort of material that automatically finds its way into your home is very revealing. For example, a wildlife artist who specializes in bird paintings has a large collection of skins, skulls and feathers, gathered on walks in the countryside. This is supplemented by material brought to him by friends who know of his interest. His collection is a valuable source of information and inspiration to which the artist constantly refers. In his field accuracy is important.

In the same way an artist interested in texture will automatically gather bits of bark, fabric and anything which has an interesting surface. A colourist, on the other hand, will gravitate towards objects that feed his particular imagination. So hang on to that collection which everyone else thinks of as junk – it is an essential part of your visual library and you will never be without something to paint.

Here the artist has taken four familiar objects from his collection and has created a simple but effective composition. It doesn't matter how often you paint a subject as long as you treat each painting as an entirely new experience, make no assumptions and look at the subject as if seeing it for the first time. For the artist every visual experience is a new one.

These shells were selected from a large collection in the artist's possession. Most artists are magpies, saving bits and pieces that catch their eye – it may be the colour, the shape or the texture which attracts them. These 'found' objects become part of their visual library and the same objects may appear again and again in their work.

1 For this painting the artist used a sheet of heavy paper (Bockingford 200lb) which he stretched on a drawing board. The dimensions were 15in×22in (37.5cm×55cm). He used four brushes, three sables – a number 3, a number 5 and a number 8 – plus a one-inch, decorating brush for spattering texture. The wax resist was applied with a white candle.

In this painting there is no underdrawing. The artist works directly onto the paper using a number 8 sable brush loaded with a dilute wash of yellow ochre and ivory black. Working quickly and observing the subject carefully, he blocks in the largest shell.

2 The smaller shells are sketched in using the same pale grey wash, a large brush and brisk, decisive gestures. This method of starting a painting demands a slightly different approach, for the artist is looking for broad forms rather than outlines. You may feel unhappy about abandoning the initial pencil drawing, but the sense of security which it gives you may be a false one. There is a tendency to assume that the drawing is correct and so forget about it once you start to apply the paint. But a good artist constantly checks his drawing, takes nothing for granted, and is prepared to make quite radical changes even at a late stage. Try this exercise – it may feel a little like walking a tightrope at first, but you'll find it exhilarating and your work will become more direct and vigorous.

3 The artist allowed the first wash of colour to dry, helping the process along by standing the painting near a fan heater. He then introduced some Payne's grey to the original wash and used this to add more detail. He studied the shells carefully through half-closed eyes to identify the lights and darks, touching-in the darker tones with a number 5 brush. The main ridges have been drawn using a wet-on-dry technique – notice the way these colour areas have dried with crisp edges which will enhance the grittiness of the shell's surface.

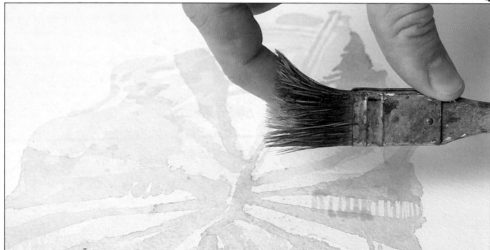

4 Shape, texture and pattern are the main concerns of this painting. On the left we have the solid symmetry of the largest shell – the stony fan of the top half mirrored in the lower part. On the right, the spiny silhouette of the larger shell contrasts with the smooth, compact shapes of the pair of small shells. Now look at the surfaces – chalky, grainy textures on the one hand and a polish as smooth as glass on the other; a creamy matt colour contrasting with rich brown spots and speckles. Here the artist spatters on colour to create a softer effect.

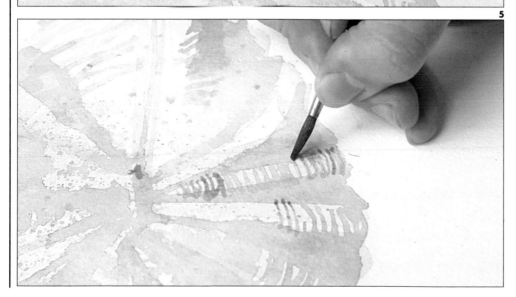

5 The artist attacks the subject boldly, taking risks to avoid the painting looking overworked. In the previous picture we saw him spattering on texture, here he tightens up the drawing by adding detail with a fine, number 3, sable brush. This method of working is ideally suited to the subject. It allows the artist to work loosely and respond to the textural aspects of the subject without losing its linear qualities.

WAX RESIST / STILL LIFE—SHELLS

6 Here the artist works into the spiny shell on the right. One of the possibilities which watercolour offers you is the gestural mark – the mark which is an important statement in its own right. The artist uses broad, bold descriptive marks for this shell, and carefully drawn, organized lines to describe the delicate tracery of the large shell. He adds more texture by flicking on heavy droplets of colour. Then, using the same technique as in picture 4, he spatters on colour with a one-inch brush, but in this case the brush is heavily loaded and deposits a coarse spray of colour.

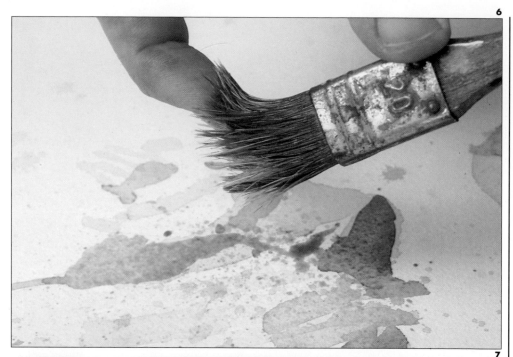

7 The artist uses a number 3 sable brush to add fine details. Again he alternates between a bold, broad approach, applying the colour freely with sweeping gestures as in the previous picture, then tightening up the image by adding details using a number 3 sable brush. Here we can see some of the repertoire of marks available to the watercolour painter. At this scale the painting has a pleasing, abstract quality which relies for its impact on the contrast between blurred edges and sharply defined colour areas, on paint which is spattered and splashed, and on a limited palette and fairly close tones.

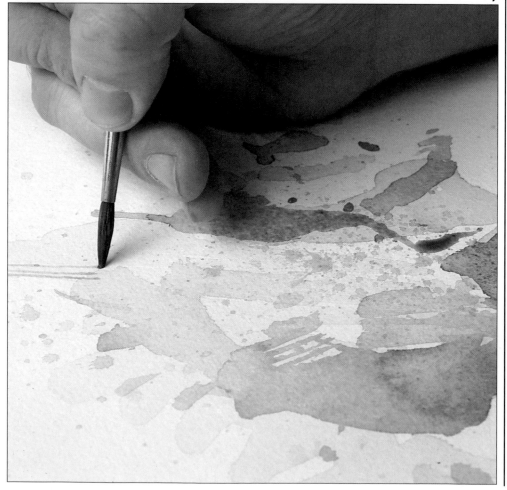

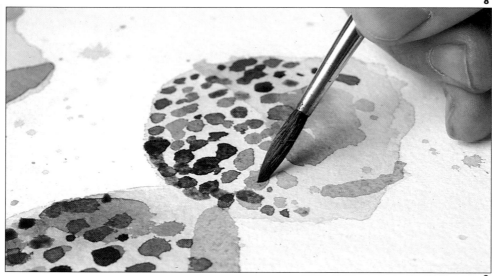

8 The cowrie shells are established very simply. Payne's grey is used to paint in the darker tones. It is fairly easy to see the tones in a subject which is a single colour; as soon as pattern is introduced the forms are broken up, confusing the eye. This is a concept which is exploited in nature by animals with a dappled coat that acts as a camouflage. The best way to see the tones is to exaggerate them by half closing your eyes. Here the artist speckles the shell with brown madder alizarin, the darker spots are sepia.

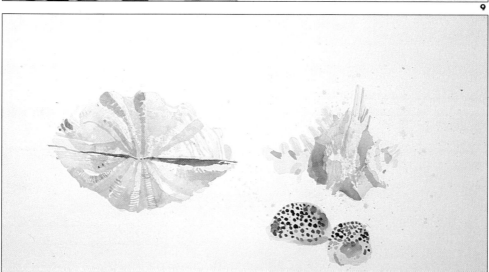

9 In this painting, the artist uses cool colours and a limited palette. This allows the quality of the brushmarks and the textural element of the composition to show to advantage. The painting is bold, the paint freely applied but the subtle pearly greys and the warmer pinky browns create a soothing, harmonious effect. A simple subject such as this allows you to explore the special qualities of watercolour – the brighter pigments are so seductive that there is a temptation to rely on colour and neglect the marks and the effects of overlaid colours.

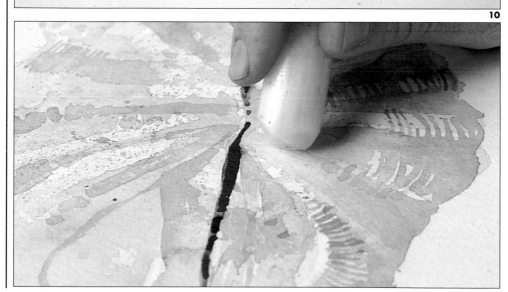

10 There is a pleasing tension in watercolour which may result from its apparent randomness and the need to control that. This random element can be explored and exploited and when it is successfully channelled the result is that special freshness and immediacy which is almost irresistible. Here the artist lays on a wax resist. Watercolour will be repelled in the waxy areas, resulting in an unevenly applied colour which is exciting.

WAX RESIST / STILL LIFE – SHELLS

11 Payne's grey is washed over the waxed area. A greasy surface repels water, so the colour breaks up into droplets which either run off or dry on top of the wax. As the candlewax was not evenly applied, the wax resist is not continuous and colour runs off and collects in areas where the paper is exposed. This effect is even more obvious on rough paper as the wax tends to rub off on the high spots causing the colour to run into the recesses, exaggerating the paper texture. An artist searches for ways of implying what he sees, of sharing with the viewer his vision of the world. Some adopt a photorealistic approach, describing the subject in minute detail. In this painting, however, he has found equivalents for what he sees.

12 If you turn back to the painting of anemones you will see that the artist masked his subject so as to lay in the background area first. Here, however, the artist has worked up the details of the shells first, only applying the background at the very end. In this case the artist was dealing with four simple shapes; the bunch of anemones on the other hand presented a more complicated outline and applying the background last would have been slow and complicated. Here the artist deliberately uses the background colour to firm up the outlines of the objects. Using a number 8 brush he takes the Payne's grey and ultramarine wash around the objects, using the wash to define the outline.

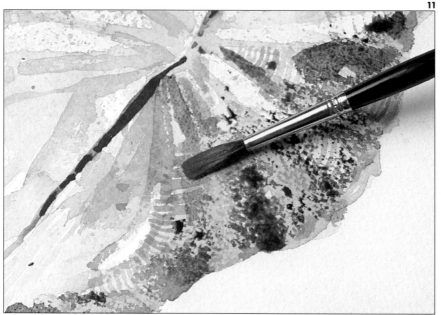

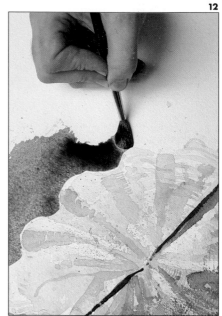

13 The flat, monochrome background gives you very little information about the spatial relationships so that in the previous picture the objects appear to be suspended in space. To rectify this, the artist mixes a dark wash of ivory black and ultramarine and uses this to lay in shadows around and under the objects. This immediately sits them firmly on the flat surface on which the shadows are cast. The shape of the shadows reinforces the illusion of three-dimensionality, for two-dimensional objects lit in this way would throw different shadows.

In this detail the artist lays a final wash of brown madder alizarin over the top of the cowries.

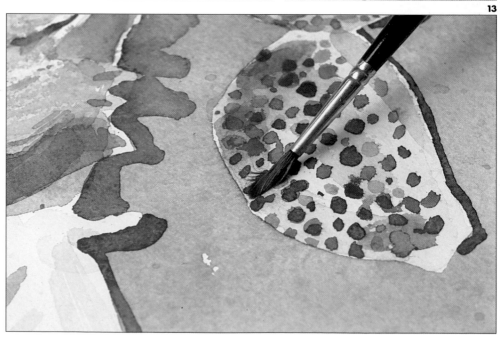

14 It was the simplicity of this subject which attracted the artist. The small, simple shapes of the shells are close in tone yet not without interest. They could have been incorporated as subsidiary items in a much larger composition, but by making them the subject of the painting the artist is able to study them carefully, concentrating on their subtle colouring and the slight differences in texture. In the process he allows us to see quite ordinary objects with new eyes. He shares his visual experience with us.

This simple still life illustrates the range and flexibility of watercolour. The artist makes clear simple statements using straight-forward techniques. He puts down patches of colour, allowing the mark of the brush to contribute to the web of colour which creates the illusion of form, local colour and texture. The approach is controlled for the artist is a skilled exponent of the medium, yet the final image is fresh and direct.

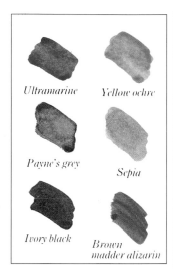

Ultramarine Yellow ochre

Payne's grey Sepia

Ivory black Brown madder alizarin

14

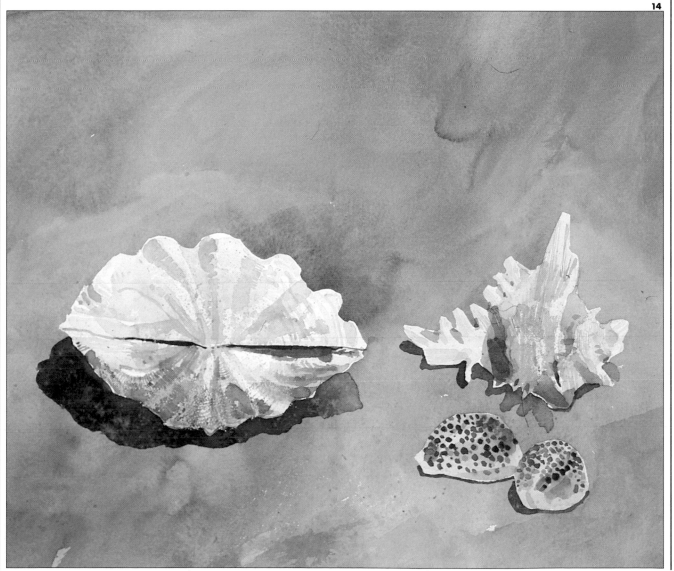

Daffodils
WET-IN-WET

Watercolour is capable of almost infinite variety and in the last two projects in this book we illustrate two entirely different approaches to very similar subjects. In this lively painting of daffodils the artist has used a spontaneous, vigorous approach, working almost entirely wet-in-wet. In the painting of buttercups which follows the artist is using a mainly wet-on-dry technique, planning the application of colour carefully and working slowly and meticulously.

Here the artist dispenses with the initial pencil drawing and starts by defining the broad forms of the subject with a wash of clean water – she is actually drawing with water. She then begins to lay-in the paint, allowing it to flow onto the damp paper. The wet area confines the flow of the paint and she imposes shapes and tones by pushing and pulling the colour with a brush, so that it builds up in some areas, leaving a very thin veil of colour in others, revealing the white of the paper in yet others. She works fast, for the technique relies on the immediacy of her response and on keeping the paper damp. She concentrates on the subject, looking for the broad forms of the bunched flowers heads, and for the lights and darks which describe the form and create a sense of volume. She continues in this way, alternatively wetting and drying the paper, touching in colour, standing back to see how it flows, moving it with the brush or dabbing it with tissue.

Described like this the technique sounds difficult, but as long as you are prepared to be bold and risk making a mistake it is no more difficult than any other method of working, and it is certainly exciting.

These delightful spring flowers were the inspiration for this painting. The colours are simple yellows and greens rendered more vivid by the sunlight streaming through the window. Flowers are a demanding but particularly rewarding subject for the watercolourist.

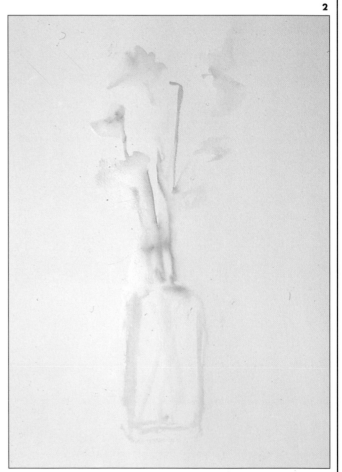

1 The support is Bockingford 140lb (300gsm), unstretched and the brushes are numbers 5 and 6 sables. Using a number 6 brush loaded with water, the artist starts to lay-in the broad forms of the subject. She then applies the colour: cadmium yellow, cadmium lemon and cadmium orange middle for the flowers, sap green for the flowers and stems. The colour is allowed to flow into the wet area, and is then manipulated with the brush.

2 Here you can see the way the artist is working – the paper is still wet and the paint spreads through it. The darker areas are where the artist has used the brush to push and pull the paint, gathering the colour to form darker tones. The ghostly form of the subject can be seen shimmering through the wet paint. The artist is searching for the shapes, rather than drawing them, building them from within rather than outlining them.

3 Using a wet-in-wet technique, the artist develops a range of subtle tones, from delicate veils of colour which barely tint the paper to rich, deeply saturated passages. She introduces more water on to the paper, then floods a vibrant Indian yellow into the centre of the daffodils. In this picture we see that colour being lifted with a brush to create highlights and impose a shape on to the colour area. To do this, the artist dries the brush and then presses it down on the paper surface so that the colour is sucked up by the hairs. Notice the softly blurred colours, the crisp dried edges, and the way the texture of the paper shows through and influences the paint layer.

4 The artist mixes a wash of lemon yellow and Prussian blue and, using the tip of a fairly dry number 5 brush, draws the stalks of the flowers, the neck and shoulder of the jar. The brushmarks are clearly defined, but not harsh, softened slightly by the wet ground. Here she works back into the stems with lemon yellow.

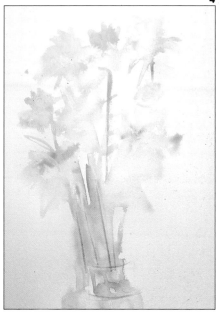

5 The artist's method of working demands that she works quickly, keeping the colour wet, moving the paint, touching-in more colour, lifting colour, judging the progress of the work, constantly assessing the work. All the time she refers back to the subject, looking for the tones that will describe the forms, but nevertheless working with the paint, rather than imposing upon it. It is a risky way of working for a painting is easily lost, or overworked. Her approach depends on the directness and immediacy of her response to the subject.

WATERCOLOUR

6 In this detail you can see the way the painting is beginning to build up. The first wet-in-wet washes have dried and she now works over them wet-on-dry. This creates crisper edges, and as the layers of colour build up the forms begin to emerge. Here the artist lays cadmium orange into the trumpets of the flowers. She constantly refers to the subject, and whilst she is concerned to establish the individual flowers in a credible way, she also wants to capture the feeling of a bunch of daffodils.

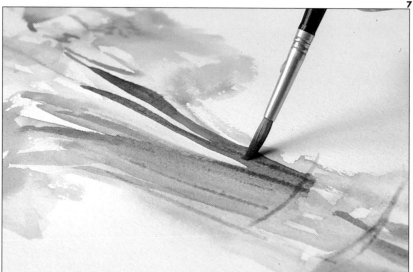

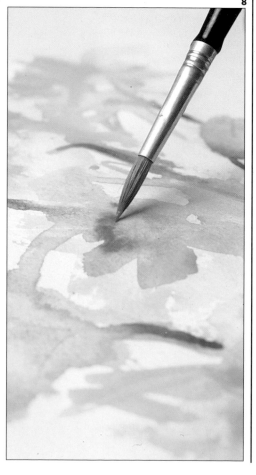

7 Here sap green is applied to the stems, to give them more intensity and form, and to imply the bunched effect. A cool Prussian blue is then used to establish the shadows within the foliage.

8 The centres of the daffodils are painted in with the tip of a very dry brush. The artist uses the paint straight from the paint, so as to get a rich, opaque colour which contrasts and heightens the transparency of the other passages.

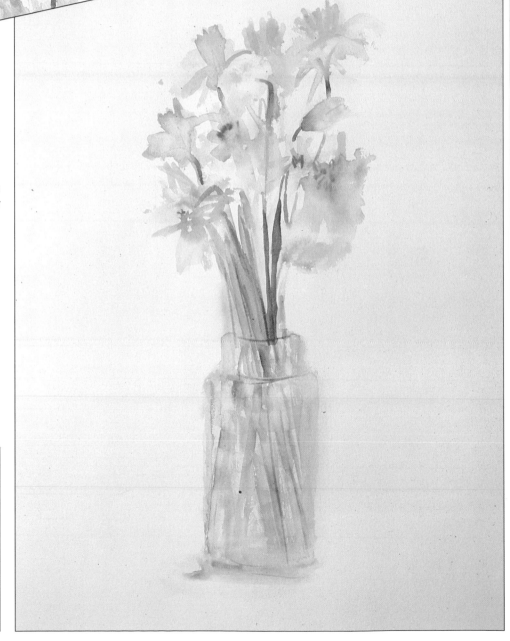

9 Watercolour is an unpredictable but expressive medium. When this unpredictability is harnessed the results can be astonishingly beautiful. The wet-in-wet technique demonstrated here shows watercolour at its most unpredictable, but the artist deliberately courts this element of risk. She explores and exploits the controlled accident which can destroy a painting but which can also produce startling and pleasing effects and images, to surprise even the person who holds the brush. Here she has created pale, delicate veils of colour which describe the most fragile petals, while the trumpets are vivid splashes of orange.

9

Detail
In this detail we see the way the artist has explored and exploited the qualities of watercolour. The colour is fresh and true, with that special vibrant transparency which is peculiar to watercolour. The techniques used work on two levels. They describe the subject accurately – there is no doubt that the subject is a bunch of daffodils. They also create a picture surface which is interesting and pleasing when viewed as an abstract pattern of shapes and colours, lines and edges.

Prussian blue *Indian yellow*

Sap green *Cadmium yellow*

Cadmium orange middle *Lemon yellow*

Buttercups in a Blue Vase
CUTTING BACK WITH THE BACKGROUND

Simplicity is the key to this pleasing and satisfying study of a bunch of wild flowers. The artist's approach is careful and painstaking, but he sacrifices none of the freshness and immediacy of true watercolour. Part of the success of the study relates to the composition. The vase of flowers is placed off-centre with its base on the bottom quarter of the picture area. The shadow links to the vase, so that the object and its shadow form one continuous shape which occupies two-thirds of the picture. The background too is divided on a one-third, two-thirds basis, the boundary between the table top and the background occurring at this point. The colour scheme is simple but effective. The buttercups are placed against a cool grey background which enhances their bright, fresh yellows. The contrasts between the cool and warm colours is also seen in the dark blue vase which is set against the ochres of the table.

The artist has described the flowers accurately, but not with strict botanical detail – this is a painting rather than a botanical illustration. He has studied the forms carefully and found a shorthand to express each element. Thus he uses only two yellow tones, light and dark, to capture the form and character of the flowers. He goes from bloom to bloom painting in flat shapes with a pale yellow, using the colour to draw the shapes, following the underdrawing only loosely. The shadow areas were then blobbed in with a darker, more intense yellow. This same formula is repeated for the leaves – light green flat shapes, with shadows added in a darker tone. He paints what he sees, and what he sees is a pattern of light and dark areas, rather than 'a stem', 'a flower' or 'a leaf'.

The background is laid-in at a late stage, and the artist has to 'cut back' around the flowers, buds and leaves. This is a difficult task, requiring a steady hand, but it allows the artist to redefine and refine the outlines of the flowers, giving them a crisp clarity.

The tiny flowers and the mesh of stems and leaves provide a challenging subject, for this our last project. The artist was attracted by the strongly contrasting colours, the yellows of the petals, the rich, dark greens of the stems and leaves and the dark blue of the vase. A further contrast is provided by the busy, detailed outline of the flowers and leaves, and the smooth, uninterrupted curves of the vase.

1 The artist used two brushes: a number 18 wash brush and a number 2 sable. The paper was a sheet of stretched Bockingford measuring 24in × 18in (61cm × 46cm). The artist starts by making a light outline drawing with a graphite stick.

2 The basic forms of the flower heads are laid in with a weak solution of lemon yellow. The colour is dropped in with a small, number 2, sable brush, and with controlled gestures the colour is then pushed and pulled into shapes which describe the flower heads. However, if you look at the next picture you will see that the artist does not stick too closely to the pencil outlines.

3 Moving on to the foliage, the artist blocks in the leaves and stems with a pale sap green and lemon yellow mixture. For this detailed work you should use a number 2 brush and keep the paint moving to avoid tidemarks which would interrupt the forms. Hold the brush in a relaxed manner, using smooth movements from the wrist to obtain natural, flowing lines. Use the tip of the brush to make the pointed leaf shapes.

Here the artist adds the dark tones on the buttercups with a mixture of lemon yellow and cadmium orange – he does not create a very dilute wash for he wants the colour here to be as deep and dense as possible.

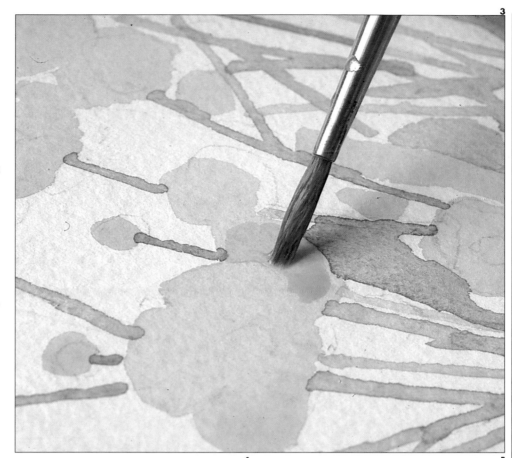

4 When the first wash of colour in the foliage is completely dry, the artist develops the darker tones with a mixture of sap green and a little black. By painting wet-on-dry he ensures clean, crisp edges. By painting the spaces between the leaves and stems he implies a sense of depth. This also helps to describe the forms of the foliage and stems, for the light areas stand out against the darker areas. He implies the positive shapes by painting the negative shapes.

5 The artist continues in this way, allowing the paint to dry between applications of colour. The complexities of the stems and foliage are resolved into an overlapping tracery of colour. A touch of dilute sap green is dropped into the centre of the flowers to describe the stamens.

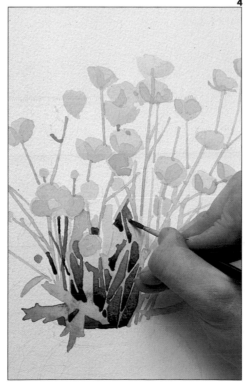

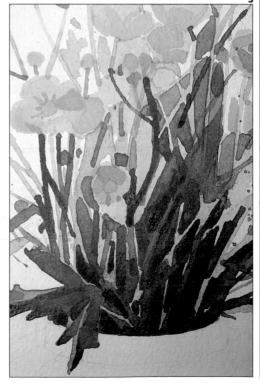

WATERCOLOUR

6 Finishing touches are added to the flowers – some of the dark tones have been strengthened to harmonize with the foliage. However, try not to overwork the buttercups for you risk losing the freshness. It is important to know when to stop. So leave the flowers, even though they may not be as 'finished' as you would wish.

Here the artist works into the background with a very dilute mixture of Payne's grey and neutral tint. Neutral tint is a useful addition to your palette, for it tones down other colours without deadening them.

8 The background is completed with lively directional brushstrokes. This places the subject in a real setting – a grey wall replaces the flat, white paper and establishes a sense of space between the vase of flowers and its background. A completely flat colour would be harsh and uninteresting, and would be an unsuitable foil for such a fresh and natural subject. The artist introduces a textural element into the wash, creating a lively surface, which enhances the composition and suggests a realistic setting. Notice the way he has used the background colour to redefine the flowers and leaves, taking the grey right up to the fragile, irregular outlines with a number 2 brush, redrawing the shapes where necessary.

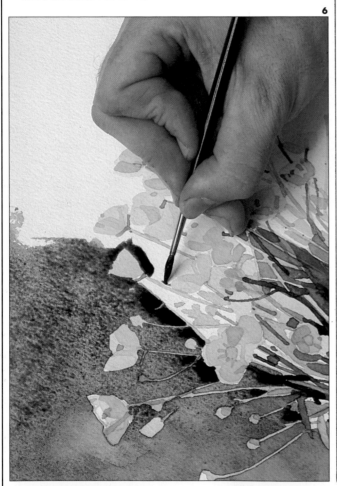

6

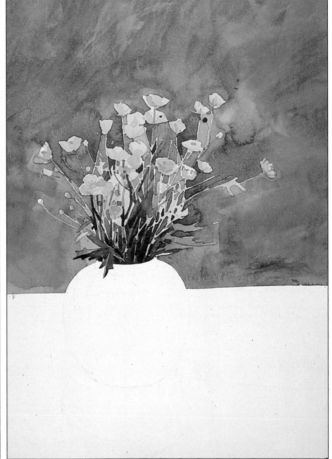

8

7 A number 18 wash brush is used to fill in the large background areas *far right*, and a number 2 sable for the delicate task of taking the background colour up to the outlines of the flowers *right*. Keep the paint moving, working clean water into the unfinished edges as you paint, to prevent the colour from drying unevenly.

7

7

9 The vase is built up gradually in a series of simple stages. The artist started by mixing ultramarine blue and indigo, applying this as a flat wash with a number 2 sable brush. The artist works carefully, leaving white paper to stand for the toothed pattern around the shoulder of the vase and the rim of the vase. The first wash is allowed to dry and then the artist applies another wash of the same colour, this time taking it over the pattern on the front of the vase, and carefully painting the reflection of the window, creating a bright highlight on that side. A third wash is applied while the second is still wet, this time the colour is applied across the lower part of the vase to suggest the shadow in that area, which helps to establish the curve of the vase. The wet-in-wet technique creates a blurred effect which suggests the roundness of the form. Contrast this with the crisp edges of the bright highlight.

9

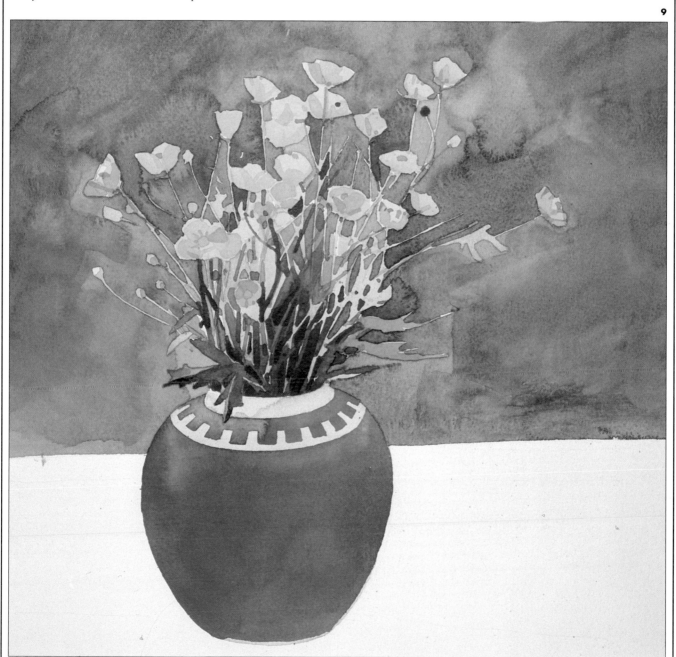

WATERCOLOUR

10 The shadows are blocked in with a dilute mixture of burnt sienna, ultramarine and indigo. The artist uses a large brush and working wet-on-dry carefully describes the irregular shape of the shadow. The crisper the edge and the greater the contrast, the brighter the light source will appear. Shadows should not be neglected, they are not an unimportant part of the background, but a significant positive shape within the composition. They also help to relate the subject to the environment. Here, for example, the shape of the shadow helps to establish the horizontality of the table top, and also reinforces the perceived roundness of the vase.

12 Next the artist mixes a wash of raw umber and burnt sienna and working broadly lays in the table surface. The colour is applied with a number 18 brush, working the colour carefully around the contours of the vase, but taking it right across the shadow, giving the shadow a rich colour which integrates it with its surroundings. To make sure that the dark tones of the shadow did not lift and contaminate the wash, the artist made sure that the area was completely dry, and applied the colour with a single stroke. The artist builds up the tone and texture of the wooden table with a series of washes.

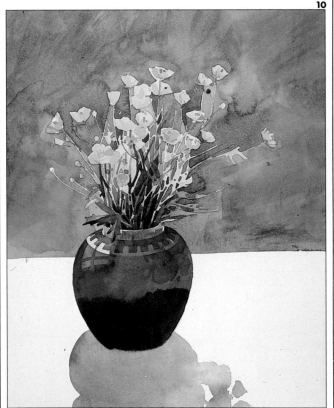

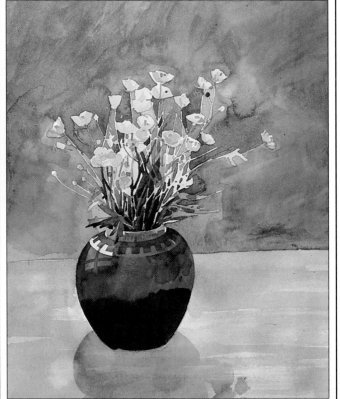

11 Do not make the mistake of thinking that shadows are grey, they vary in tone but unless there is very little light they usually contain a trace of the local colour of the object throwing the shadow – in this case the blue vase. A cool colour like this blue is often warmed with a touch of a warmer tone – here the artist uses the burnt sienna to obtain a neutral tone.

13 The final details are added to the table surface with a fine sable brush. The artist uses the same raw umber, burnt sienna mixture and paints a series of horizontal lines to suggest the grain of the wood.

14 In this painting, the artist has used a few very simple techniques to achieve a rich and satisfying image. The subject was complicated, and his approach was painstaking. The flowers and foliage were built up with layers of colour applied wet-on-dry. The crisp edges achieved in this way are used to describe the edges of the petals, leaves and stems. At first sight the stems and foliage might have appeared difficult, but by working from light to dark, using the darker tones to describe the gaps between the stems, the artist has resolved the problem. Nevertheless, the artist worked slowly and carefully, allowing one stage to dry before proceeding to the next. The painting has several richly textured passages: the complex web of the foliage; the loosely brushed background and the simple but realistical table top.

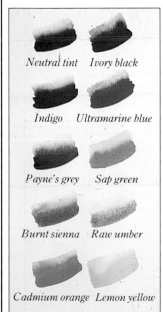

Neutral tint Ivory black

Indigo Ultramarine blue

Payne's grey Sap green

Burnt sienna Raw umber

Cadmium orange Lemon yellow

OILS

Chapter 1/Introduction

Despite the alchemy of modern chemistry, nothing has been invented to challenge the supremacy of oil paints. Once you have tried these paints, with their individual textures and exquisite colours, even though you might stray into other media you are still likely to come back to oils again and again. Even the most experienced artists are constantly surprised by oil paints – their versatility ensures a lifetime's fascination.

Today oil paints are more convenient and accessible than ever before. Modern technology has ironed out many of the former shortcomings of the medium, making the paints easier to use for artists of all abilities. No longer has the artist to gather wild damsons and stew them for hours to reduce the fruit to something usable as paint, or catch a wild boar to tweak out a few bristles to make a brush. But more than this, modern oil colours are now manufactured in such a way that many of their idiosyncrasies have disappeared – drying time and texture, which used to vary widely between colours, have been evened out. For the beginner this makes life much easier.

All paints, however, have their individual characteristics and it is worthwhile getting to know them. This path of discovery can be fascinating, particularly with a friendly voice and eye to guide you. In this book we take up the role of guide, escorting the keen painter through the steps which lead to sufficient knowledge to make a painting of which you can be proud. So, in the course of this book, the basic techniques and skills of oil painting will be laid out before you, giving the beginner the necessary guidance and encouragement to take up the brush. More experienced artists will be able to find new ideas to broaden their expertise and enliven their art.

In the first section, ideas are given on choosing a subject and arranging your composition. This is followed by encouragement to make the first mark. A guide to the mesmerising array of artists' materials sorts out what is necessary, what is useful and what you do not need. Finally, the heart of the book demonstrates those techniques which make oil paint such a versatile medium.

Introduction

THE SUPREME PAINT

Many people have set ideas about the sort of paintings produced with oil paints. They see before them Constable's elaborate vast canvases, or seventeenth-century landscapes – rich browns and greens which are the labours of days, weeks and sometimes years of thought and action. Not surprisingly, their reaction is 'I could not do that'.

But, as the examples on this page show, oil paints can be used to produce a variety of different styles. They can be applied *alla prima* – in one sitting – to produce a lively surface of brushstrokes. Or, as shown in a demonstration later, they can be diluted to the consistency of watercolour and applied with a cloth merely to stain the canvas. Conversely, the paint can be built up, letting one layer dry before adding another to qualify the first, so creating a rich surface of colour and texture. They can be thinned down to make translucent glazes and watery washes or built up opaquely in thick impasto relief.

Moreover, as will become clear in the course of the following pages, these techniques are not the exclusive reserve of the trained artist. All that is required is that you take up a brush, squeeze out some paint, and before long

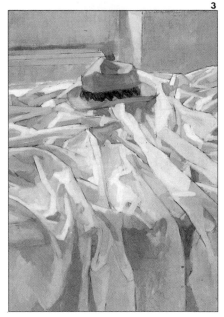

1

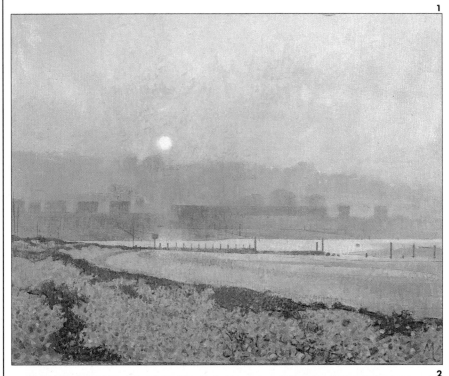

3

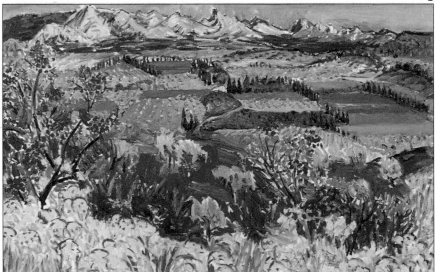

2

1 This atmospheric painting, *Evening Light, Bembridge,* by Derek Mynott, is created by layers of misty scumbles. In the foreground, dabs of broken complementary colours make this area 'sing'.

2 With a much freer style, expansive brushwork and a dramatic use of primary colours, *Val d'Entre Congue,* by Frederick Gore, makes compulsive viewing. Again, the overall effect relies on the juxtaposition of complementaries.

3 Bold directional brushwork plots the pattern of folds in Eric Luke's *Still Life with Hat.*

you will have a result. It may not be perfect, but take heed from the pages of demonstration later on and you will soon be amazed at what you can do.

Every artist develops his or her own personal style — almost a signature in itself. This is reached through experimentation, observing other artists' methods and approaches and trying them out. It requires a knowledge of what you yourself can do and what the possibilities are and, of course, what you enjoy. Some artists enjoy a tortuous intellectual style of art which requires much thought and preparation to produce an image. Others simply enjoy the tactile qualities of the paint and the challenge of the medium. The vast range of styles that are considered successful in contemporary art — by which I mean commercially successful — bears witness to the observation that in art 'anything goes'.

4 *Reflected Trees,* by Susan Hawker, is a fresh painting of abstracted natural forms, created with soft colour blendings.

5 A detail from the mysterious *Allegory of the Sea* by Barry Atherton, exemplifies a delicate painterly style.

4

5

6

7

6 In sharp contrast, *Carnation and Astromer,* by John Watson, relies on strong colour and surface pattern and an ambiguous sense of space.

7 *Still Life with Flowers and Mirror,* by Donald Hamilton Fraser, delights in a purity of form well suited to the crispness of knife painting.

CHOOSING A SUBJECT

Even though you might be aching to start painting, when it comes to the point the mind goes obstinately blank and refuses to come up with any ideas. The sight of an empty canvas causes an apparently permanent mental block. Fortunately, there are ways of overcoming this. For a start, try painting what is in front of you – a bowl of fruit, the view from the window or, like Van Gogh, the chair in the corner of your bedroom. Most artists are inspired by their surroundings, and by events in their lives, however trivial they may seem. This applies to writers, poets and musicians as well as painters.

But information and ideas can come from many sources. As you will see in the demonstrations later on, inspiration can come from your photograph album (or more likely from the piles of snaps ready to go in it). In many ways the photograph album is the modern-day sketchbook. In it we record our reactions to situations, places we have visited, people we have met, an odd juxtaposition of shapes created by shadows perhaps, or an interesting viewpoint. And photos include colour notes to jog the memory, even if the purists doubt their usefulness. You may want to recreate a view you have witnessed or just take a tree or a small detail from the photograph to include in your composition.

Traditional style sketchbooks can be fun to keep too. Flipping through old sketchbooks can often give you an idea on a horribly blank day. If you take the trouble to include written notes, the date, etc., they make amusing records of your own personal reactions to what you see around you. Many people find them difficult to maintain, however, and you are more likely to make a sketch on the back of an envelope or whatever piece of paper happens to be to hand at the time. It still serves the same purpose of recording what you see so that you can use the information later on in composing your picture.

Magazines are also a rich source of visual information, particularly advertisements. Use such source material to set off a train of thought. You need not copy such an image slavishly. After all, it is the diversions from the original image that are your own personal contribution to the finished work. Do not feel a cheat in using such material. David Hockney, the British contemporary artist, for example, has always admitted freely that he uses magazine photographs, advertisements and other such visual material to provide information for his painting. By doing so, he has done much to dispel the opinion that such an eclectic approach to art is somehow 'wrong'.

Inspiration from abstract ideas is harder work. But artists have traditionally been inspired by poetry and writing of all kinds, expressing their views and ideas through their chosen medium of paint.

151

COMPOSING YOUR PICTURE

Once you have decided on a subject, the next step is to decide how to organize the composition. Many of the considerations to be taken into account at this stage appear complicated when listed on paper. Yet most of them are natural to us and it is just a case of letting your common sense prevail.

A collection of objects – fruit, tableware, stationery, anything to hand – can make a good subject to start with. Arrange them so that they are pleasing to the eye (if that is your aim). Be aware of size, shape and texture and also of colour. Once you have decided on the arrangement you can start work. There are, however, other considerations which will help you to produce a more interesting image.

The point from which you view your subject matter can affect the way you see it. On this page you will see the same bowl of fruit viewed from different positions – obliquely from one side, from above, below, close up. Each composition attracts attention for a different reason and inspires different emotions in the viewer. Yet the subject matter – a fruitbowl on the kitchen table – remains the same. Viewed from below, the bowl becomes almost menacing and domineering. Seen obliquely from one side, the eye is lead to the bowl by the edge of the table which leads towards the focal point of the picture. The space on the left of the picture has dramatic impact – it is not boring or wasted and shows that it is not necessary to fill every square centimetre of your canvas with detail.

Such areas can provide an area of calm in a frenzied composition or give emphasis to the main subject matter.

That our eye is directed to the bowl of fruit in this view depends on the fact that in the West we 'read' a painting from left to right as we read a book. Try reversing this composition and you will see that it looks uncomfortable. So, strong compositional lines from the left will guide the eye into the picture.

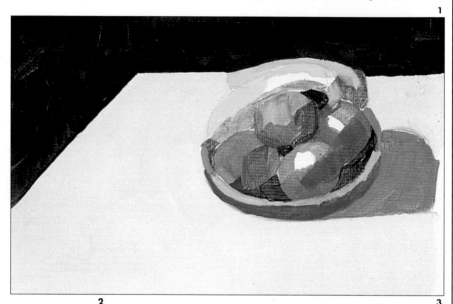

1

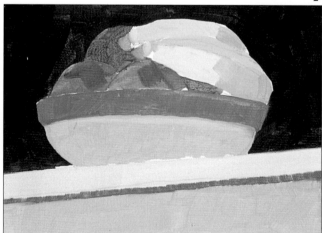

2

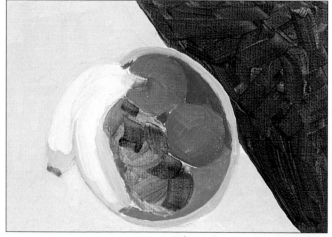

3

1 In this oil sketch, the artist takes a sidelong view of the bowl. The edge of the table leads the eye into the void on the left and then on to the fruitbowl, thereby animating the various areas of the picture space. As it is viewed from above, it is the fruit, rather than the bowl, that is the focal point.

2 Viewed from below, our basic bowl of fruit is given status, dominating the image. Painting a figure from this worm's-eye view can make it appear powerful and menacing. Note how the side of the table cuts the composition at an angle, fighting symmetry.

3 A bird's-eye view of the fruitbowl reveals new potential. Now the bowl becomes part of a pattern created on the surface of the painting, even though the ambiguous murky void on the right hints at space beyond it. A sense of tension is thereby introduced, enforced by the cutting of the dramatic diagonal with the edge of the fruitbowl.

Do not be afraid to cut part of your composition with the frame of the picture. This can stop the eye from wandering out of the picture and is also useful in visually nailing an object in the foreground.

Another aspect to take into consideration is the shape of the canvas, board, paper or whatever you are painting on. It is usual to paint on rectangular shaped supports, either vertical (called portrait) or horizontal (called landscape). Some subjects commend themselves to a particular shape. For a tall vase of flowers with predominant verticals, the portrait shape is the natural choice. The horizontal lines of a line of boats, on the other hand, would suggest the use of a landscape shaped canvas.

The size of the composition is an influential factor too. Imagine the impact of the fruitbowl seen close up if painted on a large canvas. It changes the way we perceive the subject matter. But supports of all shapes and sizes are used now, including square canvases, which were traditionally regarded as too symmetrical, and specially constructed asymmetrical supports.

Lighting is also an important aspect of composition. Bright, angled light can produce heavy dramatic shadows which stir the emotions; soft, warm lighting will increase the range of tone and give the painting a calmer feeling. Use shadows to link elements in the composition and to provide interesting patterns on the surface.

In a still life or an imaginary composition you are in control. You can move the objects around until they present a pleasing combination of line, shape, texture and colour. But when painting from life the essence of the arrangement is predestined by nature or man. Even so, the same issues prevail.

The point from which the view is painted will alter the effect. An equally testing decision is how much of the scene is included and how the frame will cut the elements. Again light will play an important part and, outside, the effects of the weather can contribute to your composition.

4

5

4 Zooming in on the fruit in the bowl presents yet another angle of the subject matter. This composition concentrates on the shape, colour and texture of the fruit. The composition is made up from arcs most clearly seen in the edge of the bowl and repeated in the banana, oranges, apples. This gives a sense of unity to the painting. By cutting the banana and oranges with the frame, this has the effect of pushing these fruit back.

5 Lighting is an important aspect of composition. Here the light source is behind and to the right of the fruitbowl. It is low down, like the evening sun, and so casts long shadows. Shadows are useful in creating pattern and linking disparate elements. In this composition, the shadow forms a strong angled line which grabs the attention of the viewer, leading the eye to the fruitbowl.

THE FIRST MARK

Now you are ready with a subject you want to paint and some idea of how you want to present it. It is time to start painting. First, however, you need to set up your painting surface so that you can work. An easel is a useful piece of equipment but by no means essential. You can paint flat on a table or by wedging your support at an angle by using whatever ingenious method comes to mind. Plenty of the world's great painters produced their works without an easel – Pierre Bonnard and Paul Klee, for example, and John Constable painted some of his oil studies with his sketchbook wedged in the lid of his open painting box.

Make sure you have all your equipment to hand so that you do not need to break off constantly to fetch

something. The light, whether you are working inside or out, should fall on your canvas so that it does not cause reflections in the paint or cause your head to cast a shadow on the paint surface. Northern daylight is traditionally recommended, but artificial alternatives, if suitably placed, will do adequately.

There are many different approaches to starting painting. Some artists meticulously prepare their composition so that nothing is left to chance. Others bravely storm their canvas, applying the paint straight away and developing the composition as they progress. Most artists, however, start by drawing the outline of their composition on to the canvas or chosen surface, copying either a still life or scene in front of

them or whatever visual material they have amassed.

Charcoal or chalk was traditionally used for this underdrawing, but to stop it muddying the first layer of paint it should be fixed with a spray fixative. The ease with which charcoal makes a mark seems to inspire a free line which is often important when copying a scene. The fact that a charcoal stick is so delicate means that it cannot be squeezed. This encourages a relaxed grip which is necessary to produce a flowing line. A soft pencil can be used for this underdrawing, but the mark is fainter and you may have trouble travelling over the weave of the canvas. Graphite pencils or the fatter sticks leave a heavier mark. They are widely used as they are soft and are much

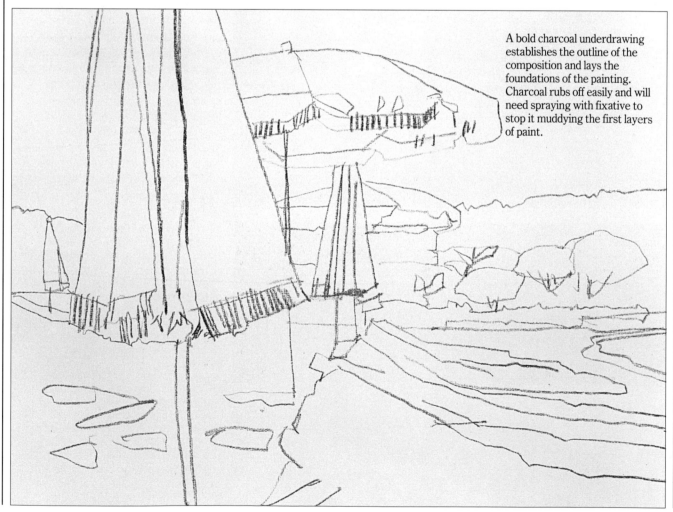

A bold charcoal underdrawing establishes the outline of the composition and lays the foundations of the painting. Charcoal rubs off easily and will need spraying with fixative to stop it muddying the first layers of paint.

cleaner than charcoal. They can be sharpened into points or wedges with sandpaper.

Some artists, particularly when painting a landscape, like to make an underpainting, outlining the main areas of the composition with a brush and a very dilute neutral mixture of colour. For this underpainting quick-drying paints are chosen, the earth colours such as burnt umber. Acrylic paint, which dries almost immediately, can be used for such underpainting.

A more spontaneous approach to oil painting can be achieved by sketching in oils in a manner know as *alla prima*. The idea is to lay one brushstroke of paint alongside another so that a single layer of paint is achieved in a fresh, unlaboured manner. The painting is therefore finished in one sitting.

For some the outline drawing is the most difficult aspect of painting. For the faint hearted, canvases can be bought with an outline already mapped out. But it may help to work out the outlines on some sketching paper first before starting on the chosen surface. Keep your composition simple, editing out extraneous details in an interior scene, for example. If you get the outline as you want it in the right scale on your sketchpad, you can transfer it to the canvas by pricking along the outline with a pin, laying the drawing on the canvas and rubbing charcoal dust along the holes with some cotton wool, or marking through with a sharp pencil. Otherwise, you can transfer and enlarge an image from a sketch, magazine or photograph, using the squaring-up method described on pages 280-85.

There is no doubt that it is worth getting the outline of your composition right at this stage. A certain amount of alteration can and probably will take place at the painting stage, but you will find it much easier if you have confidence in your underdrawing.

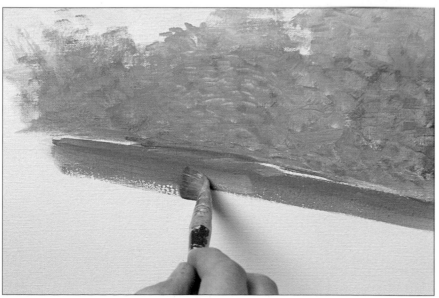

Left When painting from life, set up your easel so that you can see your subject without unduly craning your neck. Here the artist wishes to have a bird's eye view of the crabs, so they are set up at a low level. Now he quickly sketches in their outlines with a thin graphite stick, which is less messy than charcoal and makes an easy mark.

Below Left Some artists take the plunge and apply the colour direct without needing an underdrawing. This usually occurs where the forms are simple or where colour dominates the composition. Using dilute turpsy paint, the artist lays in the foundations of the composition. Anything at this stage which appears out of place can be wiped off with a clean cloth dampened with turps or white spirit.

Chapter 2
Equipment

Art stores are bewitching places; they display the enticing tools and materials which promise so much magic. Here you can dream of the masterpiece you are going to paint. The very names of the paints – burnt sienna, yellow ochre, viridian, French ultramarine – seem beguiling.

Such a store can provide many happy hours of browsing, but there comes a point when you need to make decisions. Artists' materials, if you buy everything recommended by the manufacturers, are expensive and it is a pity to buy something you will not need. It is bad ènough being faced with racks of different types of oil paints in hundreds of different colours only to find that if you open the tube the paint seems a totally different colour to the strip of colour on the outside packaging. In the following pages, you will be introduced to a restricted family of colours which will be enough to provide adequately for your needs and in due course you will get to know them all like old friends.

Oil painting need not be an expensive pastime. To start with all you need are a few tubes of paint, three or four brushes and something to paint on. In this chapter you will be given a guided tour of what is available, directed towards what is necessary and advised on what, if you buy it, may end up in the back of a cupboard covered with dust.

Where possible we point out cheap alternatives to what are accepted materials. For example, it is not necessary always to paint on expensive, stretched canvases. Cardboard makes a very good surface to paint on.

It is also worth learning how to look after and resuscitate your materials so that they give you good value. Good oil painting brushes, for example, actually improve with use. Advice and tips based on experience will help you get the best from your materials.

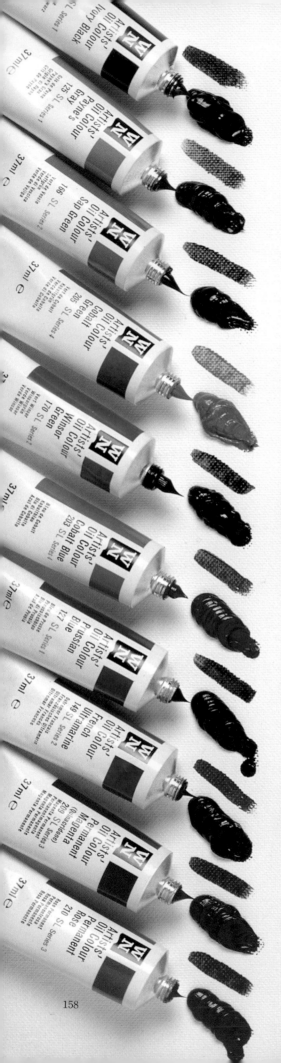

PAINTS

We are fortunate these days in being able to go to our local artists' materials store and buy tubes of oil paint of every hue which are ready to use. No longer do we need to grind the individual pigments and mix them with oil, although there are artists who still prefer to do this. Do not be wooed by the tempting wooden boxed sets of oil paints and other materials which conjure up sepia photographs of the great painters at work. They are certainly useful to keep your gear together when painting on location, but they are not essential. Most of the great painters only used about ten colours and most artists end up by using a suitable bag to keep their paints and other equipment in. Wooden boxes were not designed for artists' paraphernalia – cloths, jars and so on.

Oil colours have wonderfully exotic names which reflect their origins: the mineral colours such as those from the earth – burnt and raw umber, burnt and raw sienna, yellow ochre – and organic colours extracted from plant and animal such as sap green and Prussian blue. Some of these are artificially produced these days and many more have artificial substitutes which are less toxic, more stable or cheaper.

The pigment is ground up and suspended in a binding medium of oil which dries on contact with the air, sealing the colour to the support. Colours vary in their drying times but to a certain extent manufacturers have restricted the variations by adding quick-drying oils to slow-drying pigments.

Choosing your colour can be rather nerve-racking. On page 172 a restricted palette of paints is recommended, with an introduction to the characteristics of those individual paints. Here we will take a general look at what is available, and what to look out for when buying your oil paints.

Just by squeezing oil paint out of the tube on to the palette you can learn a great deal about it. Some pigments are noticeably oilier, others more finely ground and therefore smoother. Applied thinly or diluted, the dark blob can yield some jewel-like hues. Note how these so often differ substantially from the colour shown on the outside of the tube.

Most paint manufacturers offer at least two grades of paint, those usually referred to as artists' oils and those recommended for students which are often sold under a brand name. The latter are usually much cheaper and, therefore, contain inferior substitute pigments and more filler. Some argue that, as a result, they do not go so far and the colours are weaker, making it a false economy to buy them. Needless to say, many professional artists use these students' colours, so buy what you can afford.

EQUIPMENT

Oil paints are usually sold in small tubes of 21ml and larger ones of 37ml. Whites are available in larger tubes of 56ml and 122ml. For muralists or artists working on a grand scale some manufacturers sell large 250ml tins in a limited range. For the beginner, it may be sensible to buy 21ml tubes to start with, together with a large white, replacing them with the larger tubes once you have established your own personal palette.

Colours vary in price too. Manufacturers divide their artists' oil colours into series which differ considerably in price, from the cheap earth colours to the prohibitively expensive vermilion. Students' oil paints, on the other hand, are all priced the same. Few salesmen will point this out to you, so check before you make your final choice. The restricted palette recommended on page 172 does not include any of the expensive paints.

If we still had to grind our colours and mix our paints their qualities and idiosyncracies would soon be known to us. As a beginner, it is a good idea to squeeze out a little of each of your chosen colours and work them individually with your brush on some paper or just on your palette. You will be amazed by the variation in consistency. Some, such as raw umber and yellow ochre, are stiffer than the oilier cadmium colours. You will also see that the colours differ in opacity and strength.

Information about chemical characteristics is supplied by the makers. Oil colours vary in permanence. Some may lose or change their colour and are described as fugitive. This can be caused by contact with sunlight, pollution or through contact with other pigments. The Winsor and Newton range of paints are graded AA extremely permanent, A durable, B moderately durable and C fugitive. The initials SL on the tubes stand for selected list and applies to colours in the AA and A grades of permanence. Rowney and other manufacturers use a similar star system where **** denotes extremely permanent, down to * fugitive.

A few good habits established at the beginning of your painting career can save you a great deal of time and money. Squeeze the tube of paint from the bottom. Every now and then move up the paint from the base of the tube with the top on, by systematically squeezing it with an edge – a steel rule or even with your finger. Clean off the top of the tube after you have squeezed out the paint if it has collected round the nozzle. This can be done with a brush and the paint used; otherwise use a cloth. Then replace the cap tightly so that the air cannot dry up the paint. Paint can be left on the palette for up to twenty-four hours and sometimes longer without it drying up.

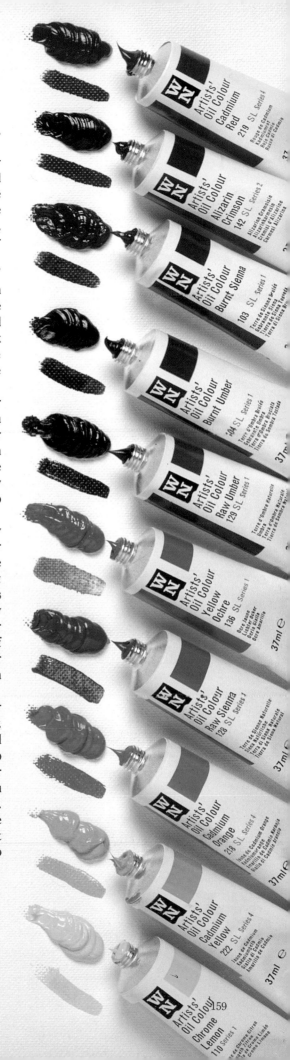

DILUENTS, MEDIUMS AND VARNISHES

Your favourite art store will offer you a blinding range of liquids and gels which promise exciting results when used with your oil paints. Many of these are not strictly necessary. In fact, in the beginning their very existence is merely confusing. Later on you may like to experiment with some of these mediums which encourage certain effects, but you may be pleased to know that most painters get along very happily without them.

Diluents

The paint as it comes out of the tube is sometimes too stiff for direct application on to the canvas. As discussed earlier, the colours vary in consistency – the oilier paints flow more easily. An important rule of oil painting is that when painting in layers (that is, placing one application of paint on top of another) each successive layer should be oilier than the one before. This is the explanation of the saying that you

should paint fat over lean. The reason for this procedure is that the topmost layer, if leaner, will be deprived of its oil content by the layer beneath, starving it so that it cracks, eventually causing the paint surface to disintegrate.

For the beginner (and indeed many artists continue to paint in this way) an easy system can be contrived by adding high dilutions of turpentine or white spirit to the first layers, less in the succeeding layers and pure paint in the final layer. For glazes, perhaps the addition of a little linseed oil will give a good gloss to the paint.

There are problems about using turpentine only as a diluent rather than a mixture of linseed oil and turpentine. As we have discussed, it may cause cracking – probably not in the next ten years, but in the next hundred or so. Turpentine also dulls the colour, removing the glossy appearance which so characterizes oil paint. On the other hand, the addition of linseed oil greatly

retards the drying time between layers.

Using only turpentine to dilute the paint will be easier for the beginner. Later, it will be easier to accommodate the more accepted procedure of diluting the paint with a mixture of linseed oil and other oils available with turpentine or white spirit, gradually increasing the percentage of oil as the painting progresses.

Fresh distilled turpentine is produced for artists so that it does not yellow with age or contain impurities. Keep the bottle sealed and in a dark place, otherwise the liquid will thicken and become useless. Ordinary turps available from DIY stores is cheaper and perfectly usable.

White spirit (or turpentine substitute) is much cheaper than turpentine and freely available in DIY shops. It is a slightly weaker solvent than turpentine but it has the great advantage in that it stores well without deteriorating.

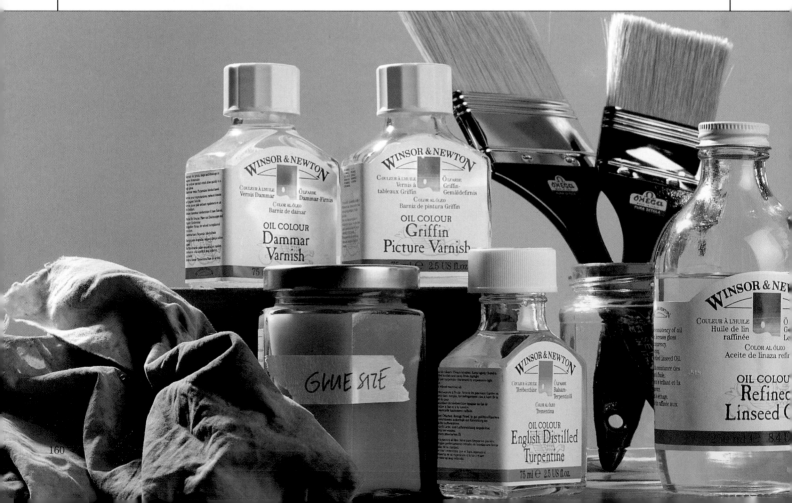

Mediums

Mediums are oils, varnishes or gels which are added to paint to create special effects by altering the consistency or behaviour of the paint. In the tubes of oil paint that you buy, the pigment is already suspended in a medium of oil – usually linseed, but sometimes safflower or the quicker-drying poppy oil.

Linseed oil is the oil most commonly used by the artist, not only to dilute the paint, as mentioned above but also to make colours glossier and more transparent – particularly for use in glazes.

Proprietary alkyd-based oil mediums, which usually come in gel form, can be added to oil paints to affect their performance. They are sold to thin the paint for glazing or for adding to paint to create the right texture for impasto (thick paint which sits in relief on the surface of the painting).

Traditionally varnishes were used as mediums, with each artist guarding his own particular recipe. Mastic, copal and dammar varnishes are all used as mediums to create certain effects. But there is no doubt that the paint is tricky to use thus diluted and so should be left to the more experienced.

Varnishing a Finished Painting

An oil painting can be protected by a few layers of varnish. It is not absolutely necessary, however, as the paint, when dry, is tough and impermeable. Varnish also has a tendency to yellow with age. But varnishing can prevent the ravages of pollution. It can also recover the gloss associated with oil paints which is sometimes lost with the addition of too much turpentine. If a matt finish is desired then it can be protected with matt varnish.

Some varnishes are applied to protect the paint temporarily, sometimes just while it dries. Such varnish is removable with white spirit.

Permanent varnish must be applied with extra care as it is difficult to remove. Make sure that the room is warm and dust free, without a through draught. Varnishing on a very humid day may cause a white bloom to appear on the surface.

With the painting lying flat on a table or on the floor, check first that the paint is dry – this may take up to a year for thickly applied paint. Dust down the surface with a clean cloth and wipe over gently with a rag dampened with white spirit. When it is quite dry, apply the varnish with a soft, well-worked bristle brush, free from loose hairs and dust. Brush the varnish across the surface in a thin layer, working the patch well out and finishing off with a light stroke to remove the brushmarks. Work systematically across or down the painting in bands, checking against the light that the surface is covered evenly. Apply a second coat when the first has well dried.

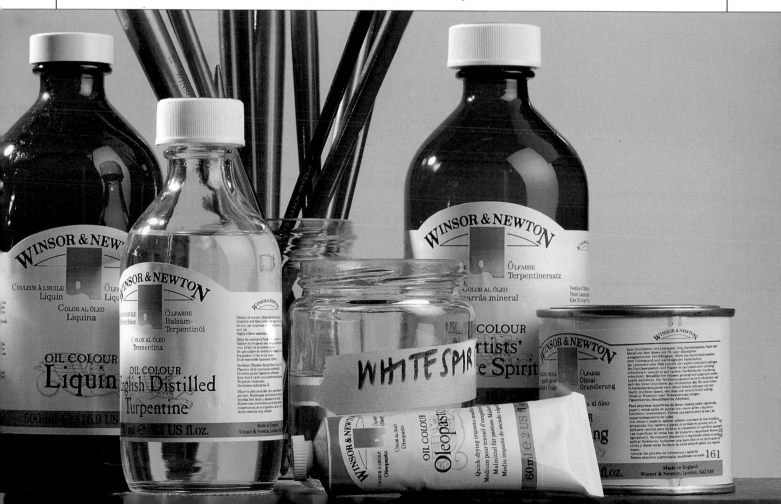

Chipboard is tough and does not warp. But it is heavy and will need well priming.

The rough side of hardboard is a good surface to paint on too. Prepare with size and a ground of oil primer or just with an acrylic primer. Prime both sides to prevent warping. It will need cradling if you intend to hang it.

Cheap and versatile hardboard, shown here with the smooth side up. A light rub with sand paper will give it some tooth and a wipe over with alcohol will prepare it for painting.

A ready-stretched and primed canvas 20 in. x 24 in. (50 cm x 60 cm). All you need to do is paint on it.

Oil paint can be applied to almost any surface if it has been prepared adequately. But it tends to slip and slide on very smooth surfaces without any tooth and some supports, such as canvas, are eventually destroyed by the oil in the paint and so they need to be sealed (primed) before the paint is applied.

Traditionally canvas has been prescribed for use with oils. Certainly the texture of the material and the give it has when stretched make a happy combination. Ready-stretched canvases are very convenient but they are expensive to buy even though the price varies tremendously between finest linen and basest cotton. Cotton duck may not be the kindest surface to work on but it is better than many of the alternatives.

Canvas comes in various weights or thicknesses and the weave varies too. A heavy weave, such as that provided by hessian or jute, will give a grainy effect to the final painting. Certain styles call for smoother linens. As mentioned above, canvas needs to be prepared to protect the fibre from the oil in the paint. You can buy ready-primed and stretched canvases or take courage and buy the canvas on a roll and stretch and prepare it yourself.

Canvas boards are cheaper, but have no give. Alternatively, you can affix canvas or muslin on to cardboard or hardboard with glue size or acrylic primer to make a cheap and highly recommended surface.

Many aspiring artists complain that a bare canvas kills off their inspiration because of the overwhelming 'importance' for generations to come. It is pointless to reassure those who suffer from such fears, but perhaps these feelings can be overcome by recommending that oil paper or cardboard be used to start with. These somehow disposable surfaces tend to defuse the situation.

Beginners tend to buy small canvases or supports, thinking that they will be easier to cover. In fact, on the whole, unless you relish detail and have a miniature subject in mind, then a larger canvas about 24 in. x 36 in. (60 cm x 90 cm) will not be so restricting. This should give you room to move and encourage a looser style so that you are not too bogged down with detail. Make sure you match the canvas with appropriate brushes – that is, not too small.

Wood
Wooden panels are not often used these days. A decent panel needs to be made of mahogany and should be an inch (2.5 cm) thick. It requires seasoning, battening (cradling) on the back to prevent warping and careful preparation. As you can imagine, this sounds like an expensive operation and it would be heavy to hang. Still, if you have a piece of wood to hand, it can be prepared with two coats of glue size and given a ground with at least two layers of oil-based primer. Both of these preparations can be obtained from art stores. Alternatively, it can be primed simply with two or three coats of emulsion glaze (80 per cent household vinyl matt emulsion with 20 per cent water). This will seal the wood as well, so the size is not necessary. Apply with a household brush, leaving the brushmarks to provide a tooth. If the surface is still too smooth, sand lightly before you start painting. Oil paint can be applied on top of oil or acrylic preparations, that is oil paint can be applied over acrylic but not vice versa.

Plywood is more easily available and comes in various thicknesses. Five to seven ply is a good weight for painting. It will need preparing in the same way as a wooden panel. Apply the size or glaze on both sides to prevent warping.

Composite 'woods'
Hardboard and blockboard – are frequently used by students to paint on. Like wood they can be prepared with glue size and an oil-based primer or just with an emulsion glaze. Prime on both sides to avoid warping. Hardboard is surprisingly good to paint on. It has both a smooth and a rough side to choose from. A DIY shop will cut it to whatever size you want but it is easy to saw up yourself. It will need cradling if you want to hang it. The smooth side can be painted on direct if you rub it down first with alcohol. Give it some tooth with sandpaper or by pulling the blade of a saw across the surface.

Chipboard is heavy but will not warp. It is not a kind surface to paint on and needs to be well primed.

Cardboard
Cardboard makes a good, very economic, surface to paint on. It just needs sealing on both sides with glue size. If you want to paint on a white surface, apply some primer when the size is dry. Otherwise use the warm brown of the cardboard like a tint.

Paper
Pads of specially prepared oil paper which have a simulated canvas surface are pleasant to work on and certainly make economic sense. In fact this surface is surprisingly resilient and will last for many years. It is also easy to pin or tape on to a drawing board, so an easel is not necessary.

A piece of ½ in. (6 mm) well-seasoned pine (the bottom panel of a drawer) which would make an excellent surface for painting. For durability, it would need careful priming and cradling.

Raw linen canvas which can be purchased in rolls of various widths and weights, ready for priming and stretching.

Sheet from an oil sketching block of 12 sheets. Blocks range in size from 8 in. x 6 in. (203 x 152 mm) to 20 in. x 16 in. (508 x 406 mm).

Cotton canvas board, ready for painting – a cheap alternative to a stretched canvas.

BRUSHES

Paint can be applied with a wide variety of instruments but there is no doubt that a good brush will go a long way to helping you achieve what your inspiration dictates. A cheap insensitive brush, though useful for certain techniques, will distract and annoy – more than likely putting you off the whole idea. The brushes, painting knives, etc, on the following pages are shown with a few of the natural marks they make. Of course, it is not recommended that you should buy this complete selection: you will need only a few to start with and what you buy will depend on your pocket and what it is you decide to paint.

Brushes come in three main shapes – round, flat and filbert – in various sizes from 00 to 14 depending on the range and with either long or short bristles. A good brush will hold its shape even after it has been wetted. Unfortunately, it is a case of you get what you pay for.

The most useful oil painting brushes are made from bristle – usually hog's hair which has a frayed end to each hair and holds the paint well. In addition, hog's hair is strong and flexible enough to cope with the consistency of the

1 No. 12 long flat hog. A large flat such as this holds large quantities of paint well. Excellent for applying paint to large areas or for working loosely. The mark made with a flat brush can be altered by the angle at which it is held to the canvas.

2 No. 10 short flat synthetic fibre/sable mix. Softer than the hogs hair, this short flat is useful for applying soft dabs of paint where a strong brushmark is not required.

3 No. 2 long flat hog. The long hair is susceptible to pressure, easily varying the width of the mark.

4 No. 2 short flat hog. A short flat brush is sometimes known as a bright. Useful for applying thicker mixtures of paint in small brush strokes.

5 No. 2 short flat synthetic fibre/sable mix. Suitable for fine, detailed work.

6 No. 10 round synthetic, fibre. This size of round brush for oil paint might be more useful in the stiffer hog hair. But even such a brush could be used for underpainting, stippling, soft glazes. Notice the different shape of the stipple mark made by the round brush.

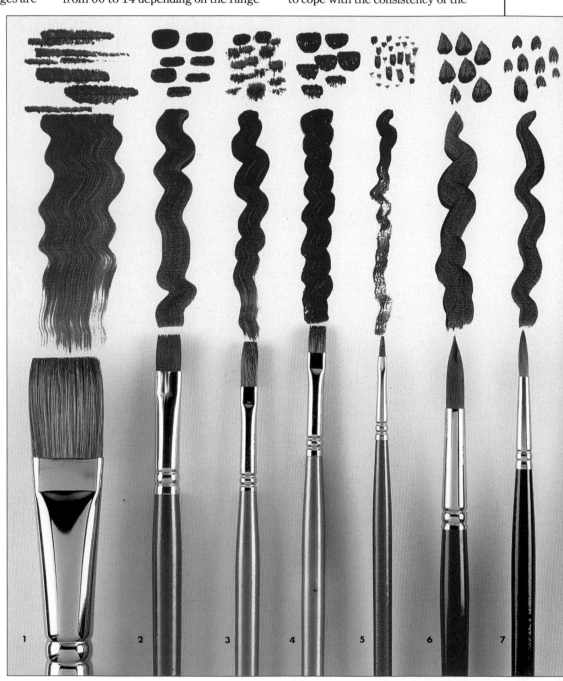

paint. The softer (and very expensive) sable brushes are mainly used in oil painting to add fine details at the end. Needless to say, brushes made of synthetic hair or mixed bristle and synthetic are worth trying. They are softer than hog's hair, more similar to sable but not equal to it. On the plus side, they are certainly cheaper and are easy to clean. Purists will point out,

however, that they are not so sensitive, do not hold paint as well and do not last as long. Oil painting brushes traditionally have long handles so that the artist can paint at a distance from the support.

The size of the brushes you use depends on the size of your painting and your style. It is common practice to start with larger brushes and use

smaller ones as the painting progresses towards more detail. Yet some artists paint almost entirely with one or two brushes. Others will pick and choose sizes and shapes to create particular strokes and marks.

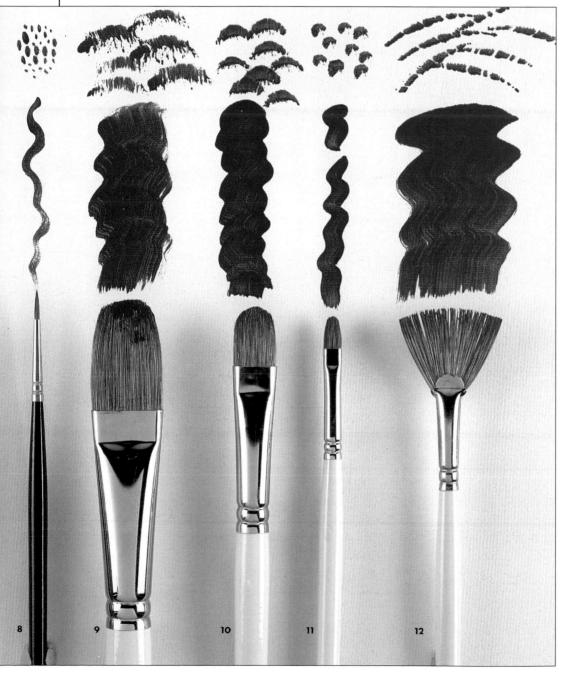

7 No. 5 round sable. A cheaper sable brush used mainly for detailed work.

8 No. 1 round sable. A very small brush for use in highly detailed work.

9 No. 12 short filbert hog. This brush is so called as it is shaped like a hazelnut and, indeed, it has a belly like the nut, making it a cross between round and flat. It holds paint well. Again, the shape of the brush affects the mark.

10 No. 8 short filbert hog. A useful general-purpose brush.

11 No. 3 short filbert hog. Makes an interesting stippled mark. For detailed work.

12 No. 4 fan blender hog. Not an essential brush but can be useful for delicate tonal blending of colours and to smooth out brushmarks where a flat surface is required.

BRUSHES

Care of Brushes

Brushes are well worth looking after; even the synthetic brushes are not cheap. Cleaning brushes can be very relaxing after a hard painting session. Leave time to enjoy it and do it well. When not using brushes, lay them on a flat surface or bristle end up in a jar. Do not leave them to soak resting on their bristles as this does untold damage.

To clean them, use cheaper white spirit rather than turpentine. Pour a little into a jar with a screw top. First, wipe off any excess paint from the brushes on newspaper or kitchen roll and then work them in the white spirit. Rinse in running warm water and then rub on a cake of pure soap (kept for the purpose as it will get messy). Roll the lathered bristle around in the palm of

your hand, rinse and repeat until the lather is clean. Make sure the paint has dissolved at the point where the hairs enter the metal ferrule. Pule them back with your thumb to check. After very careful rinsing, shake out the excess water and coax the brush back into shape. Leave to dry inverted in a jar or tin. Screw up the jar of white spirit as in a day's time the pigment will have sunk

1 No. 16 pear shaped painting knife. Painting knives have flexible steel blades and are used mainly for applying thick layers of impasto paint. They are available in various shapes and sizes. The shape of the blade will influence the mark made.

2 No. 22 diamond shaped painting knife. The edge can be used for linework. The cranked shaft of these knives allows you to mix and apply the paint without touching the surface.

3 4 in. (102 mm) blade palette knife with cranked shaft. Palette knives are mainly used for mixing paints and scraping clean the palette and sometimes the canvas. But they make an interesting mark too.

4 Natural sponge. Can be used to stipple, to stain the canvas with colour or to apply flat washes of colour.

5 All-purpose cloth. Any rag will do that is clean and lint free. A loose weave will produce a more interesting mark. Wrap round your finger or brush end to get more control (see page 194).

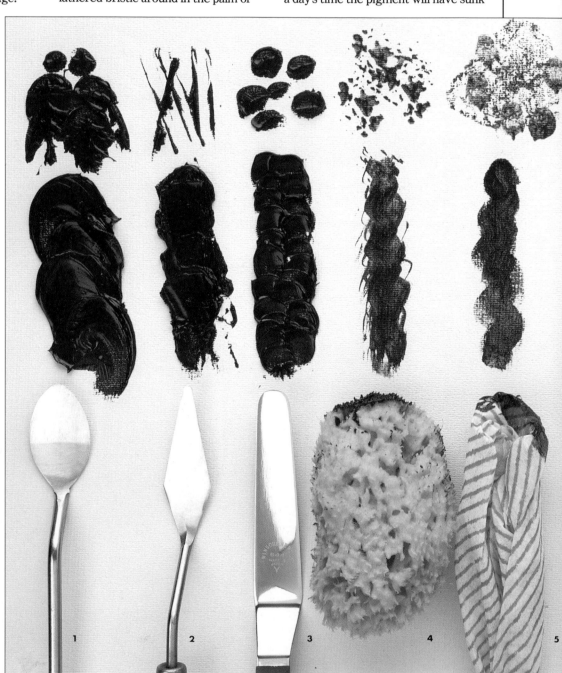

to the bottom, leaving the spirit clear. You can then pour it off into a new jar and use it again.

Sable brushes are considered a delicacy by moths, so for longer periods store in moth-proof boxes, making sure the brushes are clean and dry.

If a brush is left caked in paint until it dries out, it is not lost but it will probably not do it any good. Soak the brush in paint stripper. Then, wearing rubber gloves, clean off the brush and gently work off the paint. Wash and rinse as above.

Painting Knives

New painting and palette knives are protected with a seal and may need cleaning with white spirit or lemon juice. After use, they are easily cleaned with a rag dipped in white spirit.

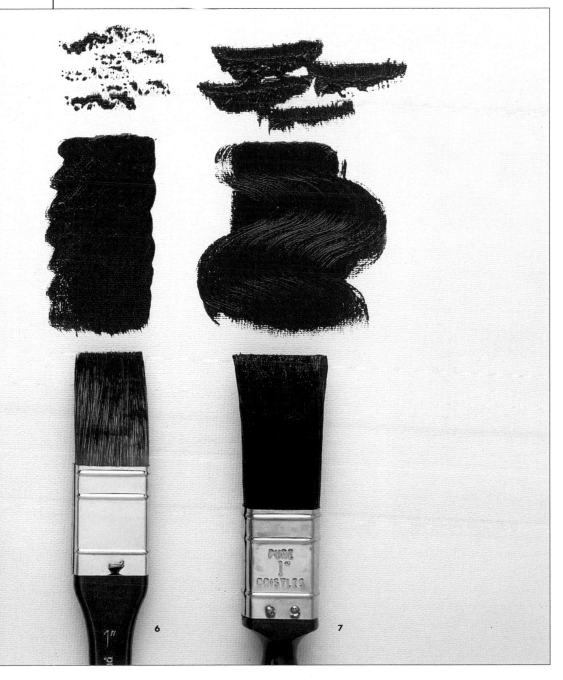

6 1 in. (2.5 cm) soft bristle brush. This would make a good varnishing brush. But it would be useful for any large-scale or preliminary painting.

7 1 in. (2.5 cm) coarse bristle brush. Available at DIY stores, such a brush is essential for applying large areas of paint as well as priming surfaces etc.

OTHER EQUIPMENT

Palettes

The traditional mahogany palette is a very expensive piece of equipment and it is by no means essential. Many find them too heavy and the wood too dark to clearly assess colour mixes. Of the two demonstrating artists in this book, one uses a piece of white formica veneered board 36 in. x 24 in. (90 cm x 60 cm), placed on portable trestles next to his easel. This provides enough room for the paints and jars, cloths and other equipment needed. It also leaves his hands free to hold the brush and cleaning rag. The other artist prefers to use a cheap disposable tin foil dish. This is very light to hold, does not distort the colour and means there is no palette to clean; it is just thrown away. This particular artist paints in white overalls on which he cleans his brush, leaving his hand free to hold the palette.

Dippers

Oil painters traditionally use dippers for holding diluents – turpentine and linseed oil. They are two small combined dishes with non-spill rims which fit to the side of a traditional palette. Small jars on a table next to the easel work well; small ceramic dishes are less easy to knock over.

Easels

An easel is probably the most expensive piece of equipment necessary for oil painting and it is certainly not essential. It is better to establish yourself as a keen painter before embarking on such an expense. By that time you will have a clearer idea of what exactly you require. In the meantime, with a canvas, either

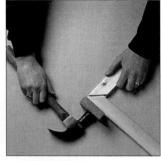

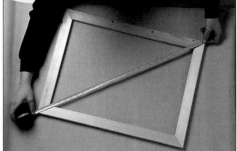

buying it ready-made. Seen here from top left: corner wedges, scissors, tape measure, staple gun, staples, hammer, block of wood.

otherwise buy a kit with all you need for one canvas. First join the stretcher by tapping the corners together. The block will cushion the effect.

measure or a piece of string. Now, cut the canvas to size with a 1 3/4 in. (4 cm) overlap all round, lay it on a clean table with the stretcher on top.

1 No unusual equipment is needed to make up a canvas, which is genuinely easier than it looks and much cheaper than

2 It is cheaper to buy stretchers as you require them and buy a roll of canvas,

3 If you have four right angled corners, the diagonals should be equal. Check with a tape

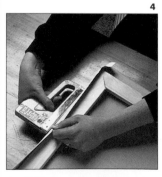

4 Fold the canvas over down one side and staple in the middle. Then pull it taught across to the opposite side and repeat. Continue with the third and fourth sides and then follow with staples in the outer edges always matched with their opposites.

5 Having inserted staples at about 3 in. (8 cm) intervals, now pull a corner of the canvas diagonally down to form the corner.

6 Fold neatly and as tightly as possible and then staple down firmly with two staples. Repeat for the other corners.

7 Now, finally, fix the small wooden wedges into the spaces provided in the corners of the stretcher to make the canvas extra taut. These wedges can also be used to adjust the angles slightly if they are not quite true.

paint flat on a table or prop up the top of the canvas with a book, holding the base steady with your non-brush hand. The paints can be mixed on on a palette on the table next to you. Oil-primed paper can be pinned to a board balanced on your lap against a wall or chair. There are many ingenious ways to work without an easel.

Having decided to go ahead and buy an easel, it is worth getting one that

works. This means one that is easy to assemble and to alter. It must be secure enough to withstand jabbing strokes without the fear that it is going to collapse. The best are made of solid wood. They are, however, very heavy so if outdoor work is your preference then a light portable aluminium-tube sketching easel is the answer. If you prefer sitting at a table then a desk easel will suit your needs.

Studio paraphernalia
Now we have looked at the main pieces of equipment necessary to start painting. There are other items you will find you require but most of these will be easily available – plenty of clean lint-free rags or all-purpose kitchen cloths, kitchen paper, jars, scissors, drawing pins, pencils, erasers, masking tape, rulers. The list could go on for ever.

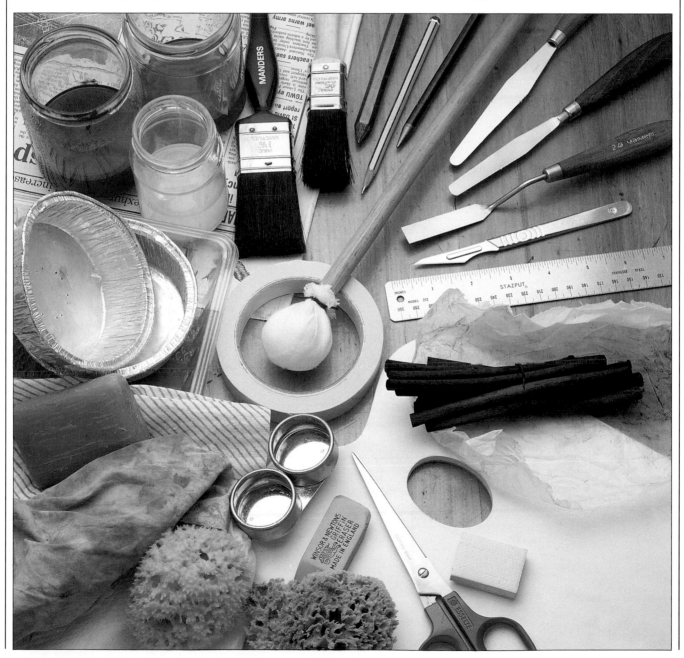

Chapter 3
Making the Most of Your Paints

The art of mixing and using colour is one which any artist will be aiming to develop and improve. Yet this is an art which is often taken for granted. There is no doubt that colour mixing and interpretation becomes easier with experience, but a little time spent experimenting with theory will greatly improve your early attempts. Needless to say, every time you use oil paints, even when you are an old hand, you will make exciting new discoveries about how the colours interact – not only when mixed together, but when applied next to each other, when laid in thin glazes one colour on another, when diluted or built up in thick impasto.

Knowing how to mix certain colours is partly intuitive and partly knowing the properties of the pigments you are using. We can learn that blue and yellow make green, but is only by experimenting with these two colours that it is possible to mix when required the infinite shades of yellowy, blue browny greens possible. The results will depend on the proportions of the primaries and on whether the original blue leans more towards violet or green or the yellow towards orange or green. Learning to use these subtle differences in colour will enrich your painting.

Colour is an important part of composition. Knowing how to use colour in this way gives the artist another tool with which to work. A strong colour, for example, can help pick out an important figure or element in the composition. It is also through the artful application of colour that the viewer of your work can 'read' the picture as you planned. The eye so prompted will involuntarily leap from one patch of strong colour to the next, taking in the full extent of the composition on the way.

It has long been recognized that colour affects us emotionally and that generalizations can be made about our reactions to particular colours. So it is that colour can help promote a particular mood in a painting. Pale, warm, rosy colours are meant to be relaxing and undemanding; cool atmospheric blues, the colour of the surreal; bright strident primaries hit you between the eyes and demand extreme reactions.

RECOMMENDED BASIC PALETTE

It is difficult to know which of the tempting range of colours to buy when starting to paint. The restricted palette of eighteen hues shown on this page will give you a basic range of paints from which it will be possible to mix what you want without too much hard work.

It is not suggested that you will use all these colours every time you paint. In fact, you will probably find that in due course your personal preferences will edit out a few of these colours and possibly add a few more. For example, if you use a lot of cadmium orange, even though it can be mixed from cadmium red and cadmium yellow, it would be sensible to buy it ready mixed in a tube.

It is surprising to find that most colours can be mixed with a five-colour palette of titanium white, yellow ochre, cadmium red, cobalt blue and ivory black and it is a good exercise to try this out. You may find to start with that such a restricted palette is easier to control in keeping the colours in harmony. But with a slightly more extended palette, the mixing of colours will be a lot easier.

General advice on buying and looking after oil paints is given on page 158. But remember that colours even with the same name vary between makes. Also, some pigments are poisonous although those that have been discovered to be dangerous have now been replaced with harmless alternatives. Even so, the cadmium colours, lemon yellow and others are designated harmful so take care to wash your hands and clean your nails after painting.

The pigments are usually arranged on the palette with the warm colours together and the cools likewise. How exactly the colours are arranged is very much a matter of choice. Try and keep to your own formula so that you can find the colour you are looking for without thinking.

French ultramarine
Deep, intense, semi-transparent, violet blue used a great deal to tint other colours, but mixes with alizarin crimson to make rich violets or with yellows for good vegetation greens. A chemical replacement for the priceless lapis lazuli based original. A slow drier.

Prussian blue (Phalocyanine blue, Winsor blue or Monestial blue)
A strong, cold, green blue with tinting power. The original Prussian blue was unstable and so to a great extent has been replaced by the chemical phalocyanine, Winsor or Monestial blue.

Cobalt blue
Bright, rich blue which makes a good clear sky blue. Also very useful in creating flesh tones.

Cerulean
A highly opaque sky blue leaning towards green rather than violet. A quick drier.

Sap green
A good ready-mixed, semi-transparent yellow green.

Viridian
A bright, rich, transparent blue green which is of the most permanent of colours.

Cadmium red light
Bright, opaque red, developed to replace the very expensive vermilion. Mixes with cadmium yellow to make a rich orange or with blue to make dull browns. A finely ground soft paint, cadmium red is durable but a slow drier.

Alizarin crimson
Truly luscious deep red crimson. Makes a rich transparent glaze though only moderately durable in very thin washes. High oil content, slow drier.

Cadmium yellow
A strong, powerful yellow which has replaced others, such as chrome yellow, because it is permanent. Soft consistency, it is a slow drier.

Lemon yellow
A deceptive colour, looking rather washed out when first squeezed out. It is a bright, cool, useful yellow, making a range of dazzling greens when mixed with cobalt or French ultramarine blue. Slowish drier.

Yellow ochre
An opaque dull yellow which is a generally useful mixer – for example, with blues to produce subtle landscape greens.

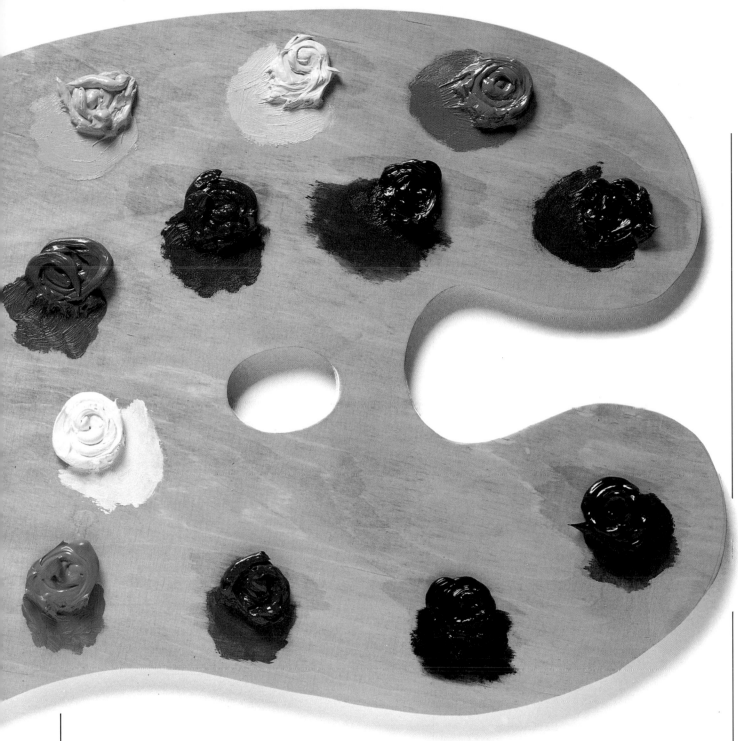

Burnt umber
Looks most unexciting when squeezed out, this is an essentially strong, dark, warm, permanent earth colour. Often used in underpainting as quick drying.

Raw umber
Another quick drying, permanent earth colour which is a yellow brown. Almost transparent, it is useful for underpainting. A very good mixer.

Burnt sienna
A transparent, reddish warm earth colour with many uses for mixing warm tints and broken colours. Quick drier.

Raw sienna
A yellow brown made from natural clay containing iron oxide. Quick drier

Paynes grey
A mixture of two blacks, ultramarine and synthetic iron oxide, this is a useful cool grey for modifying and tinting colours.

Ivory black
A semi-transparent, warm browny black which produces some surprises when mixed with other colours. Excellent green when mixed with cadmium yellow.

Titanium white
A relatively new, whiter-than-white white made to replace the poisonous flake white which is based on lead. Dries more quickly than the old whites and is more opaque. Ground in safflower oil so should not be used extensively in underpainting.

COLOUR BEHAVIOUR

Armed with your recommended palette of colours (see page 172), some glorious hues are ready at your command. Colour mixing depends a great deal on getting to know the individual paints and how they react with each other, but intuition and a palatable slice of colour theory also play their part.

In our first introduction to paints, we learn about primary colours – red, blue and yellow – and we learn the catalogue of colours achieved when these are mixed together to produce secondary colours – violet, green and orange. As you can see in this colour wheel (or flower), by mixing a secondary colour with its primary neighbour a tertiary colour is formed. In our palette, cobalt blue is the only near approximation of a primary colour. Primary yellow can be mixed from lemon and cadmium yellows and primary red from cadmium red and alizarin crimson.

Warm and Cool Colours

This wheel is useful to explain certain characteristics of colours. Round one side there are the so-called warm colours of fire and round the other the cool colours more associated with snow. These can be chosen and mixed to affect the mood of a painting. Even so, evaluating colours in such a way is purely subjective and different people will have different reactions. All colours have their warm and cool sides. You can see that ultramarine is a warm violet blue, while Prussian blue is a colder green blue.

Warm colours mixed with white, even when used in an abstract painting, will

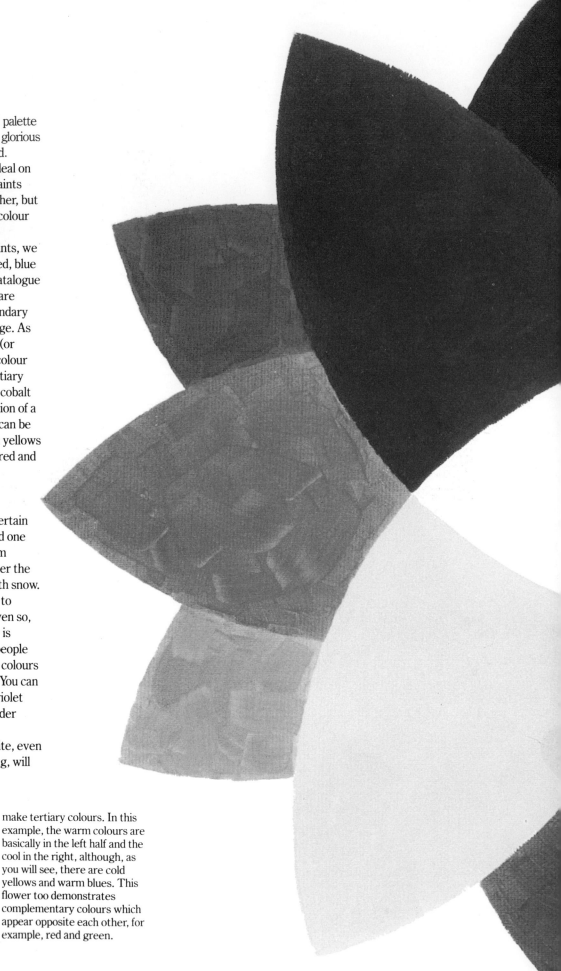

A colour wheel, or flower, is made up centrally of the three primary colours, red, blue and yellow. When mixed in equal parts with their neighbours, secondary colours are produced – orange, violet and green. Furthermore, when these secondaries are mixed with their neighbouring primaries, they make tertiary colours. In this example, the warm colours are basically in the left half and the cool in the right, although, as you will see, there are cold yellows and warm blues. This flower too demonstrates complementary colours which appear opposite each other, for example, red and green.

MAKING THE MOST OF YOUR PAINTS

not violently arouse the emotions. If anything, they will promote a feeling of well-being and contentment.

The primary and secondary red, yellow and oranges can be used in an alarming manner. But as the commercial artist knows, they are usually associated with enjoyment and the sun.

The cool colours, on the other hand, can give an ethereal, eerie, atmospheric tone to a painting, as demonstrated by René Magritte in his surreal paintings of skyscapes and bowler-hatted men.

Complementary Colours

Complementary colours are those which face each other on the colour wheel – red/green, yellow/violet, blue/orange. These combinations of colours are very important to the artist. Laid next to each other on a canvas, they can draw the attention of the viewer to a certain area, qualifying each other to appear brighter and more intense. The French Impressionists, who were much concerned with colour theory, applied these colours alongside each other in small dabs much desaturated with white. They found that this gave the paint surface a quiet brilliance.

Mixed together, complementary colours make a greyish neutral colour. Yet, a little of a complementary will dull its partner and can be used to mix shadow tones with the addition of blue. To simplify, the shaded side of a red ball can be mixed by adding some green to the red and a little blue.

MIXING COLOURS

Knowing your colours and how they behave is the secret of colour mixing, but even so colour mixing is to a great extent intuitive and rather hit and miss. As has already been said, it is only by physically mixing colours yourself that you will find out about them.

Artists usually lay out the colours on the palette in a particular order, with the warm colours together and then those referred to as the cool colours. If you always follow the same pattern you will instinctively go for a colour when mixing.

True primaries and any mix of two of them will produce pure colours, but once a third is introduced the result is darker and muddier. To keep colours fresh and vibrant, therefore, mixing should be kept to a minimum. The more

you work the paint round and round on your palette, invariably the duller it becomes. Sometimes you will just have to abandon a mix and start again.

There are so many different ways for an artist to mix colours apart from the obvious method of on the palette. The French Impressionists felt that colour was kept fresher by mixing the colour optically on the canvas. This is achieved by laying colours side by side in small areas or patches. At a distance the colours merge, so patches of red and yellow will make orange. A form of this optical mixing is achieved by artists who invariably only loosely mix their colours on their palette. The resulting brushstroke contains the constituent colours visible to the eye. The paint surface is thus made more interesting

when viewed close up and yet the effect from a distance is the same.

A certain amount of mixing is carried out on the paint surface itself. It is not advisable to use the canvas like a palette as this invariably leads to muddy colours but certainly an artist will work wet on wet and blend neighbouring colours into one another on the canvas itself, thereby causing them to qualify each other.

Another technique of oil painting, glazing, enables the artist to build up barely definable hues and tints with thin layers of transparent paint each qualifying the previous layers.

Tinting and Shading
A colour or hue is described as being fully saturated when it is strongest.

1 White can be added to a colour to lighten or tint it. Here, titanium white is added increasingly to blue, showing a gentle gradation of tone.

2 Colours are rarely darkened or shaded with black. The addition of black only muddies a hue. To darken the cadmium red, here on the left, first alizarin crimson is added and then, for the darker tones, small amounts of cobalt blue.

3 Mixing two colours together little by little can produce some surprising results. These hues will harmonize in close proximity in a painting. In this example, cadmium red has been gradually added to cobalt blue, finding hues ranging from deep violet to grey black, to deep brown.

4 Here cadmium red is added to chrome yellow to produce some good corn yellows and burning oranges.

5 Now Winsor green is added to chrome yellow, producing some cool shaded yellows and some useful clear greens. The hue can be affected by the smallest addition of pigment.

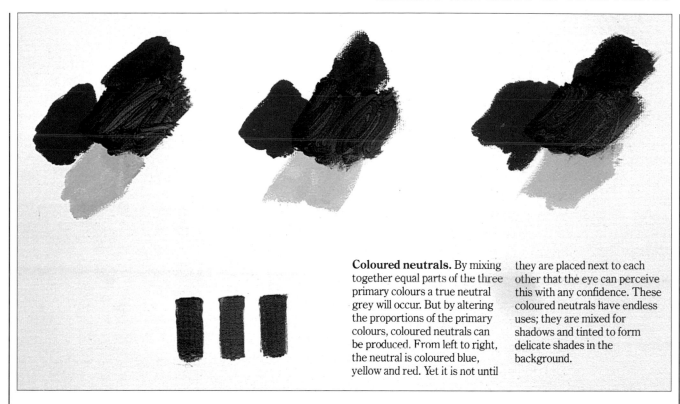

Coloured neutrals. By mixing together equal parts of the three primary colours a true neutral grey will occur. But by altering the proportions of the primary colours, coloured neutrals can be produced. From left to right, the neutral is coloured blue, yellow and red. Yet it is not until they are placed next to each other that the eye can perceive this with any confidence. These coloured neutrals have endless uses; they are mixed for shadows and tinted to form delicate shades in the background.

This does not mean darkest, but when the colour is most pure. A colour can be desaturated by tinting it, that is, adding white, or by shading it by adding a darker colour.

In these examples you will see how by adding progressively more white to pure blue, the colour becomes progressively desaturated. Artists tend to use a great deal of white, if only in tiny amounts. Colours are rarely used full strength unless for a special reason.

The examples showing the shading of colours demonstrate a very important point – colours will only become dull and lifeless if black is used to darken them. Many artists ban black from their palettes, but that is extreme as black has its uses. Learning which colours will darken others will come with experience. The most obvious examples are shading bright cool lemon yellow with warm cadmium yellow, then maybe adding a touch of red and then a touch of burnt sienna. Often it is a case of scanning your palette to look for a suitable shading agent which may indeed be among the ready-mixed colours.

Two-colour Mixing

Having experimented with tinting and shading colours, thereby providing an overwhelming range of tones to play with, now let us try mixing two colours together to increase the range of hues. Choosing a yellow and a blue or red (not a primary, but yellow ochre and cerulean or alizarin crimson) gradually add the darker colour by degree to the lighter colour. The result often contains a few surprises even to the experienced. The range of colours produced will harmonize with each other and can safely be used alongside each other on the canvas. This mixing of two colours is rarely so explicitly laid out by the artist: the different tints are more usually visible around the central mixing area between two colours. They are, therefore, picked out with the brush or progressively mixed.

Coloured Neutrals and Greys

If you mix a number of colours together they eventually form a dull greyish colour. The reason for this is that if you mix all three primaries together you will arrive at what is called a neutral. If all three primary colours are mixed in equal strengths a true grey – not leaning towards any of the primaries – will be formed. But if one colour dominates then a coloured neutral will appear. Coloured neutrals and greys can also be contrived by mixing a colour with its complementary – blue with orange, yellow with violet etc.

Neutrals play an important part in painting, often forming the receding colours of the background. Using a coloured neutral that tones with the foreground hues will ensure colour harmony. But an unsaturated colour will look stronger if placed against a background of its complementary neutral. Corot, the eighteenth-century French painter, used this ploy in his painting by drawing the eye to a dash of red set in a neutral green.

INTERPRETING COLOUR

We tend to be brainwashed about what we claim we see. A person will swear that the trunk of a tree is brown and the leaves green even if golden evening sunlight is turning the reflecting leaves yellow and casting patches of violet-coloured shadow on the trunk. An artist, to make his painting interesting, must look at what he is painting, making an effort to isolate the different hues which make up the mosaic of colour of any object. This is now accepted procedure. But when the French Impressionists recorded the truth about colour there were howls of disapproval – always encouraging to the artist. What is perceived and recorded then in paint, finally must be checked by an objective appraisal by the eye. To this end many artists look at their work through a mirror to give them a truly objective view of their work.

Yet an artist does not necessarily always want to paint exactly what he sees. He will use colour as a means of expression, interpreting what he sees before him. This interpretation of colour has been likened to music. A chord of music is made up of a number of single notes – sometimes harmonious, sometimes discordant. An observant person can distinguish the individual notes in such a chord. Just as

1 Colour is an important part of composition. Some colours, such as red and yellow, are described as advancing – they appear to be in front of receding colours, such as greens, blues. This is demonstrated here where a line of red dots across a mixed background of green and blue stand out so much that the eye is destined to follow it from the bottom left corner to the top right. In the West we 'read' paintings from left to right like a book and the artist makes use of this fact, manipulating the way the composition is viewed.

2 The same principle of advancing colours is used here with this line of fruit. The apples and orange are all roughly the same size and in a disordered line, yet attention is focused on the orange which appears nearest to the viewer, and it even appears larger. But this is an optical illusion caused by the advancing nature of the flaming orange in contrast with the green.

3 A modern interpretation of an ancient formula to denote distance using colour, the foreground is painted brown, middleground yellow green and the background tinged with pale blue. Thus a sense of space into the picture can be created with colour alone.

the composer uses such notes to express him or herself, an artist uses colour.

Composing with Colour

Colour is an important part of composition. You will find that some colours dominate a picture and attract attention and that others naturally sink into the background. Those that come forward are called advancing colours and are primarily the warm colours of the colour circle. The cool colours are described as receding colours. The extent to which this applies depends on the saturation of juxtaposing colours. A pure cold blue, for instance, will appear to lurk behind a neighbouring pure warm red but will leap forward out of a sea of neutrals.

It is through the artful application of colour that the viewer of your work can be guided round the picture space.

As an example, Pieter Bruegel the Elder leads us in a zigzag course through his crowded scenes of village life with carefully conceived patches of red – a hat here, an apron there. The eye involuntarily leaps from one to the next, taking in the full extent of the composition on the way. What appears, therefore, to be an amorphous mass is thereby given some structure.

Colour Perspective

It is by knowing the effects of colour on the viewer that the artist is able to create a sense of distance in a painting. A knowledge of seemingly complicated mathematical systems is not strictly necessary. It is simply a case of painting what you see – parallel lines receding to a single point on the horizon, the overlapping of objects and the fact that when objects are viewed from a distance the earth's atmosphere bleeds them of their colour, desaturating them and giving them a bluish tinge. Colours in the foreground are strong and vibrant and objects well defined. In the background the same objects are paler, bluer and ill defined.

Seventeenth-century painters employed a well-worn formula for landscape painting: the foreground was painted in brown, middleground in green/yellow and the background in blue.

Mind you, as in most aspects of painting, your natural intuition will guide you in such respects. If you paint a person wearing a bright red coat in the background of a painting, you will have difficulty in keeping that area in the background – this strong colour will bring it forward. This will become immediately obvious so, to overcome the problem, there is a choice of toning down the colour or changing it to a naturally receding desaturated blue. On the other hand, if you are trying to create an ambiguous picture space and confuse the viewer, you will leave it as it is.

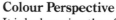

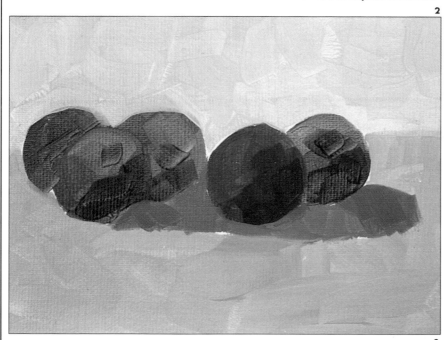

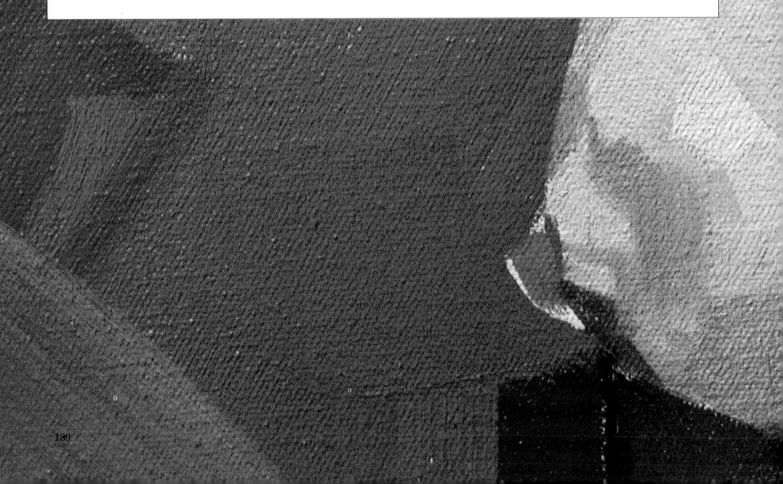

Chapter 4
Basic Techniques

At last, it is time to take up the brush. In the following pages we will see how this can be done, starting with the basic skills of painting in oils and progressing in easy steps to more complicated techniques. The aim is to give you the confidence to try your hand. Once you have, there is little doubt that you will be hooked.

Every section starts with a demonstration of useful techniques. These are photographed in the studio away from the hurly-burly of the composition itself. By doing so, it makes it possible to fully understand and practise these techniques before embarking on the great masterpiece itself.

You will need plenty of cheap paper to practise on. Wallpaper, lining paper or even newspaper will do – although the latter will tend to dirty your paint with newsprint. At this point it will not matter unduly. The aim is to become familiar with your materials – experiment with brushstrokes, use the paint, and simply sort out and get used to the place where you intend to paint. Once you feel confident about the techniques and are ready to use them in the context of a painting, turn to the project pages which follow and witness these techniques put into practice.

The two artists whose brushwork we observe in detail in the course of the following pages, have been chosen for their individual styles – styles which demonstrate different aspects of oil painting. These projects can provide the basic information for a similar painting of your own. Your work of art will not be exactly the same as that demonstrated. It should not be so: your interpretation of the subject will undoubtedly include your own observations. Alternatively, the projects may spark off your imagination and give you guidance in how it can be practically translated into paint.

Naturally it is not possible to include coverage of every brushstroke made in the course of these projects – it would make monotonous viewing. In each demonstration, therefore, a particular approach or technique is observed in detail, making it possible to consider the problems and to see the results in context. So now it is a case of harnessing your courage and taking the plunge. I can assure you it will be worth it.

Basic Techniques

GETTING READY TO PAINT

By now you will have equipped your workplace and bought your paints as suggested in Chapters 2 and 3. You will need plenty of rags, a selection of brushes and two containers of turpentine or white spirit: one, which should remain clean, to dilute the paint and the other to clean the brush in, which will soon become very dirty. At the end of the day, leave the dirty jar covered and by the next day the

pigment will have sunk to the bottom and the clear spirit can be poured off to use again. If you use white spirit you can afford to be more generous with the size of your containers (jam jars are excellent) as it does not deteriorate. Turpentine should only be poured out in small quantities as it will thicken and grow yellow in contact with the air. The small metal containers, called dippers, which clip on to the side of a palette are

perfect for turps.

It was mentioned in the section on diluents that, to start with, it may be easier to use just turpentine or the cheaper white spirit to dilute your paint. In the following projects both white spirit and turpentine are used, but oil rarely. This simplifies things dramatically for the beginner.

Now to squeeze out the paints. This artist uses a plank veneered with white

1 Squeeze out the paints on to the palette, pressing the tube from the end. If you get paint round the nozzle of the tube, clean it off before replacing the cap. It will be easier to remove next time. Most artists place the warm colours together on the palette and then the cool colours.

2 Mixing colours is an art in itself, but the only way to master it is to give it a try. To keep the colours spontaneous try not to overwork the paint. Beware, too, of the overloaded brush which will soak up into the metal ferrule and give you an unpleasant cleaning job.

Formica to mix his paints on. This can be simply supported on a table or with a couple of portable trestles. The warm colours are squeezed out on one end and the cool colours on the other. If you haven't already been lured into trying your hand at mixing paints by the previous chapter on colour, now is the time to have a go. Take a touch of turps to wet the palette, then neatly pick your colours, working them together in a

circle on the palette. Try not to overwork the colours or they lose their freshness. Take care, too, not to overload the brush so that the paint seeps up into the metal ferrule where it will dry and cake. If it does, press the excess out on the palette and wipe the brush clean with a cloth and start again.

In between different mixes of colour, clean off your brush. First, work out as much paint as possible on the palette (or

in practice on the canvas), then clean the brush out in the cleaning jar, pressing out the excess liquid on the rim, and finish by drying off the brush on a cloth.

As you can see, the artist links his colours by tinting and shading them with other mixes already on the palette. It is not necessary to revert to the tube paints all the time.

3 Using the tube colours to mix with will keep the colours bright and pure, but an artist is constantly tinting and shading his colours. A certain harmony of colour will be ensured if you tint and shade from the colours already mixed on the palette.

4 Before moving on to the next colour mix, the brush is cleaned off in the white spirit. The excess is squeezed off on the rim of the jar, and now the brush is dried off on a rag, splaying out the bristles to reach up to the ferrule.

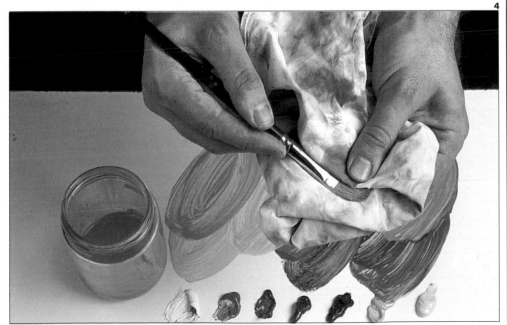

Techniques

APPLYING THE PAINT

Brushwork

One of the aims of the oil painter is to keep the surface of the painting lively and interesting. This effect is achieved in part through the brushwork.

The paint as it comes from the tube is of a consistency that will keep its shape on the support. This means that if painted on with a bristle brush the brushmark will remain in the paint, catching the light and so making the surface more vibrant. In the early stages of a painting this is not particularly encouraged as these marks will be covered with later layers, and the paint is usually diluted so that the brushmark is not retained. In the later stages this aspect of the painting becomes important.

In these first demonstrations, we suggest ways of applying areas of flat paint to achieve different effects.

1 Here the brush is loaded with pure, bright cerulean blue from the palette. Enough is taken to work on at one time without swamping the brush. The first dab is worked into the weave of the canvas, ekeing it out as far as it will go. Then another brushload is worked over the top, leaving a rich surface of brushmarks.

2 Sometimes a flat, washlike surface is required. Unlike other paints, however, with oils the paint remains fresh and workable so a flat surface can be more easily achieved. If you are covering a large area, mix up enough paint to cover it. The scenery painter's brush used here has soft long hairs which help to spread out the paint and leave a smooth surface. The result, as intended, is flat, opaque and consistent in colour.

3 Using the same brush and consistency of paint, a flat layer of chrome yellow is applied. Then the surface is worked with the brush from every direction to leave an interesting meshwork of strokes.

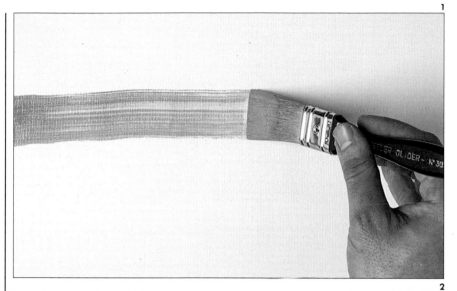

Brush control

Brushmarks are affected by the individual brushes and the way they are handled. The angle of the brush and the pressure exerted on it is important and also the consistency of the paint. For general painting hold the brush like a pen but away from the bristles, consciously relaxing your hand. A stiffly held brush produces contrived marks.

1 First try dragging the brush along in a straight line. By altering the pressure, the line can be varied. The dilution of the pigment will affect the result too. Make sure that the brush is held in a relaxed grip or the brushmark will appear laboured.

2 A more precise line can be painted with the help of a ruler or straightedge. Hold the ruler up off the surface at an angle so that the metal ferrule of the brush can run along the edge to guide the brush.

3 Here, with a ¼ in (6 mm) flat brush the artist paints a line, not by dragging the bristles along but by touching down with the tip lifting off and touching down again alongside.

4 Using the same method an arc is described. For more precise work the brush is held closer to the bristles on the metal ferrule.

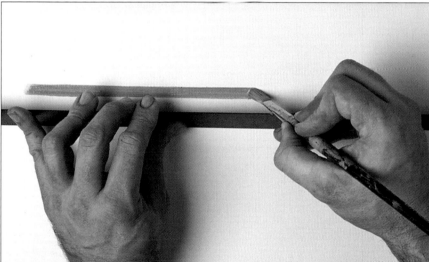

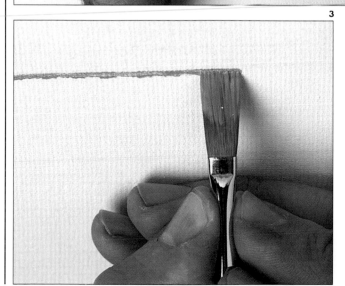

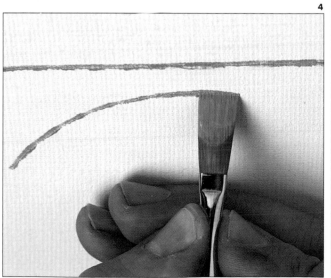

Misty Mountains
BASIC TECHNIQUES

This first, simple project gives you an opportunity to put into practice the mixing and brushwork skills suggested in the previous pages. It also demonstrates how easily a feeling of distance can be introduced into your painting. What we are painting is the effect of the atmosphere on colour when viewed from a distance. The effect of seeing the far-off range of mountains through this misty pink morning light is to bleed them of colour. This is known as aerial or atmospheric perspective. By gradually adding more white to the mixture as each succeeding range is painted (although this was not the only addition), the mountains appear to recede into the picture.

The colour mixing involved in this project poses an interesting task. The painting appears at first glance to be monochrome – that is, without colour, in tonal mixes of black and white. But the wonderful ethereal attraction of this scene is created by the colouring of these greys, making them coloured neutrals.

The artist chose to start at the bottom of the painting in the foreground and work up the canvas board to the background because it was easier to cut the lighter paint round the outline of the darker band. This means that you will need to keep your hand clear of the wet paint of the previous band.

1 The source for this painting is an atmospheric photograph of mountains in China. The artist does not in any way copy this slavishly; in the final result the colours are simplified and the shapes more regular. The photographic image simply sparks off his imagination.

Materials: canvas board 20 in x 15 in (50 cm x 37.5 cm); brushes – ¼ in (6 mm) and ½ in (12 mm) nylon flat; white formica-veneered board palette; graphite pencil; two jars of white spirit; rags.

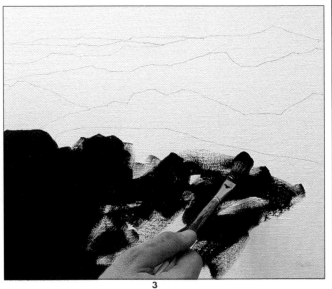

2 To act as a rough guide, the artist has already mapped out the ridges of the mountain ranges with a graphite pencil. Now he starts on the foreground, using a mix of Payne's grey, with a touch of sap green and cadmium red and a little white to give it opacity. The paint is diluted with white spirit to ease mixing but applied thickly to the canvas. Here it is almost scrubbed into the weave of the canvas, painting it out more delicately with a recharged brush over the top.

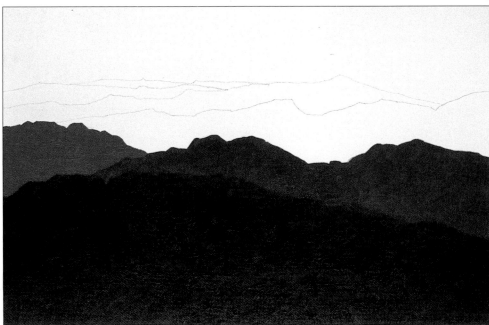

3 With the foreground painted in, it is time to stand back and appraise the situation. Note how the artist has purposefully kept the paintwork lively, preventing it from appearing too flat.

186

4 Now the receding mountain ridges are added. These ranges are mixed by adding progressively more white and modifying it with touches of sap green, cobalt blue and cadmium red. Here you can see how the soft nylon brush is carefully controlled along the undulating ridge. The brush needs to be well charged with paint, but too much will drip down on to the darker band below. Just wipe it off with a cloth if this happens, clean off the brush and patch it up. If you need confidence you might like to practise such brush control on a piece of paper first.

Take care to keep your hand well away from the picture surface as you are working over wet paint.

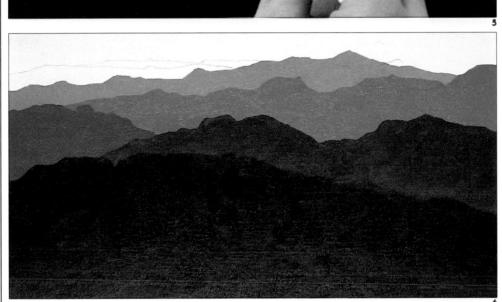

5 At the half-way stage, there is already a strong sense of recession in the picture. The artist makes no attempt to blend the paint between the bands. It is carefully laid on the canvas, joining with the darker band below but not merging with it.

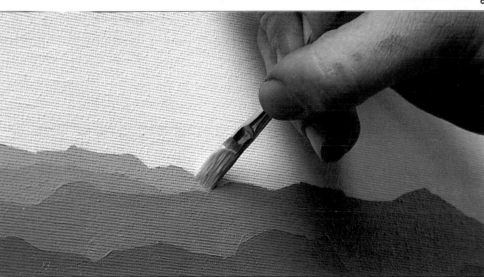

6 The artist uses various ways to apply the paint to the canvas. Here the brush is cutting in from above, using the corner tip of the flat brush to follow the ridge line. The bands have become narrower, so the smaller ¼ in (6 mm) flat brush is used. The artist is concentrating on this delicate work and for more precise control the fingers are gripping the brush nearer the bristles.

BASIC TECHNIQUES/MISTY MOUNTAINS

7 In a more relaxed manner, the paint is applied along the final ridge. Note the build up of paint along the ridges, particularly in the earlier bands where the paint is thicker. These ridges catch the light and thereby help to define the shapes of the composition.

8 The artist's palette is now beginning to look suitably messy. The different colour bands, it can be seen, grew from one another with only touches of tube colour added to modify the base mix. The sky blend is mixed by adding a touch of lemon yellow (perhaps suggested by the original photograph).

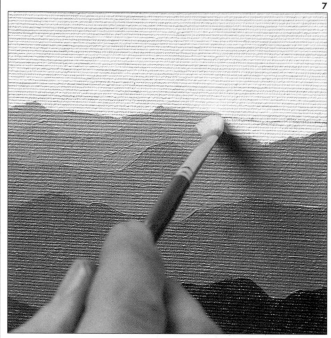

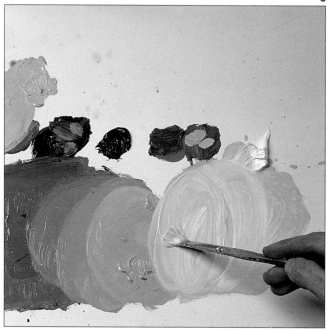

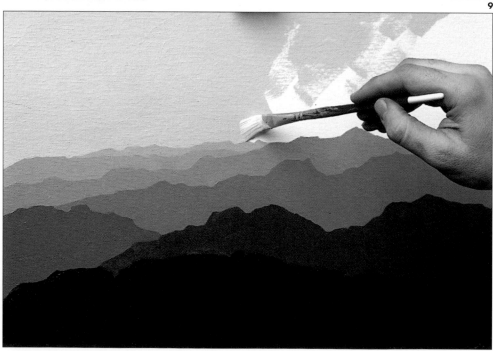

9 The sky is applied thickly using the larger ½ in (12 mm) brush again, working the paint from every side to cover the canvas weave well but keeping the surface from looking flat.

10 The finished painting has a certain luminosity which is a result of the subtle use of colour. These coloured neutrals are complementary too – greener in the foreground, redder in the background. The brushwork in this painting is not complicated but even so the receding planes of hills are not painted in flat colour – the surface is kept lively by applying the paint in dabs and working it from different directions. But towards the background the paint is more dilute and the paint applied more smoothly. This formula – thick paint and lively brushwork in the foreground progressing to thinner, smoother paint in the background – helps to create a feeling of distance. You may have found this exercise harder than it at first appeared. But having mastered the techniques demonstrated in this project, you will be ready to build on this knowledge.

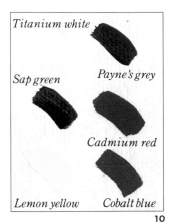

Titanium white

Sap green

Payne's grey

Cadmium red

Lemon yellow

Cobalt blue

10

Yellow Tulips
BASIC TECHNIQUES

This vase of spring-like yellow tulips makes an inviting display for the aspiring artist. Flower painting is an art in itself – the colours must be kept fresh and pure and the forms distilled down to basic shapes. But tulips are a good choice to start with – their simple and graceful petal and leaf shapes inspire confidence and invite artists of all capabilities to try and capture their graphic simplicity.

The artist has placed a strong artificial light overhead, trying to give an impression of bright sunlight. This casts interesting shadows on the white background which become an important part of the composition. This bright light also has the effect of bleaching out the subtle mid-tones, reducing the tonal areas to light and dark with not many tones in between. Although this may not appear to some to be so interesting, it makes a dramatic composition and it is certainly, at this stage, more simple.

The arrangement of the tulips and the way the artist chooses to represent them on the canvas demonstrate how we should not be slaves to rules. He decides to place the vase of flowers symmetrically in the centre of the canvas, thereby spurning traditional advice. He even measures out a central axis to guide him (primarily in the drawing of the vase). But there is plenty of asymmetry, coming principally from the tulips themselves which are left in a natural state of disarray and also from the shadows cast on the background. The artist also shuns what would seem the obvious portrait (vertical) shape for this composition, sensing that the area of empty white enhances the appearance of the flowers. In this painting, first the main shapes are roughly blocked in using mid-tone, much diluted, colours and then the forms are built up in several layers. But the artist keeps the brushwork loose, resisting the temptation to get bogged down in too much detail.

1 The yellow tulips were purposefully left unarranged to break away from the natural symmetry of the composition. The shadows cast on the white background emphasize this asymmetry and add a further dimension to the composition by locating the position of the tulips in the picture. Otherwise the tulips would appear to be suspended in space.

Materials: Coarse canvas prepared with acrylic primer 20 in x 25 in (50 cm x 62.5 cm); brushes – No.5 round and flat, No.2 round; graphite pencil; soft eraser; square wooden palette; metal clip-on dippers; turpentine; jar of white spirit to clean brushes in; cloth.

2 The paints have been squeezed out in an arc ready for the artist to mix the mid-tone yellow for the tulips – cadmium and lemon yellows and white, diluted well with turpentine.

3 The artist has mapped out roughly the main shapes in the composition. The ellipse, formed by the circular top of the plinth seen in perspective, could be a problem. It was arrived at by drawing loosely round and round in an ellipse shape until the correct ellipse was found.

The artist then removed all but the correct outline with a soft eraser.

Now the tulips are blocked in with the dilute paint using a No.5 round brush. The graphite slightly muddies the yellow paint but as this is just an underpainting it does not matter.

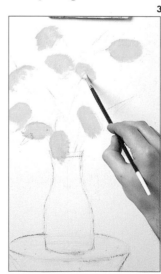

4 To block in the leaves, the same sized flat brush is used with a much diluted mixture of sap green, lemon yellow and a touch of white. As can be seen, at this stage the paint is applied quickly and roughly, simply to confirm the shapes and colours of the composition.

5 Already at this stage the artist can get an idea as to how the composition is going. He has placed his easel so that he can see the tulips without having to crane his neck or peep out from behind the canvas. The same overhead light provides good lighting on the canvas, not reflecting off the paint nor casting unhappy shadows. This artist likes to sit down to paint. His chair can be raised or lowered to suit his point of view. He uses his overalls to dry his brushes on, leaving his non-painting hand free to hold the palette.

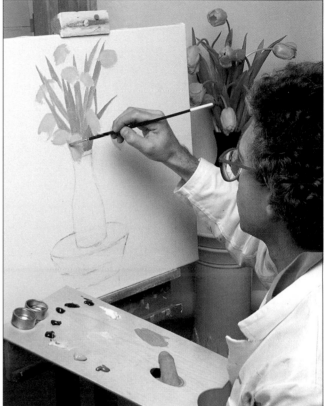

5

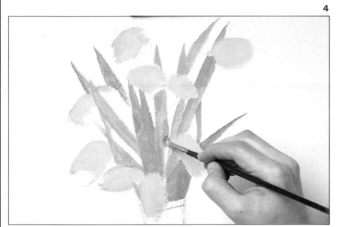

4

6

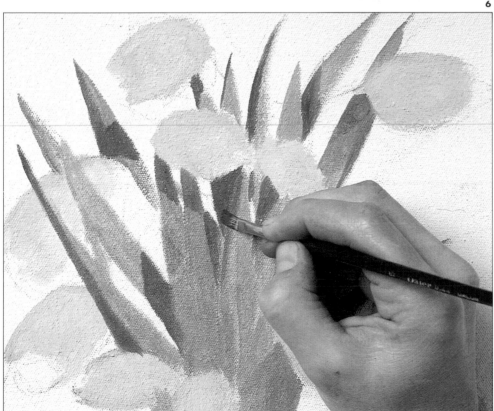

6 Now the artist adds the darker tones to the painting, starting with the leaves, by adding the merest touch of Prussian blue, which has strong tinting power, to the green mix. He is using the real tulips as a point of reference but not to copy exactly. The first layer of underpainting was so dilute, it is almost touch dry. Still the paint is diluted with turpentine.

BASIC TECHNIQUES/YELLOW TULIPS

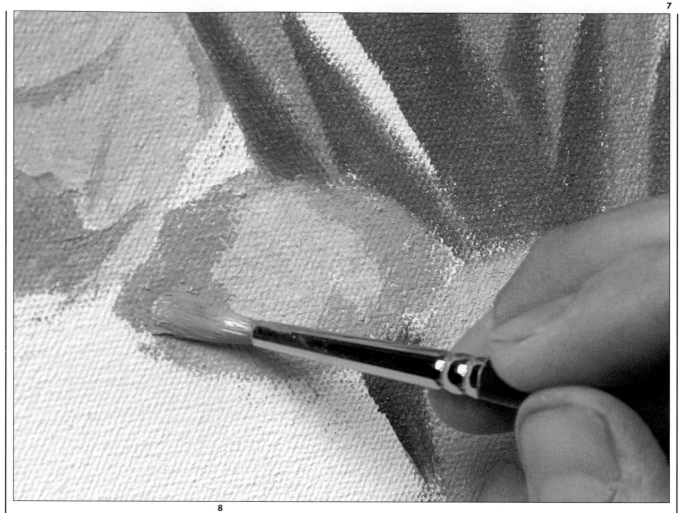

7

8

7 The same darker tones are added to the tulips – the original mixture plus yellow ochre and cadmium yellow. The artist looks carefully to locate these areas of colour and tone and applies them boldly. The aim is to keep the brushwork loose. It is possible here to see the heavy weave of the canvas. Such a weave ensures that the early brushstrokes are bold and the paint dilute, otherwise it is hard to get the paint into the weave and you end up wanting to scrub it in. After a few layers of oil paint, finer details are possible on the built-up smoother surface.

8 Standing back to look at the painting, at this point the subject does appear isolated in the centre of the canvas. But there is much more to come. Even with only two tones of colour the flowers are beginning to develop some three-dimensional form. The vase has now been blocked in with a very dilute combination of Payne's grey and a touch of Prussian blue. Note how the artist paints the vase well within the drawing guidelines, closer to the actual object.

9 The artist now chooses to bring on the vase and the base. First, a layer of stronger Payne's grey and Prussian blue is applied into the wet underpaint of the vase. Then, a much desaturated mixture is worked into this for the white base of the vase. The plinth is painted with various combinations of the vase mixture added to white with a touch of lemon yellow.

10 Here the highlight is being added – white broken with a touch of the vase colour. The paint is undiluted and must be applied with one sure stroke as the vase paint is still wet. If you dab the paint on it will blend with the darker paint and lose its strength.

11 Further highlights are added to the rim of the pedestal and to the bottom of the vase with a small No 2 round bristle brush. This highlight paint is applied undiluted so that it forms a slight impasto ridge which catches the eye.

9

10

11

BASIC TECHNIQUES/YELLOW TULIPS

12 The next task is to add the shadows of the tulips and the pedestal against the background. Diluted Payne's grey and cobalt blue added to white is painted on with a bristle brush. Avoid overworking this, aiming to achieve indistinct outlines. The edges of the shadows are further blurred with an all-purpose cloth wrapped round the finger.

13 A glance at the palette at this stage will show you how the colours have been mixed. For example, in the centre of the palette, highlight leaf green has been made by adding the shadow green to the highlight tulip yellow.

14 Lighter green tones are added to the leaves so that little of the original underpainting shows. A brighter yellow – a mixture of cadmium and lemon yellows – is added to the tulips to enliven their colouring. And now, finally, the flower stalks are added in a single confident stroke with a well-charged No.2 round brush.

12

13

14

15 The artist adds the finishing touches to his painting, checking it against the still life arrangement alongside. Note how he holds the brush at the end, allowing him to paint while 'standing back'.

15

16 The final painting has certainly captured the freshness and natural beauty of the tulips. Part of the vibrancy of the painting is due to the high contrast produced by the bright lighting of the subject matter discussed earlier. It can be seen now that this produces a somewhat stark image. But this suits these waxy flowers – soft roses would not benefit so much from such treatment. Note how the artist has emphasized the twining stalks of the tulips, undermining the stark severity of the vertical leaves and the vase.

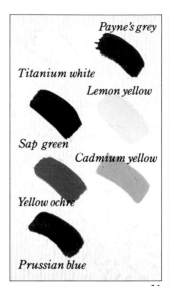

Payne's grey

Titanium white

Lemon yellow

Sap green

Cadmium yellow

Yellow ochre

Prussian blue

16

Peppers and lemons
BASIC TECHNIQUES

The artist picked these peppers and lemons for their simple shapes and primary colours. Then, by placing them on a red cloth and cutting this with another of primary blue, he arrived at a dramatic composition. This arrangement was in no way hurried. The artist tried out various combinations until the demands of his 'eye' were satisfied. But he continued to adjust the objects even after he had started drawing.

Even though the composition was arrived at in this pragmatic manner, it nevertheless satisfies some of the traditions of still-life arrangement – rules that can be learnt but which are also natural to us; rules which once assimilated are made to be defied.

The group of peppers are linked to each other by the fact that they overlap. The yellow pepper behind the other two has been set on end to give it some height (and the artist slightly exaggerates this in his drawing to make the point). The lemons are isolated in another group which is cleverly linked to the peppers by the dramatic angled line down the length of the composition where the two coloured cloths meet. Both the red pepper and the left-hand lemon cut this line and thus visually the eye passes from one group to the other. An arrow pointing from one group to the other could hardly do the job better.

The drawing is beautifully executed by the artist. But you might like to transfer the image to your painting surface in another way. There are suggestions on page 155. For example, you might like to take a polaroid photograph of the arrangement and square it up to transfer the image to the canvas, as shown in the project on page 280.

The artist has tackled the subject in a bold manner isolating the planes of colour and tone and applying them with assurance. This involves close scrutiny of your selected objects. You will probably observe details you have not consciously noticed before – such as the coloured reflections on the skins of the peppers here. Tom Phillips, the British painter, recently aptly described this voyage of discovery. 'In painting, say a still life from nature,' he relates, 'there is a moment when one suddenly becomes a tiny figure wandering among the huge apples, climbing up cliff-faces of drapery; the items on the table become an explorable world.'

2 The first task is to draw the outline of the still life. This will confirm the composition for the artist and, of course, act as a guide for the first layers of paint. For this, the artist uses a soft graphite pencil which is not as messy as charcoal, nor as hard as even a soft pencil. Even so it is sometimes hard to draw on the rough canvas weave. Canvas is tough, however, so do not be afraid to exert some pressure. The artist moved the objects around a little as he drew to perfect the arrangement. He decides to paint them on a larger scale than reality, filling the picture and making an impact.

1 The objects for this still life were chosen for their simple shapes and primary colours, with the aim of practising colour mixing. The arrangement of the peppers and the lemons took some time to perfect. The artist tried several variations before reaching this successful configuration. For a more simple exercise, the two lemons in the bottom corner might be singled out and painted on their own.

Materials: self-stretched fine canvas 20 in x 24 in (50 cm x 60 cm), primed with acrylic primer; brushes – No.5 flat bristle, ¼ in (6 mm) flat nylon, 1 ½ in (38 cm) flat soft bristle; white formica-veneered board palette; graphite pencils; soft eraser; white spirit in two jam jars; cloth.

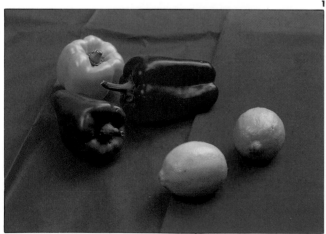

3 Using a No.5 flat bristle brush, the first paint is mixed for the yellow pepper – various shades of cadmium red and yellow, with a little cobalt blue added later for shadows. The paint is kept pure and of the same consistency throughout – that is, diluted with enough white spirit to make the paint manageable but no more.

4 Throughout this painting the brushwork is kept bold with as little blending as possible. The planes of colour are laid side by side – occasionally overlapping or almost covering a previous patch. Locate an area of colour, mix the paint to match it and then carefully apply it. Having completed an area, stand back and assess your progress, modifying any distortions.

As a rule this artist works in the mid-tones from dark to light and then adds highlights and shadows. Here, the neighbouring red pepper and the background cloth cause red reflections on the yellow pepper. These are located and slightly exaggerated by the artist.

Before cleaning out the brush see if you can use up the paint anywhere else in the composition. This will help to unify the painting.

5 Now for the lemons – a mix of lemon yellow with a touch of cadmium. The strokes are applied at different angles depending on the shape required. This means the light catches the brushstrokes and adds to the interest.

6 The shadows are added – with a red shadow from the cloth on the left and a blue shadow from the cloth below.

7 Now stand back and appraise the work and modify anything which looks awkward. You will notice that some of the lemon yellow has been used for the lighter tones on the yellow pepper and the green lemon shadow becomes the lighter tone of the green pepper.

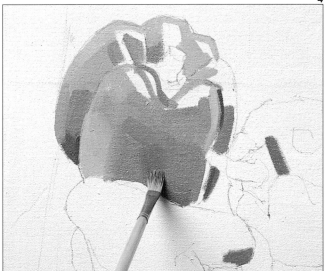

4

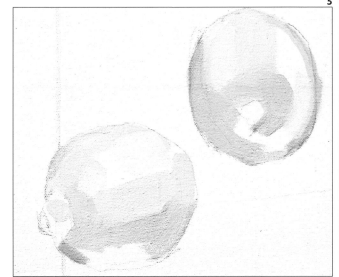

5

6

7

BASIC TECHNIQUES/PEPPERS AND LEMONS

8 Working from dark, the red pepper is built up in the same way. A mixture of cadmium red and alizarin crimson was too strong so the yellow pepper mix is added to deaden the hue. The bold yellow highlight added earlier has been modified by the darker paint but it is still visible and plays a part.

9 The contours of the green pepper are boldly mapped out with a flat brush. Some more cobalt blue is added to the pale lemon mix for the darker mid-tones of the green pepper, with a little of the red mix for the shadow. Instead of returning to the tube colours to modify the colours, the artist uses the paints already mixed. The bright tones of the red pepper are pure cadmium red and the shadows mixed with a touch of ultramarine blue.

10 Standing back, the artist now feels a need to place the peppers and lemons more in context. The folds of the red cloth are therefore sketched in and patches of shadow added to put the objects in relief. The stalks of the peppers have been built up too. But still the artist resists too much detail and keeps the colours clear and direct.

8

9

10

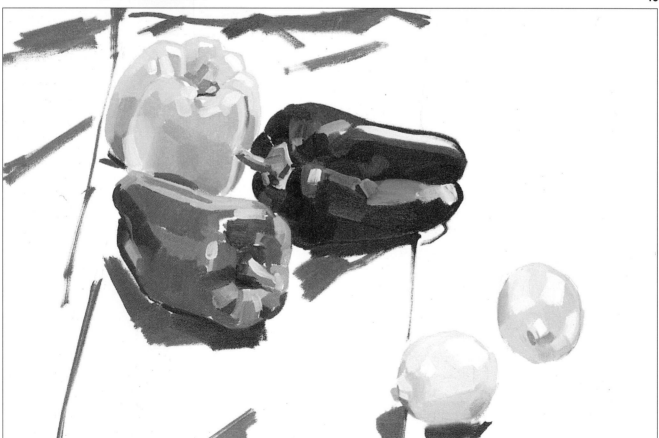

11 At this stage the palette looks like this, showing how the subtle shades of colour developed from one another. You can see too how the different colour blocks — yellow, red and green — merge into each other creating a unity of colour.

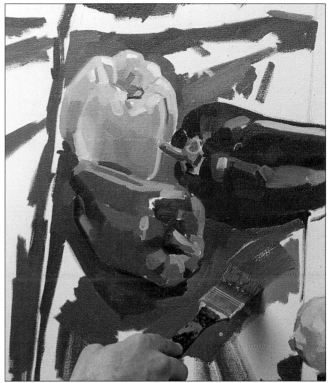

12

11

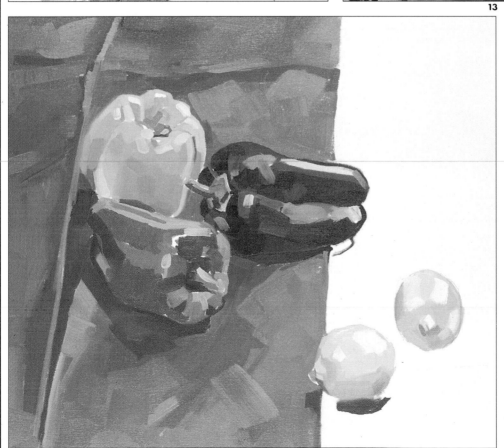

13

12 After adding the shadows, the artist filled in the lighter areas of the table-cloth. Now, with a large 1 ½ in (38 cm) soft bristle brush he paints in the mid-tone. Be sure that you mix enough paint and apply it in the same way as the rest of the painting — in bold strokes, working it into and around the shadows and highlights. The large strokes made with this decorator's brush help to distinguish the background from the foreground and fix the objects in the picture space. Here the paint is almost pure cadmium broken with a little white.

13 The cadmium is found to overpower the painting so it is toned down by working in another layer of the same with a little white and a touch of ultramarine. Lighter highlights are worked down the folds.

BASIC TECHNIQUES/PEPPERS AND LEMONS

14 The blue table-cloth is treated in the same way as the red cloth on the previous page. First the shadows are applied with a smaller brush – cobalt and ultramarine blue and white with a touch of ivory black to deaden the colour. The brushstroke cuts clearly round the outline, painting over any stray marks.

15 Again the flat area is completed with the larger brush. Some more white is added to the blue shadow mixture. It is important that it is the same tone as the red to keep it in the same plane. The contours of the lemons and peppers are emphasized by taking the brush round their outlines.

16 Finally, highlights are added to the peppers to give them a truly shiny appearance. Pure white is used but it is brushed into the still-wet paint beneath, so that it does not appear too bright in contrast with the shadows. The artist is still using the same No 5 flat brush which does not permit any fine detailing.

14

16

15

17 The finished painting is bold and colourful. The primary colours of the cloths have been reduced in tone so that they do not overpower the objects. Consequently, the peppers and lemons stand out well. Note, too, the different treatments of the textures – the shiny peppers with their bright highlights and dark shadows compared with the less reflective lemons and the soft linen cloths where the variation in tone is much less extreme.

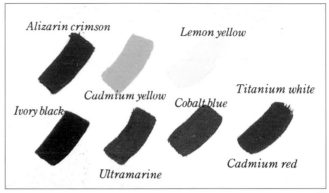

Alizarin crimson

Lemon yellow

Cadmium yellow

Cobalt blue

Titanium white

Ivory black

Ultramarine

Cadmium red

17

Chapter 5
Light and Shade

Light for the artist is an elusive element. In fact an artist who has a talent for depicting light achieves a timeless quality in his work. It is for this reason that Turner's work has remained in the public eye ever since it was first painted. His ability to capture the atmospheric effects of light, often combined with water, is guaranteed to delight anyone who sees his paintings in the original.

Depicting light, however, is a case of depicting light and shade. This may seem like an obvious statement, but sometimes the obvious is overlooked. A patch of bright sunlight will only appear bright if shown up by a patch of shadow that is tonally as dark. But light is fickle and matters are not quite so simple. Most of us find it difficult to visualize colours as tones. It is a good idea to study black and white photographs to get an idea of the distribution of light and shade over familiar objects. Tonal drawings in charcoal or pencil are good practice too. Otherwise, establish the tonal make-up of your composition with a monochrome underpainting, as demonstrated on pages 206-9. Then the paint overlaid can be matched tonally.

The type of light (natural or artificial, bright or dull, clear or misty and so on) and its position (from above or low down) affects every aspect of your painting – the tonal value, colouring, mood, composition. The Impressionists recorded the changing effects on a scene of the passing hours of daylight and changes in weather. Claude Monet's numerous paintings of Waterloo Bridge produced in the early 1900s have titles such as *Waterloo Bridge, misty morning 1901; Waterloo Bridge sun in fog 1903; Waterloo Bridge, grey weather 1903; Waterloo Bridge, effect of sunlight with smoke 1903;* and there are many more. Each study presents the subject afresh. Sometimes the subject itself, the bridge, all but disappears in a swirl of fog.

Some artists delight in the effects of light on what they see around them. Their art thrives on the gentle gradations of tone produced by, say, soft evening sunlight. Equally, the dramatic extremes of light and shade produced by bright light can provide inviting contrasts. They seek to represent the three-dimensionality of an object. For them shadows and highlights, and the vast range of tones between these two extremes, are what painting is about. Others are more interested in other aspects of art – pattern, colour, mood. More often than not, however, all these aspects of art are brought together in a painting.

Techniques

BLENDING TECHNIQUES

Blending is the mixing together of two colours or tones so that they merge one into the other to form a third. There are many ways of doing this as the techniques on the following pages will demonstrate. The nature of oil paint means, however, that the degree to which two colours are blended can be carefully controlled. If required, the paint can be applied precisely without any merging of the two colours at all.

On the other hand, working wet in wet by brushing one colour or tone into an underlying wet layer causes a spontaneous blending of colours. This technique produces a freshness in the painting, more often associated with *alla prima* painting. The two colours retain their own identity; they do not blend together completely, but qualify each other. In such a case the eye completes the blending for you.

Some artists, however, strive to produce softly blended gradations of tone for which oil paint is uniquely suited. It remains workable for a number of hours, sometimes days, so subtle variations in tone can be laid side by side and then gently blended with a fan brush or soft bristle brush. Rubens (1577-1640), in the flesh tones of his buxom nudes, shows how this should be done.

Blending
Colours can be laid down next to each other so that they retain their individuality, or the edges where they meet can be blended together so that a soft gradation of colour or tone leads you from one into the next.

1 In this exercise, the artist starts by laying down strips of colour, starting with chrome yellow and adding to it, little by little, cerulean blue until a strip of the pure blue is reached.

2 Taking a soft bristle fan brush, the oil paint is gently worked strip into strip, back and forth, stroking it from side to side, sometimes in a figure of eight pattern.

3 Such blending forms a gentle gradation of colour ranging from yellow to blue. Fan brushes are not commonly used but for a smooth gradation of tone they are unbeatable.

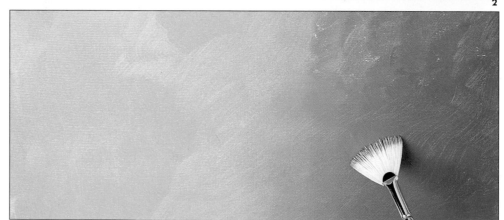

4 A similar effect is achieved by laying down the same strips as in example 1 but blending them into each other as the paint is applied. A soft nylon brush is used which will leave a smooth finish.

5 The result is similar to that produced with the fan brush, if not quite so smooth. But this is the more common way of blending in the course of painting as it can be done with the brush in hand.

6 Artists have traditionally used their fingers where they achieve the right effect. Here the forefinger is found useful for blending, producing a very flat surface. Rub backwards and forwards with the flat of the finger until the colours have blended evenly across the centre.

7 The blending is not so smooth, but the effect is interesting. Finger blending is resorted to by all artists sometimes just to deaden a bright highlight or soften a sharp edge.

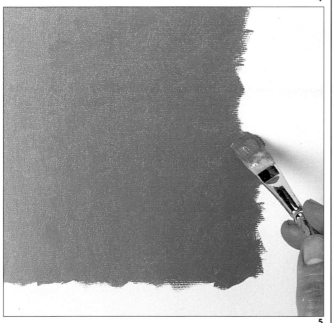

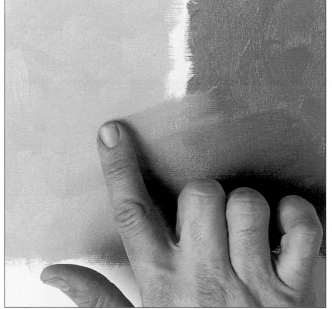

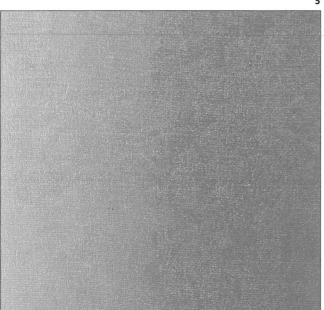

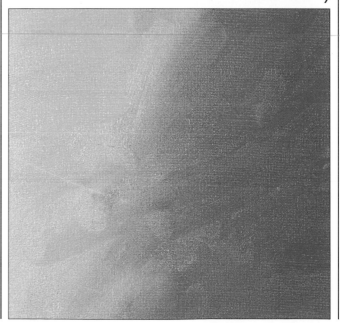

WET IN WET

Wet in wet

Spontaneous blending occurs when paint is applied on top of another layer of wet paint. But the original colours retain their own identity, giving the resulting hue a depth and freshness.

1 A layer of chrome yellow is worked into with bold brush-strokes of cadmium red. The stroke is made with some pressure, making the bristles splay out and so merging the two colours.

2 In the midst of this burning orange, streaks of the original two colours can be seen. The freshness of *alla prima* painting, which is completed in one sitting, derives partly from this technique.

3 Now dabs of alizarin crimson are added in the same way adding a further dimension to the burning orange

4 The result is a rich, lively area of colour which appears to glow. Even with two colours superimposed the original yellow layer shines through in places, giving a three-dimensional depth to the colour.

Optical blending

Patches, dabs or spots of pure colour laid side by side on the canvas will be blended optically when viewed from a distance.

1 Using the same colours as the wet-in-wet demonstration, and still applying one wet brushstroke into another, quite another effect is achieved. First the 'layer' of yellow is applied in a bold irregular pattern.

2 Adding the cadmium red, the paint is applied briskly with assurance, yet with little pressure so the pigments do not blend together too much on the canvas. The paint is drier and so covers the paint beneath more efficiently.

3 The addition of a series of darker alizarin red dabs creates a richer optical blend of colours.

4 From a distance, or viewed with the eyes half-closed, the colours will blend to form a flat area of burning orange similar to that on the opposite page.

Kettle
LIGHT AND SHADE

The old masters would invariably start painting by laying down a monochrome underpainting in dilute washes of burnt umber – a fast-drying earth colour suitable for the job. This underpainting acted as a guide to the tonal values of the painting, mapping out the areas of dark and light and thereby helping in the mixing of colours as the painting proceeded.

Such tonal exploration can also be made in a charcoal or pencil sketch. In fact, it is a useful exercise to carry out a tonal drawing before embarking on the painting itself. A photograph of your subject – particularly in black and white – will help you and certainly a Polaroid camera which will produce the photograph on the spot is useful in this respect. A photograph tends to reduce the gradations of tone and takes no account of changing light, so the situation is simplified for you. Some artists find this simplification debasing and therefore spurn the photograph as a useful aid.

In this project, the tonal exploration of the copper kettle is made in a monochrome underpainting. Then, the black and white representation is glazed over with a dilute wash of paint to transform it into a copper kettle. But the artist is not satisfied with such magic and demonstrates how to add life to the painted subject.

The artist could have followed the masters in choosing an earth colour for his underpainting, leaving the canvas bare for the areas of highlight. But he decides to spend a little time working up a three-dimensional monochrome image of the kettle. The reflective nature of the copper, as well as the beaten surface and the many dents collected over the years, combine to make a testing exercise.

2 The outline of the kettle has been sketched in with a graphite pencil. Canvas board is hard and almost slippery both to draw and paint on. But it is cheap and freely available and so provides an acceptable alternative to canvas.

3 Mixing up a dilution of Payne's grey and titanium white, the mid-tones of the kettle are located and painted in with a No.8 nylon flat brush. This is not a laborious process but completed roughly and quickly.

Feeling his way, the artist adds white highlights to the mid-tones, dabbing them on to imitate the beaten surface with a smaller No.2 brush. Note that the paint is still very dilute. The gradations of tone, describing the dents, are blended together at the edges.

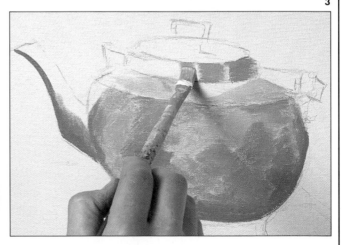

1 This splendid round-bellied copper kettle has an interesting beaten surface which is best observed in the highlights. In addition, the bright shiny copper bears the scars of many knocks it has received during its long life. Not only is the light reflected in its belly but other objects in the room, forming unexplained areas of dark and light.

Materials: Canvas board 20 in x 15 in (50cm x 37.5 cm); graphite pencil; soft eraser; brushes – Nos.2, 5, 8, 14, flat nylon, No.2 round sable; tin foil palette; white spirit; all-purpose cloth.

4 In order to bring out the contrasts, the dark shadows are added. These will counterbalance the highlights also seen here, which have been dabbed on with a smaller No.2 brush to imitate the beaten surface.

5 The artist adds the shadow cast be the kettle on the backcloth with a broader No.8 flat brush. This helps to fix the kettle in space and creates an interesting background pattern with the folds in the backcloth.

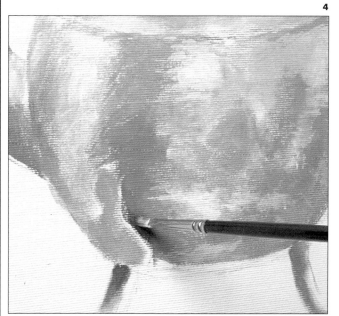

6 To complete the underpainting, details of the wooden board on which the kettle stands and the background cloth are broadly blocked in. The dilute wash of grey over the background puts the kettle in context tonally. At this stage, the painting is left to dry before further layers of paint are applied.

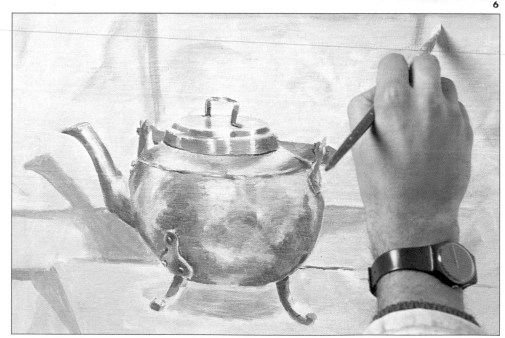

LIGHT AND SHADE/KETTLE

7 Now for the magic. The kettle is glazed with a mixture of burnt and raw sienna and chrome yellow well diluted. For this larger area a No.14 flat brush is used. Glazes in the final stages of a painting are usually diluted with a high percentage of linseed oil, which gives a rich gloss to the painting.

8 The wooden board is given the same treatment and the painting starts coming to life. But note how the kettle appears dull. It has lost its highlights and yet retained the dark shadows, making the tone uneven. Also it takes no account of the reds and golds and other colours visible in the copper.

9 The backcloth is glazed with diluted cobalt blue. While cutting in with the brush around the lid of the kettle, an undiluted particle of paint causes a bold splash on the board. It just needs redistributing with the brush. Oil paint is easily lifted off with a clean brush or cloth if it is not given time to stain the canvas.

10 To bring back the reflective quality of the copper the highlights are replaced. The white paint is applied wet in wet allowing the copper glaze to temper the brightness. Again, the paint is dabbed on to imitate the beaten surface of the kettle.

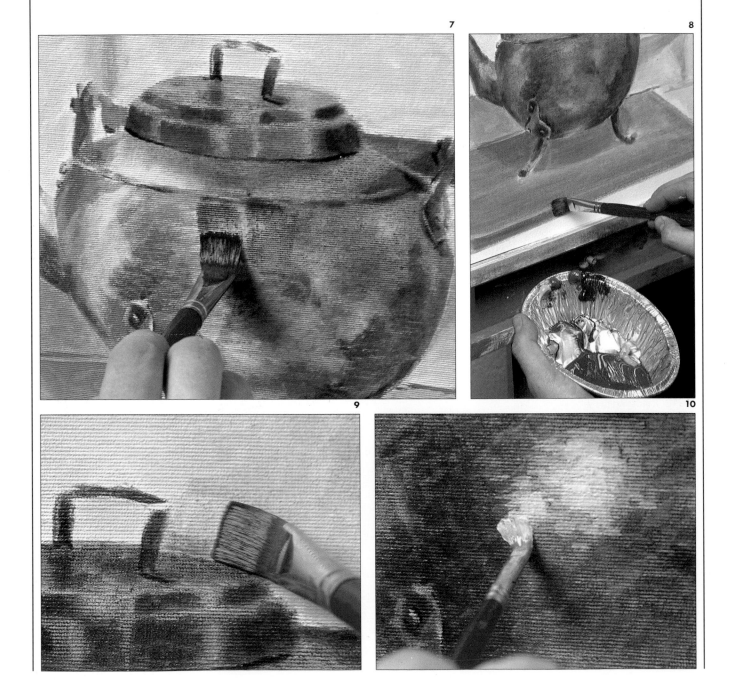

11 The artist has been working on the kettle, building up the areas of colour. The highlight on the spout of the kettle is added with a small No.2 round brush.

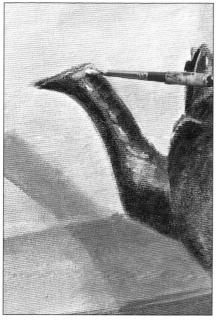

Payne's grey

Titanium white

Burnt sienna

Cobalt blue

Chrome yellow

Raw sienna

12 The exercise is completed and what might have seemed a daunting prospect has been carried out with the minimum of fuss. Different subjects require equally different approaches. It is only with experience that the correct course can be visualized from the start. Even experienced artists find their best-laid plans undone by unexpected circumstances. All that is required is a flexible mind that enjoys the challenge of such unforeseen developments.

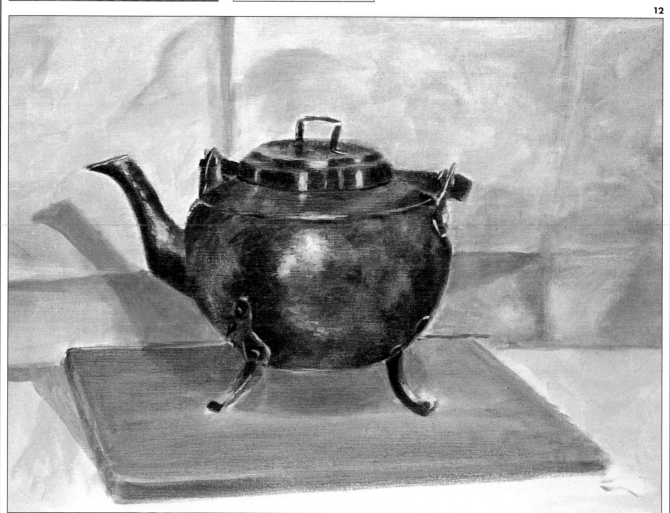

Pool House

LIGHT AND SHADE

The artist chose this photograph (an advertisement in a magazine) because he liked the arrangement of geometric shapes made by the openings in the façade of the house and the contribution made to the composition by the shadows and reflections. Bright sunlight creates strong contrasts – here in dark shadows on the white walls and dappled sunlight on the terrace. The cool blue pool in the foreground repeats the geometric shapes of the house in a separate abstract composition of reflections. So, in effect, this painting is not about creating space in the picture but about the patterns created on the surface of the painting.

The other important aspect of this painting is that the paint has been built up in layers, starting very dilute and working up to thicker paint in the final layers. But the paint is worked wet in wet, not waiting for it to be touch dry before proceeding with the next layer. The shadow areas receive most attention in this respect. Indeed, we can see how, through the application of several thin layers of paint, the shadows achieve a depth of tone which could not have been achieved with one single thick layer of paint. Even so the paint layer is not thick and the canvas is left exposed for the white walls of the house.

Note how the artist chooses to simplify some areas of the original scene. The shutters, for example, are just a single stroke of dry paint. On the other hand, he spends time on the reflections in the pool and on such details as the wicker chairs on the terrace. It is not necessary to maintain a high degree of detail over the whole composition. In fact, if the artist had done so here, it would have become monotonous.

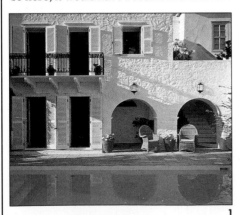

2 Very sketchily, with a soft pencil, the artist has roughed out the main shapes of the composition. Now the main areas of colour are boldly blocked in with dilute paint. This is executed quickly only to give a general idea of the layout of the composition.

3 Now the artist chooses to concentrate on the pool. First, he applies the areas of shadow into the still-wet paint. These are applied directly without working them into the underlying paint so that the first layer can be seen to qualify the second.

1 This photograph, reminiscent of summer holidays, was discovered in a magazine advertisement. The way it is cropped reduces it to a composition of geometric shapes and the surface pattern becomes the important unifying force. At first glance, the configuration of the house is not obvious. It is only on further inspection that certain details come to one's notice, such as the view of the sky and vegetation to the left of the house and the recessed right-hand side of the façade. It should be possible to explore paintings in this way, and so sustain the interest beyond the initial glance.

Materials: Stretched canvas 20 in x 16 in (50 cm x 40 cm); brushes – No.10 flat nylon, Nos.2 and 5 sable round; HB pencil; soft eraser; tin foil palette; cloths.

4 The tone of the steps needs to be lighter so a little white is added and blended with the first layer of blue.

5 With the addition of more limpid mid-blue tones and white reflected highlights, the study in blue is completed.

6 Now the artist returns to the facade of the house. This is a moment when he would look again at the source material. Note how he has pinned the magazine page to his easel for easy reference. He glances up at it every now and then, but does not slavishly copy every detail.

4

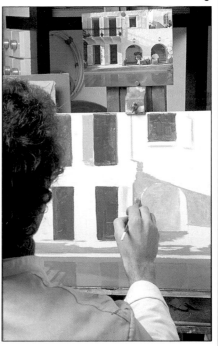

6

5

LIGHT AND SHADE/POOL HOUSE

7

7 The shadows on the house take up our attention next. Over an underlayer of burnt umber and white, a further layer of cobalt blue, burnt umber and white is added. Now the second layer is blended into the first and teased along the window frame to capture the dappled shadows. Keep the brushwork lively; shadows are rarely flat and hard. They consist of subtle variations in tone and colour which can be hinted at in the brushwork.

8 Next, the cantilevered balcony is visually condensed down to deep shadow with highlighted corbels. To clarify the areas of tone, it may help to look at the area with half-closed eyes. Here, with a No.5 round brush, the white highlight is applied.

8

9

9 A neat horizontal line forms the platform of the balcony, which is now ready for the wrought-iron railings. But that comes later.

10 The stark blue of the underpainting which outlined the heavy areas of shadow has been qualified with a further layer of the shadow mixture. The interesting, angled shadow cast across the right-hand side of the façade is brushed across. The brush is kept dryish so that the edges of the shadow are undefined, blending into the white of the wall.

11 Work starts, too, on the smaller details such as the arrangement of wicker chairs on the terrace. First, the main shape of the chair is blocked in.

12 At this mid-way stage, the house façade is beginning to fill out. The blind black window openings have been worked on, wet in wet, with Prussian blue and white, hinting at space and furniture inside the rooms. Other details have been added, such as the terracotta pots.

13 The shutters are described very simply with a single stroke from a flat brush charged frugally with a dry mixture of burnt sienna and white. This stroke of uneven colour is drawn across the shadow to give the impression of the slats.

10

11

12
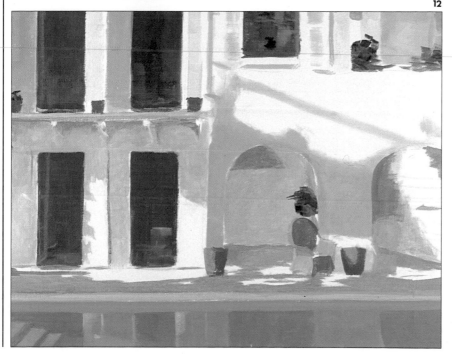

13
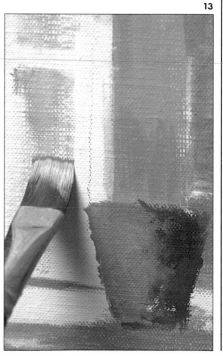

OILS

14 Now to work up the vegetation. Into the initial layer of Prussian blue and lemon yellow, the artist has dabbed white, wet in wet, so that the two pigments merge. Now he re-establishes the darker tones by stippling with a small round brush. Note, the contents of the terracotta pot get the same treatment.

15 Finally, again with the same small round brush, a further irregular scattering of lemon yellow dabs is worked in to the wet layers beneath. The effect of these successive layers of small dabs is convincingly three-dimensional.

16 When this area is touch dry, the balcony railings are added deftly with a small round brush and some dilute ivory black. This needs to be executed with assurance and some speed, so practise on some paper before you take the plunge.

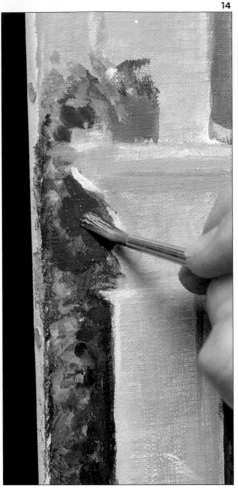

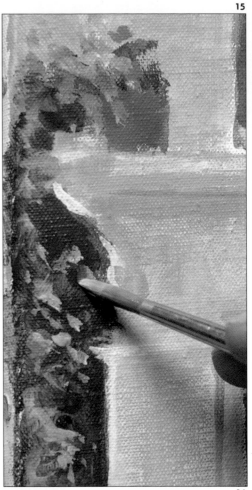

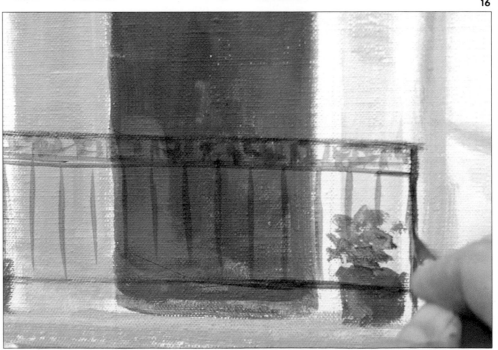

17 Attention now turns to the terrace area. The chairs and the view through the two arches are worked up. Now the artist returns to the shadows on the facade to which he adds a final layer of burnt umber and white.

18 To give the dappled shadows on the terrace further depth and warmth, a glaze of raw sienna is brushed over the dry underlayer.

19 The painting has been given its finishing touches with the addition of the lanterns above the arches. The gradual building up of the various layers in the areas of shadow has played an important part in the painting process. As a result, the artist has managed to capture the feeling of bright sunlight in this painting.

17

18

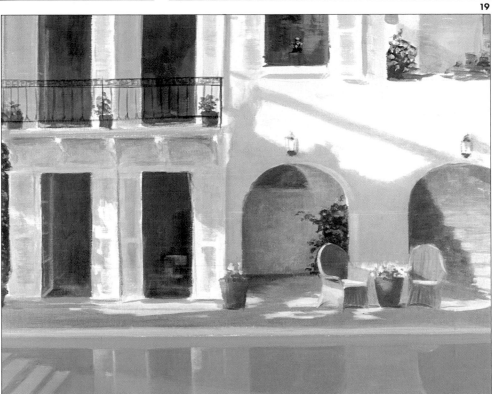

19

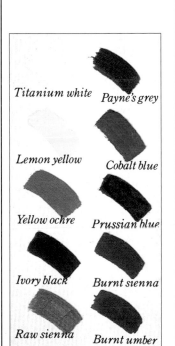

Titanium white *Payne's grey*

Lemon yellow *Cobalt blue*

Yellow ochre *Prussian blue*

Ivory black *Burnt sienna*

Raw sienna *Burnt umber*

Chapter 6
Broken Paint

By this stage you will be beginning to understand why oil paint is described as versatile. It is possible to manipulate it in so many exciting ways. This means that, by learning to use the many different techniques described, the artist will be able to translate into paint exactly what is visualized in the mind or seen with the eyes.

Of course the artist is not only concerned with precise representation, but in the various ways – or, you could say, the most stimulating way – an object or an idea can be presented. Consequently, it is worth trying out as many different techniques as possible so that this battery of skills is allowed to grow, thereby providing for a certain freedom of invention.

The techniques covered in this chapter, with evocative names such as scumbling and stippling, involve areas of broken paint brushed over an underlying layer so that patches of the paint beneath shine through. Such brushwork results in fascinating atmospheric and three-dimensional effects and deep rich areas of tone and colour.

These techniques are most effective if the underlying paint is allowed to dry. And this is where the oil painter's great virtue of patience comes into its own. Or his ingenuity – after all, breaks to allow time for the paint to dry can be timed to coincide with life's essential needs such as eating or sleeping. Fortunately, the early applications of paint are usually dilute and so take a shorter time to dry and the drying time can be speeded up with the addition of an alkyd-based drying agent. But, you will find that the thicker the paint and the more oil added, the longer it will take to dry. Some artists avoid long delays by having two or even three paintings on the go at the same time. However, hopping from one subject to another may be merely confusing for others.

But there are many ways of achieving the same result. The preliminary layers can be carried out in fast-drying media such as acrylics or pure egg tempera. Oil paint can then be taken up for the later stages of the painting. But, beware – oil paint can be applied on top of these paints but not vice versa.

SCUMBLING

Scumbling is an expressive technique whereby opaque or semi-opaque paint is applied unevenly over the top of another layer of dry paint in order to modify it. The paint can be applied in a number of ways, but in order for the paint beneath to show through, it must be applied either in a hazy veil or irregularly, in a broken layer of brushstrokes.

Scumbling creates rich textures and colours that are impossible with direct colour. Flat colour can be given the appearance of soft animal fur, wool or hair with a layer of scumble. It is also a useful technique for giving zest to what appears to be a dead area of colour. A scumble can be used to gently modify a colour as the superimposed colour will mix optically with that beneath without killing it. If your colours are too bright in the background so that they come forward, for example, a light scumble will have the effect of toning them down. As can be seen from the examples below, scumbling also lends itself to representing intangible, atmospheric masses – clouds, fog, smoke.

DRY BRUSH

Dry brush is another technique where the paint is applied with a broken uneven brushstroke so that the underlying paint is allowed to show through. Dry brush is much as it sounds: the pre-dried brush is loaded with thick undiluted paint and applied lightly on a dry surface. The bristles splay out leaving streaks of the surface below visible. Strokes of dry brush need to be quick and assured so that the paint does not have the opportunity to blend. Again, the weave of the canvas helps to break up the paint, making the surface more vibrant. The splaying of the brush can be encouraged, without having to apply too much pressure, by holding the brush down by the ferrule and pressing the thumb down on the bristles.

1 Scumbling on a hazy veil of Payne's grey, the brush is rotated, working the paint into the canvas.

2 Over the grey, a layer of alizarin crimson is scumbled, creating an atmospheric effect.

1 With the dry brush technique, the bristles are splayed with the fingers.

2 This produces a delicate mesh of blurred strokes, with an interesting texture when viewed from a distance.

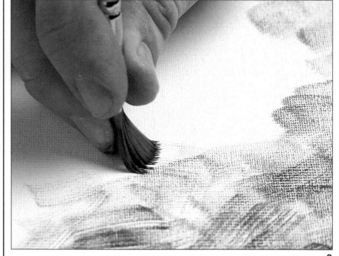

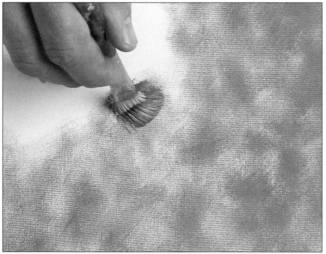

Stippling is a technique of many parts. It can involve a tiny area and be painstakingly precise or cover an expansive background, requiring healthy jabbing with a decorator's brush.

An area of stippling is made up of tiny dots of paint applied with the tip of the brush held vertically, creating areas of vibrant tone or colour. The marks made by the stippling technique can vary hugely depending on the brush used. Dots of paint can be carefully applied with a small round brush, slowly building up an area of colour or texture – such as in the crab project on page 222. Larger areas, such as backgrounds, can be quickly stippled with a large round bristle brush or decorator's brush to provide a lively surface. Nail brushes and sponges make interesting stipple marks too.

Layers of stippling can be superimposed to create a pulsating depth of colour or texture. Starting with a dark ground and working to light gives an optical illusion of the three dimensional.

The density and the size of the dots affect the tonal value. The closer together the dots, the denser the tone. So by varying the density, gentle gradations of tone can be achieved.

1 Stippling with a large round decorator's stippling brush creates a coarse mark.

2 The depth of colour can be regulated by altering the pressure on the brush and also the dilution of the paint.

3 Here a natural sponge creates a dense but regular stipple mark.

4 The result is a delicate textural area of paint with many possible useful applications.

Crabs

BROKEN PAINT

These two crabs make perfect subjects to demonstrate the art of successive layers of uneven colour. They appear to have been scumbled by nature herself. And this is certainly where their attraction lies for the artist. Their shells have a fascinating texture and colour which prompt an invitation to paint. There are neither delicate gradations of tone in the shadows nor complex compositional arrangements: the artist relies on the crab itself which is simply a masterpiece of design.

The first stage of painting was completed in very dilute paint which dried fairly quickly. Even so, an alkyd-based drying agent could have been added to speed up the drying process. Or, indeed, quick-drying paints such as acrylics, alkyds or pure egg tempera would have speeded up the early stages. The later stages could still have been completed in oils so that by the end the surface would have been covered with the characteristic richness of these paints.

The colours discovered by the artist in this crab remind us to be bold when trying faithfully to reproduce what we see. Some artists delight in colour, while others are more interested in other aspects. When this artist looks at the crabs he sees the hint of a colour – the pale magenta on the claw, for example – and exaggerates it. But note, the colour does not remain there as a flagrant patch of magenta, but it can be seen burning through the successive scumbles of red. So take courage where colour is concerned. After all, if it does not work you can always cover it, qualify it, temper it. But it will rarely need removing and, more than likely, it will energize your painting.

2 For the underpainting, the artist lays down suggestions of colours observed in the crab. Finding these colours, he claims, is largely intuitive. But it is clear that you need to be brave. After all, if the colour you choose is not right, it can always be covered over, modified, or lifted off with a cloth. The striking magenta on the claws forms the basis of the shadow but it would be hard to identify, without looking for it, in the final painting. The background was literally scrubbed into the canvas in an attempt to represent the texture of the slate. This, too, will receive further treatment.

1 The beauty of these crabs lies in their colouring and their designer armour plating. They are well shown off on this heavy slab of slate – suitably funereal, considering their cooked state.

Materials: Fine grained flax canvas 30 in x 24 in (75 cm × 60 cm); brushes – Nos. 5. 8 and 14 flat nylon, No.2 round sable; graphite pencil; tin foil palette; fine grade sandpaper.

3 Working wet in wet, the pale foundations for the large crab's left claw are laid with a No. 5 flat brush. Note how the graphite pencil has muddied the paint. Fixing the underdrawing would have prevented this, but it is not a problem as the subsequent layers will cover it up.

4 Once the lower crab has received the same treatment, then the painting is allowed to dry. The colours have been merged together on the canvas to give a gradated flat area of colour. But note that, already, the wild magenta has been modified a little.

5 The artist adds the shadows cast by the crabs on to the slate. These follow the contours of the crabs, emphasizing their three-dimensional form and throwing them into relief. It also has the effect of tidying up the outline. This delicate task is performed with a No. 2 round sable brush.

6 Now, to build up the background and give it some depth, another layer is worked over the first one. Using a large flat brush, the paint is roughly stippled over the top. These two layers of uneven colour make the surface live.

4

6

5

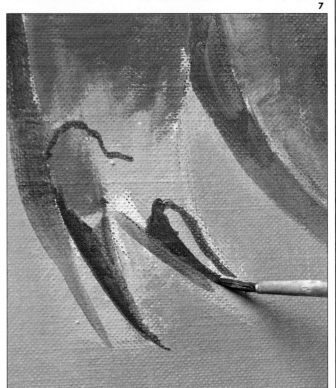

7

7 Back to the upper crab to work on its right-hand claw. With dilute ivory black and a No. 2 fine round brush, the delicate black tips of the claws are painted in. Also the shadows along the joints of the claw are carefully observed and added. These details are important as they constitute the essence of the crab. Note, too, how the claw has been filled out with a further layer of orange/red laid over the top of the dry underpainting.

223

BROKEN PAINT/CRABS

8 Again, the paint needs to be dry before this next layer of paint. Still working on the top crab, a final layer of colour is scumbled over the top. The dry paint is scrubbed quickly backwards and forwards, round and round over the surface. It is important that only a very little of the paint is applied at a time. The uneven scumble creates a soft area of uneven colour through which the underlying colours can be seen. The grain of the canvas also helps to separate the colours and produce the undefinable depth of texture.

9 The crab's right claw is scumbled with the same colour and blue highlights are added to the claw tips. Note the grain of the canvas showing through the scumble on the shell.

10 Moving to the left claw, the dull sheen of the crab is perfectly captured in the lilac highlights. The paint is applied with a small brush and then smeared with the finger to flatten and deaden it. The indentations round the edge of the shell are delicately picked out with the same pale mixture.

11 The hind claws are the last to receive attention. Still using the small round brush, the artist stipples two layers of colour, hinting at the stubby bristles. This small area breaks from the formula of the rest of the crab. It is an interesting small area of paint which delights the eye.

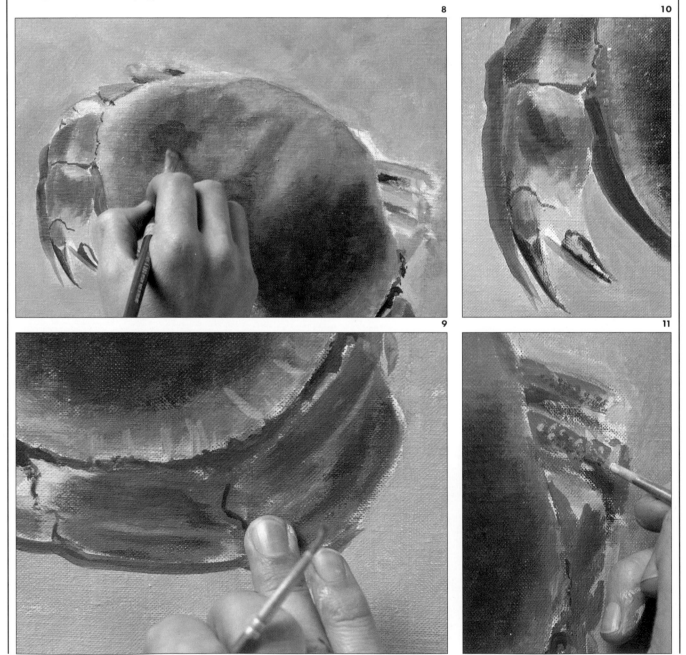

12 Now for the final touches on the lower crab which has been brought up to the standard of its larger neighbour. The chalkiness on its shell is added as some white paint is dry brushed on. Make sure the brush is quite dry by wiping it on a cloth. Take up a tip of the full-strength paint and brush it on.

13 The very final detail – the delicate feeling hairs – are added with the same No. 2 round brush.

14 To build up the texture of the background still more, the surface has been gently rubbed with fine sandpaper. To do this the paint needs to be quite dry; also take care not to rub down through the priming coats to the canvas. Even so, fine specks of white and the pattern of the canvas weave now show through the grey adding to the lively texture.

Building up layers of colour wet on dry, as has been done in this project, is well worth the time and effort. It creates a remarkable depth of colour and sense of the three-dimensional.

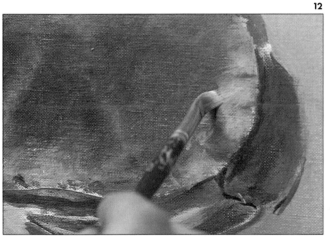

12

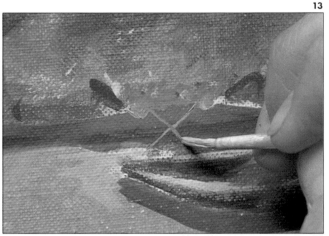

13

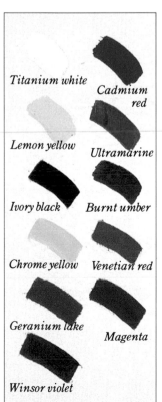

Titanium white *Cadmium red*

Lemon yellow *Ultramarine*

Ivory black *Burnt umber*

Chrome yellow *Venetian red*

Geranium lake *Magenta*

Winsor violet

14

Constable

BROKEN PAINT

Flatford Mill stream, with Willy Lott's cottage in the background, was the subject of one of John Constable's most famous paintings, *The Haywain*. It is a typical English country scene with a bank of mixed trees coming down to a sluggish river bordered with rich flora and a white cottage in the background.

Armed with a photograph of the scene today, it is a challenge to try and paint the same subject again. But not quite in the same style: the original took Constable five months to complete and, indeed, his friends paid tribute to the speed with which he completed the project. If this information makes it seem like a daunting prospect, watch how the artist simplifies the scene. He has avoided making this a detailed study of the nature at Flatford Mill. It is the atmosphere of the place that he is trying to capture.

Looking at the finished painting, the eye takes in the trees of different shapes, colours and sizes and sees among them a fir, hawthorn and maybe rowan, but precise species would be difficult to identify. It is the same with the river bank. The different plants are simplified down to a few basic leaf shapes, but flag irises, balsam and other waterside plants are assumed to be there.

After the initial blocking in of the main shapes, the artist concentrates on the foliage and riverside plants, building them up with superimposed dabs, dots and areas of stippling, so that the surface of the painting is a lively flurry of strokes broken by

the flat, still area of water between them. The artist works quickly, mixing and then dabbing on the paint, hopping from one side of the bank to the other. In contrast the sky and the water are built up with layers of soft scumbles. By leaving these two areas until last to complete, the dilute layers of underpaint have a chance to dry.

Materials: Canvas 22 in × 16 in (55 cm × 40 cm); brushes – Nos. 5, 6, 10 flat, No. 5 round; tin foil palette; white spirit.

1 This view has come to epitomize the English countryside, thanks to the painting by John Constable, completed in 1821, known as *The Haywain*. Today the scene survives intact. Still protected by a bank of trees, the slow-moving River Stour oozes past Willy Lott's cottage. It is a challenge for any artist.

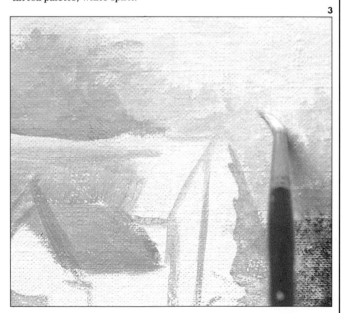

2 First, the foundations for the painting are laid down. Even at this stage, the paint surface is lively and broken, applied in dabs of dilute paint and worked out at the edges in a hazy scumble. Notice how this bank of trees is already made up into clumps of foliage, hinting at the individual trees. These neutral greens are mixed from variations of yellow ochre, cadmium yellow, cobalt blue and white. The artist is working without an underdrawing, painting straight on to the canvas and feeling his way as he goes. The area of deep shadow where the trees meet the water is put in place with a dark flat line of dilute green. This immediately draws attention to the contrasting texture of the trees and the flat water.

3 The artist starts working up the background and then comes forwards. Here, the glimpse of the distant horizon is scumbled on with a round brush and a mixture of Payne's grey, ultramarine blue and white, so that the white of the priming coat shines through. Willy Lott's cottage has a more defined structure so the outline has been economically brushed in with very dilute paint. At this stage the artist is still very much feeling his way. The pinkish colouring of the cottage roof, for example, helps the artist to visualize the composition; it is not necessarily useful as a colour base.

4 Now, the artist begins to work up the individual trees. This fir shaped tree has dabs of lighter and darker green (ivory black, cadmium yellow, cobalt blue – and white for the lighter tones) worked into the underlying scumble with a stippling motion, using the tip of the flat No. 10 brush. The paint is reasonably liquid so the foliage appears dense.

5 Beneath the fir tree, a small tree with lighter foliage is delicately formed with the same brush, using just the very tip. Make sure the brush is dry before adding a touch of paint – some lemon yellow worked into the green colour. Then, with minimal pressure, bring down the brush vertically on to the surface of the painting and quickly off again.

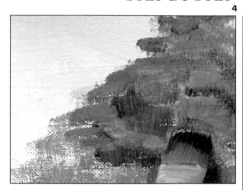

4

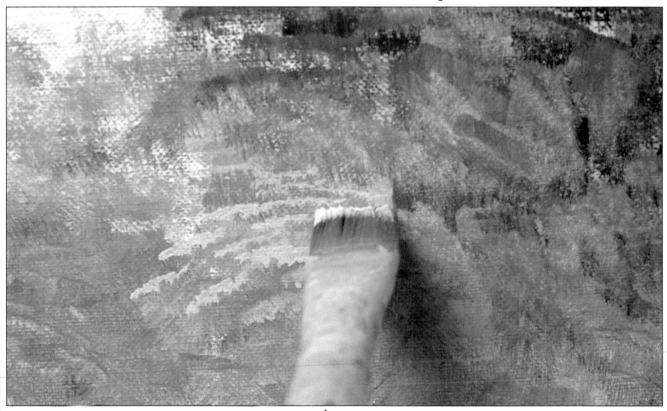

5

6

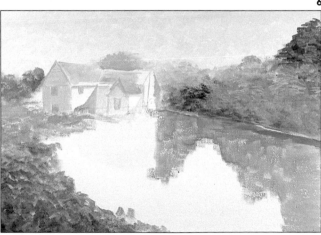

6 Taking stock and standing back, you can see that the surface is now almost covered with a lively layer of paint – more in some places. A base layer of Payne's grey, ultramarine and white has been applied to the sky area with irregular strokes. Also the reflection in the river (yellow ochre, cobalt blue and white) has been worked into the dark shadow under the trees. At this stage the painting is allowed to dry.

7 The same sky mixture, tempered with a little of the green, is worked into the river area. Water reflects the sky. So if it is flat and calm, as it is here, you will get a long stretch. In moving water, only small patches of sky colour will be glimpsed. The same mixture with a bit more green is worked over the tree reflections very gently so that the original broken layer of paint is not blended completely. Now there is a hint of the limpid depths below the reflected surface.

Willy Lott's cottage is reflected in the water, too, with just a few dabs of dry brush.

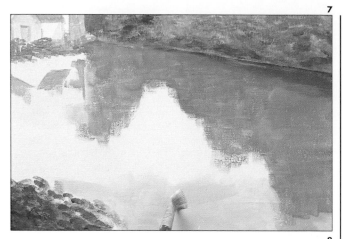

8 Now the cottage itself is given some attention. As it is part of the background, it must not become too laboured with detail. The paint is kept thin and the brushwork loose. The shadow areas of the walls have been built up with pale scumbles of Payne's grey, ultramarine blue and white. On the roof, a couple of strokes of dry brush over the pinkish foundation paint is punctuated with the rows of broken lines, conveying an impression of tiles.

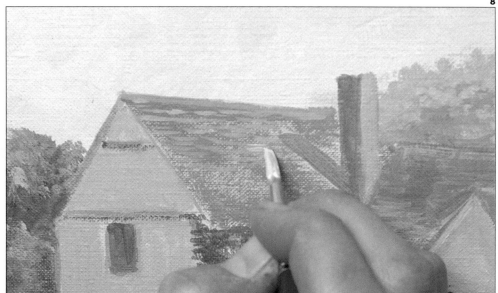

9 Further stipples of light paint are added with a small round brush to the trees by the cottage. These pale stipple marks seem to float above the murky neutral greens beneath, enforcing the three-dimensionality of the trees. The further away, the smaller the stipple.

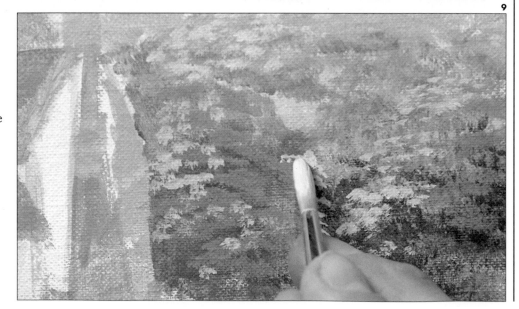

10 The artist works some darker tone into the point where the river disappears round the side of the cottage. By now, everything is beginning to fall into place and the painting is filling out. Note how the artist has used up the paint on his brush at times to build up the tone of the left bank.

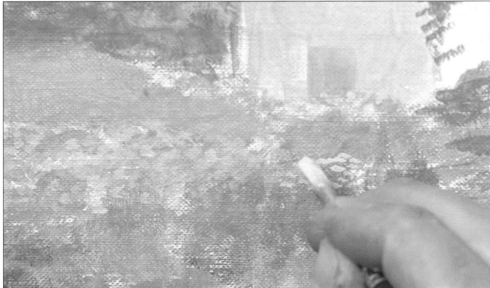

11 Now it is time to concentrate on the left bank of the river. As the artist works, he is forming the simplified shapes of, first, the clumps of plants (as in a border of flowers) and, second, the shapes of the leaves themselves. Over the top of the multishaded scumbles, the artist stipples with tiny blurred strokes.

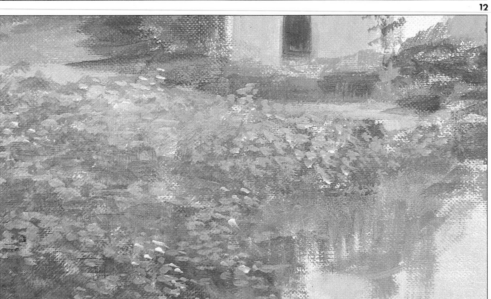
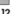

12 These pale green stipple marks are superimposed with delicate flurries of colour – more saturated in the foreground, bleached in the background. Finally, tiny specks of pure white are placed at random with the very tip of a round brush.

BROKEN PAINT/CONSTABLE

13 Now the foreground bank of rushes and flags are painted in, using a large flat brush with the bristle ends held vertically. Held like this the brush almost paints these leaf shapes for you. First, a random crop of mid-tone green leaves and then a few in the highlight green. The paint here in the foreground is thicker, adding to the sense of recession.

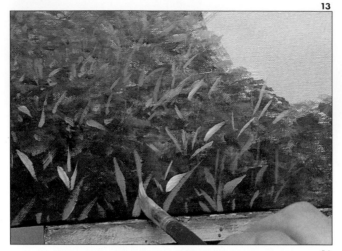

15 For the final touches on the right bank, suggestions of the trunks and branches of the trees are made with careful strokes with the tip of a dry brush in two tones of brown. It is necessary to isolate these strokes to see just how economical they are.

14 Clumps of rushes break the rather harsh line between the bank and river. Notice the slightly different colours and saturation of these leaf shapes. Still the primed canvas can be seen shining through to form glistening highlights.

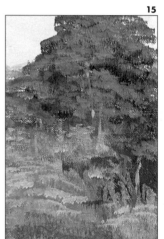

16 The rich mixture of foliage further along the bank is punctuated with vertical trunks. These are less defined as they appear further in the background.

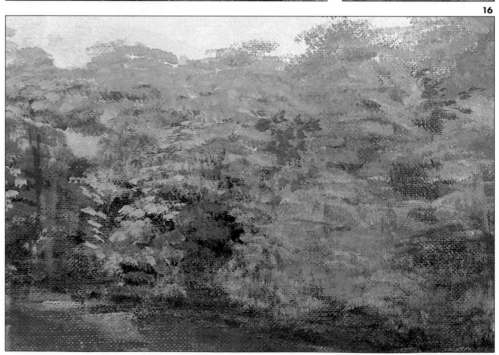

17 Finally, the artist works on the sky – soft white clouds in a blue sky. Over a layer of white, ultramarine and Payne's grey, a dab of pure white is applied neat and then worked over the surrounding area. This white paint is scumbled round and round, forming an atmospheric mist of cloud.

18 The superimposed layers of uneven paint give the finished painting a living surface which contrasts with the stillness of the scene itself. There are contrasts, too, within the painting, with the busy areas of foliage separated by the oily calm of the water. The eye naturally focuses on Willy Lott's cottage but it strives to go beyond, following the murky depths of the river. It is a peaceful scene but, as we have seen, it is made up of small areas of inspired painting that will sustain the attention of the viewer.

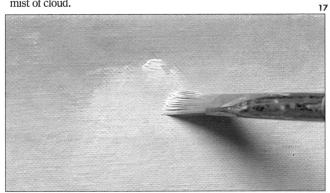

17

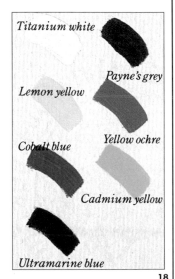

Titanium white

Payne's grey

Lemon yellow

Yellow ochre

Cobalt blue

Cadmium yellow

Ultramarine blue

18

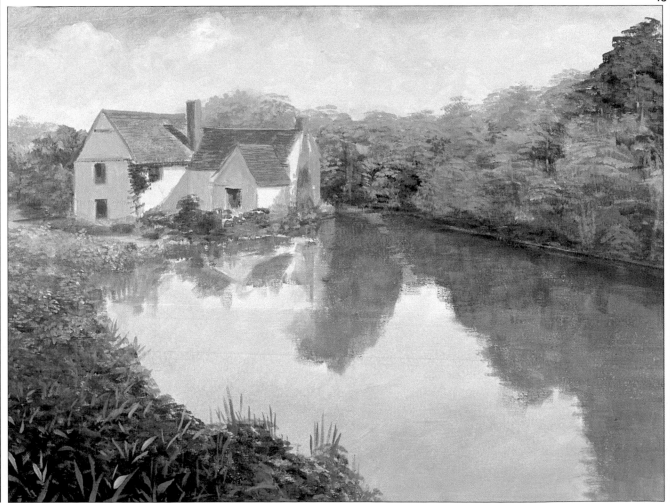

Chapter 7
Texture

By now we have a useful set of techniques at our disposal with which an enviable number of effects can be achieved. But, until now, the paint surface itself has remained reasonably flat. The textures depicted in the paintings have been achieved visually through deft brushwork. Yet one of the joys of oil paint is the texture of the paint itself – thick globs and smears of paint which break the two-dimensional quality of the surface.

Oil paint will maintain its form exactly as it is placed on the surface if it is used undiluted. And there is something spontaneous about a dash of thick impasto paint with the brushmarks still visible in it. At a distance it makes up part of the image, but, close to, it forms a direct link between the viewer and the artist.

In this chapter we look at some of the techniques used to apply paint in such a way. In knife painting this is taken to its extreme. The paint is applied like soft butter and teased into ridges and peaks. Such thick applications of paint cast their own shadows on the surface and glisten in the light, adding a further dimension to the painting.

A textured surface can be achieved by scratching into the surface or adding a granular substance such as sand to the paint. Francis Bacon, the British contemporary painter, has been known to fling vacuumed house-dust at certain parts of his paintings to give the surface a fuzzy appearance. There are really no limits to invention.

Although some artists specialize in these extremes of textural painting, most artists dabble at one time or another and perhaps add a few strokes of impasto paint in the final layer of their painting. But, by trying your hand at this type of painting, you will find it is fun to do and it will help you to learn to be bolder with your paint. With knife painting, for example, you cannot afford to get bogged down in detail, or your image will blur and get muddy.

So, take courage, and have a go.

KNIFE PAINTING

Painting with a knife is like a feast. It could almost be described as a delicious occupation. The luscious paint is applied thickly with a small, highly flexible steel knife-blade over which you have a surprising amount of control. These sensitive knives come in various shapes and sizes, each capable of their own individual marks.

As with a brush, pressure, angle and use of the different parts of the instrument affect the result. The paint can be smeared on with the flat of the blade to produce an area of thick creamy paint. Slight regulation of pressure will produce ridges that catch the light. Or the tip can be used to place precise dots and dabs of paint or dragged along to make thick juicy strokes. On the other hand, the edge of the knife can produce crisp irregular lines.

The paint will hold its impasto best if used straight from the tube, but you will find some paints are much oilier and less able to keep a true impasto. You can leave the paint to dry out a bit, or extract some of the oil by squeezing out the paint on to some blotting paper. Wait until it is the right consistency and then use it.

It is easy to get over-excited with knife painting and apply the paint too thickly. General areas should remain about 3 mm thick, with ridges and points about 5 mm. This will ensure that your masterpiece will dry – eventually. It may take a year before your knife painting is really dry and ready for varnishing.

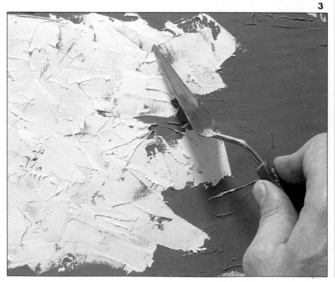

1 The different parts of the painting knife can be used to great effect. With the edge of the painting knife it is easy to make the imprint of crisp straight lines. Place the knife edge on the canvas, lifting off cleanly to leave the ridge of impasto paint.

2 By rotating the flat of the knife with the wrist, an arc of smooth paint is formed, edged with a ridge of paint which catches the light.

3 Here a 'scumble' of white paint is applied with a painting knife. Each application is applied at random encouraging the broken surface of the pigment so that the underlayer of blue shows through.

1 Glazing with a painting knife is possible too. Here a transparent layer of alizarin crimson is carefully scraped over a layer of cadmium orange.

2 The resulting area of colour smoulders with the underlying orange qualifying the deep red. The impasto ridges add to the liveliness of the paint surface produced by this technique.

3 Here the knife is used to stipple, using the very tip to dab on the paint. Scrape up sufficient paint on the underside of the knife, press down and lift off cleanly.

4 Smearing these dots with the flat of a clean knife produces an interesting blending of the colours.

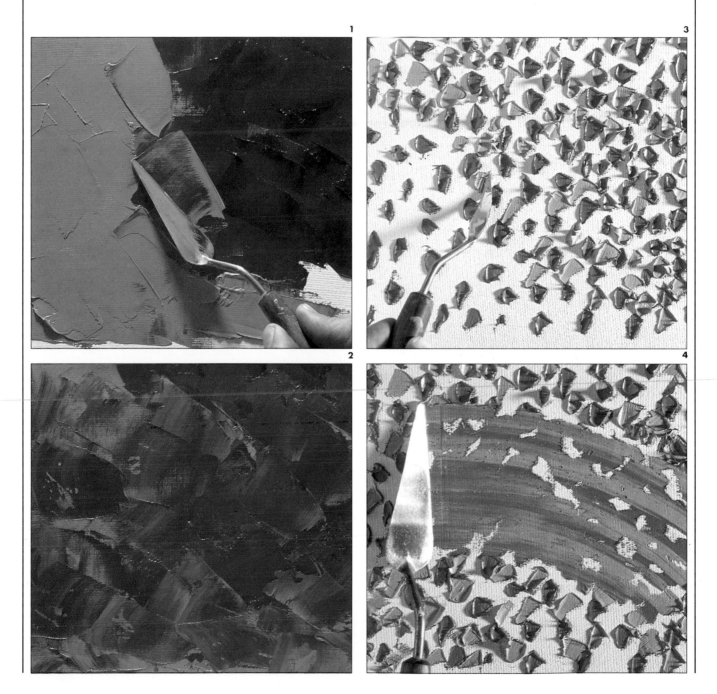

SGRAFFITO, SPATTERING AND TONKING

Spattering

Spattering is when a shower of tiny dots of paint is flicked from a brush to cover an area with a spray of minute droplets of paint. Spattering can produce the same effects as stippling, but the appearance is more mechanical and it should be used with care. The spots on the back of the trout on page 246 are perfectly captured with this technique.

You will find that the size of the spatter can be controlled by altering the distance between brush and support, and also by the choice of brush and the consistency of the paint. A toothbrush is a useful spattering tool. Hold the brush 3-6 in (7.5-10 cm) away from the surface, load the brush with paint and then pull the thumb across the bristles (see picture 1). If you want to spatter a specific area then mask it off with newspaper as shown on page 246. A decorator's brush loaded with dilute paint and simply flicked on to the surface will create a large sized spatter (see picture 2). Either pull the thumb across the bristles or bring down the handle of the brush on to your other hand so that the paint sprays forwards. You may find this easier if you place the painting horizontally on the floor and knock the spray of paint downwards.

1 For a fine spatter, the bristles of a toothbrush are pulled back with the thumb.

2 A decorator's brush, loaded with dilute paint, is brought down sharply onto the other hand so that droplets of paint fall on the surface of the painting.

3 To demonstrate sgraffito, the tip of the paint knife scratches into the paint surface to reveal the yellow underlayer.

4 For tonking, a sheet of newspaper is pressed over a still wet layer of paint.

5 Once the paint has been absorbed, gently lift off the paper to reveal an unusual textural effect.

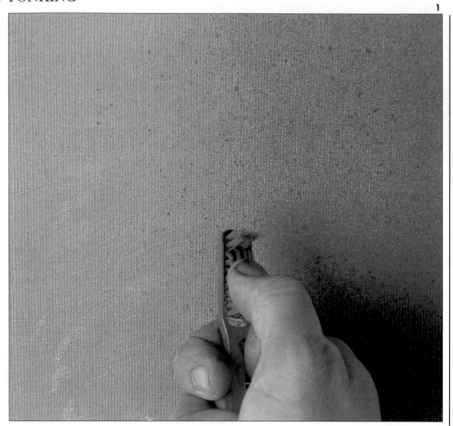

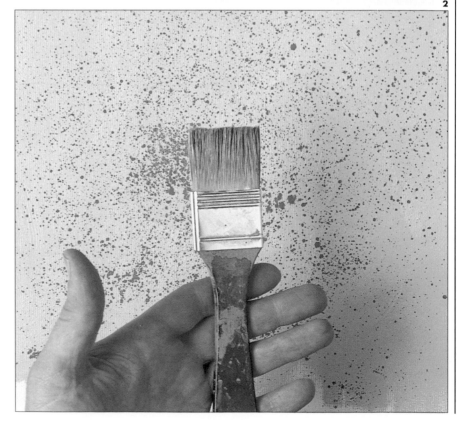

Sgraffito

Sgraffito is a method of creating linear marks on a canvas, by scratching through the top layers of paint to reveal the white priming or a stained underpainting beneath. It was a technique much popularized by the French artist Jean Dubuffet (born 1901) whose sgraffito was sometimes scratched into a dense covering of oil paint, sand and coal dust, exposing a crimson layer beneath.

Any sort of pointed instrument can be used to etch with, but the end of a brush handle or tip of a painting knife (see picture 3) does the job well. To obtain a textured effect, the top layer of paint needs to be thickly applied. Sgraffito is best performed when the paint is still fresh.

Tonking

Tonking is a process named after the artist and teacher Sir Henry Tonks whereby an area of dense paint is sopped up and partially removed by a sheet of absorbent paper. This technique can be used to produce an interesting textural effect, or, if carefully performed on an overworked area of paint (maybe more than once), it will remove the top layers of paint.

Place a sheet of newspaper over the wet paint, gently flattening it with the palm of the hand (see picture 4). Allow the paint to be absorbed and then carefully lift the paper away (see picture 5).

3

4

5

Melon and Pomegranates

TEXTURE

Having discussed the glories of knife painting earlier, we now have a chance to see the knife, or rather knives, in action. The artist has chosen a still-life arrangement where the texture of the paint can best be used to express the texture of the subject: the seeded centres of these fruit are most aptly translated into similarly juicy paint.

At first you may find the painting knife rather clumsy and restricting after the sensitivity of the brush. This style of painting requires absolute assurance on the part of the artist and you have to know where to place your colours otherwise the result will be messy. Consequently, knife painting is a good exercise in forethought and control.

If you are not used to knife painting, choose a very simple subject to start with, but make sure it is suitably textured and the colours are clear. (The melon was chosen just for these reasons.) It may help then to complete a studied drawing of the subject as by drawing it you will get to know every detail. The drawing will also help you to distil the image in your mind as the nature of the knife does not allow for delicate detailing.

But, even so, you will find that a wide range of effects can be achieved with the different knives. In this painting you can see in the richly textured seeds of the fruit the full glory of glistening impasto; yet, in contrast, the leathery pomegranate skin grows out of several superimposed glaze-like layers of paint, smeared on with the knife. As in all painting, the thickest layers of paint should be reserved for objects in the foreground. It can be seen that, on the melon, the artist tapers off the paint layer towards the back, eventually leaving the stained canvas exposed.

1 To show off the full capabilities of knife painting, the artist chose this melon and the two pomegranates, knowing their centres would reveal these glistening textured seeds. To keep these fresh looking during the painting session, they were occasionally sprayed with water.

Materials: Self-stretched, 10 oz. (285g) cotton duck canvas 20 in × 15 in (50 cm × 35 cm) prepared with acrylic primer; 1 in (2.5 cm) soft bristle brush; No. 13 (small), No. 18 (large) trowel shaped painting knives; graphite pencil; turpentine; cloth.

2 For his composition, the artist takes a high viewpoint and breaks up the regularity of the shapes by cutting the melon with the frame. First, the rough shapes of the fruit are loosely blocked in with dilute turpsy paint. It is so dilute it runs down the canvas, but this happy accident is encouraged. These delicate stainings, in the course of the painting, are allowed to show through the thick impasto paint, forming an important part of the composition.

3 While this staining layer of turpsy paint is allowed to dry (it is very dilute so will not take long), the next layer of thick paint is mixed on the palette. The paint is used straight from the tube and mixed with the underside of the knife, scraping it up and pressing it down repeatedly to get an even mix. However, you will notice that the paint is left only loosely mixed on most occasions so that the individual colours are clearly visible when applied.

4 The first exercise with the smallest painting knife is to plot the outline of the melon skin with successive applications of paint made with the edge of the knife. This line, as you will see in the final picture, forms the pale green layer of flesh between the skin and the ripe yellow flesh. To guide the artist with this line, the rough outlines of the still life have been pencilled in over the dried paint with a graphite stick.

5 Now to tackle the deeply ridge skin of the melon. A generous helping of sap green paint is taken up with the underside of the knife and smeared on, lifting the edge up to create a ridge. On top of that yellow ochre is applied in the same way, lifting up to form ridges and scraping off to reveal the darker green and form the indentations. If it does not look quite right, scrape off the paint with the underside of the knife and reapply it.

6 The light cast on this impasto glistens to form highlights on the ridges and cast shadows in the grooves, describing well the texture of the skin. But already the thickly applied paint is beginning to bring some order to the composition.

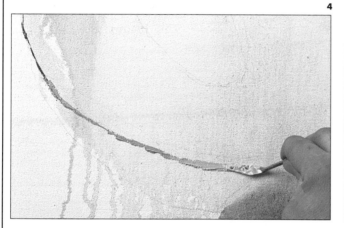

4

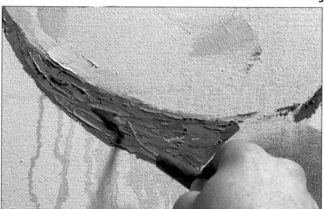

5

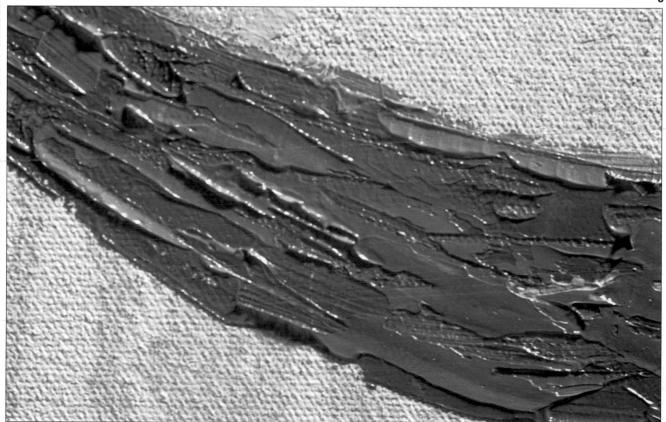

6

TEXTURE/MELON AND POMEGRANATES

7 The golden yellow flesh of the melon has been applied with the flat belly of the knife, mixing the paints on the canvas – cadmium yellow, yellow ochre and white with a little of the green mixture. Towards the back of the receding face of the melon the paint gradually gets thinner until the stained canvas is left exposed. Now to work on the contrasting texture of the seed cavity. Here the paint is applied with short sharp jabs with the end of the knife. Lifting the knife up vertically from the dab of thick paint leaves a ridge each side. Having laid down the ochre pips, the greenish shadows of the cavities are added.

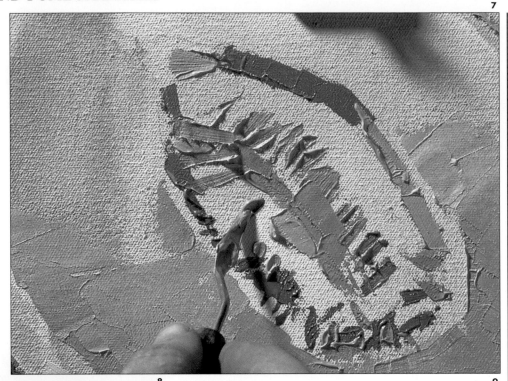

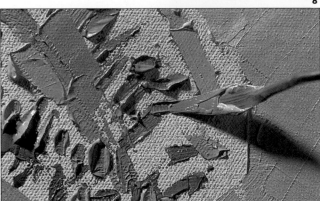

8 Building up the centre of the melon, the knife is being used to form long rich strokes of paint. Note how in this area there is a stimulating contrast between the luscious paint and the starved canvas.

9 The melon is finished. You will notice that the artist has added a lighter layer of yellow to the flesh area, working it carefully into the area of bare canvas beyond so that the eye leads gently from one to the other. The depth of the cavity itself is indicated by the row of parallel strokes from the flesh down, smearing the ends of the seeds on the far side. Stepping back, the artist appraises the situation, makes a few alterations and then proceeds with the pomegranates.

10 The juicy interior of the pomegranate is built up in the same way as the melon. The rich reds and purples are made up from different combinations of alizarin crimson, cadmium yellow and titanium white, with Payne's grey to make the deep rich burgundy. The surface is made up from small dabs and smears with the small No. 13 knife.

11 Close to, the rich confluence of paint is remarkable. Here the crimson is smeared in small dabs into the dark paint below so that they qualify each other. Note how the paint is worked into the dark seed cavities, enforcing the sense of three-dimensionality but still small patches of the stained canvas show through.

12 The gleaming leathery appearance of the whole pomegranate is captured in remarkably few strokes, glazed over the stained canvas. Using the same combination of colours as the halved fruit (but with more yellow and no white) the knife is emptied of paint on the palette and then swept across the skin area. The highlights are left as mistily scumbled patches of stained canvas. A dab of the redder colour on the skin of the halved pomegranate links the two fruit.

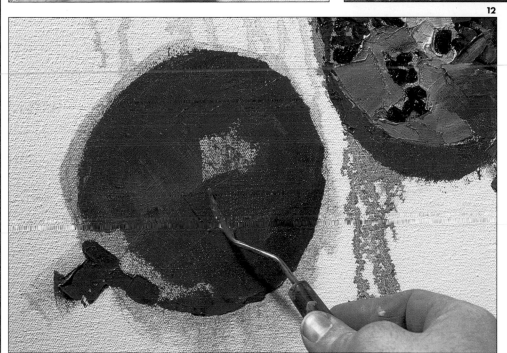

13 Now only the background needs attention to complete the painting. You will observe how the patches of stained canvas act as a unifying force between these three fruit and particularly between the two quite different faces of the pomegranate.

14 Finally, the wooden board under the fruit is filled in with a mixture of raw umber, alizarin crimson and Payne's grey. For this task a larger painting knife of the same shape is used. Here the knife is shown cutting round the pomegranate and smearing the paint outwards.

15 The job is almost finished. The paint has been applied not too thickly and in random directions. Variations are not discouraged otherwise it would be too flat and uninteresting. Most important is the thin irregular line of stained canvas left around the fruit on their lighter sides. This separates the fruit from their background and allows them to burst out in full relief.

13

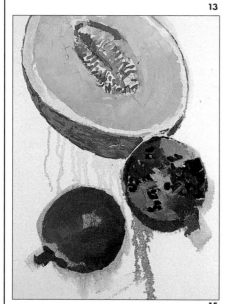

14

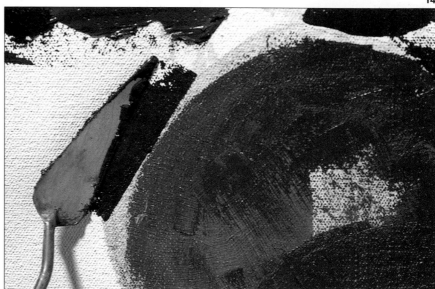

15

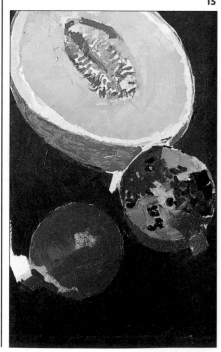

16

16 An exaggerated suggestion of the wood graining is achieved by etching into the background paint with the tip of the knife. This act of bravado neatly separates the background from the foreground, adding a linear dimension to the painting and reinforcing the three-dimensional shapes of the fruit. To this end as well, darker brown shadows have been added round the bases of the fruit. These are plausible but not as they appear in reality.

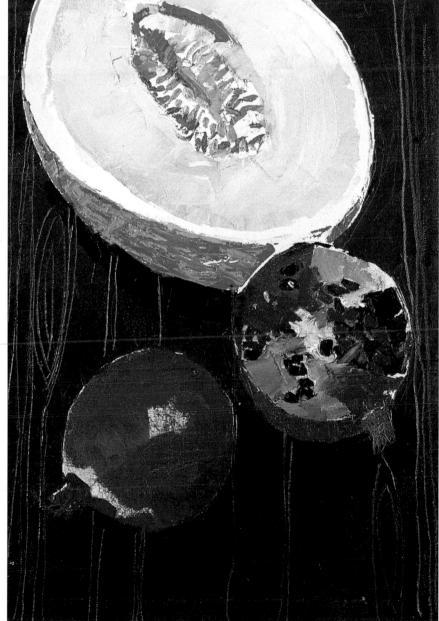

17 The tousled ends of the pomegranate halves get the sgraffito treatment too. By scratching into the paint here, the artist creates the precise texture required.

18 The canvas is now filled with luxuriant paint, creating a strong, vibrant image. The artist kept his colours fresh by minimal mixing and by simplifying the range of tones and colours.

The successful sgraffito adds a linear quality to the composition, enforcing the flatness of board and therefore throwing up the fruit in full relief.

17

18

Payne's grey

Titanium white

Lemon yellow

Sap green

Cadmium yellow

Yellow ochre *Raw umber*

Alizarin crimson

243

Fish

TEXTURE

Fish are wonderful to paint. Their silver scales reflect the light, producing unexpected flashes of colour. And if such understated hues do not excite you, then their powerful streamlined shapes and markings are liable to bring out the latent designer instincts in any artist. But apart from these artistic commendations, these four different types of fish from a market stall gave the artist the chance to put into practice some of the techniques demonstrated in the previous pages.

Perhaps at first glance these slippery shiny fish do not suggest the need for a textured paint surface. Indeed, most of the techniques are used to build up colour and a sense of the third dimension. Even so, the artist relies to a great extent on an inspired outline and very thin layers of paint. But, although the fish appear real enough by the time he has finished working on them, it is only when the background is added with the coarse areas of sand-laden paint that the smooth texture of the fish is brought into focus. This simple device establishes the contrast between the two surface textures, emphasizing the slippery nature of the fish.

In the early stages of the painting, the artist very much feels his way, laying down thin, but bold, areas of paint in an almost arbitrary fashion. A colour is located and exaggerated. Then this colour is applied across the surface, finding different points where this hue appears. Finally, it is a case of checking to see what works and reworking those areas that do not.

The background marble slab is altogether an important part of the composition. The artist uses the real thing purely as a starting point for an idea and produces his own pattern of striations. These flowing streaks of grey not only add a sense of movement to the painting but they also make a clear reference to flowing water. The fish – even though they are incompatibly from fresh and sea water – almost appear to be swimming together in and out of the current. Encouraging the ambiguity, their shadows cast on the marble surface are easily confused with the marble streaks and so the fish are left literally floating.

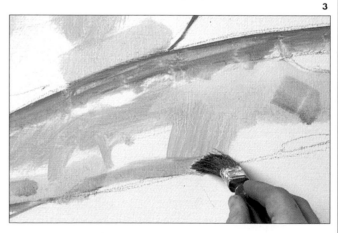

1 The artist took a while to arrange the fish so that they were pleasing to the eye. In the final solution the strong diagonals break up the landscape shape of the support and, by facing the fish in opposite directions, the focus of attention is kept in the centre of the picture space.

Materials: Flax canvas 30 in. × 40 in (75 cm x 100 cm); brushes – 2 in (50 mm), 1 in (25 mm), ½ in (12 mm) decorator's, Nos. 3 and 8 round, No. 8 filbert, No. 6 flat; graphite stick; small trowel-shaped painting knife; filling knife; newspaper; masking tape; white formica-veneered board; white spirit; cloth.

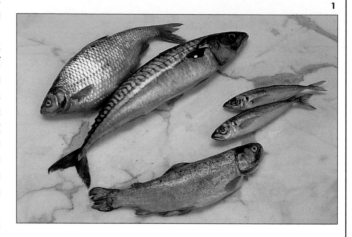

2 With a graphite pencil, the artist has briefly drawn in the outline of the fish. Then, with strong fluid strokes from a No. 8 filbert bristle brush, these pencil outlines are reinforced with paint, mapping out areas of strong colour where possible. The artist has chosen to represent these fish on a very large scale, allowing room for expression.

3 Now, with a ½ in (12 mm) decorator's brush, patches of very dilute colour are built up to give an idea of the form. These areas of approximate colour serve as a guide for the artist. Using this large brush will ensure that you keep the brushwork bold and loose. This is a time to try out ideas, standing back every now and then to assess the impact and then reworking any area that looks unhappy.

244

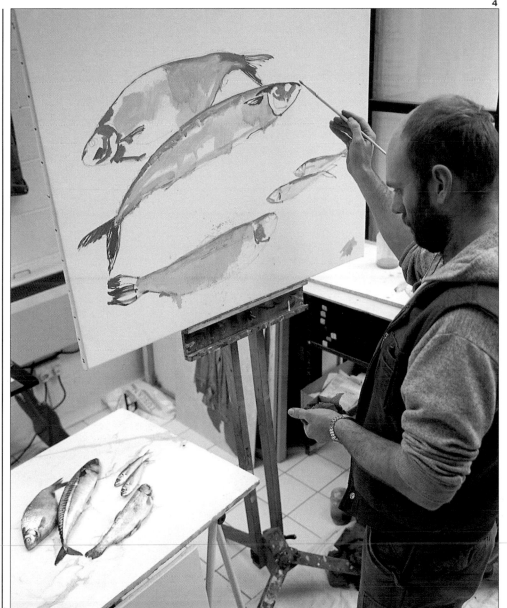

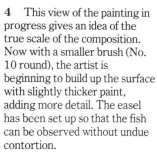

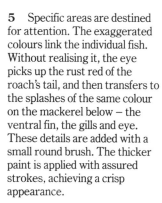

4 This view of the painting in progress gives an idea of the true scale of the composition. Now with a smaller brush (No. 10 round), the artist is beginning to build up the surface with slightly thicker paint, adding more detail. The easel has been set up so that the fish can be observed without undue contortion.

5 Specific areas are destined for attention. The exaggerated colours link the individual fish. Without realising it, the eye picks up the rust red of the roach's tail, and then transfers to the splashes of the same colour on the mackerel below – the ventral fin, the gills and eye. These details are added with a small round brush. The thicker paint is applied with assured strokes, achieving a crisp appearance.

6 Standing back, we can look at the state of the fish objectively. The mackerel's striped markings have been worked wet in wet so that the black paint merges into the coloured underpaint. Notice how the paint wanders outside the outline at times, and the trout has been treated to a desultory flick with the paintbrush. This is all part of keeping the approach loose and almost arbitrary.

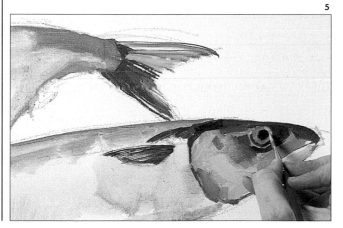

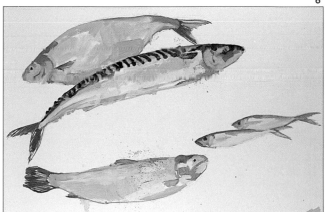

TEXTURE/FISH

7 Turning to the trout, the artist decides to spatter on the spotted markings. To confine the area of spatter to the back of the trout, a mask of torn newspaper is prepared. This is affixed with masking tape which can be stuck down on to the bare canvas without causing any damage.

8 First, with a small 1 in (25 mm) decorator's brush, the area is spattered with dark green paint. Now with a larger 2 in (50 mm) brush pink spots are superimposed. The brush is charged with dryish paint and held 3 in (75 mm) from the canvas. Here the artist is pulling back the bristles to release the spray of droplets.

9 By removing the mask, the characteristic spotted back of the trout appears as if by magic. The odd spot has escaped the mask but such accidents can be taken off with the finger or left as they are.

10 The strip of spots along the trout's back is too clearly defined so a few more arbitrary flicks with the brush charged with very dilute paint soften the gradation.

11 The spatter has successfully captured the colouring and texture of the trout. Note, too, how the artist has taken the brush laden with the pink spatter mixture (white, alizarin crimson, cadmium yellow, deadened with a little of the green mix) up to the underbelly of the roach.

12 Now, with a graphite stick, the artist livens up the surface of the fish, suggesting scales and surface texture. This assured parallel hatching along the belly of the small fish is etched into the still-wet paint with a smaller HB graphite stick.

10

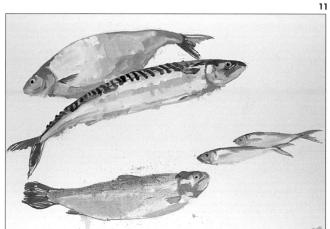

11

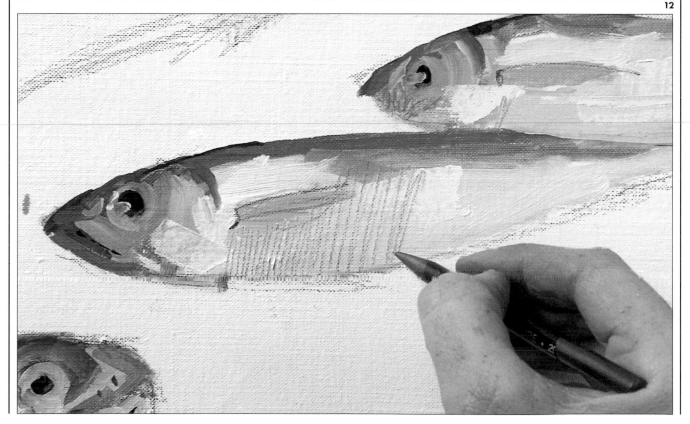

12

TEXTURE/FISH

13 The large scales of the roach are suggested with the graphite stick as well. Where the paint is thicker, this creates little ridges of paint which catch the light, capturing the silvery reflections of the scales. The flat underpaint of the fin has been built on to with a final layer of delicately traced lines of thick, almost pure, cadmium orange.

14 Now attention is turned to the background. To start with, a graphite stick, gently sandpapered to form a faceted stem, maps out the striations of the marble. The stem of the stick is pulled along the canvas, adjusting the angle to alter the width of the stroke.

15 White paint has been worked over the background with a large 2 in (50 mm) decorator's brush, working round the striations which have been built up with paint. Now the artist is blending the paint and graphite with his fingers, forming a blurred streak. To effect the subtle variations in the marble, some areas of graphite are left untouched.

17 This textured paint is applied to the surface with a decorator's knife, smearing it along the white areas of the marble, close to the fish. The sand particles in the pigment reflect the light, exaggerating the contrast in texture between the fish and background.

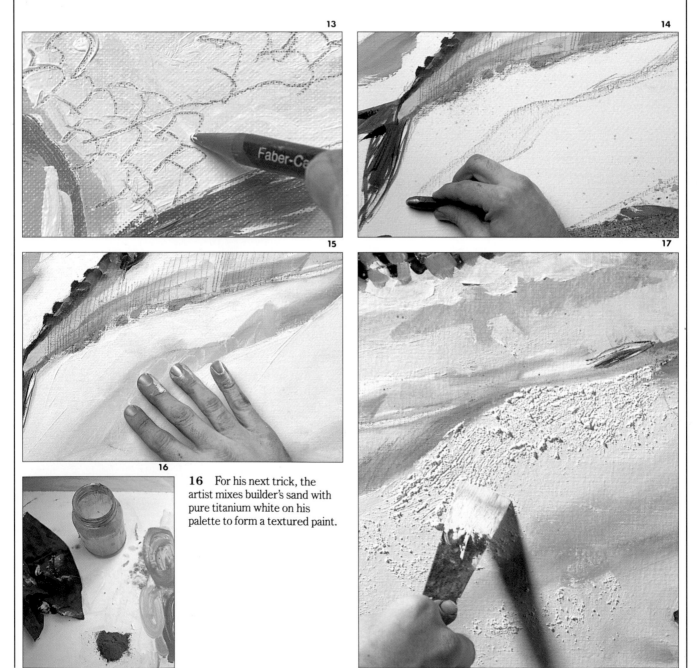

16 For his next trick, the artist mixes builder's sand with pure titanium white on his palette to form a textured paint.

18 The final touches are added. With a small No. 18 painting knife, the texture is again worked up on the mackerel. The finely hatched lines make an area of dull paint more lively.

19 In the finished painting, you can now see how the artist has encouraged the ambiguity of the background. From a distance the fish appear to be lying on a marble slab. Closer to, the textured highlights and lively striations of grey conspire to make this into flowing water. The fish appear to be passing in the current. In addition, the background introduces an important sense of movement into the painting – always a problem with 'still' lifes. The use of the textural techniques on the fish play an important part in keeping the paint lively and in capturing the intangible reflective nature of the scales.

18

19

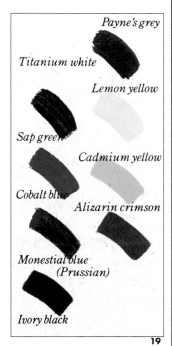

Titanium white

Payne's grey

Lemon yellow

Sap green

Cadmium yellow

Cobalt blue

Alizarin crimson

Monestial blue (Prussian)

Ivory black

Chapter 8
Creating Depth

In Chapter 7 we studied opportunities where it was appropriate to daub the canvas with an abundance of juicy paint to produce texture. Now we will look at more delicate techniques involving very thin layers of paint. Staining and glazing are two allied methods of painting which, if mastered, will expand greatly any painter's potential.

One of the problems a painter faces is mixing an equivalent colour to one he sees or, for that matter, one he holds in his memory or imagination. To a great extent, this is because colours are rarely flat and constant because light which creates them is likewise inconstant. In fact, artists recognize that some colours are impossible to reproduce by mixing on the palette. This applies to some shades of violet blue, particularly sought after by flower painters. Nevertheless, closer approximations to colours experienced by the eye can be mixed by superimposing transparent glazes of thin paint, wet on dry, so that the colours are mixed optically, like successive layers of coloured acetate or seeing a colour through a camera filter. By producing colours in this way,

a quality of hue is achieved, which cannot be contrived in other ways.

Oil paints have always been considered highly suitable for glazing. The suspension of the pigment in an oil binder enables the artist to create colours of great purity and depth. But glazing has an infinite number of other uses in painting apart from colour creation – for modelling, building up areas of shadow and representing water, to name a few. In addition, artists from classical antiquity to modern times have used a thin glaze of paint to stain the white ground of their prepared surface, sometimes for technical reasons, or now, more commonly, to set the mid-tone of the painting or to influence the colour range towards warm or cool colours. For many this overcomes the clinical whiteness of a prepared canvas.

In this chapter, apart from demonstrating the more traditional uses of staining and glazing, a method of painting with a cloth will be shown, using the staining technique – all of which goes to prove that it takes more than the lack of a brush to stop a keen artist.

Staining and Glazing

STAINING

Paint, diluted with turpentine, can be used to stain the canvas with a wash of colour. With oil paint, the canvas itself must be primed to protect it from the harmful oils, so the pigment is applied on to the ground formed by the priming layers. Such a staining layer can be applied with a brush or rubbed into the weave of the primed canvas with a cloth, as demonstrated here.

Such a toned ground or *imprimatura* makes it easier to assess the tonal values of the superimposed layers of paint. A suitable mid-tone colour is chosen for the subject in mind and the primed canvas is systematically covered with the dilute paint applied in a thin glaze of transparent pigment. It is usual to use the earth colours, ranging from warm raw sienna, to yellow ochre or burnt umber, which will dry quickly in such a dilute form. Or the paint can be applied in an opaque layer as part of the priming process. It can also act as a unifying layer of colour which is allowed to shine through the successive layers of broken paint laid on top, influencing the colours used towards a warm or cool range.

In the following projects, you will see the artist create images using a staining technique, applying the dilute pigment with a cloth and lifting off the paint for highlights.

Staining

1 The canvas can be stained with oil paint to resemble a graduated wash. Each band of dilute paint is applied with the cloth, it is spread across the canvas, working it up into the preceding application.

2 To stain the canvas, the artist mixes raw umber with plenty of turps to a thin, even consistency. If a large area is to be covered you will need to do this in a shallow dish. The artist works the stain into the weave of the primed canvas with an all-purpose cloth, in a circular motion. The staining layer of paint is kept even but cloth marks are permitted.

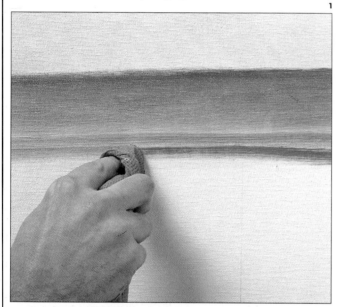

GLAZING

A glaze is a dilute film of transparent paint, laid over a dry underlayer. Applying the paint in this way allows the superimposed layer to qualify that beneath, so creating unequalled depths of colour. It gives the same effect as combining sheets of coloured clear film and requires a knowledge of how colours react with each other. Experiments will undoubtedly lead to surprises. A thin glaze of jewel-like viridian, for example over cadmium red will produce dark brown of great depth. The precise colour will be conditioned by the strength of the glaze.

Glazing can be used to build up rich, luminous areas of colour especially where shadows and reflections occur, as on a stretch of water. But a glaze is also used to enliven flat colour or it can be used to knock back an area which is tonally inconsistent.

Glazes are usually applied with a soft hair brush which will leave no brushmark and hold the liquid well. Oil is added to the paint to give the glaze a gloss characteristic of the medium which too much turpentine will destroy. On the other hand, excess oil will make the glaze move around on the canvas. To start with, it may be helpful to try a proprietary glaze medium which will dilute the paint to the right consistency and make it manageable.

Glazing

1 First, a layer of cadmium red is applied to the canvas and left to dry. A thin glaze is mixed by adding an alkyd resin-based oil medium to a little cadmium yellow. This medium thins the paint and yet leaves it manageable. Applying the paint with a soft bristle decorator's brush covers the area quickly. The paint is applied lightly and not worked in any way.

2 The result is a burning translucent orange which is a long way from the flat opaque orange that cadmium red and yellow would mix on the palette. The slightly uneven application of the glaze adds to the power of this colour.

3 Now, using the same two colours, the system is reversed. It is more usual to apply dark over light but the results here show it is by no means essential.

The underlying layer of paint this time is applied with a painting knife, leaving impasto ridges. This will take a while to dry and even then care must be taken in applying the glaze. Keep the brush dry so that the paint underneath does not lift off, and apply the glaze one stroke at a time without reworking it.

4 The angled dabs of glaze add to the resulting frenzy. This area of orange appears to move. Compared with stage 2, it has a bolder, less misty finish, but the hue is similar.

New York
CREATING DEPTH

Sometimes an artist has a idea for a painting and then has to seek out sources for the various elements of the composition. Painting can sometimes involve complicated research, but in this instance the artist quickly found a suitable window to paint in a magazine and used a photograph from his album for the New York skyline. He then combined these various elements in a sketch to make sure his idea worked. Even so, it is a painting which develops as it goes along, as they so often do. It is only when the chair is added to the foreground that sense is made of the interior space.

The artist first stains the canvas with a glowing pink which encourages the warm tones of the painting. The colours chosen for this will take a while to dry in oil paint even though applied thinly. To save time, the artist could have chosen to execute this staining under layer with acrylic paint. The effect would have been the same and such a thin layer of acrylic would take no time to dry. This staining layer is covered and lost under the red walls but it very much comes through in the central panel.

Trouble is taken in building up the colour of the walls. Several layers of paint will always produce a richer deeper hue than a single thick layer; especially if, as in this case, the underlayers can shine through successive thin glazes of transparent colour. So in the course of the painting, the artist applies four separate glazes of colour to the wall area to achieve a rich glowing red.

There is a certain ambiguity in the lighting for this painting. The artist wanted the shadow on the walls to add interest to the otherwise flat wall space. These shadows also tease the mind into wondering about the layout of the rest of the room. What casts that angled shadow? This strong interior light is countered by the light outside the window produced by the illuminations of New York.

1 A number of sources were cobbled together for this painting of an interior with a view of the New York skyline. The window was taken from a magazine photograph and the skyline from the artist's photograph album. The chair was conveniently in the artist's studio. To try out the idea, the artist makes a pen and wash sketch, searching out the tonal balance of the composition. He crops back on his sketch aware that the window, if not given prominence, may appear to be a painting on the wall.

Materials: Small canvas 24 in × 18 in (60 cm × 45 cm); brushes – Nos. 5, 9 and 14 flat, No. 3 and 6 round; graphite pencil; tin foil palette; turpentine; cloth.

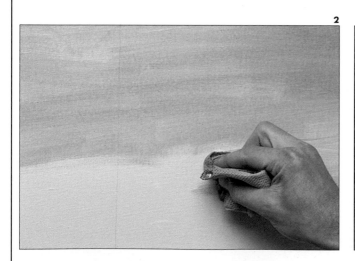

2 First the canvas is stained with a dilute mixture of cadmium red and titanium white. Mix enough to cover the whole canvas, rubbing it well into the weave of the canvas with a cloth. Use a dry part of the cloth to spread it out; it does not need to be a constant colour. This staining needs to dry before the application of more paint.

3 The window shape has been measured up and drawn in with a pencil. Now a dilute layer of cadmium red with a touch of white is brushed on round the 'window' with a large No. 14 flat brush. The paint is applied with jabbing strokes, encouraging the irregularity. Do not worry if the paint is not tidy round the edges of the opening; this can be put right later.

4 Working from the bottom of the window, the artist now adds the darker line of the foreground sketch of water (the lake in Central Park). The same tabbing technique is employed to break the paint and create an impression of ripples in the water.

5 Now to build up the scene viewed through the window of Central Park and the New York skyline. Starting with the sky, a mixture of white, ultramarine and Payne's grey is applied with the same flat brush. Scumble this paint over the pink staining, rhythmically impressing the flat of the bristles into the paint to break the surface. Add more white nearer to the horizon, working it into the darker paint above.

7 The first stage of painting is completed. Additional work has been done to the view where the reflections of the buildings in the lake have been added. The pink of the underpainting shines through the broken paint, giving the painting great luminosity. At this stage the painting must be left to dry again.

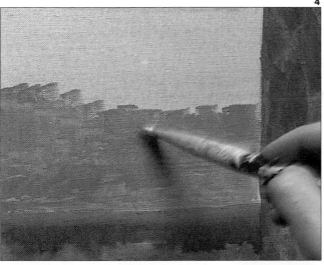

4

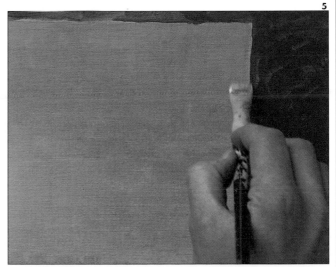

5

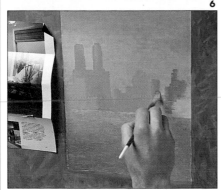

6

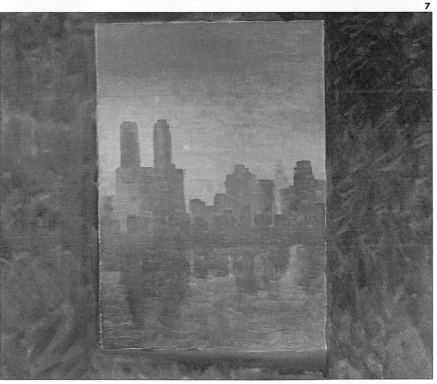

7

6 The flat brush suits the subject matter, providing almost instant buildings. Once again, the artist affixes the reference material – the page from a magazine – to the painting with masking tape. The source photograph is only a starting point: the artist develops the idea as he proceeds.

CREATING DEPTH/NEW YORK

8 Now, over the top of the red walls, another layer of purer cadmium red is brushed on. Superimposing layers of pigment like this helps to build up a rich depth of colour. Again the surface is worked up with a No. 9 flat brush whose tough bristles leave a good mark. The window recess has been painted in with a mixture of cadmium red, white and chrome yellow.

9 The recess on the other side is painted in a lighter hue where the light falls. The flat brush is suited for this narrow strip. Here, you can marvel at the full force and depth of the build up of superimposed layers of red paint.

10 A rolled blind is added to the top of the window in various shades of raw umber, yellow ochre and white, again using the width of the brush to make the marks. Once more, the canvas is given time to dry.

11 Over the top of the red walls, the artist lays a dark glaze of transparent paint (burnt umber and alizarin crimson). This rich glaze is worked over the red and then smoothed out with gentle strokes, retaining a slight irregularity. To tidy up the edges of the window, masking tape is gently affixed beforehand.

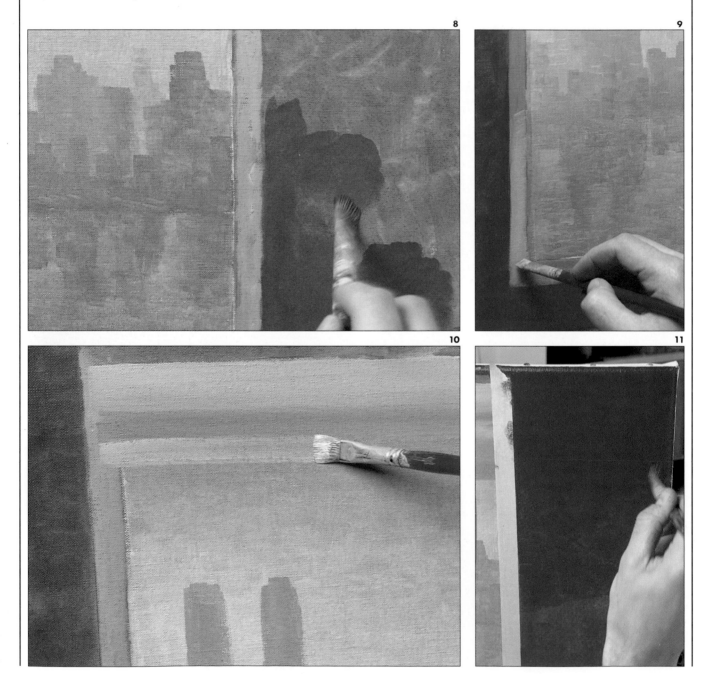

12 Now the New York skyline is given some sparkle with highlights dabbed on to the buildings with a small brush.

13 The layout of the painting is established more precisely by the addition of the corner of the chair in the foreground. This has the effect of pushing back the wall and window. Immediately, we can see that we are in a room, looking out through a window at the New York skyline. Before, there was ambiguity. The basic shape of the chair is mapped out with this dark brown (burnt umber, ultramarine, Payne's grey and white) and the same mixture is used for the shadow and (lightened) for the sill behind.

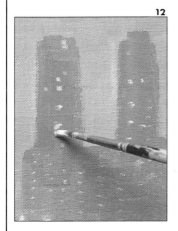

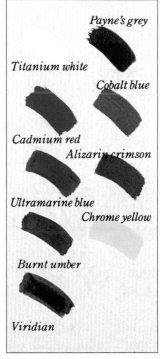

Payne's grey

Titanium white

Cobalt blue

Cadmium red

Alizarin crimson

Ultramarine blue

Chrome yellow

Burnt umber

Viridian

14 For the final picture, the artist has spent time tidying up the painting. The inner edge of the window is cleaned up with a strip of blue green – the wall viewed outside – and the blind with almost the same coloured edging. The recess shadow is added on the left and highlights and shadows to the blind. Finally, the chair is worked up to a finished state. The result is a stimulating painting which initially grabs the attention through its vibrant colouring. Still, at this stage, the original staining of the canvas shines through in the central panel.

Trompe-l'oeil
CREATING DEPTH

Trompe-l'oeil is the art of visual deception where the painted object is mistaken for reality, and this is what the artist is setting out to do here. The subject of the painting is an idyllic beach scene with the sun beating down on a row of parasols. But this fantasy scene has been painted so it appears to be on a piece of unfolded paper which has been taped on to the bare canvas. It is a pastiche, a picture of a picture, expressing the artist's wish to visit such a wonderful place in the knowledge that this is just a fantasy he keeps folded up in his mind. The artist is also making a tongue-in-cheek reference to the 'too good to be true' photographs found in travel agents' brochures.

For the beach scene, the artist chooses to stain the canvas with a cloth and dilute paint, keeping the surface flat as it represents a two-dimensional piece of paper. This inner rectangle must be masked off carefully and, indeed, if you follow the steps of this painting, your masking technique is bound to improve. With the beach scene finished, the shadows caused by the folds are added with a brush with close reference to a piece of folded paper pinned on to the easel. The result is an uncanny confusion between the space created in the beach scene and the folding of the scene which forces you to view it as a two-dimensional piece of paper.

If the addition of the shadows seems too ambitious, treat the project as a simple beach scene. Alternatively, try your hand at *trompe-l'oeil* painting on a smaller scale – your signature on a piece of crumpled paper 'taped' to the bottom of a painting, for example.

1 The inspiration for this folded beach scene comes from the artist's imagination – it is where he would like to be. The sun-drenched shore is painted before the addition of the folded paper look.

Materials: Canvas board 30 in x 20 in (75 cm x 50 cm); brushes – Nos. 5 and 6 flat, No. 3 round; tin foil palette; white spirit; all-purpose cloth; masking tape ½ in (12 mm); piece of paper.

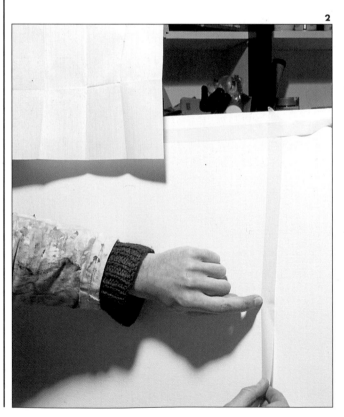

2 The first step is to measure up the canvas for the inner rectangle. Using a ruler, the artist has marked this on the canvas with a pencil. Now, a piece of paper is folded and taped to the top of the easel so that the artist can follow the outline shape with the masking tape. Here the angled edge running from the central fold is reproduced with the tape.

3 The tape has been stuck down as firmly as possible so that the paint does not seep underneath and a clean edge will eventually be unmasked. It will require a certain amount of pressure to flatten it down as the angles at which it has been laid down cause it to wrinkle.

4 Now using an all-purpose cloth wrapped round the index finger, the artist takes up a small amount of the dilute mix of paint from the foil dish and applies a thin staining wash of paint. A patch of colour is rubbed into the weave of the canvas in a circular motion and then, with a dry part of the cloth, spread out, finishing off with wide sweeping strokes from one side of the canvas to the other. The paint is applied in bands, becoming paler as the sky comes down to the horizon. Each band is carefully blended into the one above.

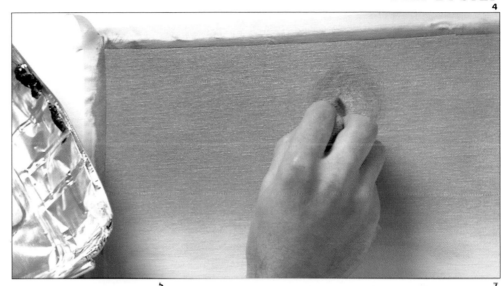

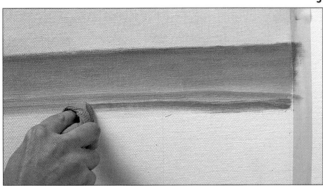

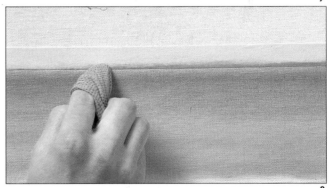

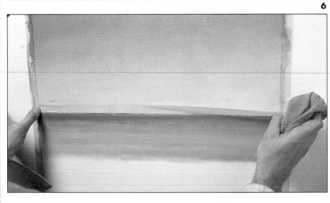

5 The same smooth staining method continues with the sea, starting with a strong dilution of ultramarine and cobalt and here with the addition of viridian which is blended into the blue on the canvas. The paint needs to be worked right up to and over the masking tape to achieve a stark edge.

6 The horizon was painted across free-hand with the cloth, but it is not straight. The artist decides to use masking tape to tidy it up. Because the tape will cover the newly stained canvas, it is stretched across with no pressure applied and anchored well at the sides.

7 Then, with the cloth, the paint is smoothed out over the tape. Keep the cloth dryish, as if you apply too much dilute paint, it will seep under the tape. On the other hand, the sea tends to get darker on the horizon line so you do not want to wipe the colour off.

8 Very gently, with a single movement, pull away the masking tape. Miraculously the line is clear and sharp and the thin layer of paint above the horizon has not been lifted off. A thicker layer of paint would need to be dry before it could be treated in this way.

CREATING DEPTH/TROMPE-L'OEIL

9 Finally, the horizon line is straight and clean. Now the artist continues with his graduated staining technique, filling in the beach area with very light washes of burnt umber and lemon yellow.

10 Next, with a clean part of the cloth, damp with spirit and tightly pulled over the finger, the nail is used to wipe off the paint, revealing the white canvas surface. In this way the artist 'draws' four sun umbrellas across the foreground of the painting.

11 Standing back, it is time to admire the deft clothwork (no brush has been used so far). The sky appears as an absolutely smooth graduated wash and the white ground shines through, producing a vibrant colour. As the wash comes into the foreground the colours are left more distinct, representing the patches of sand on the sea floor.

9

10

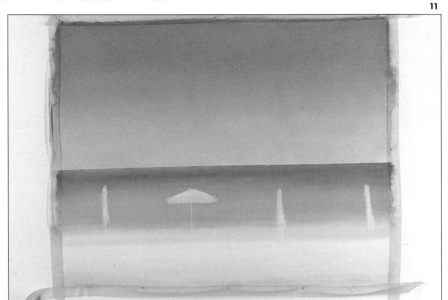

11

12 Now, taking up the brush, the shadows are added to the umbrellas and scrubbed on with a dry brush into the sand area. Note how the cloth has been used to lift off small patches of paint to represent waves.

13 The shadows on the parasols are further worked up with some white, burnt umber and ultramarine. A small round brush is used to draw in the umbrella stalks and wire supports with raw sienna added to the mixture. Nevertheless, the approach is kept deliberately loose and smudgy and the paint surface thin.

14 The fantasy beach scene is now finished. The artist has kept the paint surface flat as it is after all a painting of a painting. He is not striving for realism but for a rather tongue-in-cheek pastiche of the dream holiday location.

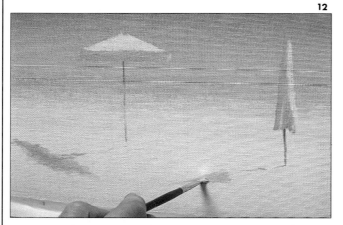
12

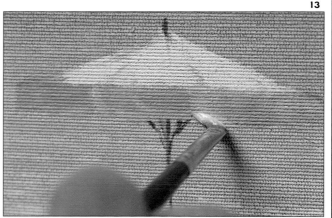
13

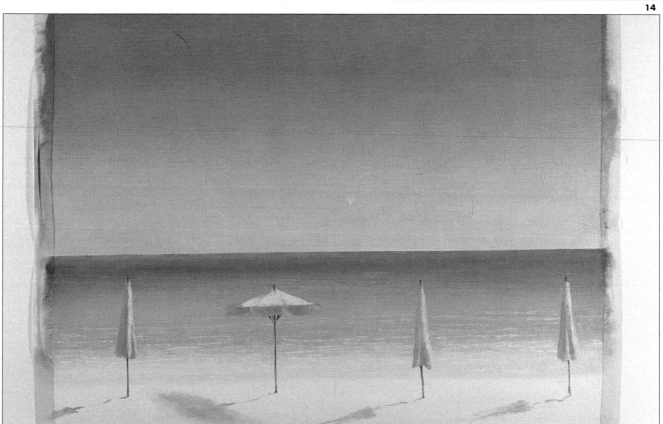
14

CREATING DEPTH/TROMPE-L'OEIL

15 Now to add the shadows of the folds to the painting which has been allowed to dry overnight. As before, the masking tape must be applied very lightly. The shadows are mixed as concentrated forms of the more dilute staining colours being covered. Take care – only a very little is used. The brush must be dry, so use one for each colour, stroking it on horizontally backwards and forwards very delicately, until the paint is well spread.

16 The tape is removed in the same careful manner as before. It can be clearly seen here that the shadow colour is regulated to the colour it covers. So the shadow turns from blue to green to yellow.

17 For the horizontal fold, the shadow and opposite highlight appears in sections alternately above and below the central crease. The artist has first wiped off the highlight with the cloth. Now, the shadows are added with the brush and masking tape, a section at a time, constantly referring to the folded sheet above.

18 Now the finishing touches are added, such as these small creases running from the points where the folds meet. The artist also darts from crease to crease building up colour here, taking it away with white spirit there. (The paint is only touch dry and so will still come away if encouraged.)

Before the finishing touches, all the masking tape is carefully removed.

15

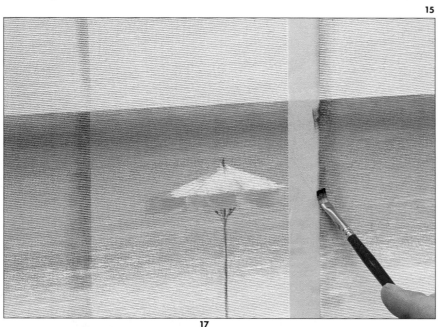

16

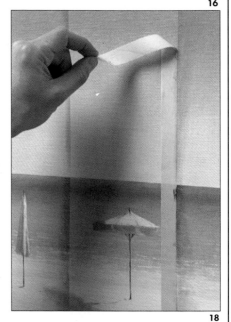

17

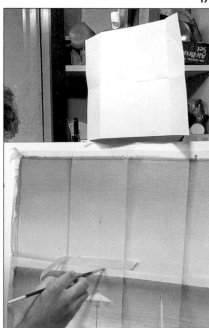

18

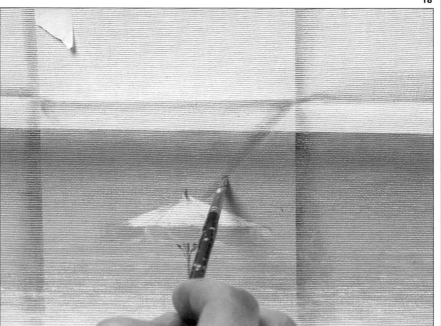

19 Now the shadows 'under' the 'painting' are added to make it appear proud of the canvas. The nearer the 'paper' is to the canvas, the deeper the shadow. These shadows are added with a No. 2 small round sable brush with shadows of Payne's grey and white. A little oil is added to the pigment to make it easier to apply to the rough canvas so that the canvas weave is filled with one coat. Even so the weave gives the shadow a perfect fuzzy edge.

20 The final witty touch: two pieces of clear sticking tape are painted so that the folded painting appears to be fixed to the canvas. This is a very dilute layer of white and raw umber with plenty of oil to give it a shine. Start above then work into the blue. A little Prussian blue is added for the shadows.

21 The idyllic but rather bland beach scene has been transformed into a witty piece of visual deception through the addition of the paper folds. The artist has succeeded in getting across his original idea – a dream location which is kept in a pocket of the mind and every now and then taken out and unfolded. The success of the painting lies in the careful application and removal of the masking tape and also on the attention paid to the reference piece of folded paper.

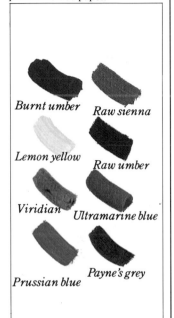

Burnt umber Raw sienna

Lemon yellow Raw umber

Viridian Ultramarine blue

Prussian blue Payne's grey

19

20

21

Horses Racing
CREATING DEPTH

OILS

Such a dramatic subject as horse racing requires all the ingenuity of the artist to achieve a successful result. But the artist here is not necessarily interested in the form or trappings of the horses: he is more attracted by the drama of the occasion and the race itself – it is the sensation of speed which is the central issue.

A painting is a still representation so depicting motion may seem like a contrary idea, but artists have developed many tricks to conjure up the feeling of speed. First, there is the representation of the cause of the movement – here the horses can be seen to be galloping. Second, you can show the effect of the movement on the form; for example, the horse's mane is seen flying in the wind. Third, as we have learnt from photography, a sensation of speed can be encouraged by blurring the image. To achieve this end, the artist chooses to carry out this project using the staining method introduced in the previous project – the blurred image and the loose approach it dictates both help promote the required sensation of speed.

Certainly, a finger covered with a cloth does not allow for much intricate detail and forces the artist to treat the subject broadly. The composition is first mapped out with mid-tone washes, then the form is built up with superimposed areas of

shadow and finally the paint is lifted off with a turps-soaked cloth to produce the highlights.

The artist has used the brightly coloured silks to great dramatic effect. The patches of red – even in a less saturated state in the crowd – lead the eye dancing across the composition. Indeed, it is only when the jockeys' caps and the horses' blinkers are added in primary reds and yellows that the eye is taken back into the picture space.

1 The source for this stained painting is a press photograph of a horse race which the artist pins to the top of his easel for easy reference. The paint in this picture is applied for the most part with an all-purpose kitchen cellular cloth, staining the prepared canvas rather than painting it.

Materials: Canvas 40 in × 30 in (100 cm × 75 cm); brush – No. 9 flat; all-purpose cloths; wooden palette; straight-edge or ruler; turpentine.

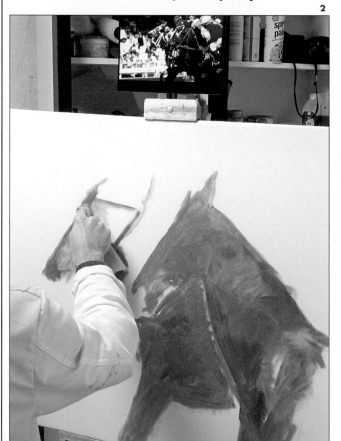

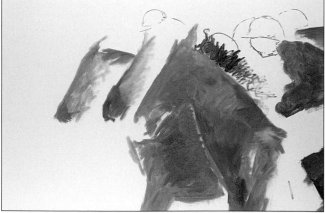

2 First, with this all-purpose cloth and a dilute mixture of burnt sienna, burnt umber, alizarin crimson and turps, the main outlines of the horses are blocked in boldly and quickly.

3 In a very few minutes, the foundations of the composition have been mapped out and already there is a sense of movement in the painting. The outline of the jockeys' heads and caps have been sketched in with a No. 9 flat brush, using up the paint on the horse's mane. Also, the cadmium red silks of the jockey have been blocked in. At this stage, such details of the composition are simply hinted at to get a feel for the structure of the painting.

4 Now the background colour – a rich mixture of ultramarine, alizarin crimson and burnt sienna – is rubbed on with a cloth. The paint is mixed with the cloth on the palette, applied undiluted and then spread out with some turps added to the cloth. This area of colour is built up with successive applications until the required depth of tone is achieved. Travelling down the canvas, the background colour is more dilute and some white is added.

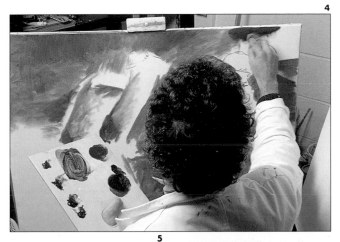

5 Still working on the background, the artist adds random dabs of burnt sienna, Prussian blue and ultramarine to represent the crowd in the stand. Then, with a clean part of the slightly turpsy cloth, the paint is lifted off to represent faces and highlights. The cloth has to be turned frequently, to present a clean side to the canvas.

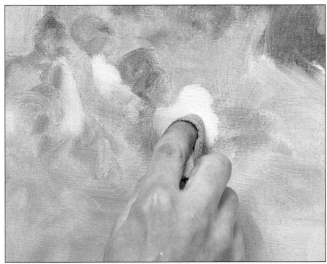

6 Continuing with the lifting-off process, the head of a grey horse is taken back, using the fingernail to get the straight line of the nose.

7 The background is filling out well. The track has been added with dilute ivory black and yellow ochre. In the foreground, the artist has added the viridian silks of the second jockey and, still using the cloth, very basic areas of shadow on the red jockey's cap and breeches.

CREATING DEPTH/HORSES RACING

8 Now attention is turned to the horses. A darker application of brown (burnt umber and alizarin crimson) is added over the mid-tone for the areas of shadow on the darker horses. The hood of the second horse is lifted off with a clean cloth. Attention is drawn to this area with the bold primary colours of the caps and the horse's blinkers.

9 Turning to the foreground jockey, the face is very broadly built up from the shadow brown mixture used for the horses, lifted off to arrive at the skin tone. With a variation of the same mixture, shadows are added to the red silks, and with the addition of Payne's grey, to the jodhpurs. Still the approach is kept very loose and blurred – the cloth allows little else. Ivory black added to the boot completes this stage.

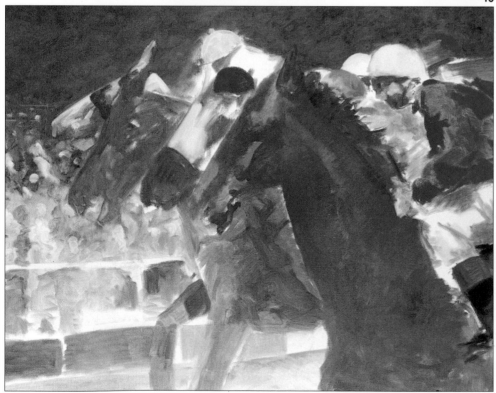

10 Standing back to appraise the situation, the forms are emerging nicely. Note how the addition of the primary-coloured caps and the far horse's blinkers takes the eye back into the picture space.

11 Now for more colour details. In the foreground, the alizarin crimson sheepskin noseband is applied, rubbing from side to side, to give a fuzzy appearance.

12 Stains of deep raw umber are loosely described to further model the form of the horse and as shadows, under the nose band, to the face and eye. The highlight on the under-rim of the eye is lifted off with the thumbnail. The darker shadows are carried across the painting, building up the three-dimensional form of the other horses as well.

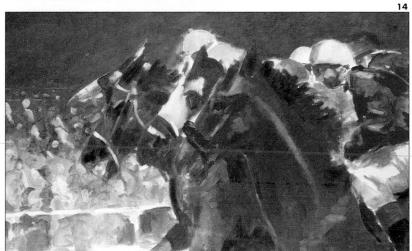

13 A few finishing touches to the foreground jockey round off the form. The shadows are softened a little with the cloth and white highlights dabbed on to the red silks.

14 Viewed from a distance, the bold approach offered with this staining technique achieves an uncanny sense of the three-dimensional. The gleaming highlight on the horses' neck has been taken off with a cloth dampened in turpentine.

CREATING DEPTH/HORSES RACING

15 Now for the bridles of the horses. For this more controlled work, the cloth is wrapped round the end of the paintbrush. Here the ring of the bit is encircled. Again the position must be changed on the cloth to get a clean mark.

16 Next the reins are picked out using the same method but with the flat of the fingernail. As the cloth picks up the paint, the mark gets less distinct, producing an ingeniously three-dimensional effect. A drier cloth is used for less distinct highlights. Note, too, the touches of ultramarine and burnt umber on the cheek-strap and reins.

17 With a few deft scrapes of the cloth, the boot is given a pleasing gleam and the saddle and stirrups defined. These well-placed highlights bring life and energy to this area of the painting. Yet, close to, the overall effect is still blurred and undefined.

18

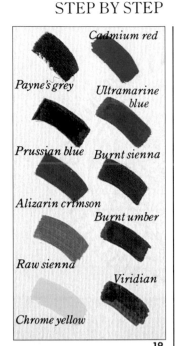

19 The final painting is full of tension and drama encouraged by the high contrast and bright colours. It also depicts a keen sense of movement, much aided by the blurred image produced by this staining technique. The paint surface is very thin and the application almost crude. But the picture relies for its success on the immediacy of the presentation – the lively surface and quick intuitive marks.

Cadmium red

Payne's grey

Ultramarine blue

Prussian blue

Burnt sienna

Alizarin crimson

Burnt umber

Raw sienna

Viridian

Chrome yellow

19

18 Final touches are added to the rails with a ruler and cloth-covered fingernail to get the straight line required.

Chapter 9
The Human Figure

To some, the painting of the human figure seems a daunting prospect. To be successful involves the mastery of so many aspects of art – drawing, knowledge of anatomy, modelling of the delicate gradations of the form, creating flesh tones and so on. But, like so much in art, if you approach the project with confidence and determination you are half-way there. A painting is rarely successful first time – or at least the artist will not think so. It is this self-criticism and dissatisfaction with your own work that will cause your painting to improve. And that is not to say that sometimes you will be pleased with your work – you will be, even if only part of it.

Nevertheless, to specialize in figure painting does require the careful study of anatomy. But there are artists who include figures in their paintings who are not necessarily figure painters.

In the three projects in this chapter, one includes figures seen at a distance as part of the composition. In the second, a nude, the human figure becomes the focus of the composition. The third is a portrait where the artist zooms in even closer and seeks to capture in paint the characteristics and character of a particular human being.

These are all different aspects of painting the human figure, requiring wide-ranging accomplishments. In addition, the artist approaches the painting of these figures in different ways, ranging from a broad approach, involving the simplific- ation of form, to the optical mixing of pure colour on the canvas to make the flesh tones 'sing'.

But where do you start? Study figures in photographs, magazines and draw them from life as much as possible. Then eventually the form will become second nature. When you start to paint, establish the masses first and then build up the colour. You will see how, in the painting of the nude, the artist feels for the form, constantly reassessing his progress and modifying the brushwork in the light of his objective appraisal.

That is the joy of oil paints; they can be reworked without degenerating into muddiness. Even so, be aware when it is time to stop. Nothing is more annoying than spoiling a good painting by overworking it. But, again, oil paint will allow you to stop, take some rest and regain objectivity. You can then start afresh the next day, or week, or month.

271

Alice in the Pool

THE HUMAN FIGURE

The systematic approach pursued in this painting requires a certain strength of mind on the part of the artist but it undeniably reduces the complications associated with figure painting and the modelling of skin tones.

Throughout the painting process, the artist resists the temptation to represent detail, keeping the approach broad and loose. This means that blocks of tone are carefully laid down with dilute paint, starting with the dark tones and working to light. Then these areas of tone are confirmed and reinforced with layers of thicker, less dilute paint. Even so, the paint layer is never very thick and, painting with a ¼ in (6 mm) brush, the artist maintains a loose approach throughout.

This simplification of the subject matter is similarly pursued in the artist's treatment of the water. For compositional reasons, the water above the adult figure is made uniformly darker and that below, lighter, dividing up the painting with another diagonal corresponding with the arms of the swimmers. A sense of movement is introduced by the fragmented view of the swimmers' bodies below water and their reflections in it. You will notice that the artist adds such reflections where he expects them rather than where he can necessarily see them in the transparency.

The artist's recipes for the skin tones are given where possible but, having mixed the first few tones, these are then modified from the other colours on the palette. So, the artist's brush hovers momentarily above the palette, diving to lift a tip of yellow here, blue there. Such facility with mixing colours can only grow with experience, but a positive approach will make sure there is a sense of spontaneity in your painting. After all, any divergences from your intended image can always be modified – by overpainting, adding a glaze or scumble. The choices are now limitless.

1 This photograph of a mother and daughter swimming together in a pool was chosen by the artist for its high contrast and bright colours, encouraging a loose approach. Do not be put off by the complications of the water. The broken reflections in the water add an interesting dimension which, when simplified, are a pleasure to paint.

Materials: Hardboard cut to 12 in × 14 in (30 cm × 35.5 cm), smooth side prepared with four coats of an acrylic gesso primer; white formica-veneered board palette supported on trestles; brush – ¼ in (6 mm) flat; turpentine; cloth; small viewfinder for transparency.

2 With a graphite pencil, the artist maps out the outlines of the figures and the areas of tone on the board. Then, with a dilute mixture of burnt sienna and Payne's grey, he blocks in the areas of dark skin tone (and the reflections in the water). The brushwork for this turpsy underpainting is quick and purposeful, picking out the disparate patches of dark tone. A ¼ in (6 mm) flat brush is used (as it is throughout) which would be considered large for this size of painting. But it will ensure a broad approach.

3 Round and into these dark tones, a pinker mid-tone is worked (cadmium red and cobalt blue with a touch of white added to the above mix). Now the yellow swimming suit is added, in two tones.

4 Next, the flesh tones are developed, introducing shadows and highlights in slightly thicker paint. The brush is loaded with Payne's grey and the 'swimming suit' yellow for the parts of the body seen through the water. A mixture of the tones already on the palette makes up the highlight colour too.

5 Here the immediacy of the strokes can be seen. The artist is placing his strokes at great speed, dabbing here and there with assurance. The red armbands are similarly expressed.

6 Standing back, the two figures are beginning to emerge as three-dimensional forms. The eye blends the loose brushwork and translates it into smooth gradations of tone.

7 Now the background colours are added. Above, a thin turpsy layer of cobalt and Payne's grey is worked round the ripples of the same, less dilute, mix. This collects in the grooves of the gesso and drips down the board, but it does not threaten the figures and is allowed to run its course. Below, a thicker layer of cobalt, lemon yellow and white, is deftly cut in round the swimming child. The paint is applied from all angles to encourage an uneven appearance. Now the painting is allowed to dry.

8 Squinting into the viewfinder, the artist is able to check on his progress. A transparency will reproduce the colours and definition better than a photographic print, but this way of using source material takes practice and you may need a print as well.

9 A further layer of blue-grey has been added to the top half of the painting, roughly working it round the areas of highlight. Next, the figures are further built up, reinforcing the patches of skin tone with more dense paint. Any temptation to let the approach become more detailed is sharply resisted.

10 To capture the ripples on the darker stretch of water, first the dark tones are applied at random (Payne's grey, cerulean blue and lemon yellow). For the highlights round these soft undulations, white is added to this mix and carefully painted round the dark tones. Notice how the face has been suggested with just a few dabs of paint.

7

8

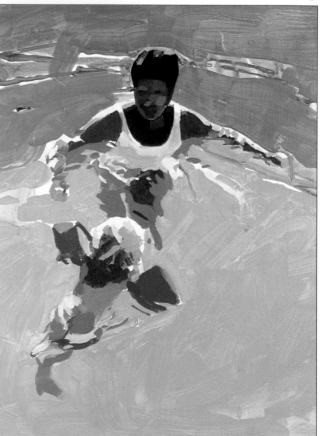

9

10

11

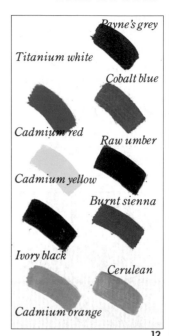

12 The addition of the grey shadows in the blue water unite the two figures and complete the painting. The blurred white highlights in the water either side of the armbands introduce a sense of movement into the painting. Now the child appears to be kicking and splashing. From a distance it is difficult to appreciate the loose approach and lack of detail in this painting – the eye fills in the omissions from the clues supplied by the artist.

Titanium white

Payne's grey

Cobalt blue

Cadmium red

Raw umber

Cadmium yellow

Burnt sienna

Ivory black

Cerulean

Cadmium orange

11 Finally, dabs of pure white are added to reproduce the sparkles of broken water. These are blurred with the finger tip. Even at this stage the grooves, encouraged with the brush when preparing the board with gesso, still play their part in enlivening the surface texture.

12

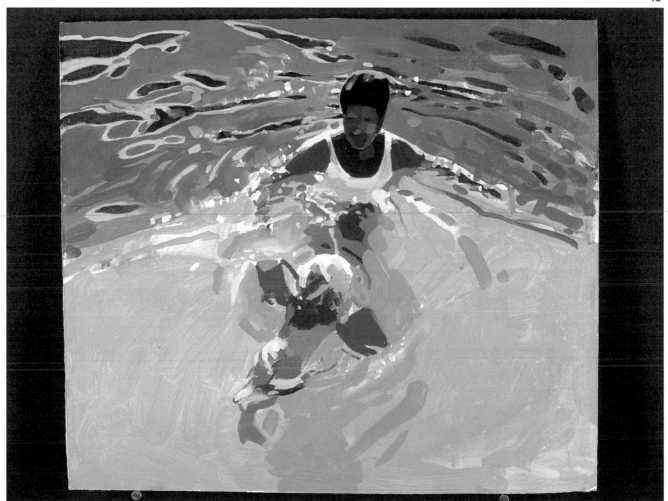

Nude
THE HUMAN FIGURE

In this study of a nude, the colours have been kept as pure as possible, applying the pigment straight from the tube in places, so that the hues appear fresh and singing. These pure reds and yellows, seen from a distance, are mixed optically, revealing the tonal modulations of the female form.

Such an approach, with a choice of warm colours, also successfully captures the heat of this sunlit scene. The nude is represented *contre-jour*, with the light mainly behind her but playing down her left side, producing extreme contrasts in the skin tones.

The artist first lays down the areas of dark shadow and then quickly builds up the form of the torso with bold strokes of undiluted paint, following the contours of the figure. At regular intervals, the artist stands back to assess progress, modifying strokes which appear unruly. To get a good perspective with such a bold work, it might help to view your progress in a mirror. This will instantly give you an objective view of your work and will save you having to remove yourself to some distance from your painting to achieve the optical mixing of the colours.

Note, too, that the background to this nude is mostly painted in flat dead colours in contrast with the vibrancy of those of the main subject. This has the effect of focusing attention on the figure and throwing it into relief.

1

2

2 A careful outline drawing is made of the composition but there are no tonal indications. To establish the tonal contrasts, the artist blocks in the darkest shadows on the hair and window recess, then adding the light mid-tone skin colour, where the sun falls on the face and catches the collarbones (cadmium red, orange and yellow with white).

3 Still laying the foundations of the composition, the face is built up with a few deft dabs of paint, wet in wet. After painting in the window frame in the background, the same colour is taken to the neck, ribcage and thigh. Note too the addition of the precisely applied patches of red on the collarbone and left arm.

1 The nude in this photograph is posed against the light, with strong sunlight falling on the left side of her body. In this painting the artist applies the paint boldly, often in its pure form, so that the hues are mixed optically.

Materials: Canvas board 12 in × 18 in (30 cm × 45 cm); Brush ¼ in (6 mm) flat; graphite pencil; white formica-veneered board for palette, with trestles to rest on; turpentine; cloth.

3

4 Here, the simplified structure of the face can be seen in detail. The dark band across the eyes is the shadow from the window strut. But note how the light side of the face is made up from simplified areas of skin tone. On the right side of her face, the original ivory black shadow is modified with the skin tone, marking the features more with brushstrokes than colour.

5 As the artist proceeds with the face, he uses up the paint on the body – the shadows on her neck, right arm and breast, and then the left thigh. Important observations are made, such as the shadow across her left arm cast by the bottom of the window. The sky and trees outside have been added in a cursory manner, keeping the brushstrokes lively.

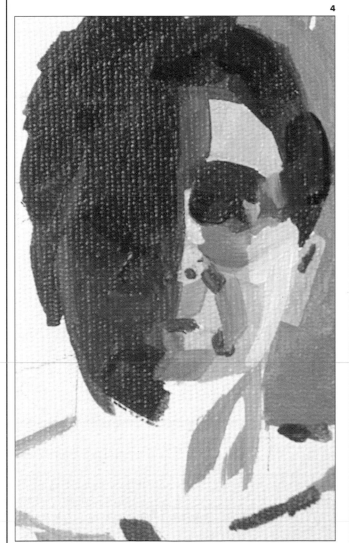

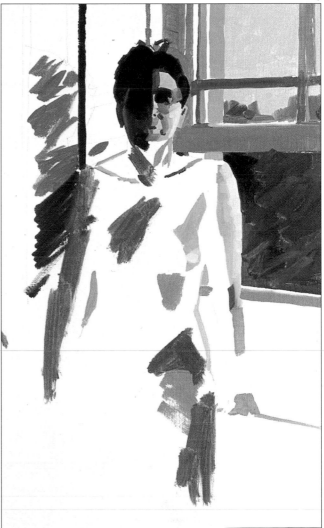

OILS

6 Having been skirting the issue, now the artist appears to attack the body with a shower of powerful strokes, mixtures of most of the colours on the palette – except white and Payne's grey. These are kept broad and clean, not blending these browns and reds on the canvas, simply feeling for the form. Note how the direction of the brushstrokes follows the contours of the body.

7 After the addition of a few more highlight tones, it is time to stand back and assess progress. The subtle half-tones of the shadowed part of the body are developing well. At a distance the colours blend into one another optically creating gentle gradations from what we know is a patchwork of strong colour.

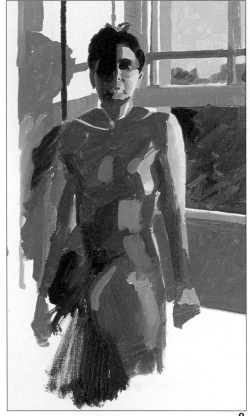

7

6

8 Now, with paint literally straight from the tube, glorious patches of lemon yellow impasto are squeezed on to the window recess, suggesting dappled sunlight.

8

9 The torso has been built up with further layers of thick juicy paint. Looking back at step 6, you can see how the artist has modified his original strokes of colour but he is still applying the paint cleanly, wet in wet, without any attempt to blend the paint. Following the same principle, with a mix of cadmium red and alizarin crimson, the paint is laid on to the underlying browns with touches of raised impasto.

9

10 Standing back, you will notice the cadmium yellow has been taken down the figure with the brush and worked into the underlying layers, wet in wet – on the face, arm, breast, rib cage, thigh – even a small glistening touch highlights the end of the neck bone. Striations of this pure yellow, like the red, are left unblended.

11 Establishing an even more long-distant view, the success of this undiluted broken colour can be assessed. Indeed the reds and yellow are absorbed by the underlying browns, yet it is with these strong colours that the warmth and intensity of the sunlight has been captured.

10

11

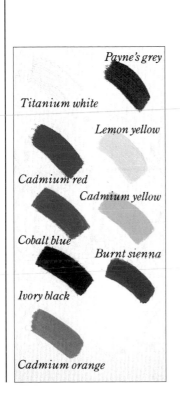

Payne's grey

Titanium white

Lemon yellow

Cadmium red

Cadmium yellow

Cobalt blue

Burnt sienna

Ivory black

Cadmium orange

Portrait of Cyclist

THE HUMAN FIGURE

A portrait, like any subject, can be treated in a number of ways. To a great extent this depends on the sitter. Is the character focused in the face or are the clothes and personal belongings important for a completed picture of the personality? Here the artist chooses to concentrate on the head and upper torso of his subject, a keen amateur racing cyclist. The shirt, hat and shades are enough to characterise the sport.

The artist knows the subject of his portrait well but to help him with his painting he takes a number of transparencies. It is useful at this stage to make some sketches too. Exploring the facial features with a sketch will help familiarise you with the subject. In this case, the artist chooses what he considers the best transparency and has an enlarged print made. The colour and definition of this print will not be good but the artist has the transparency for reference.

The print image is transferred to the canvas using the grid method. Equally, this method could be used to transfer the outline of a sketch to the canvas. Having established the outline, the artist tackles the subject with the same systematic approach he follows for more mundane subjects, for example, the peppers and lemons on pages 196-201. A small area is isolated and carefully painted, usually starting with the dark tones and working to highlights. Frequently the overall effect is appraised and, if necessary, moderated in the light of the whole.

Even though the print and transparency are constantly consulted, the artist's general experience, his knowledge of human anatomy, as well as his acquaintance with the subject, allow him to add to the information supplied by the photograph and create a lively portrait.

1

his portrait. The sunlight is bright, bleaching out the mid-tones. This is more obvious in the print from the transparency used by the artist which has lost much of its definition. But such blurred prints are sometimes useful in helping to simplify the image.

1 Painting a portrait is always a challenge. There is no straight recipe for success: a good portrait depends on so many things. But capturing a likeness is the first step. The artist started by taking a number of photographs of the subject, choosing one to help him with

Materials: 10 oz (285g) white cotton duck canvas, stretched and primed ; brushes – ¼ in (6 mm), No. 14 flat, No. 3 round; white formica-veneered board with trestles for palette; graphite pencil; sheet of clear acetate; white spirit; cloth.

2

3

2 Most portrait painters prepare very precise preliminary drawings of their subjects before they start painting. In this way the form and character of the sitter can be absorbed. This is important groundwork on which you will need to rely to a great extent. If you wish to transfer your sketch to the canvas, or the proportions of the sitter from a photograph, try using the grid method shown here. A sheet of clear acetate is drawn up with a grid of ½ in (1 cm) squares and this is placed over the photograph. The canvas is then likewise squared up with 2 in (5 cm) squares using a graphite pencil. By carefully observing and marking off where features intersect the grid and transferring these points to the grid on the canvas, the likeness can be reproduced.

3 Your subject's clothes are important if you are tying to capture a likeness. This cap with its upturned brim characterizes the sitter, so the artist takes some trouble with it. The markings are carefully observed and painted in. But, although the logo appears to be precise, closer inspection reveals how only the impression of the lettering has been captured. The artist has taped the print over the face to stop his hand smudging the drawing.

4 The careful drawing can be fully appreciated here, and also the finished cap. The artist is only applying one layer of paint, so it is diluted as little as possible – just enough to allow it to brush on easily. It is applied with assurance, not moving it around on the canvas. So, with a ¼ in (6 mm) flat brush the artist has filled in the shadow on the brim, delicately cutting in round the lettering with the corner of the brush. This shadow is a subtle mix of ivory black, cobalt blue, yellow ochre and white. The rest of the cap is blocked in with white deadened with a little of the shadow mixture.

5 Next, the artist works on the hair, filling in the areas of dark tone with broken ivory black and now bordering these areas with a mid-tone colour of yellow ochre added to the other ready-mixed colours. This is cut round the first colour, blending it slightly at the edges but no more.

THE HUMAN FIGURE/CYCLIST

6 Before starting on the ear, the light tone has been added to the hair, again carefully placing it round the darker tones. This is a good example of refining detail which is the hallmark of a good portrait. The artist is following the reference, but not slavishly – as long as it 'looks right'. This is why the artist needs to get to know the subject through his drawings before he starts. Now the ear is built up in the same way, working from dark to light. It may seem as though the red/orange mid-tone is strong. But ears are often quite a startling red. Look at the artist's in step 1.

7 Now the dark glasses are filled out in murky tones based on ivory black. The edges of the frames are here carefully encompassed making a series of imprints with brush end.

8 For the flesh tones, the artist mixes a mid-tone of cadmium red, cadmium orange, chrome yellow, titanium white and cobalt blue, darkening it with cobalt blue and cadmium red and lightening it with chrome yellow and white. Now the artist studies the cheek, painting in all the important patches of light and shadow, starting with the dark, which is also blended into the glasses.

9 Another few dabs and the nose comes into existence. See how the mid-tone marks out the forward plane of the nose but the bright illumination removes the tonal details of the side plane of the nose, reducing it to a patch of highlight tone.

6
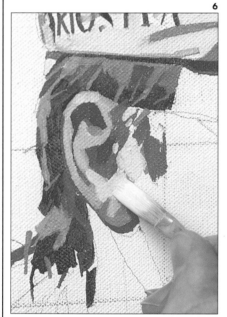

7
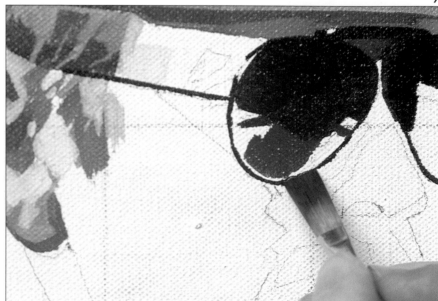

8
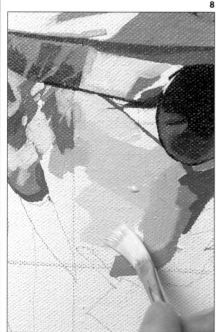

9
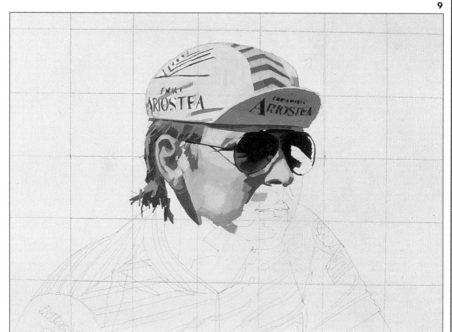

10 It is necessary to stand back constantly to assess progress, adding a dab here or there to modify the image. Even though the artist is tackling the portrait area by area, he is checking to see that these isolated patches fit into the overall likeness, which is already beginning to grow out of the canvas.

Next, he paints the mouth, which is a very elusive feature. Working on the same system, the dark tones are located first – very dark where the two lips meet; slightly lighter, shown here, on the forward plane in the centre of the lower lip.

11 Now the mid-tones are carefully built up, including a touch of the red/orange tone used for the ear, but also to be seen on the tip of the nose. The artist searches for patches of the same tone using the paint on the brush, moving from the subject's left cheek and upper lip to his chin.

12 To finish the mouth and lower part of the face, the light tones are added. Now this patchwork of tone emerges as a three-dimensional face – and not just any face but an excellent likeness of the cyclist.

THE HUMAN FIGURE/CYCLIST

13 The low definition print neatly shows the areas of highlight, but the gradations of tone are lost. These are added by the artist from knowledge gained from experience, keeping the surface of the painting lively when viewed from close to as well as from far away.

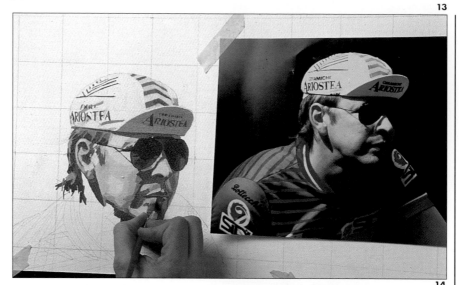

14 With the same precise approach, the artist fills in the red stripes of the T-shirt. First with the mid-tone; the darker red shadow will be added along the folds next.

15 Now the green stripes are added, cutting in along the red. Here is a perfect example of complementary colours in action. You can see how these two fully saturated complementary colours affect each other. The red stripes still bordered with the primed canvas appear darker and less bright than those bordered with the complementary green on the cyclist's back.

16

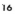

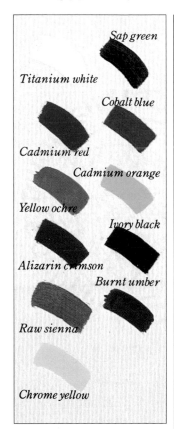

Sap green

Titanium white

Cobalt blue

Cadmium red

Cadmium orange

Yellow ochre

Ivory black

Alizarin crimson

Burnt umber

Raw sienna

Chrome yellow

16 With the cyclist finished, the artist turns to the background. This is speedily completed in a very stylized manner so as not to divert attention from the main subject. The trees are blandly filled in with a mixture of sap green, cobalt and white, then adding the trunks in the same colour.

17 In the final painting, the background has been completed in the same stylized way, although the expansive area of grass and sky has been applied with a lively slightly broken stroke. An objective view of this portrait reveals a remarkable likeness. Although the artist relied on the photograph as a physical reference, he was able to use his knowledge of the human form, his preliminary drawings, and his appreciation of the subject as a friend, to guide him in his painting.

17

ACRYLICS

Chapter 1/Introduction

Acrylic, one could say, is the most versatile of all painting mediums and this book demonstrates just that to both the beginner painter and to the more advanced artist. For the beginner acrylic paint can radically simplify the many exasperating technical problems that other painting mediums present, and to the more competent artist it opens new fields. Not only will it adapt itself to the techniques of oil and watercolours but it goes further, stretching these traditional techniques and offering exciting opportunities for flexibility in the artist's work. Frequently, established painters will not give acrylic a fair run, only too often bestowing on it their preconceived ideas about watercolour or oil paint, and give up before they have had time to explore its great potential. The beginner, on the other hand, who is not hampered by traditional techniques or prejudices will benefit most from this comparatively new paint which, in truth, is probably the easiest to use.

Acrylic, it seems, has gained an unfair reputation as having an advantage only when used in flat areas of bright colour. This, of course, is absurd and this point needs to be emphasized. The truth is that this paint is no brighter or harsher than any other. By trying for yourself, with the help of this book, it is hoped that you will gain a thorough understanding of the medium.

Introduction

WHAT ARE ACRYLICS?

Acrylic paint manufacturers use exactly the same pigments (colours) that makers of other painting mediums use. These are usually mineral, derived from the earth, or chemical products.

Paints only differ in their binder (the substance or adhesive which holds the dry ground pigment together). In watercolour the binder is gum arabic, which is solvent in water, with oil paint it is linseed oil, the solvent being turpentine or a petroleum substance, and with acrylic the binder is man-made plastic. The pigment is suspended in a milky-white liquid plastic which, on drying, turns perfectly clear. This is why acrylic paint tends to dry darker. The solvent for acrylic is water. While the paint is still wet or even damp it can be removed or dissolved with water, but when it is dry it is probably the hardest of all painting mediums to move.

WHY CHOOSE ACRYLIC?

People decide to use acrylic for any number of reasons. Perhaps they normally use oil or watercolour and want a change, or perhaps they have never painted before and wish to have the freedom of choice that acrylic offers. Being such a versatile medium it can be used in most of the techniques of any other type of paint.

Many people are bothered by the strong smell of oil, paint and turpentine

and so choose to use acrylic as it has very little odour. When using the traditional oil technique of building up a painting but employing acrylic, you will find the underpainting will dry very quickly and so allow the process to advance. Therefore consecutive layers of paint can be added quite rapidly. In the final stages of the picture glazes can be added within minutes Likewise final highlight opaques may be added almost instantly.

Mistakes can easily be corrected by painting over with white paint or acrylic gesso and then repainting. Minor mistakes can be easily corrected by just painting over the area as soon as it has dried. This is a fine medium for amateurs attending painting classes as transportation of the picture is so much easier. By the time the student has cleaned her brushes and put away the tubes of paint etc., the painting will be dry and can be popped into a bag or carried on to the bus without sticky problems. Storage is also much easier for the same reasons.

When using acrylic in watercolour techniques the painter will find laying one wash over another a simple task as the subsequent wash, of course being allowed to dry first, will not move or pick up at all, consequently producing very fresh watercolour-like paintings.

Acrylic used in any technique is permanent and will retain its colour indefinitely; it will not yellow with age as oil paint does (the effect of the linseed-oil binder) or fade as with watercolour. It can be painted on to any non-oily surface and is often used to paint large murals. Due to its flexibility paintings executed in acrylic paint on canvas, paper or any pliable material can be quite easily rolled up, without worry of the painted surface cracking.

Acrylic paints are manufactured at the Talens factory in Holland.

HISTORY OF ACRYLICS

Developed in the United States in the 1920s, acrylic paint was a product intended only for industrial use and until the late 1950s and early 1960s was generally only utilized in this field.
The first artists to employ acrylic were probably of the American art movement called 'Pop Art', and this is most likely where it gained its reputation as a bright-coloured medium. It suited the imagery of these artists;

they were painting a plastic world of billboards, soup cans, hamburgers, and bus stops, and a modern plastic medium such as acrylic must have appealed to them. At the same time American Abstract painters were experimenting with the medium – they were probably impressed by the rate at which acrylic paint dried as their art was instant and vital. Waiting for oils to dry must have been frustrating.

Acrylic was introduced into Europe in the 1960s, where artists such as David Hockney contributed greatly to the growing popularity of acrylic in the world of representational art. Hockney was renewing his interest in literal representation and his choice of paint was changing from oils to acrylics. During the 1960s and 1970s he painted many of his now well-known large portraits, mainly of his friends in their

normal everyday environment, and used the newer medium, exploiting it to its limits.

Another artist of this era using acrylics was Roy Lichtenstein, an American 'Pop' artist. In 1960 he began to base his work on comic strips. Portrayed on these two pages is a reproduction of his painting "Wham". He imitated the dots of the printing press by laying a metal screen which had regularly spaced holes on to the canvas and brushed paint on to this with a toothbrush. With its quick drying quality acrylic was the perfect medium for this style of painting.

"Wham". Roy Lichstenstein 1963. Acrylic on canvas. 68 in × 106 in 172 cm × 269 cm).

HISTORY OF ACRYLICS

1 *Dedicated to Florence,* by
Terry Duffy illustrates the
textures that can be obtained
with Acrylics.

2 *The First Marriage,* by David
Hockney – the English artist
whose name has become
synonymous with Acrylic
Painting.

3 *The First Horn,* by Martin Nash is a forceful composition of Acrylic and mixed media on paper.

4 The soft subtle qualities that can be achieved with Acrylics are amply demonstrated by Stewart Lees in his landscape study, *Near Lathones.*

5 Bold, bright and richly coloured; *Glass Comport* by Tina Lambert.

6 A different technique again helps to demonstrate the full range of Acrylics; *Petals* by Joanne Wills.

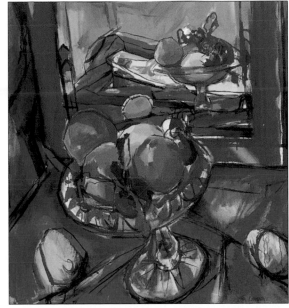

Chapter 2
Equipment

Painting with acrylics tends to be a mystery to many people; they seem to think of it as a new and unknown invention, requiring all sorts of special equipment. This is not so. In fact, with a relatively small amount of materials one can set out to paint a picture using any technique or method of painting.

It is advisable to buy a limited amount of materials to start with, but do buy the best that you can afford. Cheap paints, supports and brushes will only frustrate the budding artist and your interest in painting will soon wane. Art shops can be fascinating but they can also be overwhelming – full of all sorts of weird and wonderful equipment for the artist at exorbitant prices. So beware. Make a list out before you go shopping for the basic essentials and stick to it. With experience you will discover exactly what you need to add to your initial collection of materials.

To begin with half a dozen or so tubes of paint should suffice. It is a good idea to buy a large tube of white as you will probably be using it a lot to lighten the other colours. Two or three brushes should be adequate. A piece of hardboard or plywood found in the garage (or bought for a few pence at your local hardware shop) and primed with household undercoat will make a good first support; maybe later you will want to use canvas or canvas board.

The rest of the materials can be collected from around the house – large jars of water, rags, paper towel, a pencil and an eraser. A large plastic plate or a piece of formica can be used for a palette – preferably white being the same colour as your support it will simplify colour mixing.

The one other piece of equipment that you will want to have is an easel. These come in a very wide range of sizes and prices, from the small wooden table easel to the very large electrically operated roll about studio easel. The best type to buy is the folding easel which can be transported effortlessly, from room to room, to your art class or out on a day's painting trip to the country. They are very moderately priced and are made in wood or aluminium. Putting up the wooden ones tend to be a bit like tackling a deck chair; the metal ones are far more straightforward and have greater stability.

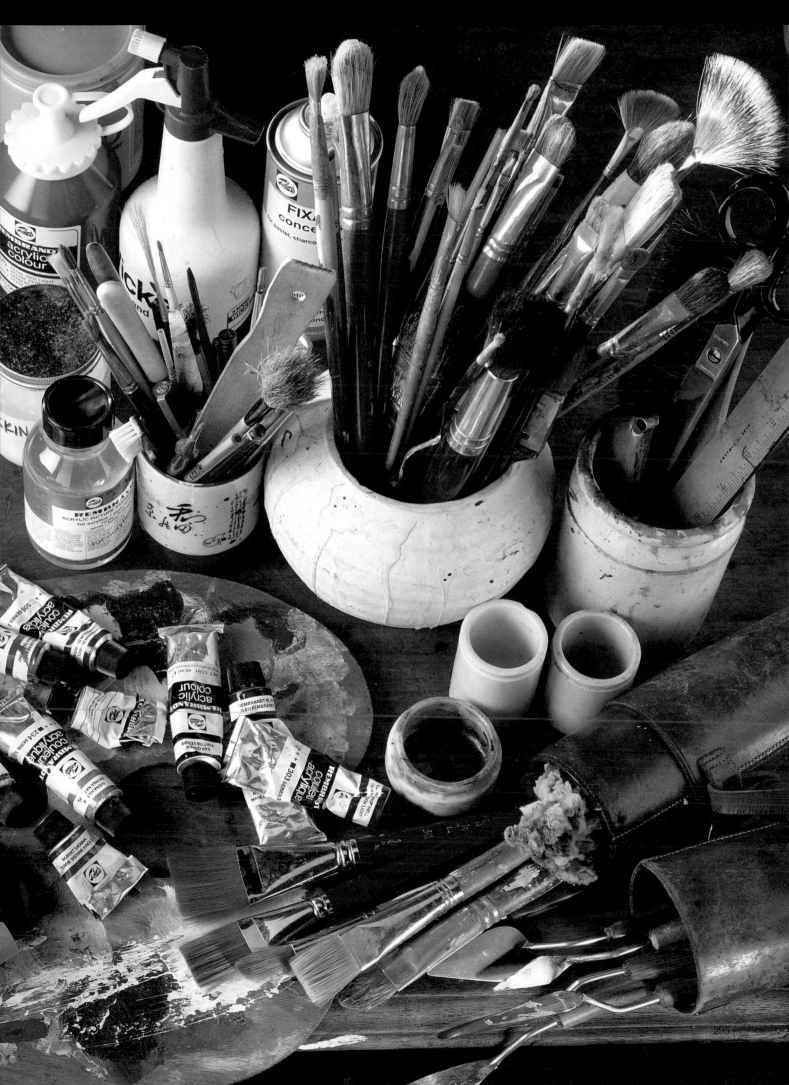

Equipment

PAINTS

Acrylic paint is produced in as many colours as other painting mediums and is available under the same pigment names, for example raw sienna, ultramarine blue, etc. Most manufacturers do produce some colours under their own brand name, such as Talens yellow (Talens-Rembrandt), Rembrandt blue (the same manufacturer) and Winsor blue (Winsor and Newton) etc. You will find, though, that all manufacturers of paints will have equivalent colours; for instance the Rembrandt and Winsor blues are very similar colours. Although the manufacturers produce many colours, it is not essential to have every colour. Most artists work with a limited palette (see pages 304-5); this means that they only use a small number of colours, perhaps eight or less.

When applied to the support acrylic paint has a butter-like texture; used straight from the tube it is quite thick and retains the brushstroke well, although layer thickness may decrease slightly owing to the evaporation of the water in the paint.

Most artists' quality acrylics (there are cheaper varieties) have very good light fastness and mix together extremely well. They can be thinned with water or an acrylic medium, but when dry are water resistant.

The binder, the fluid that holds the dry pigment together, causes no yellowing of the pigment over any length of time and is extremely durable. A problem with oil paint is that the oil binder in time yellows the pigment, altering the colour. On the canvas the acrylic paint film does not change or yellow and is flexible; once dry a painted canvas can even be rolled up, and no cracking will occur, not even after years. Drying time varies from minutes to a few hours, depending on the amount of humidity in the atmosphere and the thickness of the paint.

There are several different types of acrylic paint on the market. Most art material manufacturers produce artists' quality although they do vary in thickness from company to company, some being quite runny. One company does produce a more fluid acrylic, called 'Flow Formula', which is especially designed for covering large flat areas often essential to abstract and hard-edge painters.

A cheaper range of acrylic colours are PVA and vinyls, less expensive because the pigments used are inferior to those used in the artists range. In addition, they are bound together with a polyvinyl acetate resin instead of an acrylic resin. These paints often come in large size tubes and are frequently used by mural painters. Generally acrylic is sold in the standard 40 ml tube but the more popular colours and white can be purchased in very large tubes varying in size from 115 ml to 150 ml.

When starting out with acrylics it is better to buy just a few tubes at a time

and add to them when you need extra colour (see the suggested palette on pages 304 and 305). Large polished wooden boxes with a couple of dozen tubes of paint, brushes etc. may look tempting, but you will find that most of the contents are not what you need. The brushes supplied are too small or too large, paints the wrong colour and so on; furthermore, they cost an awful lot of money.

There are many auxiliary materials to support acrylics. Although they are not essential (just water can be used to thin paint and wash brushes) they do allow the artist to pursue different techniques with the paint. The most useful accessory is a painting medium; this can be bought as a liquid in a bottle or as a gel in a tube. Acrylic liquid medium is a milky-white substance that dries to a transparent and water-resistant finish. It can be obtained in a gloss or matt finish. When using a painting medium the paint film

remains elastic and the colour brilliance is maintained, if not improved. It gives the painting a more transparent effect, producing further depth to the picture. The matt medium has all of the qualities of the gloss, but dries to a matt eggshell finish. The gel medium is of course, firmer than the liquid; it is a clear paste-like material which can be squeezed on to the palette along with the paints, no receptacle is required to hold it. Another medium which dilutes and stretches the paint, but also slows down the drying time, is retarder. The addition of a small amount to the paint lengthens the drying time considerably. The use of retarder is demonstrated on page 384-7.

To add a relief-like surface to a painting or to produce heavy texture, modelling paste can be used. This can be applied on a non oil-containing rigid surface such as cardboard, wood, canvas board, walls and concrete. When mixed with about 50 per cent gel

medium, modelling paste can also be applied on flexible grounds such as linen and cotton.

To prime boards or canvases before painting, acrylic gesso universal primer can be used, although many people do use ordinary household base coat. Universal primer is more flexible and durable than any other primer and can be tinted with acrylic paints, and also used in the actual painting as a substitute for white if large areas are to be painted. This can be bought in a variety of sizes from small plastic tubes and tins to large gallon (5 litre) size containers. It is cheaper when purchased in large amounts.

BRUSHES

A variety of brushes can be used with acrylics and your choice will depend on the techniques that you are employing. If applying the paint in a watercolour style, you would use watercolour brushes. For most other approaches you would employ oil painting brushes. There are brushes which are especially made for acrylics but if you already have oil brushes they will suffice. Household paintbrushes can be used if tackling a very large painting or mural.

The best watercolour brushes to use for acrylic are those which are synthetic; not only are they less expensive than sable but much harder wearing. Acrylic tends to wear out brushes faster than any other medium. It is not advisable to use very cheap brushes; often beginners will buy inexpensive brushes thinking that when their painting has improved they will buy better ones. The problem is that using a cheap brush will probably hamper their progress. Poor quality, low priced brushes have no spring in them and more often than not the bristles fall out. When buying a watercolour brush make sure it has a good point on it. It is quite acceptable to ask the shopkeeper for a jar of water to dip it in to ensure that the hair comes to a point.

The most popular brushes used by acrylic painters when working on canvas, hardboard etc. are bristle brushes which are made from hogs hair. They are made in four shapes: flat, bright, filbert and round. Flat brushes are square-ended, while bright brushes are flat with rounded tips; the length of the bristles varies. The shapes of filbert and round brushes are self-explanatory.

Choice of brush is personal and depends on your style of painting. Buy only one or two brushes to begin with, a

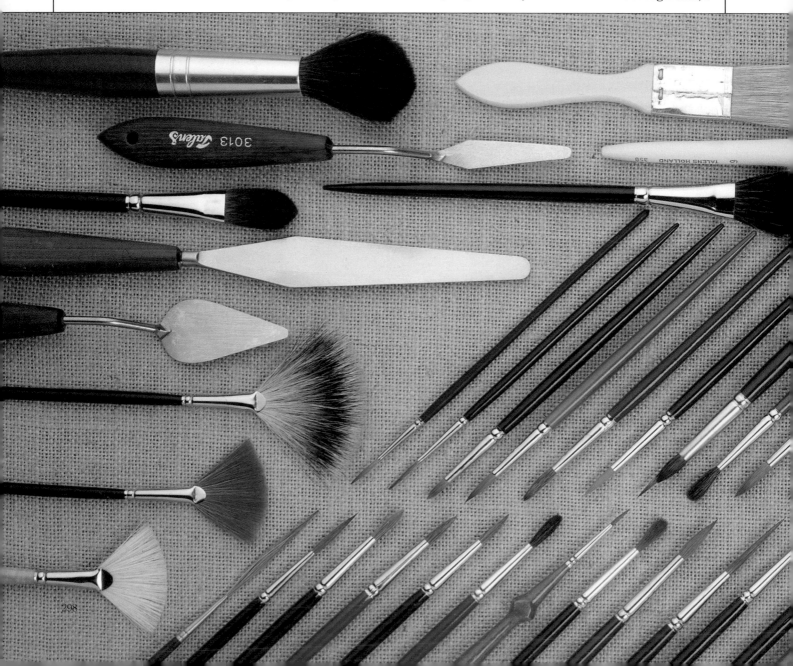

small to medium size and a medium to large, say a No. 7 and a No. 12. As you gain experience you will then know what other brushes you need.

A very special brush, and one that is used quite often is this book, is the 'rigger', or 'script liner' as it is known in America. This brush usually has stable, hair or synthetic bristles which are much longer than the average brush. It is very useful when painting bushes, plants, rigging on ships (from where it gets its name) etc. For a demonstration of its use, see page 350.

Other brushes which are often employed by the artist are sign writers' brushes, shaving brushes (for washes) and even toothbrushes (see page 74). Fan brushes, so named because of their shape, are quite useful both for blending brushstrokes and for painting foliage, etc. There are so many different brushes to choose from and every sort of brush has its peculiarities.

Many artists like to paint with palette knives; these too come in many shapes and sizes and it is through trial and error that the artist must decide which suits him best.

An extremely important point when painting with acrylics is NEVER to allow the paint to dry in the brushes; if you do, the brush will be ruined. When working on a painting keep a large jar of water handy to put your brushes in until you need to use them again. When finished for the day, make sure that you give your brushes a thorough wash with soap and cold water, making sure that you get all the paint out of the heel, the part where the bristles enter the metal ferrule.

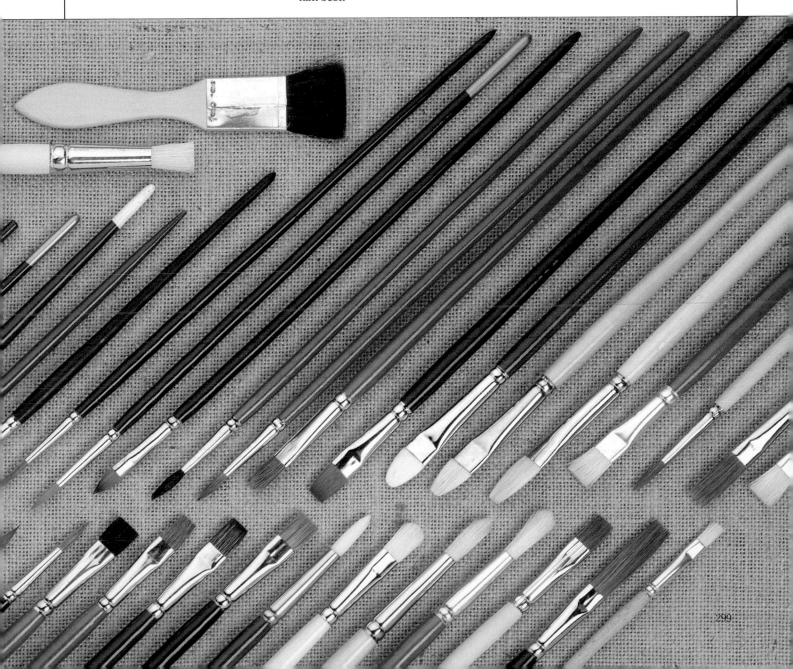

SUPPORTS

It is not quite true that acrylic paint can be applied to any surface, although it will adhere to many. It is best to avoid surfaces which contain oil or wax as the paint will peel off when dry. Do not use canvas board or canvas which has only been prepared for oil paints; often this is marked on the back of the boards, so make sure that you check. These days manufacturers usually prime with acrylic gesso which will take oil or acrylic paints.

Many artists work on hardboard; it is usual to prime it but is not essential. If the painting is to be very large, it is best to support the board with a wooden frame (simple wooden strips attached to the back). Both sides of the hardboard can be used, although mostly it is the smooth side which is painted on. To prime hardboard, first give it a light sanding with fine sandpaper, The first coat of acrylic gesso should be mixed with half water so that it absorbs more readily into the board. When this is dry is should be lightly sanded and then painted with full-strength gesso, the brushstrokes all going in the same direction. When this has dried the procedure should be repeated, with the brushstrokes going in an alternative direction. Raw canvas which has been attached to stretchers can also be

Watercolour Paper

Watercolour Board

Abrasive Board

Canvas Board

Canvas Paper

300

primed in this way.

Other surfaces that will accept acrylic paint are cardboard, plywood, chipboard (all can be primed in exactly the same way as hardboard). Any untreated cotton or linen will accept acrylic as well as wood, plasterwork, earthenware or concrete. On surfaces which are highly absorbent, dark, smooth or uneven, it is advisable to apply a coat of gesso acrylic primer.

Of course, if the paint is to be used in a watercolour technique, then a suitable paper will be needed. Watercolour paper comes in several different surface textures: 'hot-pressed' which is very smooth, 'not' which means that it is not hot-pressed and has a slight texture, and 'rough'. There is quite a variety of surface textures in 'rough' paper, varying from slightly rough to very rough. Watercolour paper also comes in

several different thicknesses depending on its weight; 45 lb (100 g) is the thinnest and really is too flimsy to paint on. Other weights are 70 lb (150 g), 90 lb (200 g), 140 lb (300 g) and so on up to 500 (1000 g) or 600 lb (1300 g) which is very thick. An advisable weight to use is 190 lb (400 g); it is fairly robust, will stand up to quite a lot of working and will not need to be stretched.

Chapter 3
Looking at Hue

Colour or Hue is the artist's most important tool; without it he is very limited. Knowing how to make it express an emotion or action is very satisfying to the artist. Colour can add depth to a painting or bring things closer, create atmosphere or describe a mood. Used creatively it offers endless possibilities.

In this chapter, we suggest using a limited number of colours, the reasons for using each and what they can do for you. Following this, the spectrum is discussed and described in a fairly simple manner, complementary colours and their uses are explained. This is a very important area when learning to paint and it is worth spending quite some time experimenting for yourself; doing so will take a lot of the guesswork out of colour mixing.

There are several terms used in art to describe colour and this seem to cause a lot of confusion. It is quite important to understand these terms as they will occur often, not only in this book but in other art books you may read or conversations about art you may hear or have.

Value
The lightest colour the human eye can perceive is white, the darkest is black. There are countless shades of grey between these two extremes. Every colour has literally innumerable shades. The relationship of any of these shades to black or white is what we call the value of the colour. The closer a colour is to white, the higher its value. The closer to black, the lower its value. Blue, red, brown, green, orange, pink and so forth are different hues but they can all be of the same value, or each colour can have many values. The value of each colour is of great significance in painting.

Warm and Cool Colours
Reddish and yellowish colours are considered warm because they remind us of fire and flame. Bluish and greenish tones are cool because they are reminiscent of ice. Thus, colours containing a larger proportion of red or yellow are warm colour while those with a greater amount of blue or green are cool.

BASIC PALETTE

An artist's palette is not just the piece of wood he squeezes his colours on to, it is his actual section of colours. Most painters work with a limited palette; that is, a few colours carefully selected. An individual artist's work can be recognized by the colours he has used as well as his style. The beginner will learn a lot about mixing colours by sticking to a limited palette and with experience will know intuitively when he is ready to add a new colour, take one away or exchange one colour for another. Using a limited palette makes it easier to keep colour harmonies in hand.

The colours shown on these pages are the ones which are used throughout this book; together with white they make an ideal palette for you to begin.

From top left to right:

Burnt sienna
Perhaps the most useful colour on the palette. Mixes with other colours to produce many earth hues: bricks, tiles, wood, terracotta, copper, ground, etc. Also very useful in skin tones and a little is effective when added to ultramarine blue and white to produce a grey blue sky. This is a semi-opaque colour so not recommended for glazes.

Raw sienna
Another earth tone used a lot by landscape painters. Also useful in some skin tone mixtures. This is an opaque colour so has great covering qualities.

Rembrandt blue
A greenish blue, a very strong staining colour. Makes a good summer sky blue when mixed with ultramarine blue. This is transparent and good for glazing

Raw sienna

Burnt sienna

Sap green

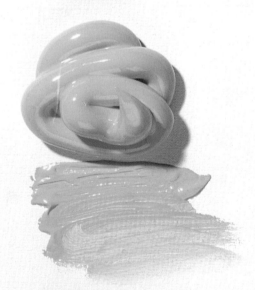

Talens yellow

Ultramarine blue
A primary blue and perhaps the truest blue of all the pigments. It makes a very useful grey when mixed with burnt sienna, producing a very light tone when mixed with large proportions of white or very dark, almost black when no white is added. A transparent glaze applied over the background of a landscape will give the impression of distance.

Cadmium red
A bright primary red, very similar to vermilion. Very useful for mixing skin tones, makes a very delicate grey when mixed with Rembrandt blue. All cadmiums are opaque.

Lemon yellow
A primary colour, a cool yellow which can be warmed by adding a small touch of cadmium red. Also mix it with cadmium red to

make a bright orange and with sap green to produce a very delicate spring green. This colour varies from transparent to semi-transparent depending on the manufacturer.

Carmine
Useful for mixing with ultramarine blue to produce a strong violet. Mixed with white it makes a delicate pink, but not for use in skin tones.

Talens yellow
A ready-made orange, makes a good glazing colour as it is transparent, will bring forward and add warmth when applied very thinly over the foreground.

Sap green
A soft transparent green, useful alone for springtime foliage. Produces a beautiful misty grey green when mixed with ultramarine blue and white

Ultramarine blue

Rembrandt blue

Cadmium red

Carmine

Lemon yellow

THE SPECTRUM

To the artist, colour is a means of expression. It has a direct and powerful influence on our lives and emotions, it surrounds us; when our eyes are open we see colour. For these reasons alone, it makes sense that the artist spends some time studying and understanding colour and how he can use it to express mood and atmosphere, to stimulate or to provide tranquillity. Learning a few basic rules will eliminate a lot of the frustrations that the beginner experiences. Additionally using a limited palette (see pages 304-5) and experimenting with the chosen colours will prepare you for more demanding work later. A lack of knowledge will produce only unsatisfying work, paintings that will cause feelings of irritation and tension with the painter not understanding what went wrong and why his paintings are not harmonious.

To begin to understand colour, we must appreciate that there are only three true colours: red, yellow and blue. These we call primary colours and with them we can make any other colour except, of course, white which is not actually a colour. If we set out the three primary colours in a triangle, one at the top and two at the base in any order and we mix adjacent colours, that is we mix red and yellow to produce orange, yellow and blue to give green, blue and red to make violet, we have the three secondary colours, orange, green and

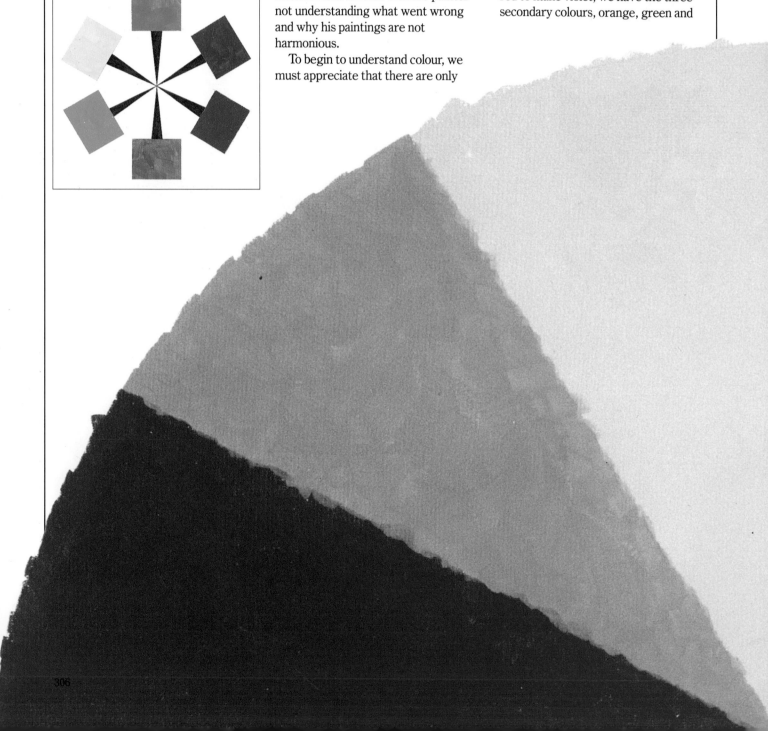

violet, which we place in between their parent colours. If you have set out your colours in a similar manner to the small diagrams on these pages, you will have constructed the spectrum or the colour wheel as it is often called. You could go further to develop tertiary colours, that is mixing any two secondary colours together, but by doing so your chances of ending up with a mud colour are very likely, as by mixing two secondary colours together you are mixing all

these primaries in different proportions.

At this stage you are probably asking yourself why, if there are only three real colours and I can make any hue with them, do I need to buy more? The answer is simple: convenience. Colours that are used very often, such as raw and burnt sienna are easier to buy ready made than to spend a lot of your valuable painting time mixing them. It also depends on the three primaries you choose from the large range of reds, yellows, and blues, as to the particular colours you can mix. The three that the artist uses are cadmium red, ultramarine blue and lemon yellow. This

red, mixed with the blue, does not produce a satisfactory violet, however, and so the artist used carmine, which mixed with ultramarine blue, does. Ultramarine blue and lemon yellow do not make shades of blue green and so the artist added Rembrandt blue to her palette.

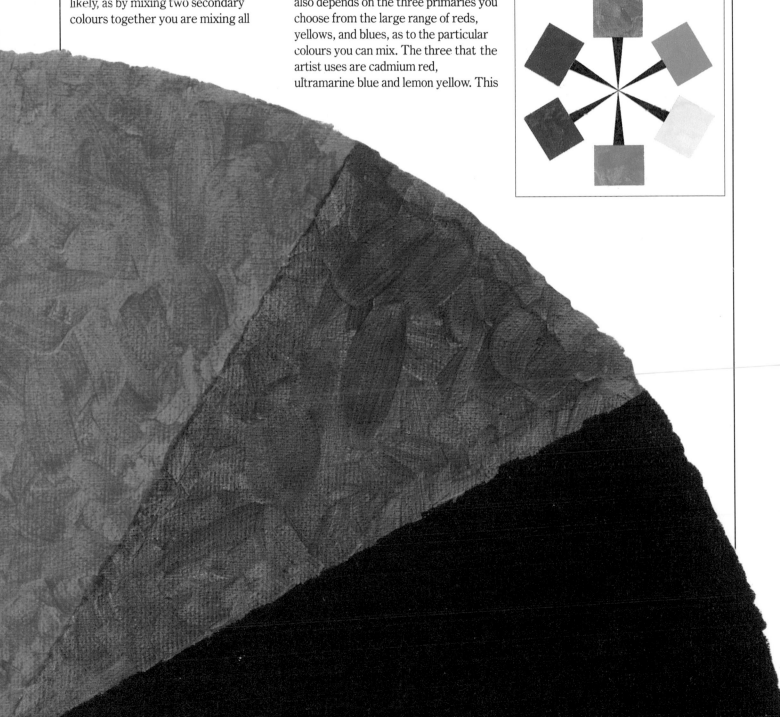

COMPLEMENTARY COLOURS

With the spectrum in front of you, you will notice that red is opposite to green, yellow is opposite violet and orange opposite blue. It doesn't make any difference in what order you set your triangle of three primary colours, the same opposite will always occur. These opposites are called *complementary* colours, and to achieve satisfaction in your painting you need to have an understanding of complementaries and how they can help you.

One of the first problems that we encounter when beginning to paint is that we do not know how to tone down our bright colours. We add a little black and it looks too dull, so we add a dab of something else and before you know it all you have on the palette is mud. This is where the use and knowledge of complementary colours begins, and the rules are simple. When a colour is too intense, add a little of its opposite colour, its complementary. For example, to tone down yellow, we add a little violet, for red we add green and so on.

In contrast to muting colours, complementaries will also intensify them. Rather than mixing the two colours, however, we place them side by side. Paint a strip of blue next to a strip of orange; the blue look bluer and the orange looks oranger. This theory was used by the Impressionist school around the middle of the last century and further developed by the Post-Impressionists. Paul Cézanne was the first artist consciously trying to achieve effects by juxtaposing certain colours. He found that a lemon looks brighter with violet blue next to it and a red apple appears to be more brilliant on a green cloth. Likewise, by adding touches of red to foliage, grass, etc. you will find that it appears to shimmer more and the flatness will disappear.

'What colour is a shadow?' is a question often asked by students who frequently use the same tube of grey paint for everything, thus producing uninspiring works. The colour of a shadow depends on the colour of the

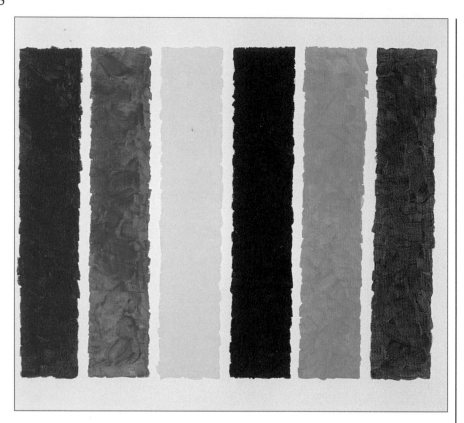

object and the light. The examples on these pages show how complementary colours have been used on the dark sides of the fruits to produce a shadow — green on the red apple, blue on the orange and violet on the banana.

Further to these uses of complementary colour is the mixing of greys or neutral colours. To do this mix any two complementaries together. Red and green will create a brown, orange and blue a grey and so on. To vary the tone and value of colour, the painter must vary the amounts of each colour he uses in the mix.

In the three paintings of fruit complementary colours are used in the shadows - blue on the orange, green on the red apple and violet on the banana.

Chapter 4
Basic Techniques

While the artist using acrylics can produce paintings as delicate as the Victorian watercolour to large, bold, flat abstract paintings, brushstrokes can be just as varied. Large areas can be smoothed out to appear completely flat and devoid of strokes or the paint can be applied thickly straight from the tube, allowing ridged brushmarks to remain. Many tools other than brushes can be utilized to apply acrylic paint – sponges, knives, pens, the fingers. Perhaps you will experiment and come up with some new ways of applying it.

Acrylic can also be used in building up a collage. Tissue paper, old torn-up paintings or cloth can be glued to a support with acrylic medium, either flat or crumpled. After the medium is dry and the material held in place, acrylic can be painted over and then perhaps more material, paper etc. added. Very interesting and colourful collages can be created in this way.

It is a good idea for the artist in any medium to keep a source file. That is, to collect pictures and pieces of pictures from all kinds of sources and to file them away for future reference. They can be collected from newspapers, magazines, your own sketches, or photographs (your own and others). These references are not to copy, but to help you when composing a picture. For example you may be painting a rural scene and want some cows to complete the picture. This is where your reference file comes in handy. Further to this, you may want just to stick the picture of the cows on to the painting; with acrylic this is possible. Just coat the back of the picture with acrylic medium and apply it to the painting. When it is dry, just paint over with more medium and your cows will be fixed forever in place. This type of art, combining painting with photographs or stuck-on cuttings, is called montage.

If mistakes are made in any form of acrylic painting, it is very easy to correct them. When the area that is wrongly painted is dry, simply paint over the top of it, or completely blank it out with white paint and begin again.

Acrylic varnishes are available in art shops in both matt and gloss finishes but they are not essential; acrylic medium will accomplish the same job. A thin coat after the painting is finished will bring all areas up to the same gloss or matt finish, and if at later date you wish to change the image, there will be no problem in working over this varnish and then revarnishing.

Basic Techniques

BRUSHSTROKES – APPLYING COLOUR

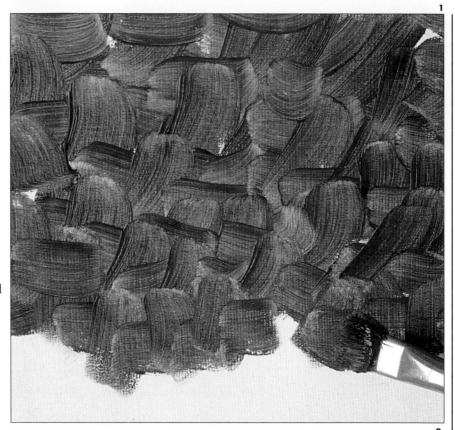

1 One would think that applying paint with a brush is an easy task – just slap it on. But, not so. Brushstrokes are the means by which the artist expresses his personality, through paint applied with thought and care. There are many ways of applying paint, and a few are illustrated here to get you started. Eventually you will develop a brushstroke which is as unique to you as your handwriting.

Here the artist, using a fairly large brush, cross-hatches the paint. That is she paints a stroke in one direction and then turns the brush to cross back over the first stroke.

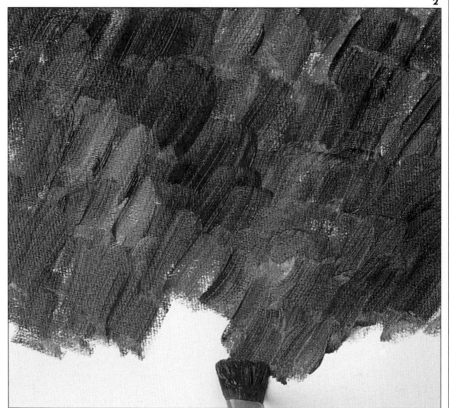

2 The brushstrokes in this demonstration are all going in the same diagonal direction. This technique was employed by several of the French Impressionist painters in the nineteenth century.

Whatever technique you employ stick to it throughout the painting; do not change stroke mid-stream, but aim for a unity in your technique. Using different brushstrokes from one area of the painting to another will fragment your work just as introducing odd areas of isolated colour will. If you are using descriptive brushwork, following the form of your subject as Van Gogh did, then make sure that you complete the whole painting in this way.

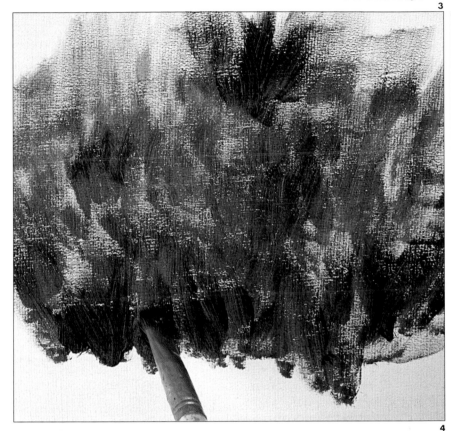

3 This technique is produced with a stiff bristle brush. With paint it is used to depict grass, rough ground or foliage. To achieve this the brush is sometimes pushed up against its bristles and other times used upwards in a flicking motion. Another way is to use the brush in a scrubbing motion to apply the paint.

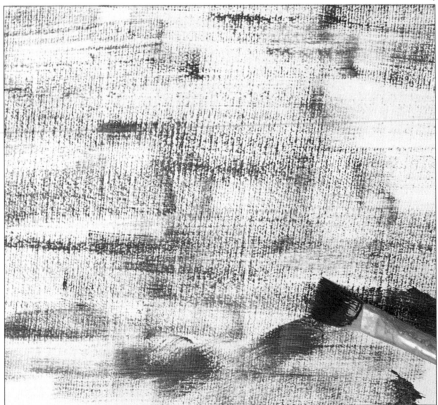

4 Scumbling is a method whereby you can soften or blend with an upper coat of opaque colour, applied very thinly. You can also produce an effect of broken colour by exposing the colour below the top one. This technique employs quite a dry bristle brush with a little paint on it dragged over another colour. This is very useful for creating texture, a dark colour being dragged over a lighter one. It is a technique often employed by landscape artists to depict old fences, tree trunks, roads, etc. Portrait painters often use scumbling, too, when illustrating hair.

SOURCES OF INSPIRATION

Working from Photographs

There is nothing worse than going into an adult art class and seeing the students meticulously copying chocolate box postcards. Unfortunately this sort of activity has given photography a bad name as far as the artist is concerned, and this is regrettable. Photographs used in the right way can be a great asset to the painter. It is most important only to use photographs that you have taken yourself of objects or, if taken by other people, of subjects that you are fairly familiar with. Perhaps when on holiday something you see really inspires you but there is no time even to make a sketch, then by all means photograph it. The next step is not to copy it exactly but to make several sketches from the photograph, add objects, take things out of the picture, simplify the composition. Now put the photograph away and be creative with your colours. Perhaps you will turn a winter scene into summer, or add a different background. Whatever you do, do not become a slave to the photograph and do not be afraid to experiment; the snapshot should only be your initial inspiration, your take-off point.

Sketching

There is no substitute for sketching, for this is where the artist gains his memory bank, his store of images. Use of the sketchbook cannot be emphasized too strongly. The sketchbook notation is important under any circumstances. It avoids the pressure of time, but serves for jotting down a movement, line, a group of shapes or even the behaviour of light. The student artist should never be without his sketchbook. When preparing to execute a painting on location or in the studio, the sketchbook is an important item. Time spent working out the compositioning, sketching the subject from different angles, will in the end produce a more satisfying image to the artist.

Composing a Still Life

Good material for still-life painting is
everywhere; no one need go in search
of a subject. Look in the kitchen at the
pots and pans, copper and brass, glass
bottles, fruit and fruitbowls; the choice
is endless. What about the shed, the
garage or the garden, even the attic?
These places are filled with objects just
waiting to be portrayed. Actually
choosing a subject and setting it up is
absorbing and enjoyable; this is where
the creativity process begins. Select
objects and shapes that interest you –
an old pair of favourite shoes, a musical
instrument, plants or flowers. Whatever
you choose, be sure that the individual
objects relate to each other, kitchen
pots and utensils with vegetables, or sea
shells next to a bucket and spade. Make
sure also that the background has an
affinity with the subject, flowers in a
vase on a window ledge, toys in the toy
cupboard for example.

Whatever you choose, it is
unimportant as far as the painting is
concerned. An exciting picture can be
made of a cabbage, and a dull one of a
leaping horse.

Painting from Still Life

Once you have chosen your subject and
sketched it, working out your
composition in your sketchbook, you
are ready to paint. The discipline of
still-life painting can be very rewarding
in your progress as a painter and can be
just as exciting and pleasurable as
landscape or any other type of painting,
with less hazards. Working in the studio
away from the distractions of the wind,
changing light and people, you are able
to concentrate on the problems of
drawing, composition and the selection
and mixing of colours.

Many artists throughout history have
been influenced by the disciplines of still
life. By studying these either in
museums or books, you can gain
inspiration and ideas for your own
paintings.

TECHNIQUES – MAKING A CANVAS

Making a canvas does not demand a lot of time, is quite easy to do, cheaper than buying ready-made canvases and, above all, an enjoyable preparation to painting. By shopping around, you can buy canvas at a reasonable price: many mail order art companies sell it at a discount. It can be purchased in linen (this being the best) and cotton – from coarse heavy fabric, suitable for large landscapes, to very fine close weave for portrait painting. Non-multipurpose is not suitable for acrylics, and only use canvas that has been pre-coated with gesso. Stretcher – the wooden frame that the canvas is attached to – can be purchased in all lengths, usually in 2 in (5 cm) intervals, for example 16 in (40 cm), 18 in (45 cm), 20 in (50 cm) etc.

1 The tools needed for making a canvas are a hammer, scissors, staple gun or tacks and a tape measure. A carpenter's hammer is handy, as is a small block of wood.

2 The stretchers are put together; usually they can be attached by hand, a tap of the hammer afterwards securing the corners well into place.

3 Measure the frame diagonally in both directions. Checking that the measurements are exactly the same will ensure that the corners are perfectly square.

4 Place the stretcher frame on to a piece of canvas, allowing a 1½ to 2 in (3.75 to 5 cm) cut all around.

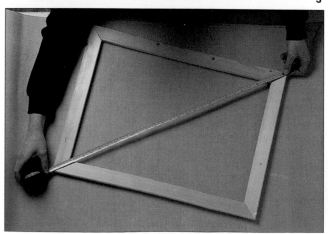

1

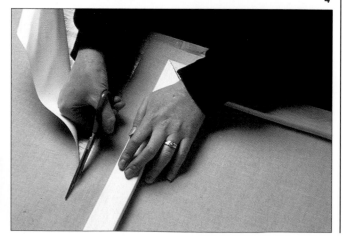

2

3

4

5 Beginning from the centre of one of the longest sides, staple or tack the canvas into place, move to the opposite side, pull and staple. Work all the way around the canvas in this manner, moving from side to side, omitting the corners.

6 Bend in the point of the corner creating two ears.

7 Flatten the two ears to form a flat diagonal line, and put two staples across this seam.

8 With the corners finished and the canvas stretched, now is the time if you are using raw canvas to prime it. Three coats are·advisable.

Chapter 5
Exploring Acrylics

Acrylics can be applied to any non-greasy surface, which in itself gives a lot of scope. Paper, cardboard, wood, canvas, tin, glass, even walls, are all exciting and possible supports. As for techniques, acrylics can be used quite simply just by mixing them with water and employing them like poster paints, or you can experiment with them to their fullest potential. Use them like watercolour in thin flat washes, try them straight from the tube as thick impasto oils, mix them with a medium and glaze, or use larger brushes and paint a mural size picture.

The problems encountered when learning to paint with acrylics are basically the same as with any other medium – difficulty with composition, perspective and colour etc. But as far as the actual materials are concerned, if comparing oil, watercolour or acrylic, then acrylic is far the easiest medium of all to handle.

Learning a few simple rules about painting is a help in the beginning and once you begin to break the rules it will be an indication that you are becoming more proficient. When you begin, choose a familiar subject, something that you see everyday; it will help as you will already have a good idea of the required shapes.

It is quite important to be able to draw but with practice this will come, try using a sketchbook whenever you have a spare moment. Don't be afraid; every stroke that you make with the brush is a step in the right direction. Painting, it is often said, is drawing with a brush. Practice makes perfect.

In this chapter we shall explore not only handling acrylic but also some of the basic points of putting together a painting, composing a picture. We shall discuss the basics of form, the shape of your proposed painting and the positioning of the focal point in a composition, with some guidelines on how best to use the available space. Perspective, both linear and aerial (colour) is an enormous subject which many students find daunting, but this is covered as simply as possible. With a little understanding of its principles you will find that you look at things differently and will feel more confident in translating them into paint.

FORM

Form is a device that artists use to explain the shape of the images in their work, whether they are representational or abstract. To make form more understandable, the artist employs light and dark. When a painting is of one value, no lights and darks, we say it is 'flat'; it has no form. When an object is lighted from one side by the sun or artificial light, this means the delineation of form is expressed by

sharp contrast of light and dark. This effect is shown and formalized by means of at least three values. The diagram on this page demonstrates this in monochrome; the image is made up of a light, middle and a dark tonal value. These values explain the shapes of each object clearly. On the opposite page, the same diagram is shown, but this time in colour. The values are still the same, just the hues are different – the darkest

areas of the blue, green, red etc. are equally as dark. On the square objects note that the colour value, light or dark, stops at the sharp edge where there is a definite change in direction, whereas on the round objects the curves are continuous and gentle. The darkest and lightest areas do not finish as abruptly nor do they continue to the edge of the drawing because in reality there is no edge on a round object: it is not a flat

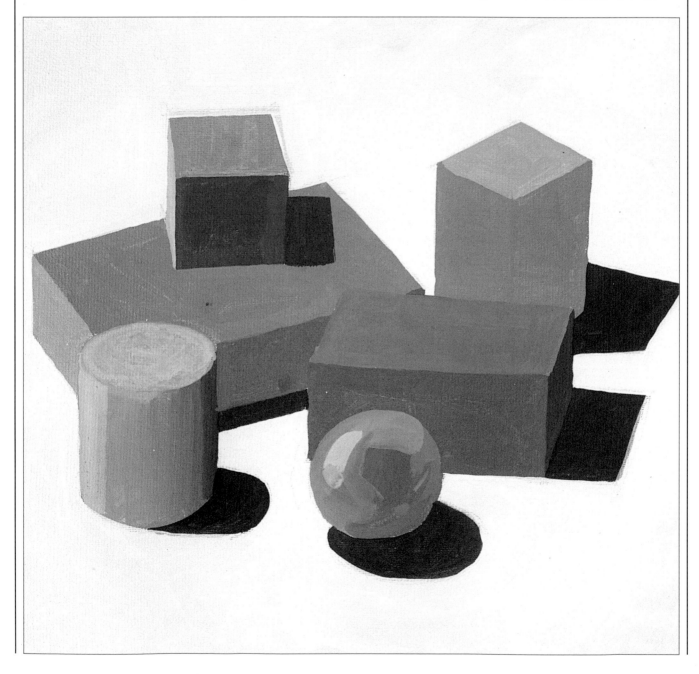

shape, and so there is always a reflected light coming around.

We do not see form; we see only one surface of an object as we see a photograph, flat. Learning to draw solid shapes is almost a re-education of the senses. Since we were born, we have been touching objects, feeling their shape, walking around the back, so trying to see things as flat shapes is a new idea to us.

You can learn to compose with forms as well as with lines. Objects may be placed in relation to each other by means of light and dark to show their position in space – a dark object placed against a light one, or a dark background for a light subject. The painter's problems are similar to those of the sculptor; the artist refers to weight, modelling, finding the form and other terms which have to do with the

appearance of actual solid forms, with the difference that painting is just a set of symbols on a flat surface which are recognizable to the observer.

The shapes of these objects both in black and white and colour are easy to recognize as value is used to describe their solidity.

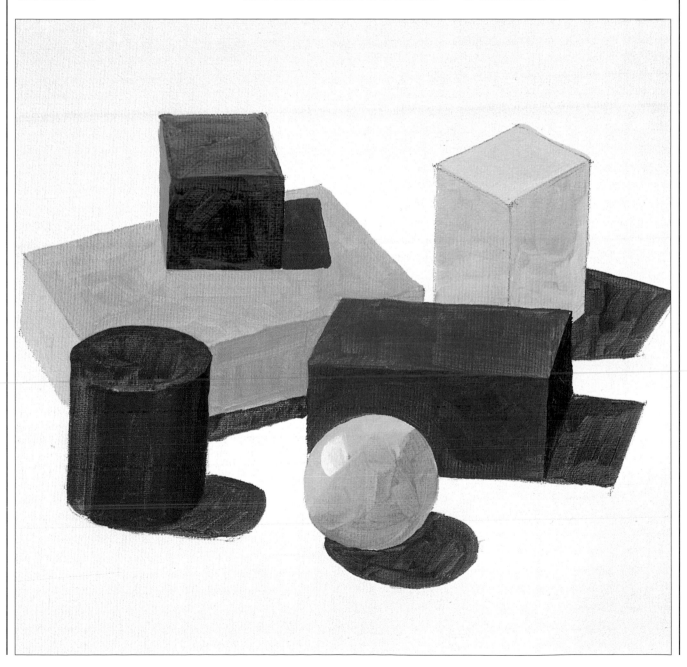

COMPOSITION

Compositional standards and ideas change from artist to artist and year to year. Some artists will forget all rules of composition. Here we suggest a few basic rules to use as guidelines in the placement of an object. In the first picture the vase of flowers and the table seem to be falling off the left side of the support. Altering the angle of the top right corner of the table and carrying the line to the lower right side of the

canvas would remedy this.

The second picture shows the vase seeming to disappear off the bottom of the picture, showing the whole vase would have been better.

In picture number three the subject is too close to the bottom and the right side of the canvas and the edge of the table leaves the support at a corner forming an arrow which leads the eye out of the painting.

In the last picture, the vase is well placed on the table. The table leaving the support on three sides, anchoring the image on the picture. A well-knit composition holds the eye within the surface of the picture plane.

POSITIVE AND NEGATIVE SHAPES

Positive shape refers to a space completely enclosed by a contour. The empty spaces between distinct forms are often referred to as negative space. The problem in painting is not defining the terms but how to recognize negative areas and transform them into positive shapes. All space on the painting surface must be positive. The artist must work towards encompassing all of the allotted space within some form of contour and holding that space within the boundary lines of the painting. The eye must never be forced out of the picture by negative areas; all parts must hold the interest of the viewer with line, texture or colour.

In the first illustration the subject (positive space) has been removed to leave the background (the negative space). In a profile portrait, when the face is looking decisively one way, the space that the model looks into is positive and the area behind the head is negative. For this reason, much more space should be in front and very little behind.

One must be careful when composing a painting not to clutter negative space with incidentals, stones, tree stumps, etc. This very often emphasizes the negative space, making it appear fragmented.

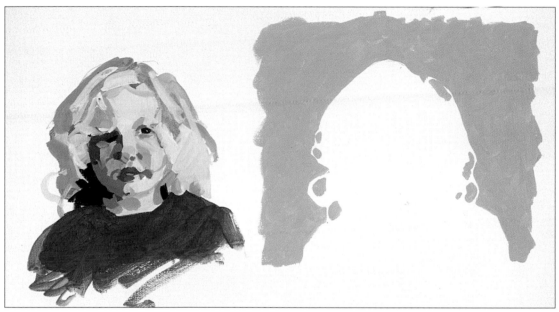

AERIAL PERSPECTIVE

Sometimes called colour perspective, this is the art of creating the impression of distance in a painting and bringing the foreground close.

When standing on high ground and looking into the distance to hills and trees, we notice that the further away the range of hills, the lighter they look; very often the furthest hills will look only a shade darker than the sky. This is especially noticeable on a summer evening when the mist is rising, or early in the morning. Looking into the distance one sees layer upon layer of trees – all in flat shades of grey, a tonal picture in itself. To give the illusion of depth in painting the artist must capture this phenomenon created by the moisture and miniscule dust particles in the atmosphere. In the distance, details of hills, meadows, houses and trees become vague and colours fade. Each colour becomes bluish, sometimes almost violet. You can still distinguish between a meadow and a wooded area, or between a winding road and a winding river, but distant scenery resembles something covered by a light blue veil on a sunny day. To keep colours in perspective the painter should save the brightest and strongest colours for the foreground.

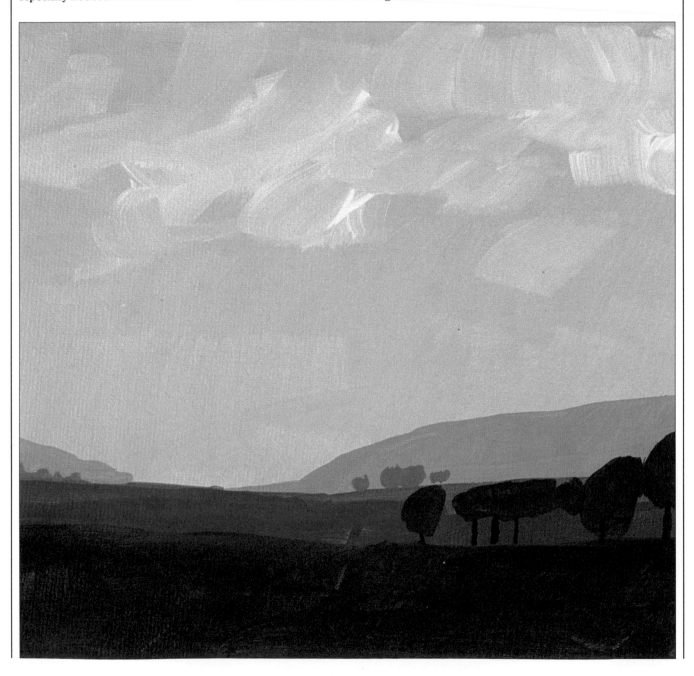

To draw a three-dimensional object on a flat (two-dimensional) piece of paper, some knowledge of linear perspective is essential.

We do not see objects, angles and lines as they actually are. They diminish in size as the move into the distance. Hold a pencil in front of your eyes and look down a street, corridor or long table, then measure the width of the distant end along your pencil and then measure the closer end and compare the two. You will find that the closer measurement is far greater than the distant. This is how we must draw it although we know in reality that if we actually measure the table top, it will be exactly the same width at both ends.

But to produce a convincing picture, we must draw as we see. Parallel lines (the edges of the table, sides of a road, etc.) never actually meet, but in perspective, the way we see them, they seem to. They always meet at our eye level, which in art terms is called the horizon. The point at which the parallel lines converge on this horizon is known as the vanishing point. Our horizon line corresponds with our position. If we stand up to draw it is higher than if we sit down. This is, of course, because we are altering the level at which we see, our eye level. Parallel lines below our eye level come up to it; the horizon and parallel lines above our horizon come down to it. The drawing on this page shows that the artist's horizon (eye level) was at the top of the ground-floor windows. Here we can run a straight line through the picture; all lines below this horizon come up to it and all lines above come down.

Using a right angle triangle the artist checks the vertical lines in the drawing.

Watering Can and Flowerpots

EXPLORING ACRYLICS

The ellipse shape (the elongated top or bottom of a round object) almost always enters the world of the beginner painter at an early stage.

Here we explore the putting together of ellipses along with other shapes and compose a picture of simple objects found around the home. Tea cups and saucers could be used though they would probably be more difficult because of the handles, but any objects of simple shape found in the home can be used for this demonstration. Man-made round shapes (pots and watering cans) and a square shape (box) were chosen because they are perhaps the most common of all shapes that we see around us.

Choose the support (board or canvas) on which you are going to work so that it suits your subject. A tall narrow support will not contain a square subject – that is, where the subject's height is the same as its width. Likewise, a square canvas will not suit a subject such as a long thin figure or landscape, so choose your support carefully.

Once you have the surface on which to paint the next problem is where to begin. If you draw the largest or most important object on to the board, placing it where you instinctively feel it goes best then it is easier to relate all other objects to this, comparing size and looking to see how far up, down or across the additional objects will be in comparison to the shape which you have already drawn.

The painting of the pots and watering can is built up in quite a simple way – first the drawing, then building up the painting, middle tone (colour) first, then dark and finally light areas.

If using acrylic paints for the first time here are a couple of hints which you may find useful. First, it is a good idea to use a plant atomizer (the type used to humidify plants) to spray the paints squeezed out on to the palette. Doing this every fifteen minutes or so will keep the paint moist and usable for a much longer period of time – acrylic paints tend to form a skin over them if allowed to dry. Second, it is important to have two or even three large jars of water by you at all times as the brushes must be kept in water when not in use – acrylic plaint allowed to dry in the brushes will be almost impossible to remove. Always give the brushes a thorough clean at the end of a day's painting.

Materials: Canvas board 20 in × 24 in (50 cm × 60 cm); brushes – Nos. 2, 7, 10 and 12 flat; disposable palette; water sprayer to keep paints moist on the palette; 3 large jars of water; rag or paper towel.

1 This subject was chosen by the artist to demonstrate the use of common shapes – circles and squares – found in our everyday environment. Displayed in a good light, the subject can easily be divided into three tonal values – light, middle tone and dark.

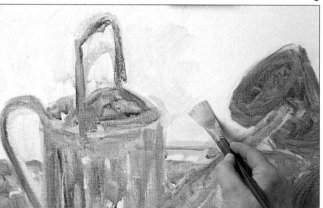

2 The objects are drawn on to the canvas using a No. 7 brush dipped into burnt sienna greatly diluted with water. Drawing with a brush is much simpler than it perhaps seems, it allows a lot more freedom than using a pencil or charcoal. If a mistake is made it can quickly be wiped out with a damp rag. Don't be afraid to paint large; draw the biggest object first and relate all other shapes to it. When drawing ellipses, take your stroke the whole way around as it flows much easier than just drawing a part; you can always wipe out the part that doesn't show.

3 Satisfied with the drawing, the artist squeezes out the rest of the colours to be used on to her palette, giving the paints a quick spray with the atomizer to keep them moist. Using a No.10 bristle brush and diluting the paint, the middle tone colours of each object are blocked in. Ultramarine blue and burnt sienna are mixed for the watering can, cadmium red and burnt sienna for the pots and tiles. Raw sienna is used for the wooden box, the front being painted in lemon yellow which is carried through for the background.

4 With an even layer of thinnish paint over the whole canvas, all areas are blocked in, including the tiles on which the objects are standing. The artist now begins to apply the darks – first to the watering can, using a stronger mixture of ultramarine blue plus burnt sienna straight from the tubes and applying it with a brush dipped into water.

5 Using a No. 10 brush the artist applied the darks to the flowerpots. The mixture used is cadmium red light, burnt sienna and ultramarine blue. In this detail you can see that the brushstrokes are quite free – try to achieve this yourself.

4

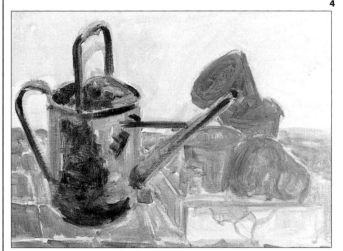

5

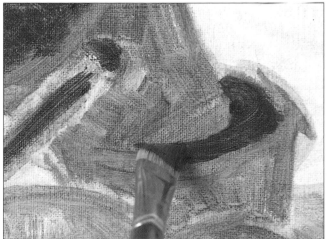

6

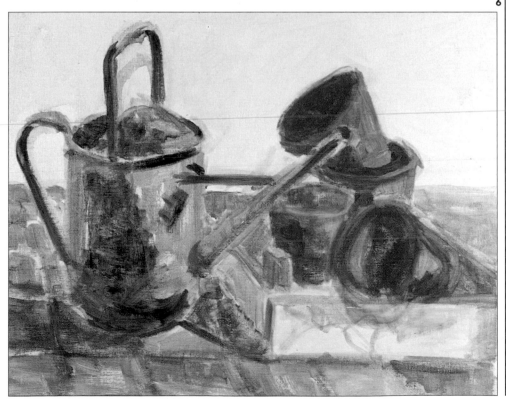

6 The painting is now beginning to take shape; all the darks have been added including some shadow areas. The darks in the yellow areas were painted in violet – a mixture of ultramarine blue plus carmine. A great way to distinguish between light and darks is to look at the subject through squinted eyes. Doing this makes the darks appear to be darker and the lights much brighter, leaving the middle tones quite flat. At this stage the shape of the tiles has been emphasized by adding darker paint.

7 Now the subject is looking recognizable we can begin really to paint, building up the layers. Here the artist has added white to her palette, painting the background with a No. 12 bristle brush in cross-hatching strokes. The paint used is lemon yellow, and a little violet (made from ultramarine blue plus carmine) mixed with a lot of white. Be careful not to over mix on the palette, allow the paint to mix as you paint and remember to spray your paints on the palette with water.

8 The artist brings the background well over the objects, making sure that she leaves enough showing to indicate their edges. By the time the flowerpot is painted the background will be dry (the beauty of acrylic) so there will be no fear of a muddy mess.

9 The background colour is brought down to the tiles which are levelled up by painting over the edge of them. It helps to work from the background to the foreground and to overlap the paint on to objects in front so as to avoid white gaps all around each shape or object.

7

8

9

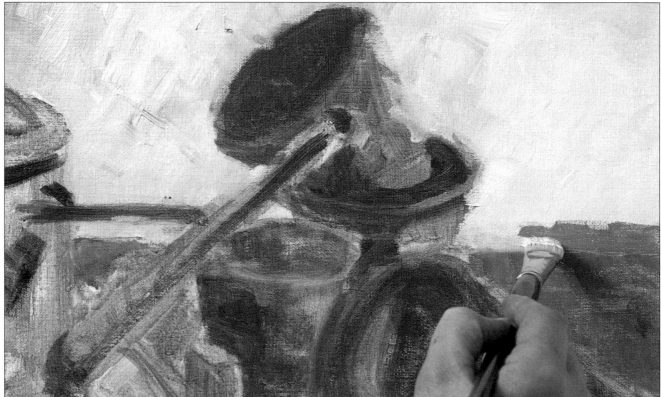

10 The tiles are now painted, as in the picture they form a background for the objects; that is, the watering can and box containing pots are in front of the tiles. Once again the artist works well up to and over the edges. For the tiles she uses a mixture of cadmium red light, burnt sienna and a touch of ultramarine blue. Keep your brushes in water when not in use.

11 While the paint is still slightly damp the artist uses the pointed handle of a brush to scratch some lights back into the paint to indicate the edge of a few of the tiles. Using paraphernalia other than brushes to make marks on a painting is not cheating as some will have you believe; all that matters is the end result and that you are happy with it.

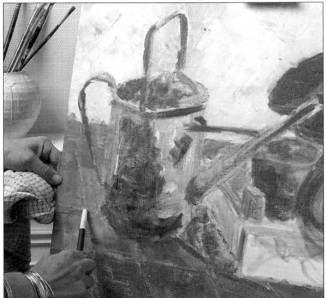

12 The artist now returns to the objects, having completed the background. Burnt sienna is applied with a No. 12 brush to parts of the watering can to indicate rust. Darks are strengthened where necessary and highlights are added to the handle, the spout and drum. A little ultramarine blue and burnt sienna added to a lot of white is the mixture for the highlights on the can.

13 Edges are sharpened; where the background overlapped the objects is now repainted. One long stroke of the brush, a No. 10 flat, will suffice for narrow parts such as the spout and handle. Highlights are added in the same way.

14 The artist now paints the flowerpots, strengthening the darks if needed, straightening up the edges and adding highlights. These are made by mixing cadmium red, burnt sienna (a little of each) plus titanium white.

15 Continuing with the flowerpots, detail is added. A crack is put into the foreground to add a little character to the painting. Details of flowerpot lips are put in and the shadows separating one pot from another are given attention.

16 The artist has once again scraped away some paint to indicate the edge of a tile; she feel that this shadow being in the centre of the painting needed breaking up with a touch of light. This time the paint has to be scraped out with a knife as it is completely dry.

17 The wooden fruitbox is painted – raw sienna with a touch of violet (ultramarine blue plus carmine) for the darker areas, raw sienna and titanium white for the light areas and the back of the torn paper. A little shadow is applied on the box behind the torn paper to really make it stand away. The detail is painted with a No. 2 flat brush, the letters added using cadmium red.

17

18 The painting is complete. The artist steps back to take a long scrutinizing look, checking to see if anything is not quite right. The wonderful thing about acrylic is that at this point small corrections are very easily made. Still-life subjects are all around you, nothing is unworthy of being drawn or painted. A little time spent drawing familiar objects each day will help tremendously when it comes to putting it down in paint. By following the steps of this painting almost anything around you is paintable.

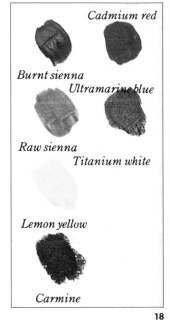

Cadmium red

Burnt sienna

Ultramarine blue

Raw sienna

Titanium white

Lemon yellow

Carmine

18

Seascape
EXPLORING ACRYLICS

How often have you sat on a beach enjoying the view only wishing that you could paint it? Here the artist demonstrates how, using acrylic paint, you can do so. This medium is ideal for painting out of doors; it can be applied with virtually any brush, large or small, on any size support. Even quite large paintings can be produced in a comparatively short period of time; this is important, as any painter who has battled with the elements will tell you. Conditions may look fine as you set out on your painting trip but weather conditions change.

In this painting the artist composes a picture using three main elements: the large shape of the sky, the land mass and the sea. Using large brushes and attacking the problem boldly, paying little attention to any particular technique she demonstrates how even the most inexperienced artist can produce a work of art. Each section of the canvas is painted directly, no underpainting first. The sky is painted very quickly using three values, light, middle and dark, and while still wet all are carefully blended together. Great depth is achieved by layering the cliffs, making colours stronger as they approach the foreground.

The only detail to the rocks is in the foreground; distant ones are painted flat. It is the uneven brushstrokes that give the impression of detail. A large brush used in a relaxed way will produce a fairly competent painting without too much frustration.

Materials: Canvas board 16 in × 20 in (40 cm × 50 cm); brushes – Nos. 10 and 12 bristle brushes, No. 3 watercolour brush, 1 in (25 mm) blender brush (a household paintbrush can be used instead); disposable palette; water atomizer – to keep paints moist on palette; 3 large jars of water; rags or paper towel.

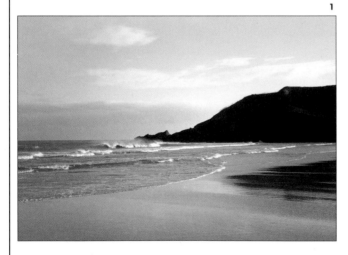

1

2

1 A typical photograph taken by many of us when on holiday at the seaside. The artist has decided to elaborate on this subject, adding more cliffs in the distance and detail into the foreground cliffs and beach. You will find that the more you paint the easier it is to add to your paintings or take away objects not required. If you feel that your imagination doesn't run to this yet, there is no harm in taking ideas from several photographs (preferably ones that you have taken yourself so that you have a feel for your subject) and putting them together in one painting.

2 The drawing is made with a No. 10 brush using ultramarine blue greatly diluted with water. The support (canvas board) is simply divided up into three main shapes: the sky, the sea and the land. Make sure that no two shapes are of similar size and shape, and check that the horizon line does not cut your support in half.

3 First, the artist applies the blue of the sky, working fairly thickly and direct, no underpainting. She thinks about the shapes of the clouds and the kind of sky she wishes to paint. Here she makes it more windswept than the photograph. The blue patches of sky are a mixture of Rembrandt blue, ultramarine blue and white. After this has been applied, dark areas for the base of the clouds are added, using the same mixture of blues and adding burnt sienna. The dark at the base of the clouds is actually a reflection of what is below: land, sea etc. Work fairly quickly so that the sky colours do not dry before you have them all on the canvas.

4 Pure titanium white is added to the bare patches of canvas board and, while the whole sky area is still fairly damp, a clean, dry 1 in (25 mm) or 1½ in (38 mm) blender brush is used to create a blended misty atmosphere. To do this just drag the brush back and forth across the wet paint.

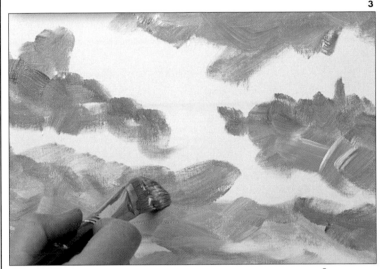

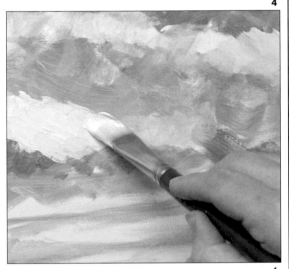

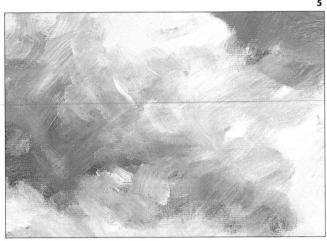

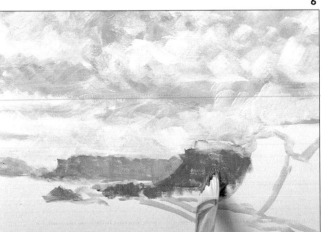

5 This detail shows how the clouds have been softened with the blender brush. Acrylic paints do dry fairly quickly, so to achieve this nebulous effect the artist must also work quite fast. Of course drying time depends on the atmosphere. A painting rendered outside on a misty day will take much longer to dry than one painted in a warm, centrally heated studio.

6 Working from the background to the foreground the artist paints in the cliffs. Using the same mixture that was used for the grey in the sky, but adding more white to it, the distant cliffs are painted in a flat mass. Detail cannot be seen in distant objects. As the artist moves forward to the next cliff protrusion she adds more of the blue and burnt sienna mixture to darken the grey a little. And so on to the third group of cliffs.

ACRYLICS

7 This area is still a little darker, and detail is beginning to appear. Depth is shown in a painting by strengthening and weakening colour. Distant colours are weaker, lighter; close-up ones are much stronger, darker. This effect is called aerial perspective. Detail is added to this area of cliffs in the form of grass at the top, which is a mixture of sap green and titanium white.

8 The artist, still using a mixture of ultramarine blue, Rembrandt blue and burnt sienna but this time no white, finishes painting the cliffs right up to the foreground, the right edge of the canvas board.

9 Because the cliffs on the right are in the foreground they will not only have very dark areas in them but other values will appear. Here the artist adds some middle tones and highlights using the same grey mixture with titanium white added. Stand back and take a look. The painting is progressing wonderfully and has a great depth to it.

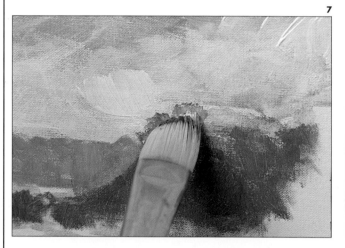

7

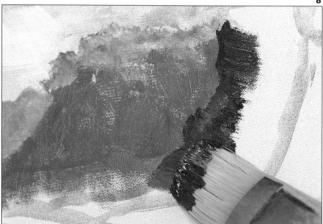

8

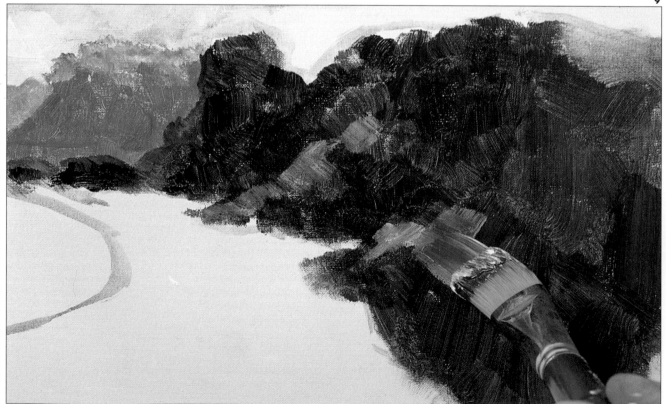

9

10 Still using a No. 12 bristle brush the artist mixes sap green with a little titanium white, keeping the mixture a little stronger than last time, and adds green to the top of the closest cliffs with a fairly free cross-hatching brushstroke.

11 With a No. 10 bristle brush and a mixture of Rembrandt blue, burnt sienna and titanium white the sea is painted in. Beginning with the mixture slightly darker for the distant sea and fairly long, smooth brushstrokes, the artist works towards the beach area. She leaves a little white space at the base of two small rocks which were added while painting the foreground cliffs.

12 As the sea gets closer the brushstrokes become shorter and spaces are left to paint in the white surf. Contrary to the rules of aerial perspective (colours fading as they recede) the sea often looks darker in the distance. Possibly this is because of the great density of volume and colour of the water.

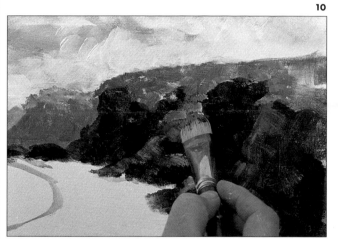

10

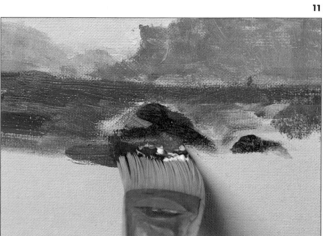

11

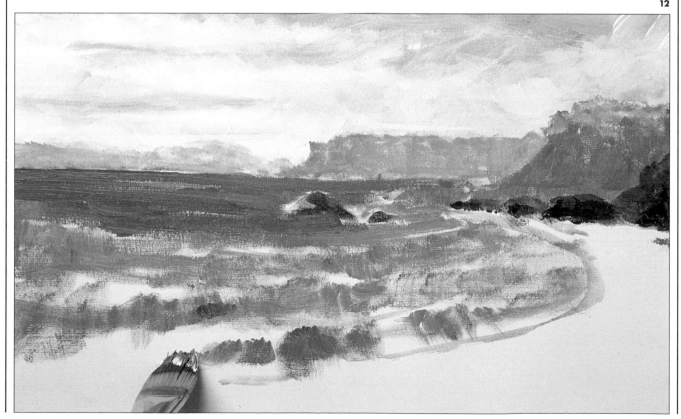

12

ACRYLICS

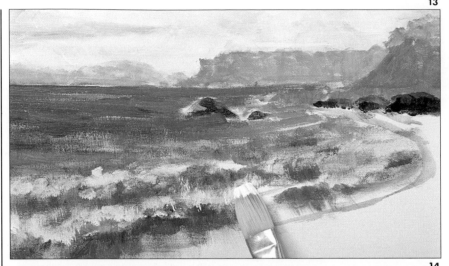

13 While the paint of the sea is still wet the artist adds titanium white, fairly thickly in places. In the distant sea a little white paint is scumbled (dragged) over the dry blue surface with a very dry brush.

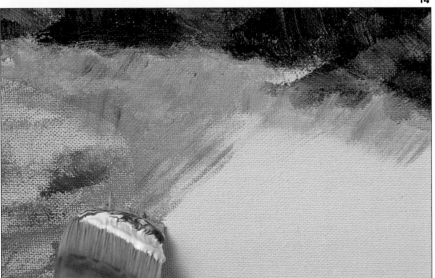

14 After having a cup of tea and allowing the painting to dry (with acrylic this will only take from ten to thirty minutes depending on the thickness of the paint) the artist paints the beach. The mixture is burnt sienna with a tiny touch of ultramarine blue to which titanium white is added to produce the right colour. The colour will get stronger as it comes towards the foreground. The paint for the beach is dragged thinly over the edge of the sea to give the illusion of the water lapping on the beach.

15 A little titanium white is dragged into the beach area to indicate the surf running up on to the beach. The paint is applied very carefully and sparingly as too much white will ruin the effect. If the artist feels that she has overdone this area, the paint can be quickly removed with a damp rag.

16 Extra detail is added to the foreground beach with the help of a sponge (see page 413). Using the sponge in this painting gives the illusion of pebbles or shells on the beach and on the rocks it gives the appearance of holes or barnacles. Dip the sponge into different colour mixtures that have been used throughout the painting. Begin with darks: ultramarine blue plus burnt sienna; and then light: Rembrandt blue plus white.

Don't forget to wash out the sponge after each colour has been applied or use another piece of sponge.

The artist makes a very watery mixture of ultramarine blue and burnt sienna. Using a No. 3 watercolour brush she makes little motifs to represent seagulls.

16

17 To complete the painting, a glaze (a thin covering of paint, see page 390) is laid across the foreground rocks. This adds warmth to the area and brings it forward. This picture could just as easily have been painted on location providing the weather permitted, as it was fairly direct without too many details and stages. It actually took the artist only an hour and a half.

Titanium white

Ultramarine blue

Burnt sienna

Rembrandt blue

Sap green

17

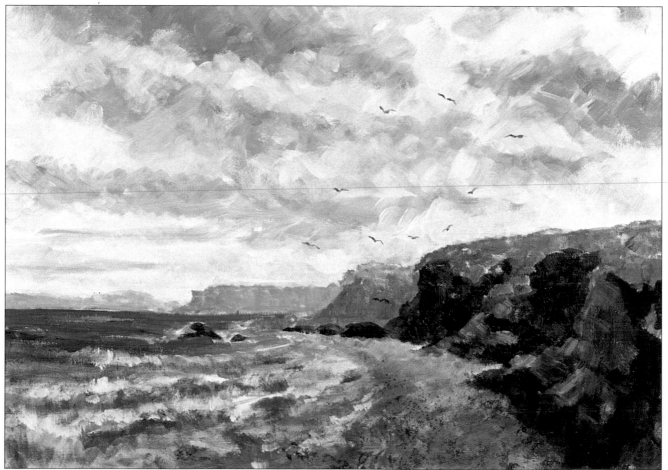

Boater and Blazer

EXPLORING ACRYLICS

This still life was set by the artist to demonstrate the techniques of painting folds both straight and angular. Draped fabric is very often avoided by the inexperienced artist who feels that it is too complicated. Painting folds can be likened to landscape painting, a subject which even the most unskilled artist may attempt.

Rolling hills bear a resemblance to soft folds, while mountains are similar to sharp-edged folds. Observation is the only secret. When attempting to paint a picture which you feel to be difficult, time spent making observational sketches is invaluable. A trick to use when painting folds is to look with half-closed eyes, which breaks the areas into flat values of dark, mid-tone and light. A painting is made up of flat shapes on a flat surface, two dimensional, and learning to paint is actually retraining one's eyes to see the world in a series of flat areas of colour.

In this painting the artist has chosen to take a closer view of the still life. She has moved right in and the subject is touching the peripheral edges of the support. If the back of the jacket was not touching the left edge of the canvas while the rest of the image was going off the bottom and right-hand side of the support, then to the viewer the objects of the painting would appear to be slipping off the right-hand corner. It is quite important to anchor the image on to at least three edges or none at all.

There are as many ways to compose a picture as there are artists. Try different approaches for yourself. Spend time with a sketchbook trying different ideas before you begin to paint. Any subject can make a dynamic painting in the hands of a competent artist. Think about your subject as you sketch, what shape of support would best suit it. Think about the negative spaces (the space around the actual objects) – they should be as interesting as the subject itself. Try to get strong tonal value; it is the contrast of lights and darks that make this painting work so well.

Materials: Canvas paper 16 in × 12 in (40 cm × 30 cm); brushes – Nos. 2, 4 and 6 flat synthetic, Nos. 10 and 12 flat bristle; disposable palette; water sprayer to keep paints moist; 3 large jars of water; rags or paper towels.

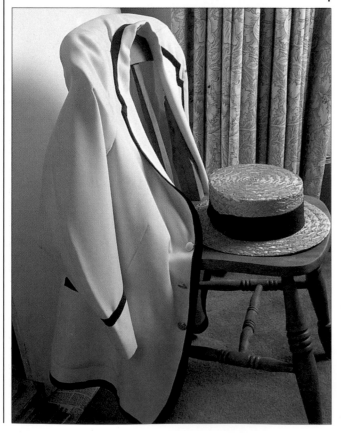

1

2

1 The still life is set up in a corner of the artist's studio. A strong light coming in to the picture from the right-hand side helps to dramatize the folds. Light-coloured fabric tends to emphasize the folds more than a darker colour. Here we have a mixture of straight folds – the drape of the curtains in the background – and angular and curved folds in the blazer.

2 With a No. 6 flat synthetic brush the artist draws in the subject, using a very thin mixture of raw sienna and water. The composition is a close-up 'zoomed in' view of the subject. If you decide to arrange your painting in this way be sure that the subject goes off your support (canvas paper) on at least three sides. In this way the subject will be well anchored to the surface and will not appear to be sliding off on one side, carrying the viewer's eye out of the picture.

3 Mixing cadmium red with Rembrandt blue and using a No. 10 bristle brush, the artist paints in the background. All brushstrokes are diagonal, from top right to bottom left. Darks are painted into the inner folds of the curtains using the same colours. Still allowing the drawing to show through, Rembrandt blue and burnt sienna are mixed and applied in the shadow areas of the blazer. Talens yellow is the underpainting colour for the hat and raw sienna for the chair. Darks are added to the hat and chair using the same mixture as the darks in the blazer. The artist remembers at all times to keep her used brushes in a jar of water and intermittently sprays the paint squeezed out on the palette.

4 At this point the artist steps back to view the painting's progress. This is a very important exercise and it should be repeated many times throughout the painting's evolution. Here she sees that the background is too dark and does not allow a strong enough contrast with the darks of the blazer, so mixing cadmium red with Rembrandt blue and adding titanium white she repaints the background, all the time using diagonal brushstrokes. A painting developed in this technique, with the brushstrokes all going the same way, tends to produce a static uniformity to the picture which lends itself perfectly to this subject.

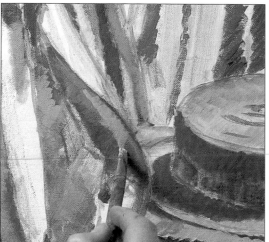

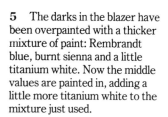

5 The darks in the blazer have been overpainted with a thicker mixture of paint: Rembrandt blue, burnt sienna and a little titanium white. Now the middle values are painted in, adding a little more titanium white to the mixture just used.

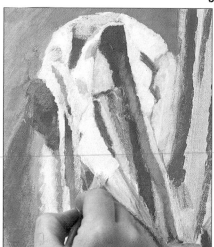

6 Titanium white with a very little Talens yellow added to it is used for the lightest areas of the blazer. Adding yellow or orange to white makes the white area look brighter; it gives a warmth to white. The artist observes the folds of the jacket very carefully; touches of light placed prudently introduce life to the painting.

7 With a strong mixture of Rembrandt blue and cadmium red (so strong that the colour looks almost black) the artist paints in the ribbon on the blazer. For this she uses a No. 4 flat synthetic brush.

8 Details of seams are added in the lapels, shoulders, down the sleeve and the dart in the jacket body. This is done by dipping the edge of a large flat brush, No. 12, into a mixture of ultramarine and burnt sienna and carefully placing the marks with the tip of the bristles.

9 The artist has added a little highlight in places along the seams using the same method with the large flat brush, only this time using the mixture of titanium white with a touch of Talens yellow. The buttons are now painted, first placing in the darks and finishing with a light touch for the shiny highlight of the chrome buttons.

10 Paying close attention to the changes in tone the artist paints the curtains. Mixing Rembrandt blue with a little each of Talens yellow and cadmium red she strengthens the darks and adds any which were not observed earlier. Then the middle value is added, mixing a little titanium white with the dark mixture. Finally, the lightest value is painted in, this time adding a lot of white.

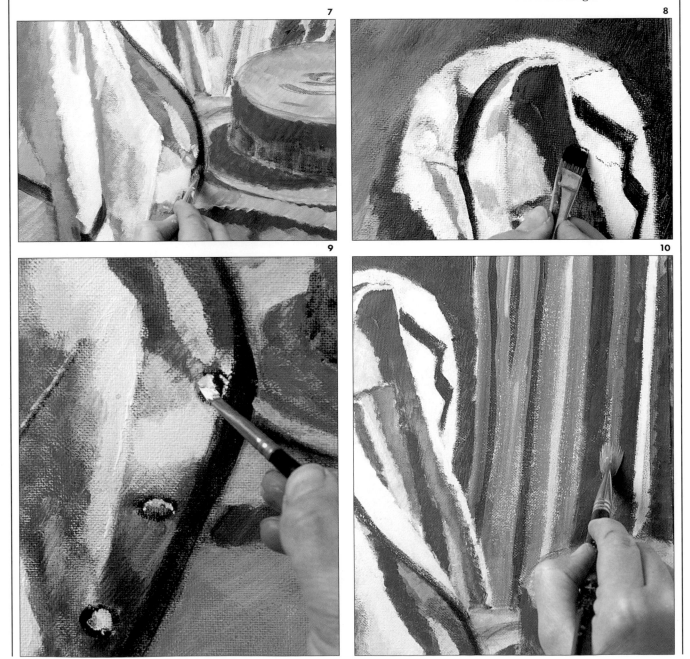

11 All that is left now to complete the painting is the boater and chair. The artist makes a mixture of Talens yellow, cadmium red and a little Rembrandt blue for the dark sides. Then, using the same mixture but omitting the blue and adding more titanium white, she paints the crown and the lighter areas of the brim, scumbling lightly over the darks, allowing them to show through.

The dark edges of the chair are painted with raw sienna, Rembrandt blue and a touch of cadmium red, the light seat and back with raw sienna and titanium white.

12 The final touches are added: shadows behind the buttons, the ribbon around the hat. For these the artist uses the dark mixture of Rembrandt blue and cadmium red light. Adding titanium white to this she finishes the floor area under the chair. What a striking painting a simple subject makes.

11

12

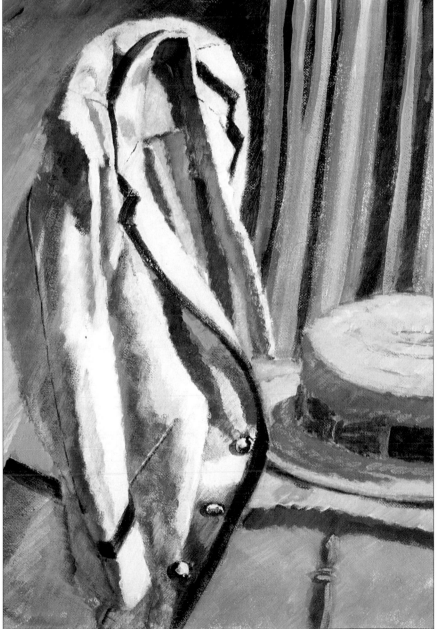

Raw sienna

Burnt sienna

Titanium white

Cadmium red light

Rembrandt blue

Talens yellow

French Street

EXPLORING ACRYLICS

While on a painting trip to France the artist was inspired by this row of very old farm houses with beautiful cobbled courtyards, ivy-covered walls and a backdrop of wooded hills. An area such as this will provide the artist with hours, days, even weeks of work, and it is not necessary to spend a lot of time searching for subject matter. The houses in this street all face into their individual courtyards with only the ends visible as we look along; this provides the artist with a perfect subject for a painting based on perspective.

The artist spends quite a measurable amount of time sketching as well as painting while on location, as this provides her with a store of optical images as well as producing sketchbooks which are a source of reference for the future.

Materials: tracing paper; 2B pencil; kneadable eraser; conté crayon; ballpoint pen; canvas 16 in × 12 in (40 cm × 30 cm); spray fixative; disposable palette; water atomizer, to keep paints damp on palette; 3 large jars of water; rags or paper towels; acrylic gel medium.

Quick sketches of complicated details such as chimney pots, gates, parts of boats etc. take away the guesswork when finishing or painting pictures in the studio.

By using a cool blue, cerulean throughout this painting, the artist has implied a sunny by cool atmosphere. The colours used are mostly delicate, contrast being provided by the strong foreground shadows created by the early springtime sunshine.

1 The artist spent many hours in this street, not only painting but collecting information for further work back in the studio. Many sketches were made of the nooks and crannies, backyards and children as well as photographs taken. This photograph provides a good prospect for a painting based on linear and aerial perspective, the houses and street appearing to diminish in the distance both in size and colour. The houses in this street are quite different as they all face into their individual courtyards, leaving only the ends apparent on the street. This provides a simple scene for the artist to paint, the linear perspective being uncomplicated.

2 The subject is first drawn, using a set square and 2B pencil on to tracing paper (see the second drawing in perspective on page 325). When the artist is satisfied with the drawing, she goes over the lines at the back of the paper with conté crayon and then, using a ballpoint pen, transfers it to the canvas. NB a ballpoint pen is used in the first instance to enable the artist to see which of the pencil lines she has transferred without going over them twice, and in the second, it provides a sharper line than using a coloured pencil.

1

2

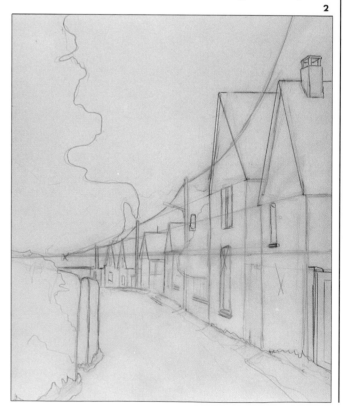

3 After spraying the transferred conté drawing with fixative (hairspray can be used) a tonal painting was made using a No. 10 brush and burnt umber paint. For areas of detail, a No. 4 brush was used.

4 Using cerulean blue and a little burnt umber, mixed with acrylic gel medium, the darks in the sky are painted. Working quickly, not giving the dark sky areas time to dry, titanium white is added to this sky colour and blended in.

5 Using the side of the little finger in a circular motion, the sky is blended. More white is added in places and blended in this same way. The finger can be a very useful tool when painting, especially for areas of sky.

6 Working from the background to the foreground, the artist uses a No. 4 flat brush with cerulean blue, burnt sienna, a little titanium white, mixed with gel medium to put in the distant trees. First the mass is painted and then, using the tip of the flat brush, the trunks are added using burnt umber.

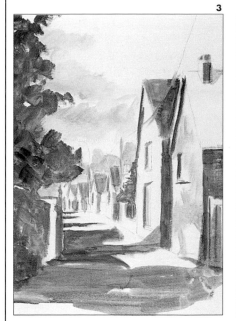

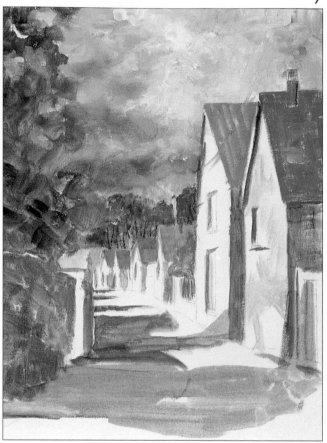

7

8

7 The artist, working from the left side of the painting to the right, paints in the rooftops. For this she uses cadmium red and cerulean blue, adding titanium white for the distant houses. The paint is mixed with the gel painting medium (this stretches the paint, diluting the colour, but does not thin the paint) and applied, allowing the burnt umber underpainting to show through in places. For the light brown roof raw sienna is mixed with cerulean blue and titanium white.

8 With burnt sienna, a little cerulean blue and a small amount of titanium white, the darks are re-established in the houses, keeping the darkest paint mixture for the foreground houses. A little of this same mixture is used to indicate the shadow on the wall by each window, under the window ledges and under the eaves of the overhanging roofs. Following this step, the artist paints the sunny side of the houses using titanium white and raw sienna. For the pink foreground house, she uses raw sienna, cadmium red and titanium white. A little of this mixture is lightly scumbled over the shadow side of the foreground house to provide an impression of detail.

9

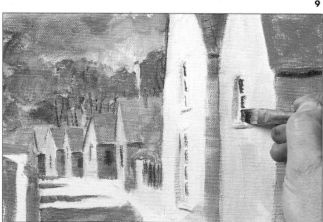

10

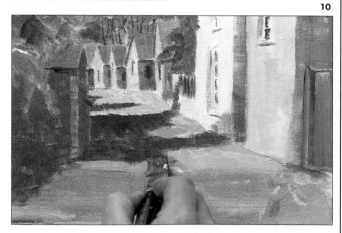

9 Burnt umber, applied with a No. 4 brush, is used to paint in small dark shapes for the inset windows. At this stage all other dark detail is introduced, adding a little titanium white to the umber as it is applied to distant buildings. The fence on the right is added using the same mixture.

10 After painting the foreground gate with cerulean blue, burnt sienna and white, the artist paints the road. This time she uses burnt umber and cerulean blue in the dark areas; raw sienna with a touch of cerulean blue and titanium white in the light ones. Sap green is now mixed with a small amount of titanium white and the artist paints in the short stubble of early spring grass at the base of the buildings.

11 Telegraph poles are added and also the vines, remembering that they will not be taut but will sag in the middle. Using the same brush, a No. 4 flat and burnt sienna, the artist also indicates the wintering creeper on the pink house.

12 The foreground of this painting is not only the road but the tree and wall on the left. To complete this painting, the artist painted this area loosely, without much detail. The subject of the painting is the row of houses. By adding minutiae to the tree and wall in the shape of leaves, bricks etc. the eye would be carried away from its topic completely. The artist has kept all detail away from the edges of her painting except for the right side, where the gate leads the eye down the row of houses and the street to the focal point of the painting.

11

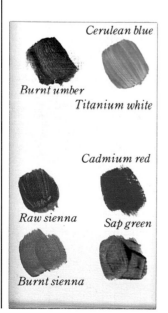

Cerulean blue

Burnt umber

Titanium white

Cadmium red

Raw sienna

Sap green

Burnt sienna

12

Chapter 6
Watercolour Techniques

In this chapter we demonstrate how acrylic paint can be used to do just about everything that traditional watercolour can do and a great deal more. Painting with watercolours can be an exasperating experience for the beginner, but using the same techniques with acrylics can eliminate many of the headaches.

Before embarking on the painting of a complete picture the painter is advised to spend some time practising with the materials: learning to lay washes, flat and graded, mixing colours and experimenting with different types of supports. This is especially important when using acrylics like watercolours as the pigment will soak quite quickly into the paper and will become virtually impossible to remove or correct. Learning to paint is very exciting, but it doesn't happen overnight. One needs patience and time to practise; fifteen minutes spent every day painting a sky or drawing a cup and saucer – it doesn't matter what you draw or paint – will very quickly add up and in a relatively short while you will discover that your work is improving and that you are enjoying it more and more. A little time spent frequently is a hundred times more effective than a longer time, say two hours, but only once a week.

And so to start a painting. Whether practising with the medium first or going straight in, it is quite important to prepare a fairly accurate drawing to begin with. The first washes are laid and left to dry – this is where using acrylics has an advantage as once this first wash has completely dried nothing will remove it, so subsequent washes can be painted quite freely without fear of disturbing the first layer or lifting it. Because each successive touch of the brush doesn't dissolve the underlying tone, every stroke retains its precise shape and colour. Several layers can be applied without producing muddy tones.

When using the traditional water medium, one is normally advised to work from light to dark as it is almost impossible to apply light paint over dark. In acrylics this is not so; a lighter colour can be applied in a semi-transparent wash over a dark area and still retain its transparency. However it is advisable to begin the painting by working light to dark.

Many people find it virtually impossible to tell the difference between a painting executed in traditional watercolours and one painted using similar techniques only in acrylic paint.

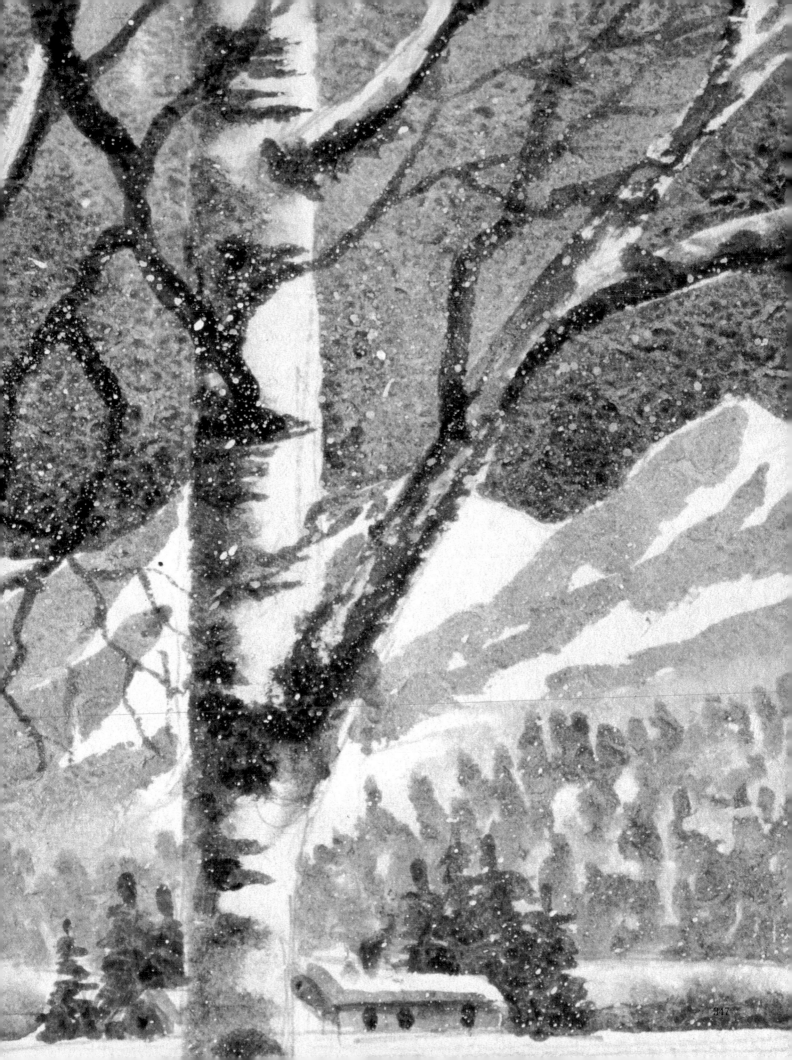

347

Techniques

WET IN WET

'Wet in wet' is a watercolour technique which can be employed by the acrylic artist with great satisfaction. The paper can be completely soaked in a sink or bath or small areas can be wetted with a brush. It takes time to recognize when the paper is ready to receive the paint. If the paper is too wet, the paint will just disperse everywhere, completely out of control. If the paper is too dry, the paint will not move at all, but just form a hard edge. The secret is to wait until the shine has just disappeared on the surface; some of the water has evaporated and the paper has absorbed the rest. At first, it means staying fairly close and keeping an eye on it. Going off to make a cup of coffee while the paper reaches its required state is fatal; all too often you will find that is has passed the right stage and is too dry.

If you wish lightly to draw in your subject, this should be done before the paper is wetted.

Once the paper is ready – still quite damp – apply the paint to the desired areas. You will find that it slowly runs and is quite controllable, effecting soft edges. With acrylics, once the first wash has been applied and is thoroughly dry, the paper can be completely rewetted to apply the next and subsequent layers. Details can be added finally when the paper is dry.

1 For this demonstration, the artist used unprimed hardboard for the support. Using a No. 12 large bristle brush and lemon yellow mixed to a very fluid consistency with water, she very freely applied the drawing.

2 Drawing in this way, lines can be pulled or large areas blocked in to describe the object.

Acrylic paint works wonderfully well in watercolour techniques and for the beginner it is easier than the traditional medium as once it is laid and dry no amount of overworking will disturb it or muddy the colours.

The traditional technique as used for hundreds of years by many well-known artists is the building up of values in the form of flat washes, working from light to dark, allowing each wash to dry completely before adding the following one. No white paint is used; the white of the paper is saved or used for pastel tints.

A great master of this technique was John Sell Cotman 1782–1842, a member of the Norwich school. His work is well worth studying. His paintings have a clean, fresh crispness about them; they are linear patterns of flat smooth shapes.

The following demonstration shows how this technique is applied, and whether it is a plant pot that you are painting or some other object, a field, a house or a person, the same principles apply.

1

2

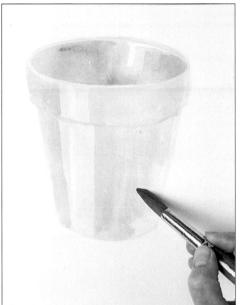

1 After the plant pot is lightly sketched, the artist applies a thin wash of paint, omitting areas (saving the white paper) in areas of highlight or shine. The colours used are a mixture of burnt sienna and cadmium red thinned down with water.

2 The light source coming from the right, the artist paints in the second value over the original wash which is completely dry.

3

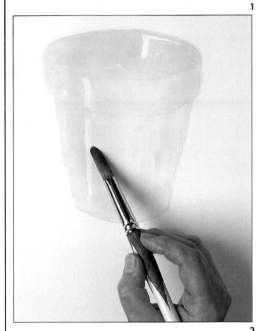

4

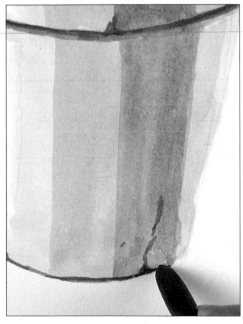

3 The third and darkest value is added. Note that neither the darkest dark nor the lightest light are at the edges. To do this would flatten out the round object.

4 Final details are added with the colour mixed a little stronger than the strongest value in the object – under the pot, in the cracks and under the rim. This technique can be applied to all subjects.

USING WHITE SPACE

When using acrylics as a watercolour medium, we apply the same rules, and the most important is not to use white paint. The white of the paper furnishes the light areas. To make a colour lighter, thin it down with water; when applied to white paper it will appear as a light shade.

1 When painting a dark area behind a light or white area, it is advisable first to sketch in the areas to be saved and to paint carefully around these areas. In this demonstration, only the trunks and main branches have been kept white. Further along in the painting, the artist would darken parts of these areas and save space to represent snow blown against the trees or the white birch of the silver birch. It is advisable to plan the picture carefully when intending to save white areas, as once it has been painted over, even if removed immediately, it is impossible to regain the crisp whiteness of the paper.

2 It is recommended to use it with quite liquid, very wet paint. To achieve the knobbly effect of branches, push the brush with the tip of the bristles slightly bent. Flicking it will create grasses and reeds and by pulling it you will be able to create long lines such as telegraph wires, clothes lines and rigging. To make a line that goes from thick to thin press down on the brush and as you move along the line, gradually lift off and lessen the pressure until you have a fine line.

3 The toothbrush is a useful adjunct to the artist for adding texture and atmosphere. Here, loaded with white paint, the thumb is drawn across the bristles causing the paint to splatter on to the painting, giving the illusion of snow. Used with dark paint on tree trunks, old wooden boards and rocks, it gives the illusion of tiny holes. Different colours, such as ultramarine blue and orange splattered individually on to a road, gravel path or beach can produce interesting textures.

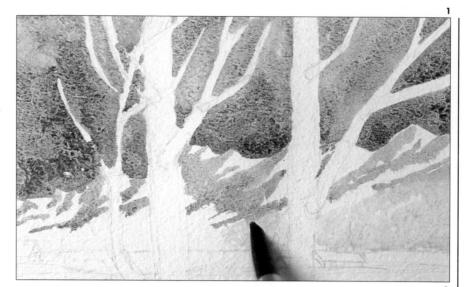

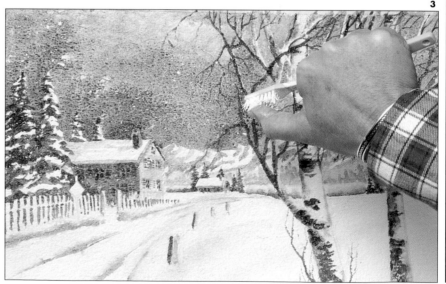

Masking fluid is a rubber solution which can be applied to paper to save white areas. It is especially useful for minute areas such as seagulls in a strong blue sky or flying in front of dark cliffs, for blossoms on a dark green tree or tiny highlights on a shiny surface. To apply it, use an old paintbrush or a pen. It is a good idea to keep one brush especially for this project. If the bristles of the brush are rubbed on to hand soap before use, the masking fluid will wash out easily.

1 Masking fluid should never be used in the sun as the sunlight changes its properties and it becomes very sticky and virtually impossible to remove. Also it should not be left on the paper for weeks and weeks as this too will make it difficult to remove.

2 After the masking fluid has completely dried, you can apply your paint over it; either one wash or several, it won't make any difference.

3 The painting finished and absolutely dry, the masking fluid can be removed. To do this, lightly rub your clean fingers over the areas where the fluid is applied and it will just roll off as stretchy little bits of rubber. Another way to remove it is with a putty eraser.

Old Car

WATERCOLOUR TECHNIQUES

This old car has stood for many years waiting patiently to be restored, resting silently on its bed of ever-changing foliage. Whatever the season, it stirs the imagination of the artist. The ruggedness of the old metal and the sharp edges are complemented by the softness of the rolling sky, the misty distance and the roundness of the little blue car in the background.

Painting with a limited palette of only four colours, the artist used acrylic paint in the traditional watercolour technique of laying one wash on top of another, each consecutive layer being darker than the one before. Using acrylic in this way is perhaps easier than using the traditional medium. An initial wash over with watercolour can be tricky. If the artist passes the brush over the same area several times, the underpainting (first wash) will lift and mix with the current colour. With acrylic this is not possible, as once the paint has dried it is permanent. Of course nothing is perfect; the one drawback is that the acrylic acts as a size paper sealant, and the second wash is not absorbed by the paper but lies on the top. It must be added, though, that only the most trained eye will be able to ascertain if the work is rendered in the traditional medium of watercolour or acrylic.

In this painting, the artist has created her own sky to complement the diagonal line of the car. Painting skies is exciting and the artist can be very imaginative, creating a sky that will dramatize the subject. The painting was built up from background to foreground, soft layers of flat washes providing a mysterious backdrop for the historic cars.

Masking fluid is used sparingly by the artist to save small areas of white paper. It can be a wonderful adjunct to the painter when used correctly, but too much of it will ruin a painting. The fluid should only be used for small areas where it is fiddly to go around each little area with the brush. It is very useful for saving highlights on shiny metal and glass, as is used in this example. Using the masking fluid in large areas could prove to be quite disastrous; the surface of the paper can be damaged and it can produce hard mechanical edges. It was also found to be useful for the foreground of this painting for the light foliage growing in front of the dark undercarriage of the car. It would have been very difficult to paint around each leaf, and the finished painting would have appeared to be much busier at the bottom, therefore taking the eye down and away from the subject.

1 This old car, a Rover, belonging to the artist's brother who for years has threatened to restore it, has been the inspiration for several paintings. From this angle, it provides a dramatic subject, proud and majestic on its throne of weeds. The rounded and not quite so old Austin in the background provides the artist with a subtle contrast.

Materials: Waterford HP 140 lb (300 g) watercolour paper 15 in × 11 in (37.5 cm × 27.5 cm); 2B pencil; putty eraser; brush – No. 20 synthetic watercolour brush; disposable palette; water sprayer to keep paints moist; 3 jars of water; paper towel; masking fluid.

2 Using a piece of Waterford 140 lb (300 g) watercolour paper, the artist sketches out the image lightly with a 2B pencil. If a mistake is made, she uses a putty eraser to remove it, this being more sympathetic to the paper than an ordinary eraser. It is of the utmost importance not to damage the surface of the paper as it will not receive the paint smoothly. After the drawing is complete, masking fluid is applied to all areas of the cars which the artist wishes to remain white, highlights etc. and left to dry. She also applies masking fluid where lighter weeds will be in the foreground. For this, she uses a very old watercolour brush. Masking tape (1 in 2.5 cm wide) is then used on the edge of the paper to create a white border and to stiffen the support (paper) a little.

3 Drawing completed and the masking fluid dry, the artist begins to paint. Using a very large watercolour brush, a No. 20, and lots of water, the artist applies a mixture of ultramarine blue and burnt sienna to the dry paper, leaving areas for the shape of the clouds. With a very clean wet brush, she softens some of the edges. Clouds are like everything else that we see; they diminish in size and colour as they disappear into the distance, a fact often overlooked by those beginning to paint.

4 Working in this traditional watercolour technique, each area painted must be allowed to dry before the next is applied. If you lightly rest the back of your fingers on the area believed to be dry and it feels cool to the touch, this means that it is not dry, and therefore you must wait a little longer. Many artists, when using watercolour or acrylic in a watercolour technique, paint two or even three pictures at a time so as not to waste time. A hair dryer used on a low temperature can be used when painting indoors.

With the sky already dry, the artist now adds the distant landscape, using a very thin mixture of sap green and ultramarine blue to form a soft grey green, painting the area flat as no detail will be seen in the distance. Note that white is completely omitted from the palette of this painting.

5 With the colour slightly strengthened, a middle distance is added to the whole width of the painting, carefully carrying the paint around the two cars and also through the windows of the Austin.

3

4

6 The artist has darkened the green by adding burnt sienna to the mixture. She introduces this as shadows into the middle ground foliage. This will have two effects: it will show from which angle the light source is coming into the picture and, by introducing a second value to an area, it will bring that part forward, so pushing the previous wash back and creating the illusion of distance.

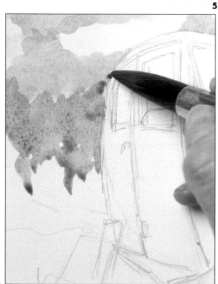

5

6

A C R Y L I C S

7 The artist has applied the first value of blue to the lightest areas of colour of the small car. This was applied all over, covering the masking fluid too, by using the No. 20 brush and a very watered down ultramarine blue. The same colour is then quickly applied to the Rover.

8 While it is still quite damp, the brush is washed out and a little burnt sienna, thinly mixed with water, is applied to the areas of rust. This technique is called wet into wet (see page 348).

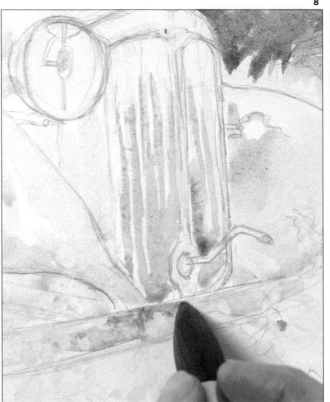

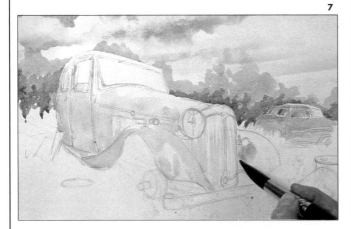

7

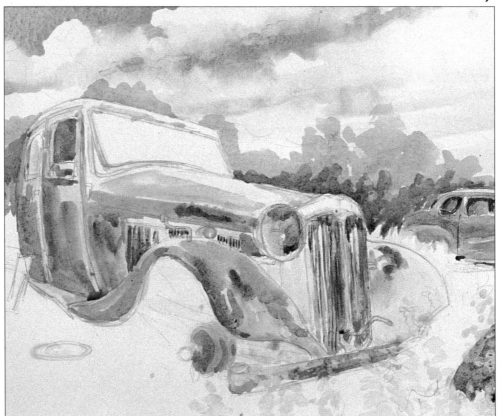

9

9 The painting is becoming quite exciting, and waiting for areas to dry can be frustrating when the artist is keen to progress. But to keep the painting looking fresh, this is a necessity.

With a stronger mix of ultramarine blue and burnt sienna, she adds a second value to the cars, being careful all the time to leave the white areas.

10 Air vents are painted in using the tip of the No. 20 brush. When buying a new watercolour brush it is important to choose one with a good point. This can be checked by dipping the brush into a glass of water, provided by the shop, before you make your purchase.

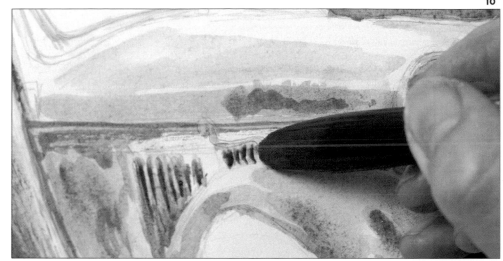

11 Using the same mixture that was used for the air vents, ultramarine blue and burnt sienna, but not so much water added this time, the artist darkens the area under the mudguards.

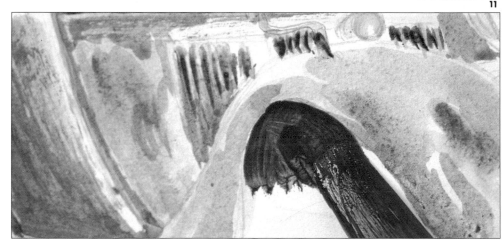

12 The rest of the third value darks are added inside the Austin, underneath it, inside the Rover and underneath, in the radiator, on the offside mudguard and the spare tyre lying in the weeds. The artist now steps back to admire her work: is the background strong enough or too weak, has enough white been left, does the contrast, so far, in the cars describe the form? Being satisfied she progresses.

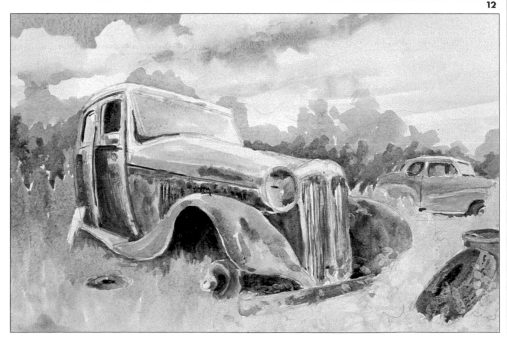

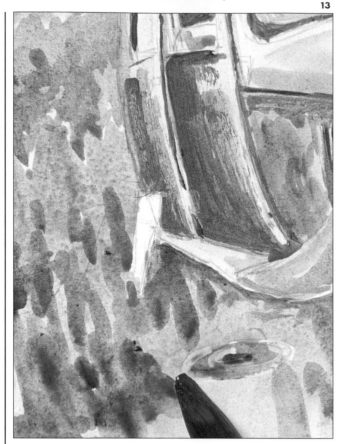

13 A flat wash of sap green and lemon yellow is applied all over the foreground, including the areas of masking fluid. When this has dried a mid-tone is added, leaving parts of the light area to shine through, eventually giving a darker value. Burnt sienna is dropped in while the green is still wet to provide contrast – red (burnt sienna) is complementary to green.

14 When all areas are totally dry, not at all cool to the touch, the hand of the artist is gently rubbed across the painting to remove all traces of the masking fluid, leaving clean white areas.

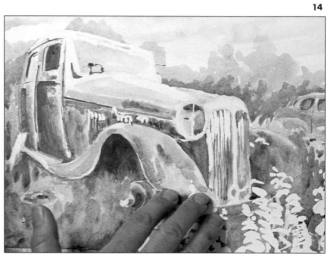

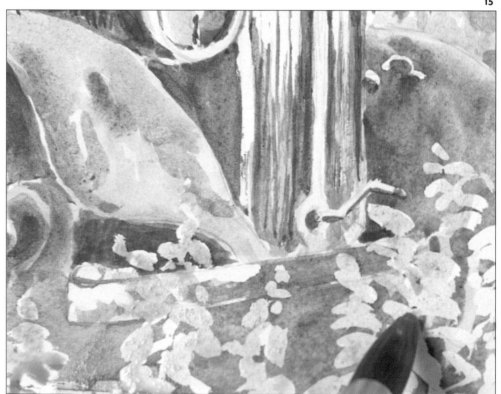

15 The artist mixes lemon yellow with sap green to produce a fresh light green with which to paint the foreground weeds. When it is dry she strengthens the colour and adds some detail to the plants.

16 With observation, the artist notes that a strong dark is needed behind the foreground plants and beneath the car. Without this the car seems to be floating on a bed of green fluff. For the darks she again uses sap green and ultramarine blue, but this time adds a small amount of burnt sienna. At this point the painting is again checked for any missing detail, and this is corrected.

17 The masking tape is now carefully removed, keeping the hand close to the painting and pulling away (not up, as this will tear away the surface of the paper, sometimes taking bites from the sides of the actual painting).

18 What a delightful painting this subject has made and how fresh the work looks. For anyone not used to applying actual watercolour, acrylic will be much simpler to employ as each wash, after it dries, cannot be lifted by the subsequent wash, thus dismissing any worry of colours becoming muddy.

Ultramarine blue *Burnt sienna*

Lemon yellow

Sap green

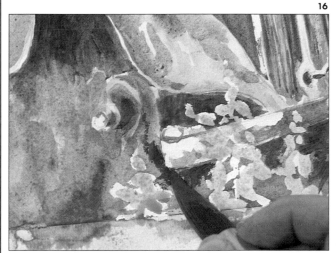

16

17

18

Anemones

WATERCOLOUR TECHNIQUES

ACRYLICS

Here the artist uses acrylics in the watercolour technique of wet into wet painting. She chooses a beautiful bunch of brightly coloured anemones for her subject, offset by an antique lace cloth and a preserves jar. She feels that there is more character in a jar than a formal vase.

Painting wet into wet is fascinating technique and actually means that wet paint is applied to wet paper. The degree of wetness on the paper from flooded shiny wet to dull and damp will affect the control of the paint. Wet paint applied to very wet paper will run uncontrollably, whereas drier paint put on to only damp paper will hardly move, so you have all of these degrees of wetness to explore. Perhaps it would be a good idea to practise before you apply the technique to a painting.

The anemones were chosen for this demonstration because they seem to lend themselves to the technique employed; the soft edges of the petals and leaves almost appear without effort. Many accidents will happen when painting wet into wet; the secret is to recognize them and use them. Often the paint will run away with itself and before your very eyes wonderful things will happen – unexpected tones and textures appear, beautiful shapes, just perfect for the area. When things go wrong do not be in too much of a hurry to correct them; learn when to leave things alone, when to accentuate the mistake or even build a picture around it. To the artist's amused annoyance, very often the one area of your painting that is most admired by everyone is the 'happy accident', and you have not had a hand in the matter at all.

1 For this wet into wet demonstration, anemones were chosen for their bright translucent colours with fresh green contrast of stalks and leaves. The artist chose to put them into an old preserves jar in preference to a vase, liking the less formal image and the view of the stalks through the glass. The white lace-edged cloth was added to complete the composition.

Materials: Cotman 140 lb (300-g) watercolour paper 16 in × 17 in (40 cm × 42.5 cm); brushes – 1 in (25 mm) wash, Nos. 20 and No. 4 watercolour brushes; 2B pencil; putty eraser; disposable palette; water atomizer; rags or paper towels; 3 jars of clean water.

2 Using a piece of Cotman 140 lb (300 g) watercolour paper, the artist lightly sketches with a 2B pencil, paying particular attention to the shape of the jar and the lettering. The positions of the flowers are only indicated with a very light circle. The drawing completed, the artist wets the paper with a 1 in (25 mm) wash brush, not allowing the water to go over the areas of jar and table; this will allow some hard edges to form around these sections.

3 While waiting for the shine to disappear from the paper, indicating that the water has been absorbed but the paper is still wet, the artist mixes the paint for the blooms. Carmine and cadmium red are used for the red flowers, carmine alone for the pink, and carmine and ultramarine blue for the violet ones. When the paper has reached its right degree of dampness, the paint is gently touched to the paper in the right spots with a No. 20 watercolour brush; slowly it disperses into a soft flower petal. All the flower heads are painted in this way.

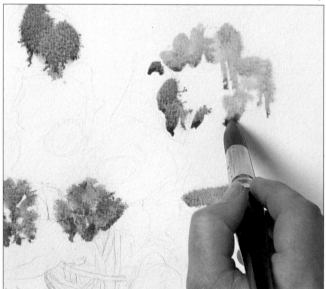

4 It is necessary to work quite quickly while the paper is still damp, but if the paper dries, small areas can be rewetted with clean water or the whole painting can be allowed to dry, thus making the paint permanent, and then the whole sheet can be wetted again. Here leaves are added to the wet paper using a mixture of lemon yellow and ultramarine blue.

5 With the paper still damp, a mixture of ultramarine blue, burnt sienna and carmine is applied with the No. 20 brush to the centre of the anemones. It is very important to keep the water used for mixing the colour clean. Change it often to retain the freshness in the painting.

6 The artist now adds some petal detail to the painting using a dark shade of colour to separate them in places. Parts of the paper will still be damp and parts completely dry; this does not matter as it will give the artist the contrast of some soft edges and some hard. If the painter is not too sure how the colour will appear when applied, she finds it helpful to try it out on a piece of scrap paper.

7 The stalks of the flowers in the jar have been painted with a little lemon yellow mixed with sap green. Where they are tinged with brown, burnt sienna is lightly touched in while the green is still damp. Note how the refraction of the water alters the direction of the stalks. To indicate water in the jar, the artist observes and paints the shapes of the reflected colours, noting that some of these shapes are rather dark.

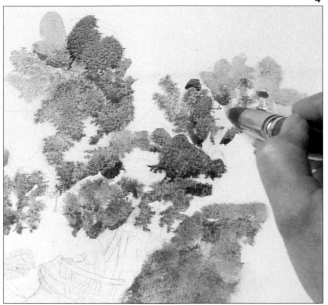
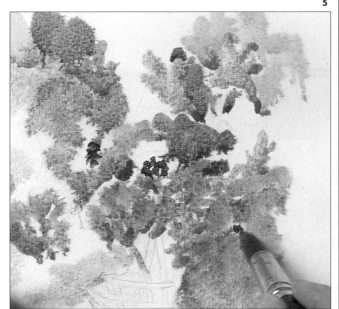
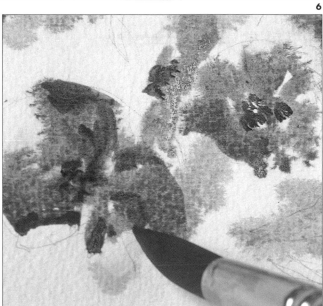
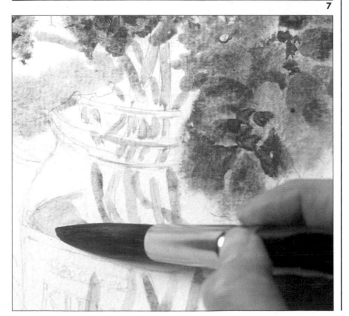

359

WATERCOLOUR TECHNIQUES/ANEMONES

8 Before adding some darkened detail to the leaves with a No. 20 watercolour brush, the artist changes to a No. 4 brush and works a little on the neck of the jar.

9 The background area is dampened again and a watery mixture of ultramarine blue and burnt sienna is flooded in, stronger behind the cloth to emphasize its whiteness. The background colour is graded upwards, the colour almost disappearing as it reaches the tops of the flowers.

10 With a No. 4 brush, the lettering of the trademark is carefully added to the jar. The complete letter is not necessary, just enough marks to give the impression that the word 'kilner' is completely written.

11 The artist observes the shape of shadows and folds in the white tablecloth and paints them in with a soft grey colour made from ultramarine blue and burnt sienna. (See folds on pages 338-41.)

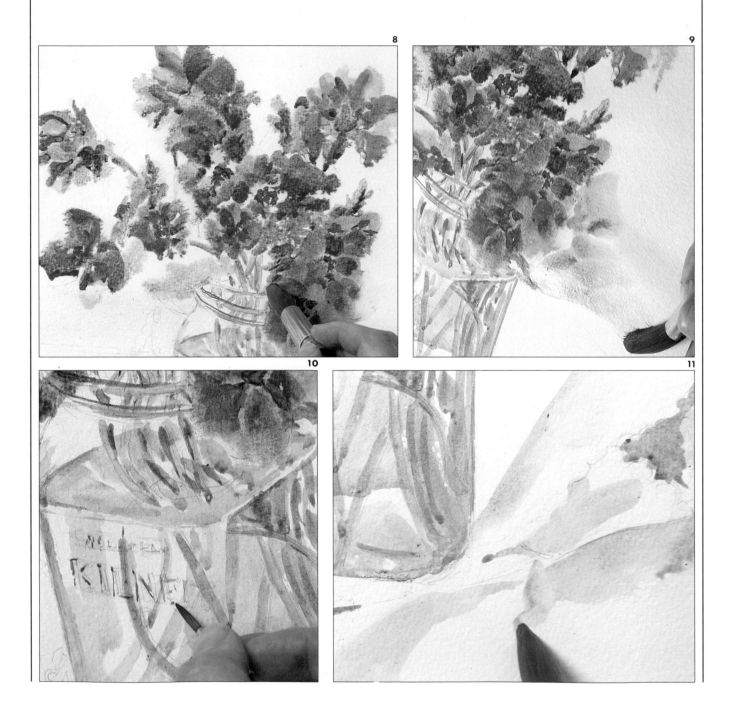

12 Finishing touches are added to the painting. The holes of the lace are added with a stronger mixture of the grey used for the folds in step 11. The table top is painted with the same two colours, but using more of the burnt sienna. A shadow is added on the table beneath the folds of the cloth.

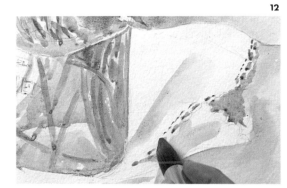

13 An interesting feature of the finished painting is that it touches and overlaps all edges of the support. Very often paintings portraying vases of flowers have the image placed in the centre with a great deal of negative space surrounding it. Using the space positively and filling it as the artist has here tends to produce a more pleasing image.

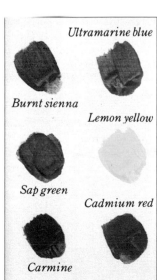

Ultramarine blue

Burnt sienna

Lemon yellow

Sap green

Cadmium red

Carmine

Snow Scene

WATERCOLOUR TECHNIQUES

Setting yourself the task of creating a painting from several sources can be exciting. Here the artist uses two photographs taken in summer and trees from her 'memory bank' to produce a stunning snow scene. The finished product seems to bear no resemblance to its source material but is a creation of the painter.

Photographs should not be copied detail for detail but just used as a take-off point. When developing a picture from several sources, it is advisable to work your ideas out in a sketchbook or on a scrap of paper. This will save a lot of rubbing out and damage to the surface of the watercolour paper. In this painting, the artist has limited her palette to only two colours, ultramarine blue and burnt sienna. From these two colours, she has achieved many hues, tones and values. These two colours, when mixed together, produce a grainy effect which is complementary to this subject. A very rough paper has been used which also adds to the result of the finished picture. When developing a painting, take care to think about the materials you will use and the effects they will produce.

No white paint at all is used in the actual painting of this scene; it was used only in the last instance smeared onto a toothbrush and flicked over the painting to produce the impression of snow over the darker areas. The white sections of the painting, even the picket fence are all the paper 'saved'.

1 The painting was inspired by the artist's love of winter in the Alps. These two

photographs, which she used for reference, were taken by her when she lived in Oberammergau in Germany. The foreground trees were added from her memory bank. If you feel that you have not had enough experience in drawing and painting to do this, it is quite permissible to add objects from any source – encyclopedias, magazines, books, or preferably your own sketches made on location.

Materials: Very rough Aquarelle watercolour paper 140 lb (300 g), size 12 in × 19 in (30 cm × 47.5 cm); brushes – No. 20 watercolour, No. 1 watercolour rigger; 2B pencil; putty eraser, masking tape 1 in (25 mm) wide; rags and tissues; disposable palette; 3 jars clean water; water atomizer; toothbrush.

2 Working on a very rough watercolour paper, the artist plans out and sketches her composition. Before she begins to paint, she adds masking tape to the edges of her paper to give it a crisp finish when removed and to give extra strength to the paper while she works.

A mixture of ultramarine blue and burnt sienna, rather dark, is applied to the already wetted paper. This was accomplished with a No. 20 watercolour brush, omitting the trunks and main branches of the trees and only bringing it down to the tops of the mountains, keeping a crisp edge.

3 After allowing the area of the sky to dry thoroughly, the shadow side of the mountains is painted in. Once the light source has been established, it must remain the same throughout the painting.

4 Before the paint on the mountains is allowed to dry, it must be weakened with water and washed down to the edge of the distant field.

5 A dark line of paint is taken across the whole width of the painting, omitting trees and houses, just at the top of the foreground snowfield. While it is still wet, the brush is thoroughly washed out; the top edge of the paint is then carefully softened with the clean wet brush, while the bottom edge is left hard, which gives the impression of a dip in the terrain.

6 Using the point of the No. 20 brush and a light mixture of the grey, fir trees are added in clumps coming down the lower slopes of the foothills. The colours are kept lighter in the background, becoming stronger as they approach the foreground.

7 The artist, continuing to develop the painting, makes a stronger mixture of ultramarine blue and burnt sienna and paints in the fir trees around the houses in the distance, being very careful to keep the snowy roof tops crisp around the edges.

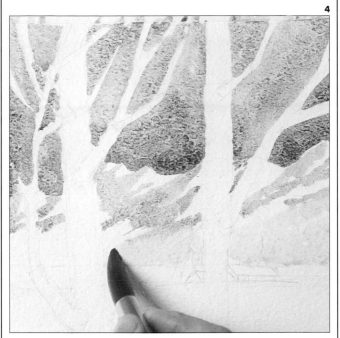

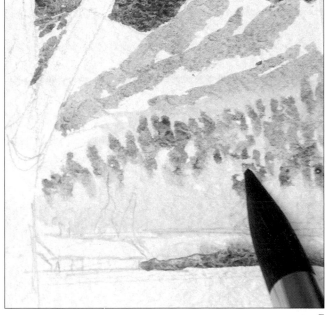

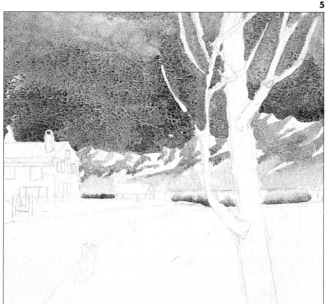

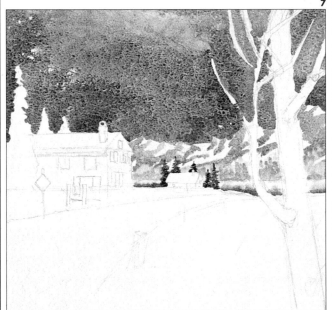

8 A weak solution of burnt sienna is painted over all the houses, including the chimney pots. When this is dry, a darker paint is added, using the burnt sienna with a touch of ultramarine blue to darken it. This is applied to the left, darker side of the walls and chimney pots, under the eaves and along the shadowy edges of the windows.

9 Using the two colours strongly this time, the artist puts in the dark interiors of the houses as seen through the windows. A common mistake of amateur artists is to paint dark frames around the windows and to leave the glass light. Windows are normally only light when viewed from inside looking out. Using the same mixture, a little dark detail is added under the eaves in the foreground house.

10 The thickness of the snow is indicated on the roofs by applying a line of watered-down ultramarine blue. A little of this colour is also dragged across the snowy roof to suggest shadows from the pine trees.

11 With a strong mixture, the artist paints in the foreground firs, being careful to save areas of white paper signifying fallen snow on the heavy branches.

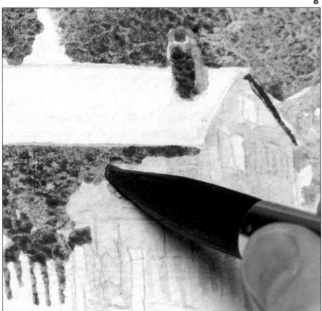

8

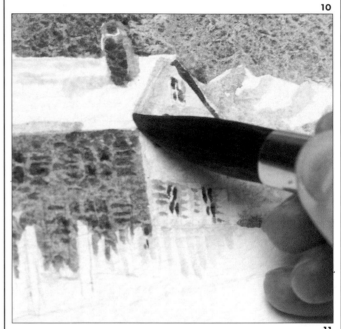

10

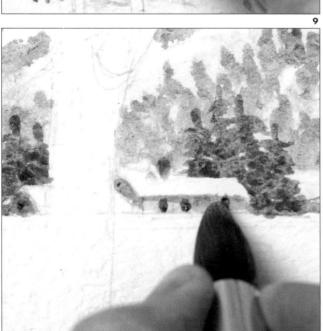

9

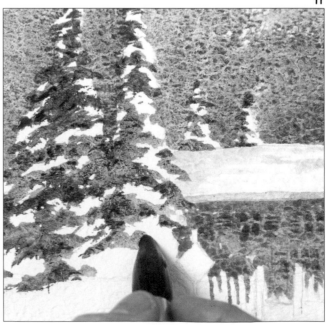

11

12

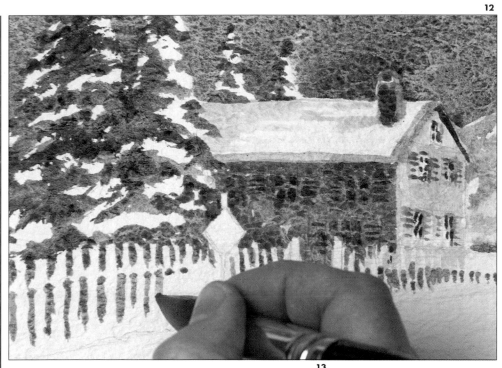

12 The artist then paints carefully around the street sign and the picket fence. No masking fluid and no white paint are used in this painting at all.

13 The last touches are added to the distant scene before the trees are painted in. Ultramarine blue and burnt sienna are mixed to a medium strength, and lines are painted on the road where a car has passed through the freshly fallen snow. The brush is then quickly washed out and one edge of ruts is softened. Following this, a little of the blue is well watered down and boldly swept across the foreground snow field.

13

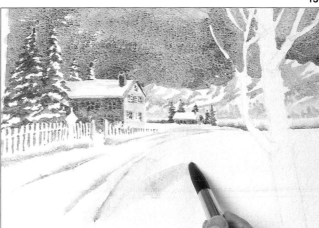

14 The white paper left for the silver birch trees is now wetted and, after the shine has gone, a dark grey mixture is applied in small areas of the trunks and main branches, and to the posts along the edge of the street. When this is dry, the dark eyes of the silver birches and the dark of the marker posts are painted on.

15 Using a No. 1 rigger brush, the artist paints in the middle size branches of the trees. To make broader branches, she presses down on to the brush and for lighter ones, she uses less pressure.

14

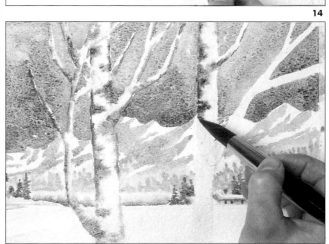

15

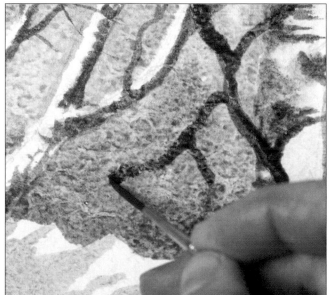

16 The only time that the artist uses white paint is to spatter snow on to the painting. To do this, she puts the white paint into a saucer or old bottle lid, keeping it clear of the other colours. Using a wet hard toothbrush and holding the painting in a vertical position so not to drop large splodges of white on to it, she flicks the paint off the toothbrush on to the painting, giving the impression of snow falling.

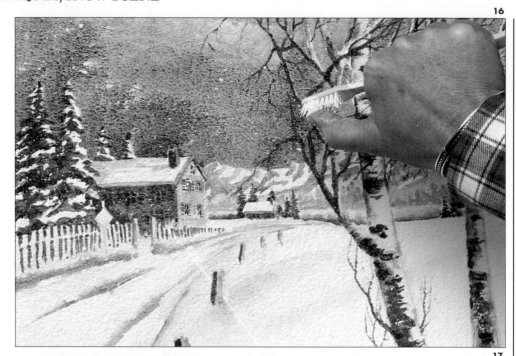

17 This is a close-up detail of the painting, a picture in its own right. Here you can see quite clearly the fine branches painted with the No. 1 rigger brush and also the spots of white snow flicked on with the toothbrush.

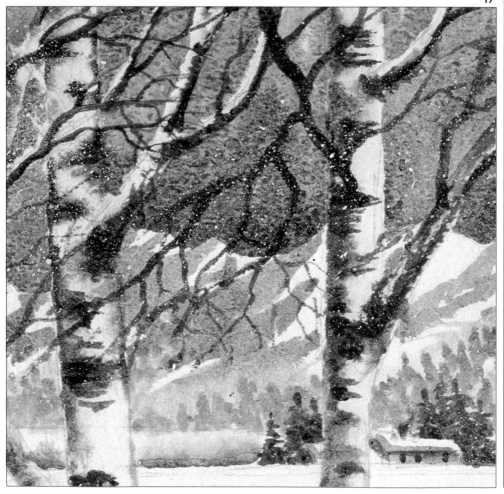

18 The finished painting with the masking tape removed to reveal a clean crisp edge to the picture. A seemingly complicated subject has been handled simply with a very limited palette – only two colours. The artist, using her imagination, has developed a delightful painting from two unlikely photographs and a little creativity.

Ultramarine blue

Burnt sienna

18

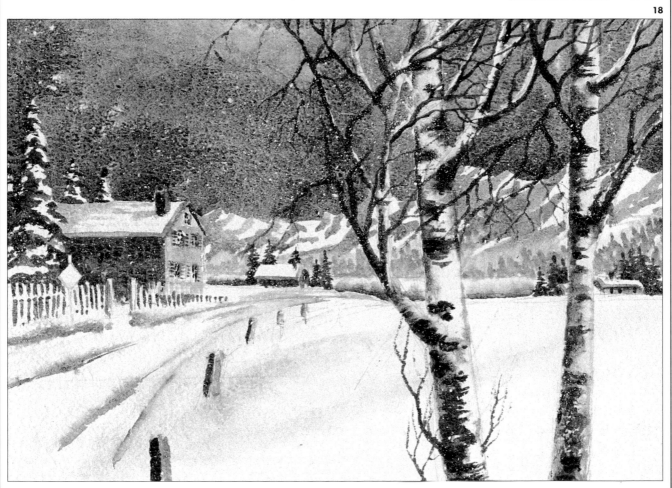

Chapter 7
Oil Techniques

The painter can continually learn from his fellow artists, both contemporary and former. Painting should be a life-long learning experience, with the artist evolving in a natural way. Those who continue to paint the same way over and over because they are 'good at it', turn their art into a craft – a repetition of techniques to produce a finished object. Try to keep an open mind, go to as many exhibitions as you possibly can, not just to look at the kind of work that you prefer but to look at the different and unconventional too. If this is not possible, the next best place is your local library. There you will find art books on all periods, very often describing the techniques, palette etc., of the individual artist. Trying to assimilate other artists, perhaps not actually copying the original picture but using similar subject matter and techniques, can be very satisfying and will open up your imagination to other things that you will want to try.

This chapter demonstrates using acrylic in oil techniques. In the first instance the artist employs techniques used by Van Gogh and also steals his subject matter to produce a painting in the modern medium, acrylic. I am sure if Van Gogh had been alive today, he would have experimented with acrylics and possibly produced some of his great works with them. The accelerated drying time of this medium would have surely lent itself to his work. In the second demonstration, the artist uses another technique borrowed from the Post-Impressionist era, pointillism. This is a process in which dots of unmixed colour are juxtaposed on a white ground so that from a distance they fuse in the viewer's eye into appropriate intermediate tones. This technique is especially helpful to beginners as it is quite controlled and colours are used from the tube undiluted and unmixed. By laying one colour against and over another the painter quickly learns the possible effects of the individual colours.

The last painting in this chapter, a self-portrait, demonstrates how, with the use of a retarder to slow the drying time of the acrylic medium, the paint can be blended in a manner similar to manipulating oil paint; this is particularly useful when painting flesh tones. It is very often impossible to discern if a picture has been painted in oil or acrylic, especially if the finished product has been varnished or a gloss medium has been used throughout the painting. Pure acrylics dry to a matt finish, but contemporary oil painters often varnish their finished work with a matt varnish, so it can become very confusing.

DRAWING WITH THE BRUSH

Drawing is an essential part of painting. It has been said that painting is just drawing with the brush. Drawing is form without colour.

Drawing with the brush allows the artist more freedom of expression. Using charcoal or a pencil means sacrificing the fluidity and sweep that can be attained with the brush and a liquid medium.

When preparing to do a painting, the student may often get carried away by laborious detail only to have wasted time by losing all that he has painstakingly drawn when the underpainting is applied.

Any colour can be used to execute the drawing as most of it will be lost in the painting, but it makes sense to use a colour that will blend in with the painting. If the lines you have drawn are wrong, instead of trying to wipe them out, just change the colour on the brush, remembering which colour is the correct drawing.

Employing this technique of going straight on to the bare support with a brush is especially enjoyable when tackling work on a large scale.

1 Using a large brush and lemon yellow paint the artist quickly sketches in the chair.

2 Mistakes can easily be corrected as the painting develops.

STIPPLING

Stippling a technique whereby paint is applied in little dabs instead of actual brushstrokes. Following the rules of Seurat, the nineteenth century Post-Impressionist, the paint is used pure, unmixed straight from the tube. The only mixing is with white when a paler tone is required. This improves the luminosity of the colour. For darker colours, hues that would normally be mixed on the palette are applied to the canvas individually in layer upon layer of dots until the required depth of colour is acquired.

1 Dabs of ultramarine are applied for this demonstration of stippling. Dots are applied close together where the colour requirement is strongest and further apart where the colour will be paler.

2 After allowing the first application of paint to dry, the second colour is added in much the same way. Consecutive layers are built up until the

required value is achieved.

3 The paint, Rembrandt blue, is mixed with white as a paler colour is wanted. White is a very strong opaque and applied over any other colour would completely block it out.

4 Pure burnt sienna is stippled on. As a dark tone is required here, several layers will be built up of two individual colours.

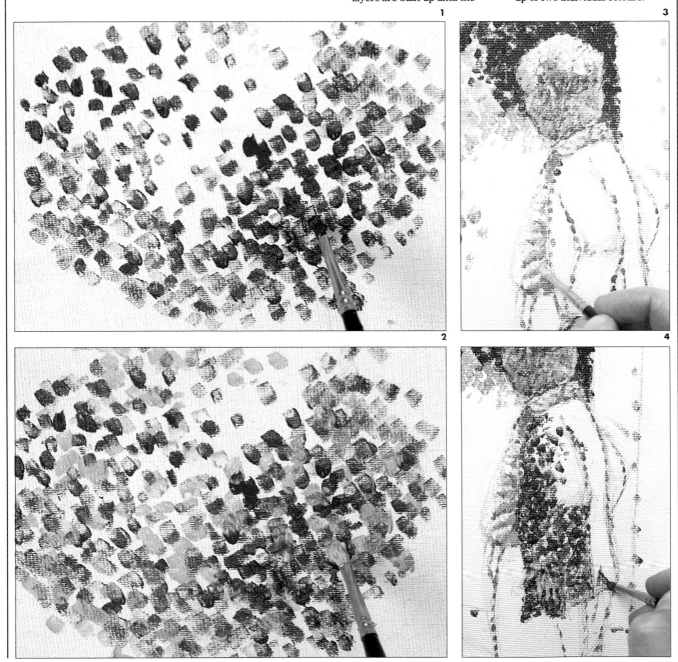

371

Chair with Pipe
OIL TECHNIQUES

Using a very large piece of hardboard and painting very boldly with rather large brushes, the artist shows how an old master's painting can be interpreted in acrylics. Rather than working from a reproduction of the original painting, the artist simulates the still life with her own kitchen chair standing in a sunny corner of the kitchen. A great deal can be learned by working as the old masters did; the following demonstration is just one approach. Often painters will go to galleries and museums and actually copy the original so that they can be sure of copying the colours exactly.

This artist is using entirely modern materials to simulate a Van Gogh. Unprimed hardboard is used to replace raw canvas and acrylic plaints instead of oils. She approaches the work in much the same way as Van Gogh: no drawing, straight in with a brush working direct and bold. Shapes are blocked in in their local colours with expressive brushstrokes. As the painting progresses, the drawing of the chair is strengthened with bright blue lines like Van Gogh's. Perhaps when he said, 'I study nature so as not to do foolish things . . . however, I don't mind so much whether my colour corresponds exactly, as long as it looks beautiful on my canvas', this is what he meant.

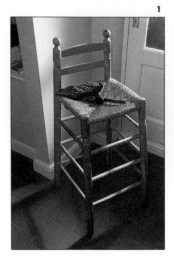

1 This rush-seated wooden chair was placed in the sunlight in the artist's kitchen. Standing on red quarry tiles, it already captures the impression of a Van Gogh painting – old pipe and spotted handkerchief lying on the seat. What a wonderful eye Van Gogh must have had to see beauty in the simplest of objects and want to make them into paintings.

Materials: Hardboard, smooth side unprimed, 24 in × 48 in (60 cm × 120 cm); brushes – Nos. 10, 12 and 16 flat bristle, Nos. 2 and 4 flat synthetic; disposable palette; rags or paper towels; 3 jars water; water atomizer.

2 Where the old master used oil paint and unprimed canvas, this artist is using the more modern materials to make a facsimile of the original painting. Here she uses unprimed hardboard, with a lemon yellow acrylic paint to block in the composition loosely with a No. 10 bristle brush, without drawing first. The perspective in the drawing is not correct, but with this medium that is not a problem as it will be dry in minutes and can be painted over.

3 Using the same brush, the artist blocks in the tiles around the feet and legs of the stool. To do this, she uses a mixture of cadmium red and burnt sienna.

4 The wall is blocked in next. Because of the size of this painting, a great amount of white paint will be needed, so instead of using titanium white, the artist uses acrylic gesso primer. This works perfectly well when the artist does not require a heavy build up of paint as it is a little runnier than tube paint, and also cheaper. To the white gesso is added Rembrandt blue. The resulting light blue colour is applied to the hardboard with bold strokes with a very large, No. 16, flat bristle brush.

5 The corners of the wall and the skirting board are created by developing the values. Burnt sienna is added to the Rembrandt blue to darken the colour and worked into the areas furthest from the light. White is added to the Rembrandt blue in considerable amount to lighten it to denote the places that the sunshine catches.

6 The artist now begins to develop the darks in the chair. For this, she uses Talens yellow, burnt sienna and Rembrandt blue. Using the No. 16 brush, she paints very boldly, pulling long brushstrokes along the bars of the chair.

ACRYLICS

7 With the same brush and colour, detail is applied to the rush seat. To do this, the artist uses only the tip of the brush held at an angle.

NB It is very important to keep the brushes in water when not in use. Owing to the size of the painting, a lot of paint will be squeezed on to the palette, so keep it damp by spraying with the water atomizer.

8 Highlights are applied with a No. 10 flat brush. Talens yellow mixed with white is the colour used. If you look at the subject with half-closed eyes, the highlights will be more apparent to you.

9 A blue line 'à la Van Gogh' is drawn around parts of the image, usually along the darker edges, but sometimes in the lighter areas to add contrast to the painting. The blue line recedes and so throws forward the bright yellowy orange chair. Blue is complementary to orange (see pages 306-9 on colour) and so the two will be enhanced when juxtaposed.

10 Rembrandt blue and Talens yellow are mixed to form a grey green which is used to draw the tiles in perspective on the floor. The mix is the right colour for the cement between each tile. The lines are drawn with a No. 6 flat brush. Each individual tile is then painted with a dark red mixture of burnt sienna, cadmium red light and a little Rembrandt blue to darken it. The artist discovered that the lines of tiles were not quite in perspective. This is not a problem with acrylic as she just overpainted the original grey green lines and minutes later reapplied them. After the tiles were established, the artist painted in the strong dark shadows using a darker mix of the floor colour. Now she paints the sun-dappled areas. Using a thin mixture of Talens yellow and cadmium red light, she gradually builds up the brightness, blending the soft edges.

11 The main part of the painting completed, the artist is able to draw in the pipe and handkerchief. Using oil paint, Van Gogh probably had to wait for weeks to do this as, according to art historians, he too added the pipe when the chair was completely dry. The outline drawing is made with a No. 4 brush, using a mix of burnt sienna and Rembrandt blue.

12 The handkerchief is blocked in with Rembrandt blue and white. The drawing is left to show through in places.

OIL TECHNIQUES/CHAIR WITH PIPE

13 Using a No. 7 flat brush, the artist observes and paints in the darks of the handkerchief. She does this working in flat planes with Rembrandt blue and burnt sienna. The light areas are added in the same way; this time Rembrandt blue and white is the mix.

14 With a No. 2 brush and pure white, the dotted pattern is added. Viewers of paintings are often impressed by pattern in a picture, but in actual fact it is probably the simplest part for the painter. Not every spot need be added, just enough to trick the eye into believing that every spot is carefully rendered.

15 The pipe is painted; first the middle tones are blocked in, next the darks and finally the light rim around the top and light along the side. Various mixes of Rembrandt blue and burnt sienna were used, more blue when the colour needed to be darker, white added to make it lighter.

16 Shiny highlight is added to the pipe using white. Shadow is also applied under the pipe and handkerchief on the chair. For this, the artist used burnt sienna, Talens yellow and Rembrandt blue.

13

15

14

16

17 A close-up detail to show the finished handkerchief and pipe on the seat of the chair. How convincing they look; the handkerchief crumpled, just thrown there.

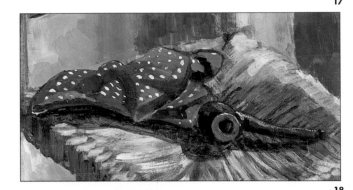

18 Van Gogh would never believe it, a large painting like this completed in a matter of hours and the paint totally dry almost as soon as the work was finished. I am sure it would have convinced him to use acrylics.

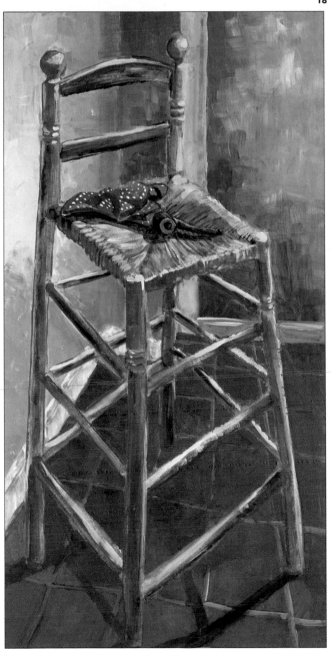

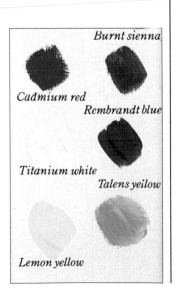

Burnt sienna

Cadmium red

Rembrandt blue

Titanium white

Talens yellow

Lemon yellow

The Two Gardeners

OIL TECHNIQUES

Towards the end of the nineteenth century, Georges Seurat developed a technique of painting which was later named 'pointillist'. Using oil paints, he worked with only pure colours (straight from the tube) to develop his method of producing pictures with only dots of colour. White, which he considered to be of no colour, was the only paint that he mixed; this was crucial to his work as he felt that it increased the reflected powers of the other colours and evoked a feeling of natural light. A drawback for Seurat was the length of time that oil paint took to dry. The build up of paint was a slow process as he worked in a wet over dry technique to retain the purity of the colours.

The painting in this section of the book is fashioned after Seurat, using his technique and working from a photograph that the artist took of two figures known throughout her life from a small village in Leicestershire.

Time should be spent establishing a good drawing from which to work. Following this, little can go wrong as the painting method is very controlled and mistakes can be caught and corrected very quickly, as this artist shows in her demonstration. The confusion of colour mixing, often a problem for the amateur painter, is avoided, as paint is used straight from the tube with no other colour additions. Although this technique is time consuming, it is well worth the effort – the end result a shimmering picture of fresh colours, a delight to even the most unartistic eye.

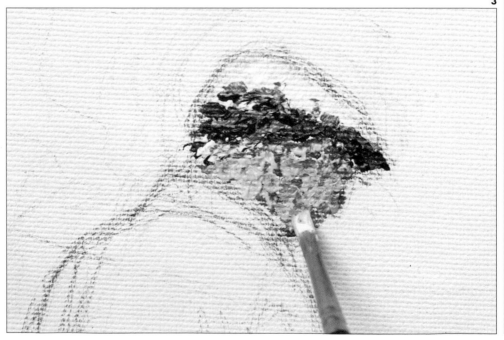

1 Figures unposed in action can be a problem for the artist. Working from life, all that is normally possible is a few quick sketches before the subject moves. People are animate and even when standing still are moving hands and heads and shifting their weight from one foot to another. This artist takes many photographs of people and incorporates them into her paintings when necessary.

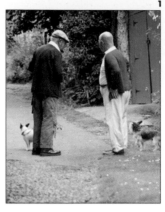

2 The figures are drawn carefully onto the canvas with a 2B pencil, and the artist checks to see that all proportions are correct.

Materials: Canvas 14 in × 10 in (35 cm × 25 cm); brush – No. 2 flat synthetic; 2B pencil; eraser; disposable palette; rags; 3 jars water; water atomizer (to keep paint moist on palette).

3 Only a No.2 flat brush is used throughout the painting. The colours used are always as they come from the tube unless they are lightened. For this, the titanium white is added. Darks are made by placing a lot of colour on top of another – the colours being mixed optically on the canvas. The darks in the cap are painted by the artist, first making dots with ultramarine blue, followed by similar marks of burnt sienna. The hair is painted using the same two colours and white. The brush is not dragged in a conventional stroke but dabbed on to the canvas and removed. Now the artist applies colour for the face – first cadmium red, followed by lemon yellow, and last burnt sienna mixed with titanium white. All colours show through when finished and the eye mixes them to produce the skin tone.

4 Using ultramarine blue, the artist goes over her pencil drawing with little dashes so as not to lose it. Following this, she applied burnt sienna to the jacket area.

5 Consecutive layers of ultramarine blue and burnt sienna were built up to develop the volume of the jacket with more in the darker areas. Raw sienna is used for the lighter tones and titanium white is then added to it for the very bright areas such as the shoulders.

6 The shoes are painted with the same two colours as the jacket, again the burnt sienna being the predominant colour. White areas are added last for the highlight on the side.

7 The artist finishes painting the man on the left. For his trousers, she first applies burnt sienna to the shadow areas. Over this she uses ultramarine blue for the mid-tones and then titanium white added to the blue for the light. Part of the background is now applied using a mix of cadmium red and titanium white. Because of the speed that acrylic dries, whole areas can be painted flat – for example, the brick wall in the background; then plants and bushes can be painted over almost immediately.

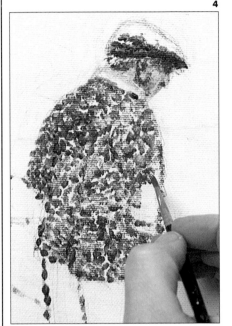

4

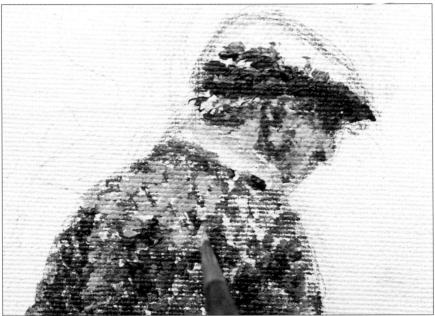

5

6

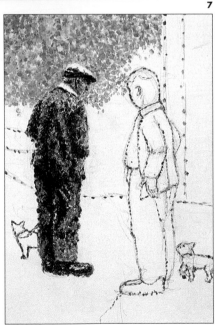

7

ACRYLICS

8 Continuing with the background, the artist uses sap green, sometimes straight from the tube and at others with titanium white. The copper beech tree is painted by laying carmine over burnt sienna.

8

9

9 The man on the right is given the measles treatment –dabs of cadmium red. To develop the volume of his head, sap green is used in the shadow areas, lemon yellow in the light, followed by burnt sienna mixed with titanium white.

10 A very light mixture of burnt sienna and white are used for his bald head, finishing with a few dabs of pure white for the shine.

10

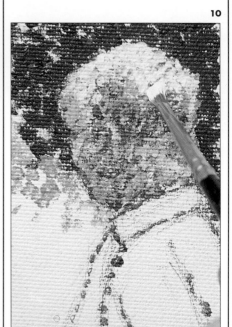

11

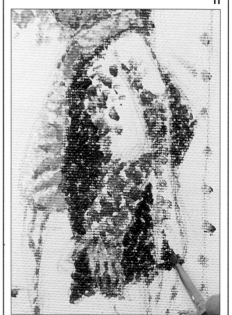

11 His shirt is painted with Rembrandt blue and titanium white. Burnt sienna is then applied to the darkest parts of his cardigan. Rembrandt blue goes over the sienna to form the folds and darks.

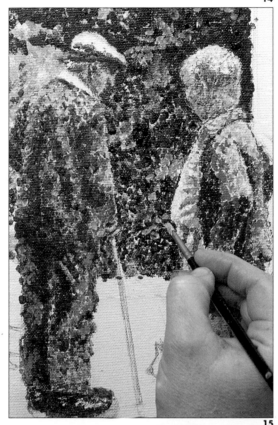

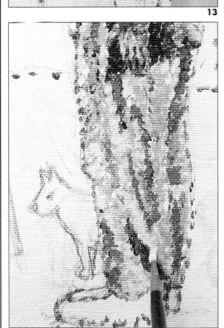

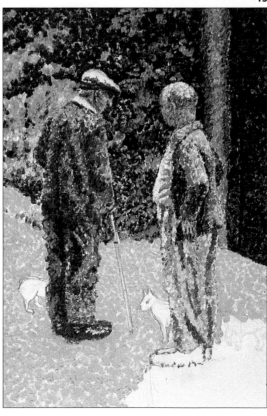

12 Titanium white with the slightest amount of Rembrandt blue is applied to the areas which are to be highlighted. These are the collar, the shoulders, the bottom back of the jacket and the forward elbow.

13 Working from dark to light the artist first establishes the folds in the trousers with burnt sienna. Over this she applies raw sienna. For the middle tones pure raw sienna is used. To finish the trousers raw sienna is mixed with titanium white and the highlights are applied.

14 Using a No.2 brush and a mixture of Sap Green and Titanium white the artist carries the background further using it to strengthen the edge of the right hand figure. Make sure that all edges butt up to each other.

15 The dark background helps to describe the shapes of the figures. The colours in the old garage doors on the right are ultramarine blue and sap green.

ACRYLICS

16 Continuing the technique of small brushstrokes of paint, the little dogs are portrayed. The darks are applied with ultramarine blue followed by burnt sienna and raw sienna. The tail end of the dog on the right is mostly titanium white.

17 The artist has painted the road with successive layers of ultramarine blue, raw sienna, carmine (mixed with white) and titanium white. The walking cane has also been painted in two values – a dark side (ultramarine and burnt sienna) and a light one (raw sienna with white) – using dots. The artist now paints the foreground grass using sap green, lemon yellow and titanium white in sequence.

18 Stepping back to examine the finished painting, the artist feels that she has painted the bald head too large. Oh!, the wonder of acrylic – she just extends the background colours to reshape the crown.

19 After all that dabbing, the painting is finished. What a vibrant picture this technique produces.

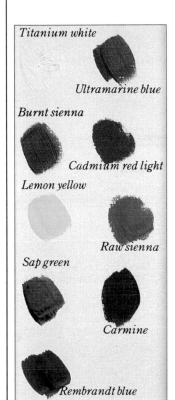

Titanium white

Ultramarine blue

Burnt sienna

Cadmium red light

Lemon yellow

Raw sienna

Sap green

Carmine

Rembrandt blue

Self-Portrait
OIL TECHNIQUES

Most students of art have a desire to paint portraits but are often afraid to ask someone to model, so where better to begin than with a self-portrait. Set up a free-standing mirror very close to your easel and within 2 ft (60 cm) of yourself. It is very important when painting a portrait to be close to the model, whether it be self or other, as relevant detail such as eyes cannot be seen from the other side of a room. This is where portrait classes often fail; the room has so many easels set up that one cannot get close enough to the model. The artist in this instance feels that the eyes are the most important feature as they seem to express the character of a person. Time spent with a sketchbook studying individual features from different angles can be a great asset when it comes to the time to get out the paints. To attain a likeness, the planes of the face must be closely observed; these make up the actual face and give each of us our individual characteristics.

Painting portraits from photographs is a possibility if the photograph is very clear and large. Trying to produce a painting from a snapshot is almost impossible; normally the face is too small and features are just a blur, the shape of the eyes, nose and mouth impossible to see. It is also not advisable to paint a portrait of someone who is unknown to you from a photograph as people have many faces and one photograph will only show one of those. If you are acquainted with the person then not only do you have an image of that person imprinted on your mind, but you also have a feeling for them and this is what brings out the character in portraiture.

Acrylic paint is ideal for portrait painting. Because of the accelerated drying time skin tones cannot be overworked and made to look muddy, but retain their freshness. A hand accidentally brushed across the surface of the painting won't smear an eye or a nose which has been carefully painted. Paint retarder is introduced into this painting to slow down the drying times of areas that need some blending. This can be done with the brush or even with a finger. Retarder can prove to be very helpful in large areas where different values are incorporated, such as skin tones in the planes of the face.

1 Sitting in front of a mirror, the artist makes a drawing of herself on a 20 in × 16 in (50 cm × 40 cm) fine-grain canvas using a 2B pencil. She begins by drawing the eyes: first the right, then the left. From these, she relates all the other measurements of the face, working outwards from the centre. This makes it easier to locate the contours of the face. The outline of the hair is added, then the shoulders and, finally, the background.

Materials: Fine-grain canvas 20 in × 16 in (50 cm × 40 cm); brushes – Nos. 2, 4 and 6 flat, Nos. 10 and 12 flat bristle; 2B pencil; disposable palette; water atomizer; paint retarder; rags or paper towels; 3 jars water.

2 In this painting, the painter is using a retarder to slow down the drying rate of the paint, enabling her to blend the paint if she wishes. This artist nearly always paints the eyes first when working on portraits. As with the drawing, it helps her to relate to the other features of the face and adds life to the blank canvas. She begins by painting the whites of the eyes with a No. 4 brush and titanium white, tinged with ultramarine blue; the whites of the eyes are never pure white but slightly blue/grey. Next, the iris: here she does not overmix the paint, so that it will appear on the canvas speckled as the iris normally is. The artist has brown eyes so she uses a mixture of burnt sienna, raw sienna and a little ultramarine blue. For the pupil, she does not use black, but a strong mixture of ultramarine blue and burnt

sienna; this closely resembles black. A little pink is painted in the corner of the eyes and along the bottom lid. For this, the artist uses cadmium red, titanium white and a tiny speck of ultramarine blue to dull the colour slightly. This is applied with a No. 2 flat synthetic brush. To add a sparkle to the eyes, the artist, using the same small brush well cleaned, very carefully adds the highlights with titanium white. It is important not to overdo this as a white spot can easily look like a dab of paint and not a highlight, so it must be kept very small.

3 The artist puts in the tonal values. For this she uses raw sienna, burnt sienna and a touch of ultramarine blue. The white canvas is left for the lightest value; the mixture is watered down and applied for the mid-tone and used as it is mixed for the very dark areas. The paint is applied with a No. 12 brush in quite a free manner.

4 Before she progresses with the portrait, the artist feels that the background should be added. This constitutes an area of abstract shapes comprising mainly straight lines which lead the eye to the portrait. It is painted in neutral, low-key colours, consequently pushing the figure forward.

2

3

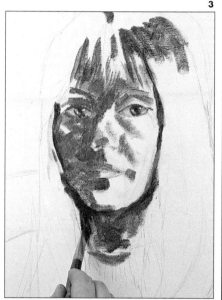

4

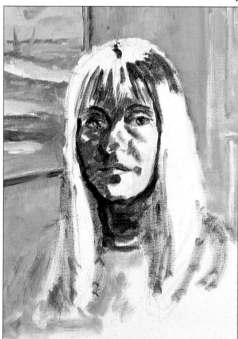

5

5 Using a No. 12 flat brush, the local mid-value stain colour is applied. For this, the artist uses raw sienna and cadmium red. This appears to be too bright so she adds a touch of ultramarine blue to tone it down. To this mix is added little of the retarder medium; it stretches the paint as well as slowing up the drying time. The paint is applied over the whole face and neck, lightly over the dark areas so as not to lose them. Dark and light areas are re-established, white is added to the paint used for the skin to paint in the light tones.

OIL TECHNIQUES/SELF-PORTRAIT

6 The artist looks into the mirror and scrutinizes the portrait so far, then she applies a mixture of raw sienna, burnt sienna and a small amount of ultramarine blue for the mid-tones of the hair. This is put on with a No. 12 flat bristle brush.

7 The darks are added to the hair using a No. 12 brush in long sweeping strokes, following the natural fall. Underneath the hair, around the face and by the neck it is very dark. This provides a strong contrast with the face.

NB It is important to remember to keep the brushes in a jar of water while not in use and also to spray the paints on the palette with the atomizer to keep them moist.

8 With a mixture of raw sienna and titanium white, highlights are added to the hair. The No. 12 brush is used sideways so that long thin strands can be applied.

9 Detail is added to the mouth. The line between the lips is strengthened, the top lip is darkened as it is in shadow, a small triangle of shadow which is apparent in most portraits is painted at the corners of the mouth, and a light line where the light catches the ridge on the upper lip is applied using the side of the brush.

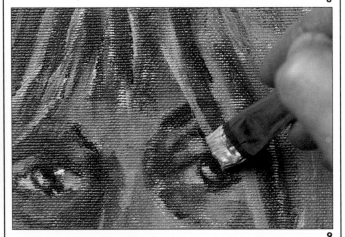

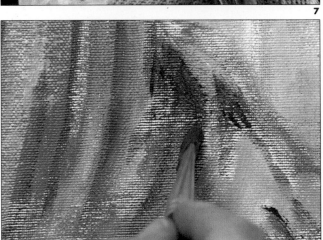

10 Further detail is added, the area around the nose is strengthened and a little light is added for the shine on the tip. Noses are most difficult when painted from the front as they have no definite shape, not like the profile. The artist must observe the abstract shapes of light and dark to develop this area.

11 The sweater is painted quite loosely without too much detail; this will keep the viewer's interest on the actual face of the subject. A grey is mixed using ultramarine blue, burnt sienna and titanium white; darks are added by omitting the white and light areas by adding more. The silver necklace is painted using the darkest grey and highlighting it with white.

12 This is a very loosely painted portrait, completed in three hours. For the amateur artist wanting to paint portraits, where better to begin than a self-portrait; so much better than painting from photographs as you will learn a lot about skin tones, shapes of feature, etc. and also how to get character into your work. Working from a photograph is a poor substitute.

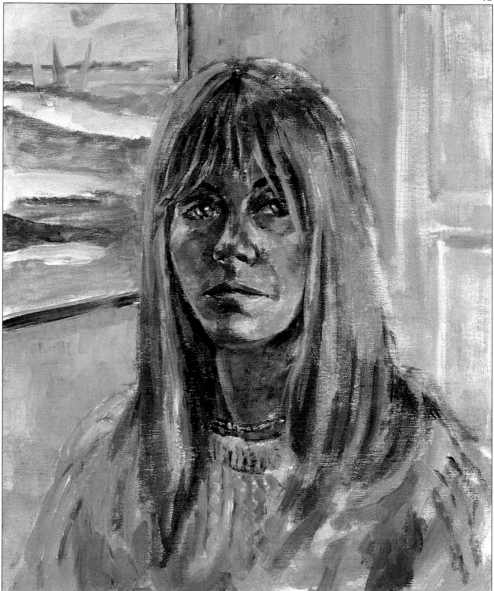

Titanium white

Ultramarine blue

Burnt sienna

Raw sienna

Cadmium red light

Chapter 8

The Beauty of Acrylic

In the previous two chapters we have described how acrylic paint can be used as a substitute for watercolour and oils. We are by no means suggesting that you throw away your other mediums. It is very important for the artist to remain versatile and adaptable, to be able to work in many methods and materials, thereby having the freedom to choose the most suitable technique to describe his subject. What this book intends to convey is that without a lot of expense and hoards of different tubes and pans of paint, the artist who uses acrylics has the freedom of many techniques and styles.

This medium stands alone as a unique material which has qualities that no other paint possesses. In this chapter we describe how it can be built up in a tonal manner, with flat areas of colour placed one over the other to produce the effect of three-dimensional volume. Because of the rapidity at which each subsequent layer can be applied, the finished painting has a spontaneous quality. The second painting in this chapter, 'Glass and Bottles', is developed in a very similar way to the 'Boy on the Beach' by the building up of tones, but here it is accomplished in tones of grey only, the colour being added last

as a glaze. This was applied immediately the tonal painting had totally dried.

With acrylics, glazes can be completely transparent, the pigment thinned down with water or medium and applied in the same manner as the colour in the wine bottles on page 124, or the glaze can be semi-transparent to create an effect of distance, delicacy or atmosphere. This is created by adding a touch of white to the thinned-down coloured glaze.

This technique was used in the background of the painting 'River Scene' which is illustrated in this chapter. Using a technique peculiar to acrylic paint, the artist has broken the composition down into three areas, transferring each section from a tracing paper drawing after the previous area has dried. Figures are added simply by the use of brushstrokes depicting form and colour, void of detail. By close observation you can see that the figures, although convincing, are merely dabs of paint.

These paintings describe just some of the variable uses of acrylic; try these and experiment for yourself. Acrylic paint is a new medium in comparison with other paints; perhaps you will discover a virtue of the medium that no one else has.

GLAZING

A glaze is a transparent or semi-transparent coat of paint applied over another colour, which must be perfectly dry, to get certain effects. Transparent oil paint is the traditional medium to use for glazes, but a drawback is that oils take so long to dry. With acrylics glazes can be applied almost instantly. This is especially advantageous when it comes to applying several glazes one over another. The Old Masters who developed this technique had to wait weeks, sometimes months, between each glaze. Another disadvantage to the glazing of a painting with oils is that

1 A board has been coated with yellow acrylic paint. It is then divided into four sections: one quarter is left yellow, while a glaze of ultramarine blue acrylic paint mixed with gel medium is applied thinly over the other three quarters of the painting. This is allowed to dry and then burnt sienna is mixed very thinly with the same medium. This is glazed over half of the board, allowing one quarter of the board to show as yellow and one quarter green where the ultramarine blue glaze is left. By applying one glaze over another, we now begin to get some interesting colours. On the last quarter of the board an additional glaze of ultramarine blue is added; this gives the appearance of a grey colour with many other hues – yellow, green, blue, burnt sienna – and in various tones. The possibilities of glazing are endless. It can by employed in many ways – for shiny metal (brass, copper, silver, tin etc.), glass (both coloured and clear), water, or fabrics such as silk and velvet.

When glazing, it is important that the surface be clean, entirely free from dust and perfectly dry.

they are likely to be removed at some future time, when the varnish of the picture must be removed to clean it. With acrylics, this will not occur as acrylic varnish does not yellow or crack and the picture can be satisfactorily cleaned simply by sponging over with a solution of soap and water.

2 This paste-like gel medium makes acrylic paint more transparent and glossier. The consistency and colour brilliance of the paint hardly change at all. It can be added without limit.

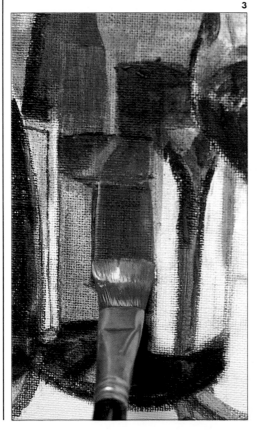

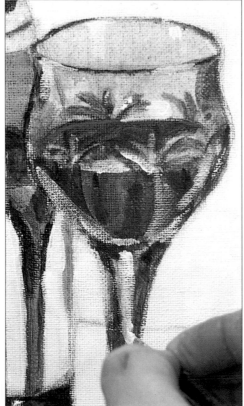

1 The artist's subject of wine bottle, glass and port decanter have been drawn on to a canvas and are being prepared for glazing by employing a monochrome underpainting.

2 After the dark shadows have been applied, thinner glazes of the monochrome underpainting are added.

3 A second glaze of green, sap green, and ultramarine blue was applied to the whole bottle. After this had dried, the artist felt that the area containing the wine was not yellow enough, so a third glaze of sap green and lemon yellow was applied. Each glaze was thinned with gel medium to a very transparent quality.

4 After the final glaze has dried, opaque highlights are added. Do not destroy the beauty of the transparent paint by overstating the opaque.

Boy on the Beach

THE BEAUTY OF ACRYLIC

Children are always a delight to portray; their soft features and lithe bodies have inspired many artists. This subject is chosen to demonstrate a straightforward approach to painting in acrylics, using a building-up technique of flat areas of colour.

A square canvas was chosen for the support as it emphasizes the shape of the figure. The square support is not utilized as often as the rectangle as some artists consider the square too static with both sides measuring the same. In painting, it is an asset to keep an open mind and to experiment with any different ideas. We could take example from Anthony Green RA, the contemporary artist who uses all kinds of configurations in the form of supports. More important is the composition within that shape. Keeping the negative space (the area surrounding the subject) to a minimum, the artist in this painting has drawn the figure rather large, filling the best part of the canvas. She has made the negative shape positive by adding interest to it with design, colour and brushwork.

Further to this, the figure is placed to the left side of the canvas, his body facing into the wider area on the right, along with the shells. This makes this area of the painting interesting and positive.

The painting is built up quite effortlessly. All areas are painted in a flat middle tone, dark areas are added in flat definite shapes as they are observed on the figure and the painting is completed by adding passages of light in the appropriate sections. Despite the fact that each area is painted in only one value, texture is achieved by the artist using interesting brushwork which remains quite visible to the viewer.

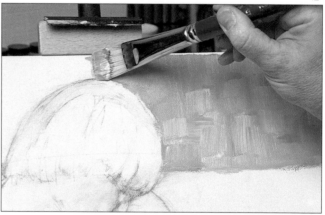

1 On fine-grain canvas with a 2B pencil, this drawing was made of the figure of a boy, taken from a photograph of two children photographed by the artist some time ago. The outline drawing is placed to the left of the canvas allowing space in front of the figure which is drawn large enough to almost fill the square canvas. This image lends itself to the square, which is a refreshing change from the norm of oblong canvases.

2 Other than the drawing, no other preliminaries were employed. The artist paints with full thick paint, mixed with a gel medium, straight on to the primed canvas, building the painting up with large flat areas. With a No. 12 flat brush, she applies a mixture of Rembrandt blue, ultramarine blue and titanium white to the sky area in a cross-hatching manner. The only variation in the sky colour are the marks of the brush and the lights and darks of the not overmixed paint on the brush.

Materials: Fine-grain canvas 18 in × 18 in (45 cm × 45 cm); brushes – Nos. 10 and 12 flat bristle; 1 in (25 cm) wide glazing brush – any soft brush will do; 2B pencil eraser; disposable palette; rags or paper towel; 3 jars of water; acrylic gel medium.

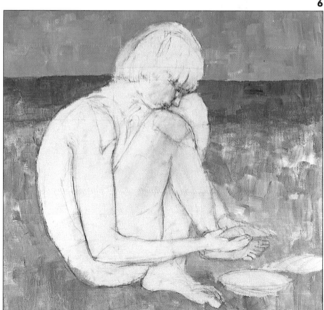

3 Rembrandt blue with a touch of burnt sienna to dull it, plus titanium white, is the mixture applied to the sea. Note how the artist paints a very straight hard edge where the sea meets the sky.

4 Where the sea and sand meet, the artist drags the brush to make an uneven edge. The brush is a No. 12 bristle used boldly in definite brushstrokes, brushed this way and that.

5 This painting is developed in flat shapes of colour. The sand is one flat area of raw sienna and titanium white. This colour is brushed into the rough area where the sea meets the sand, thus giving the appearance of the water washing over the beach.

6 The background is painted; the artist stands back to take a long look. Detail has been kept to a minimum so as not to draw the eye from the figure.

7 For the flesh colour, the artist has mixed cadmium red light, raw sienna and titanium white which she lays on with a No. 10 bristle brush in a very flat manner, disregarding any figure structure, but allowing the drawing to show through in just enough places so as not to lose it.

8 The middle tone of the hair is painted in much the same way as the body. Using pure raw sienna, the artist paints the area flat with long brushstrokes describing the roundness of the head. She then paints in the basic hue of the shells with burnt sienna, ultramarine blue and white.

9 Once again the artist views her work – a very important step in the process of developing a painting. Often obvious mistakes cannot be seen close up, but once the painter steps back the error will stick out like a sore thumb. At this stage the whole canvas is blocked in with abstract shapes of flat colour.

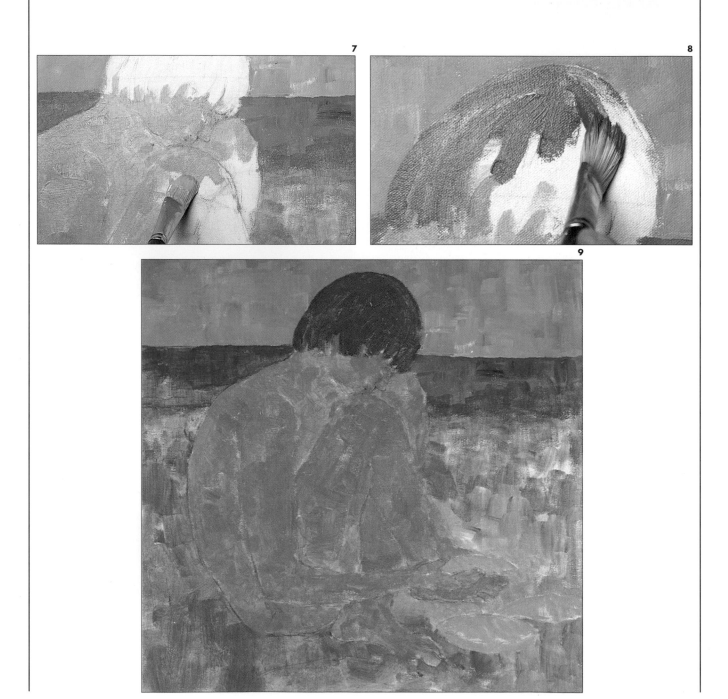

10 A transparent glaze is used to apply shapes of dark to the figure. The features are carefully depicted and the profile strengthened by the addition of a shadow on the far knee. To do this, the artist mixes ultramarine blue and burnt sienna with an acrylic gel medium. This thins the colour of the paint but not the consistency.

11 Using the same mixture, the artist applies darks to the hair and to the shells. In both instances, she uses the brush to describe the shape by pulling long brushstrokes around the curve of the image.

12 Small details of light are added to the face in definite shapes, brushstrokes are left unblended. More light areas are added to the body in flat, hard-edged, abstract shapes.

13 The impression of fine strands of blond shiny hair is the next step. This is achieved by dragging a rather dry brush, dipped into raw sienna and titanium white, over the darker areas.

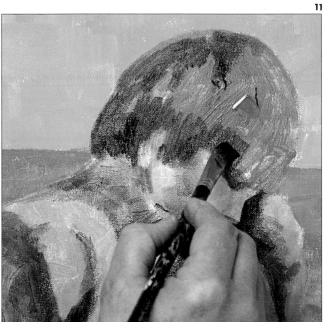

THE BEAUTY OF ACRYLIC/BOY ON THE BEACH

14 A close-up detail of the head and shoulders shows how, with three values, the artist has built up the painting so far. Some knowledge of figure drawing helps when attempting to capture the human form.

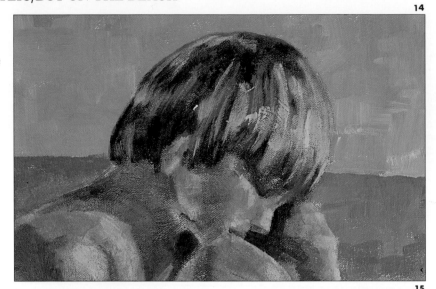

15 The dark areas of the shells are strengthened and the bright edges are highlighted.

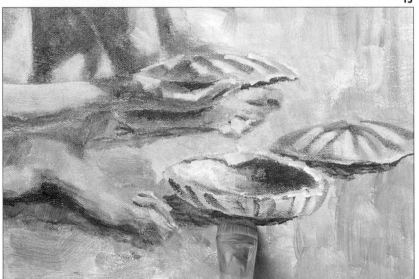

16 With a glaze of ultramarine blue, burnt sienna and gel medium, the artist applies shadows to the painting – under the shells, on the sand beneath the figure, and slightly over the lower part of the body, close to the sand. These she applies with a clean No. 12 brush.

17

17 When all is dry, the artist mixes a warm thin glaze of cadmium red light and raw sienna. This produces a lovely orange-like colour. This she applies to the whole figure to give the skin a warm glow. In places she wishes to remove it to highlight sections. This is simply achieved by wrapping a soft rag around the index finger and wiping off the excess paint.

18 Painting figures is quite an ambitious task, but not beyond the realms of anyone. Attending life-drawing classes can be a great help. Here the artist demonstrates how after you have completed your drawing the painting can be quite simply developed in easy-to-follow steps.

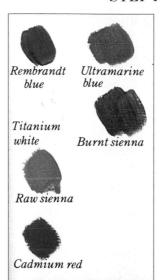

Rembrandt blue *Ultramarine blue*

Titanium white *Burnt sienna*

Raw sienna

Cadmium red

18

Glass and Bottles

THE BEAUTY OF ACRYLIC

Art students can feel intimidated by a still life of glass objects – very often beginners will say, 'how can you paint glass, it hasn't any colour'. They tend to forget that it is transparent, that the colour of articles around and behind will be reflected onto its shiny surface or seen through its body. The painter should try to remain objective and to look at the subject in an abstract way. Within the outline of a glass or bottle is an arrangement of shapes, light and dark, and it helps to delineate these while making the initial drawing. Even if the underpainting covers the lines, the mind will have a mental picture and will be reminded to add these shapes. Preliminary sketching is a great help to the artist; time spent studying and sketching the glass objects on a piece of scrap paper or in a sketchbook will add to the success of the finished painting.

Contrast is of paramount importance in the rendering of glass objects, with light and dark shapes juxtaposed. Often the beginner painter will shy away from darks, being afraid that they will 'ruin my painting', where, in fact, just the opposite will happen. There cannot be dramatic lights if there are no darks as there will be nothing in the painting to produce a contrast. The Italian word 'chiaroscuro' describes the arrangement of light and dark in the picture, the dramatic quality of form relieved by light against dark.

In this painting, the artist has used chiaroscuro to develop the picture before adding any colour to it. The colour is added in the form of glazes: thin passages of colour suspended in an acrylic medium which makes the paint transparent but does not thin its consistency.

These glazes are then applied over the monochrome painting with a soft brush. This is a technique that has been used for many years by the Old Masters, but until the arrival of acrylic, always with oils. It is very important to apply a glaze over dry paint, so the practice of building up glazes was a lengthy process due to the drying time of oil paint. In this painting the artist was able to add the first glazes almost immediately after completing the monochrome painting. A second glaze of yellow over the wine in the green bottle followed immediately after the green glaze had dried – a matter of minutes. The painting was then quickly finished by the touches of opaque white paint for the (sparkle of glass) highlights. One must be very careful not to overdo the opaque highlights in a glaze as it can quickly take away from the delicacy of the luminous colours.

Materials: Canvas board 12 in × 16 in (30 cm × 40 cm); brushes – Nos. 4, 8 and 10 flat synthetic, 1 in (25 mm) wide glazing brush – a wash brush can be used; 2B pencil; eraser; disposable palette; rags; 3 jars of water; water atomizer for keeping paints moist; acrylic painting medium.

1 This still life was set up to demonstrate a technique of painting glass: plain, coloured and cut crystal. The objects are placed on a white tablecloth and against a white background. A strong light source throws interesting shadows on to the wall and also adds more life to the glass by adding sparkle.

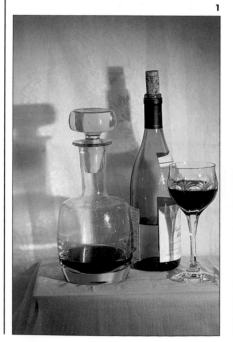

1

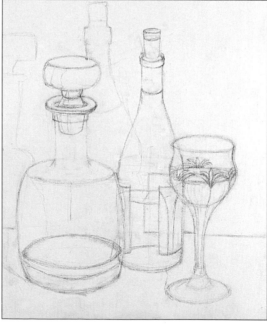

2

2 The drawing which fills the greater part of the canvas board is developed using a 2B pencil. The artist uses her pencil and an outstretched arm to work out the sizes of the objects in relationship to each other. She begins each object by breaking it down to basic forms: for example, the wine bottle is first divided into a cylinder with a cone on top and is developed further from there. The easiest way to get both sides of a symmetrical form equal is to draw a line down the centre and to measure the width of each side from it.

3 To begin this painting the artist first applies the dark areas, and at once the objects begin to look like glass. When rendering glass, it is very important to paint the darks very dark so as to provide a strong contrast when final lights are added. Many people are confused by the idea of painting clear glass, thinking it an impossibility. There is no trick to it, the painter must look and observe carefully all the shapes and colours and apply them.

4 The shadows have been painted into the background with the two colours that were used for the darks in the glass. Lemon yellow and white are now painted quite thickly all over the backdrop, the shadows are scumbled over with the same mixture and brought right up to the edge of the glass objects.

5 Using an acrylic painting medium and a medium grey made with ultramarine blue and burnt sienna, the artist glazes over all areas of glass. The glaze is fairly thin, allowing the darks to show through.

6 Folds are added to the tablecloth with definite brushstrokes, using the grey glaze. The artist then stands back to check the monochrome painting; is it ready for the colour glazes?

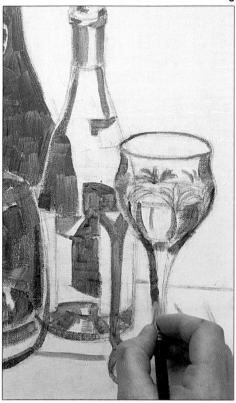

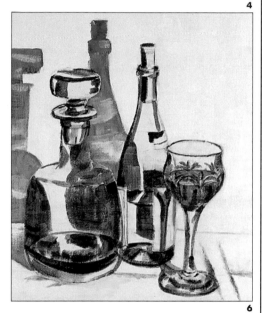

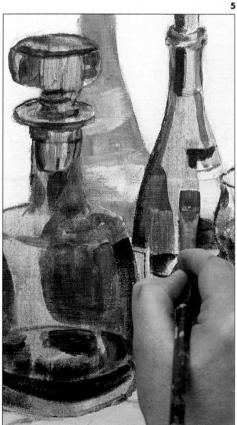

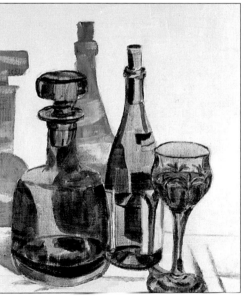

THE BEAUTY OF ACRYLIC/GLASS AND BOTTLES

7 Satisfied with her work, she progresses. A rich ruby port colour is mixed with carmine and ultramarine; this is too violet and so the artist adds a touch of burnt sienna, just right. This glaze is applied to the wine glass and also to the decanter using a 1 in (25 mm) wide hair glazing brush.

NB A glazing brush is not a necessity. Glazing can just as easily be accomplished with a large soft brush of any description.

8 Sap green is added to a little painting medium to provide a glaze for the bottle. This same colour is reflected in the port decanter, a little in the foot of the wine glass and quite a bit in the shadow on the wall.

7

8

9 The glass has quite a yellow tinge where the wine is still in the bottle so, mixing lemon yellow with a tiny touch of burnt sienna into the acrylic medium after the green is dry, the artist applies a second glaze. It is possible to build many glazes up in one area so long as the previous one is completely dry. If using oil paints, this would mean waiting days in between instead of minutes as with acrylics.

10 It is now time to add sparkle to the glass. For this, the artist adds a speck of lemon yellow to titanium white. This will warm the white slightly and it will appear brighter than pure white. To apply it, she uses a No. 4 flat brush, being careful not to overdo this stage.

9

10
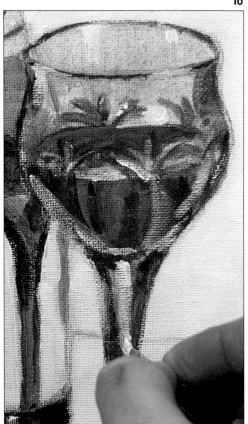

11 Finishing touches are added. A brushstroke of pure cadmium red light is applied to the liquid in the decanter and the glass to create a glow where the light is shining through.

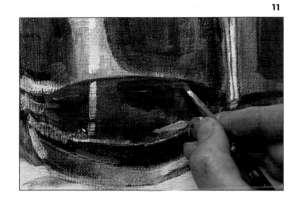

12 To finish the painting, the artist paints a dark shadow to delineate the back of the table. This she gently blends away, upwards. Shadows are then added on the tablecloth behind the decanter and also behind the glass.

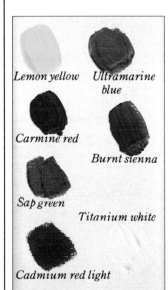

Lemon yellow *Ultramarine blue*

Carmine red

Burnt sienna

Sap green

Titanium white

Cadmium red light

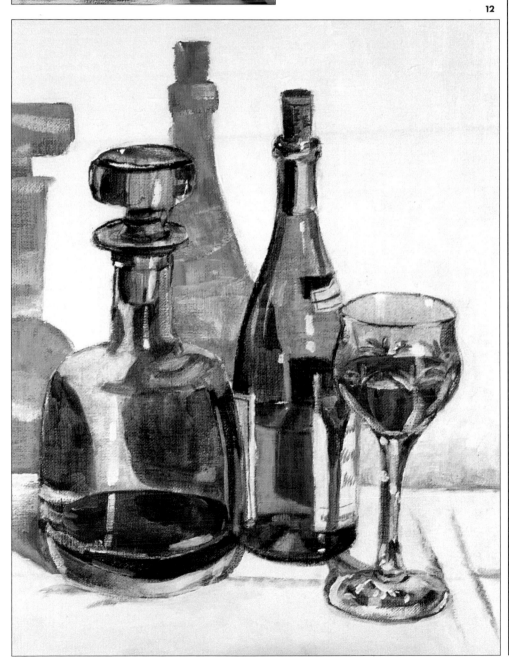

River Scene

THE BEAUTY OF ACRYLIC

An idyllic scene, a warm summer's day, cows in the pasture, fine for a walk or a picnic by the river, an activity most of us would like to participate in. But what a complicated subject for a painting? No, not at all. By following this demonstration, you will see how this artist breaks it down into simple elements.

This painting was developed in the studio, which is obviously easier than painting out of doors. It is, however, essential to the landscape painter to go out and to study his subject at first hand. The outdoors provides a wealth of subject matter, every nook and cranny offer the possibility of a painting. When going on a painting trip, it is important to keep materials to a minimum. One small rucksack should carry everything including the sandwiches, with the exception of an easel which can be carried on a shoulder strap, leaving hands free to open and close gates, climb fences, etc. Acrylic paint is the ideal medium for the artist on location as its unique character gives the painter several choices: to paint thickly in oil-colour style, to thin the paint right down and use it as you would watercolour, to use it fluid with a small brush like ink or line and wash, to sketch with it or to use it in a very quick spontaneous manner, perfect for acrylic.

Consequently, a sketchbook of reference material – skies, trees, hedges, animals, etc. – will be of great value back in the studio where you will perhaps want to develop your studies into more monumental works. A small camera kept in the rucksack often comes in handy, especially for photographing people or animals in action: a horse and rider galloping through the woods, children playing, a boat on the river. All these subjects move too fast even to contemplate a sketch, so here the camera is indispensable; it stops the action for the artist, allowing him to make his sketch from the photograph at a later date.

Landscape artists tend to be attracted to water; perhaps it is the challenge of the reflective, often moving, surface that appeals. Those just beginning to paint tend to shy away, feeling the subject too difficult to tackle. Leaving the area of water until almost last, this demonstration shows how water can be broken down into lights and darks, and simply rendered. The artist, with half-closed eyes, identifies as closely as possible the middle tone, painting it in a flat layer. Observing again she classifies the light and dark areas and paints them in. A question often asked is 'What colour is water'. To the painter, water is what it reflects; a moving pattern of colour, lights and darks. Detail is best kept to a minimum in reflections, objects suggested rather than described. Tones kept generally *en masse* rather than fragmented will maintain the peaceful tranquillity that water transmits in a painting.

Materials: Canvas 18 in × 30 in (45 cm × 75 cm); brushes – Nos. 10 and 12 flat bristle, No. 4 flat synthetic, No. 1 watercolour rigger; tracing paper; pencil; conté crayon, putty eraser; ballpoint pen; disposable palette; 3 jars water; water atomizer; rags or paper towel; matt acrylic medium.

1 Working from this photograph of students by a river, the artist shows how with acrylics a painting can be developed one area at a time. She also demonstrates how to paint water and figures in a landscape.

2 The horizontal composition is drawn onto a piece of tracing paper the same size as the canvas – 18 in × 30 in (45 cm × 75 cm). As this is quite a complicated painting, depicting several elements, it is easier to develop the drawing on to the tracing paper and transfer it a section at a time. This is only possible with acrylics on canvas: oil paints are so slow to dry that it would take the artist forever to complete a picture. Another advantage of this technique of drawing on tracing paper is that it saves a lot of rubbing out and putting pressure on to the canvas. After the drawing is complete the artist goes over her lines at the back of the paper with conté crayon or chalk. At this stage only the main areas of the painting are transferred.

1

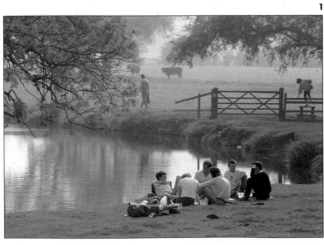

2

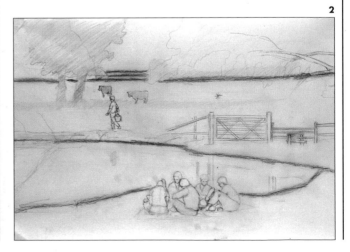

3 To keep the impression of a misty distance, the artist paints the sky a warm grey. For this she uses raw sienna and ultramarine blue, painting in quite a flat manner. Matt acrylic medium is used throughout this painting. Paint is applied in most areas in its final tone; no underpainting is employed. The distant colour is achieved by adding a little sap green to the sky colour. As the artist works toward the bottom of the canvas (the foreground) she gradually strengthens her greens with more sap green and the addition of ultramarine blue.

4 The sky and land areas dry, the artist, after first going over the back of the lines with conte crayon, traces in the middleground objects -- trees, cows, man and gate. To do this a ballpoint pen is used, which

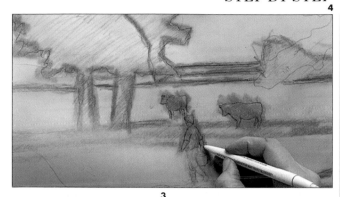

enables her to visualize which lines she has already transferred. In addition, it provides a finer drawing on the canvas than other implements would imprint.

5 With a mixture of lemon yellow, ultramarine blue and titanium white the artist paints the trees on the left of the picture plane. The colour is kept soft and misty to imply the impression of a hot misty afternoon in early summer. Continuing with the middleground, the cows are added. Using a No. 4 flat synthetic brush the cow on the left is painted using raw sienna, ultramarine blue and titanium white.

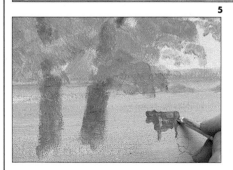

6 The middle ground is progressing. With ultramarine blue, titanium white and burnt sienna the artist paints the cows, the man's hair and the gate. His clothes are ultramarine blue and white and flesh burnt sienna and white. Burnt sienna and ultramarine blue suggest a shadow under the trees.

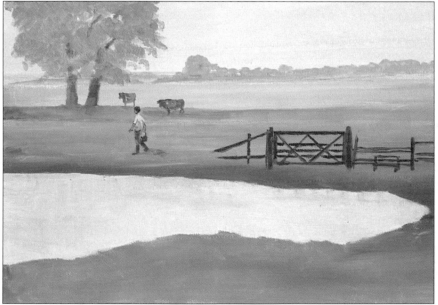

ACRYLICS

7 The tracing-paper drawing is reapplied to the dry painting – and all other elements – figures, trees, reflections – are transferred onto the canvas. Detail is then painted into the riverbank. Burnt sienna and raw sienna are used on a No. 12 flat bristle brush for the muddy bits; ultramarine blue, burnt sienna and sap green for shady grassy areas.

8 The middle value of the figures is now painted. Various blues and greys mixed from ultramarine blue, burnt sienna and titanium white are used. To do this, a No. 4 flat synthetic brush is employed.

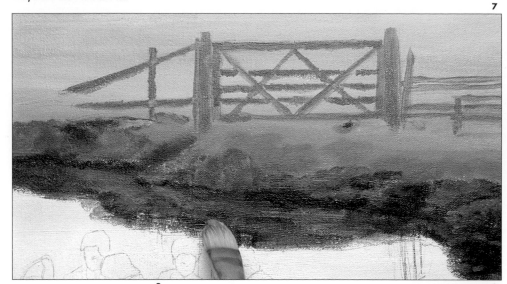

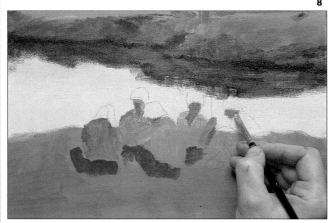

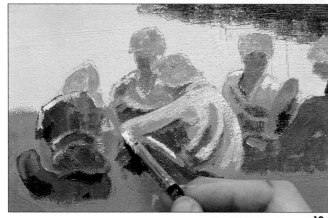

9 The dark value has been added to the figures and now the artist adds the highlights.

10 The figures are completed by adding rugs beneath them. One is raw sienna and white with a little blue detail added, the other burnt sienna and white. A dark shadow is applied underneath to give the impression of the rugs being rumpled. For this the artist used ultramarine and burnt sienna. The detail in the figures is kept to a minimum so as not to detract completely from the rest of the painting.

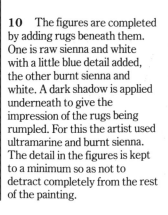

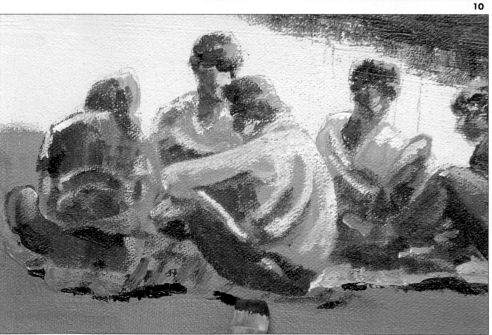

11 Branches of the left foreground tree are painted in with burnt sienna and ultramarine blue. A No. 10 rigger brush is used for the larger branches and a No. 1 for the smaller ones. The rigger brush is a wonderful aid to the artist once he has mastered it. It is quite a good idea to practise with it on a piece of scrap paper. This artist finds that for painting branches, gently pushing the brush with very wet fluid plaint gives the desired effect.

12 With a No. 12 bristle brush and a paint mixture of sap green and burnt sienna, the artist paints in the darkest leaves. For the middle value she adds lemon yellow to this mix, finally adding titanium white for the lightest leaves. The brush is used in a stabbing motion, allowing the bristles to spread out as they meet the canvas.

13 Short vigorous diagonal strokes using the side of a No. 10 bristle brush with a grey green paint mixed from ultramarine blue and raw sienna is the formula for the weeping willow tree on the right-hand side of the canvas.

11

12

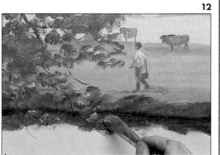

13

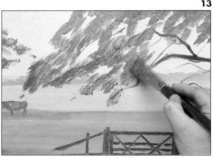

14

14 The artist steps back to scrutinize her work which is progressing rapidly. When painting a landscape with water, this artist leaves that area until last, so that she can adjust the tone of the painting, either lighter or darker. In this instance, she sees, when standing back, that the painting has an overall dark tone, so to balance this she decides to keep the general value of the river light, creating tonal balance and contrast within the composition.

THE BEAUTY OF ACRYLIC/RIVER SCENE

15 With a No. 12 brush and a grey green (raw sienna and ultramarine blue) mixture of paint the artist scumbles (see pages 313 and 412) the paint on to the canvas in vertical strokes and then with a dry No. 10 brush rapidly blends the paint horizontally, depicting reflections of the overhanging tree in the water.

16 Directly below the gate, and using the same colours that were used to paint it, the artist paints the reflection in the bend of the river. A little ultramarine blue and burnt sienna is used to describe the reflection of the walking man.

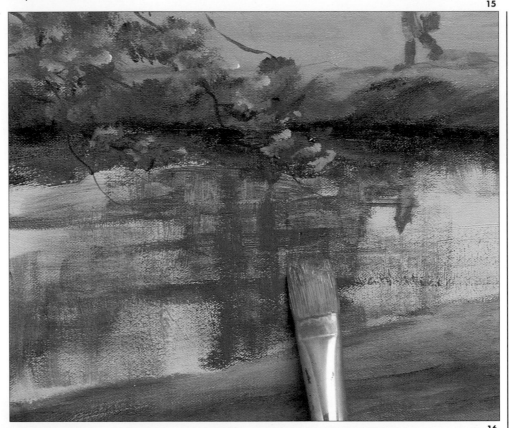

15

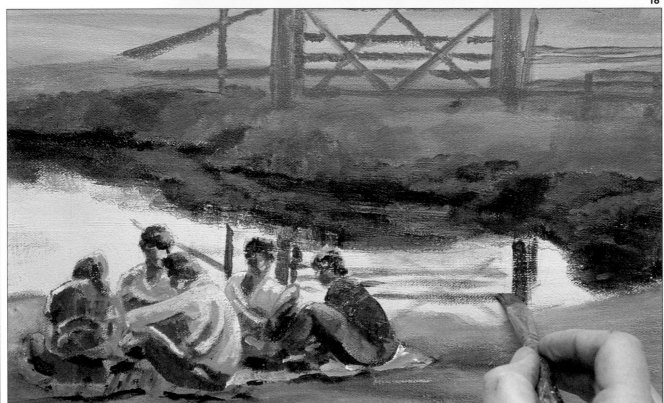

16

17 As a final touch, white paint is lightly and minimally scumbled horizontally to add water.

18 The horizontal composition in this painting and the dramatic dimensions of the support add to the theme of repose and peace. The horizontal shape as opposed to the square or shorter oblong shape creates a feeling of calm and restfulness and the lines in this painting only add to that.

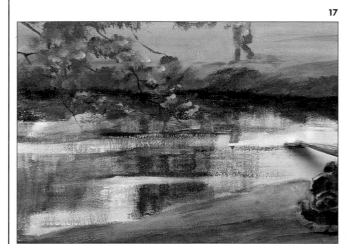

17

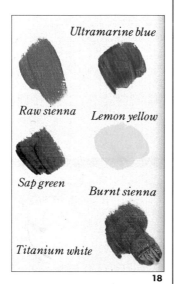

Ultramarine blue

Raw sienna *Lemon yellow*

Sap green *Burnt sienna*

Titanium white

18

Chapter 9
Further Techniques

In this chapter we show how acrylics can be used in mixed-media painting, as a sketching medium and, finally, applied with devices other than brushes to render textures.

For mixed-media painting, the artist has decided to do a figure study. Beginners will perhaps think this subject too difficult to tackle – not so. When drawing and painting one must keep an open mind and look at the subject objectively. Painting the figure is no different to approaching a still life or landscape. The artist observes the individual shapes of any subject; the figure like the landscape, is made up of curves and angles, areas of light and dark, and shapes of different colours. Look at your subject with squinted eyes to cut down on detail, observe the large flat areas and draw or paint them. Of course, it does help to go to a life-drawing class. By doing this, your ability to draw will increase rapidly. Painting is an extension of drawing; it is essentially drawing with a brush and using different colours other than black and white.

For the second demonstration, the artist shows how you can actually use acrylic paint with a brush and still produce what we think of as a drawing. The paint thinned to this extent could also be applied with a quill pen or even with an airbrush.

Many illustrators use acrylic paints for their airbrushed works.

Finally, we demonstrate how this paint can be applied in ways other than with a brush. To illustrate this, the artist sets up a still life of textured objects in the studio and then adds an imaginary background to complement the subject. A sponge is used to create the illusion of gravel. Painting with sponges (see page 413) is not a new idea but is most often employed by watercolourists. It is possible when using this medium to produce a whole painting with sponges. A palette knife is also used in this painting (see page 428). These come in a multitude of shapes and sizes and it is really up the the artist which he chooses for himself. As with sponge painting, many artists produce complete paintings with the palette knife alone; this produces quite a thickly textured painting.

Murals are often painted with acrylic because it can be painted on to almost any surface, so it is the ideal paint for such projects. Indoor murals can be painted directly over an ordinary household paint undercoat.

Outdoor murals are a little more tricky; the wall to be painted on needs to be prepared and treated first to ensure that the mural stands up to the elements.

WIPING OUT

In the technique of 'wiping out' acrylic paint is used only for the underpainting and allowed to dry. Opaque pastel oil colour could be used in much the same way, but would probably take two weeks to dry instead of a matter of minutes. Soft pastels can also be used as an underpainting to oils, but must be made fast with a fixative. When using this wiping out of oils technique, it is advisable to use only transparent colours. This enables the colour of the underpainting to shine through to a certain extent. It becomes quite easy to recognize the transparent oils as opposed to the opaque ones; often this information is marked on the tubes. Passages of transparent paint are known as glazes (see page 390). By lifting areas of glaze from the painting, you are exposing the coloured acrylic ground underneath, representing the middle-tone value. The remaining glaze encompasses both the middle-tone darks and the darkest darks. Lights are added to this middle value by means of very light opaques in the final stages of the painting. Muslin cheesecloth is ideal for wiping out, but any soft rag will do.

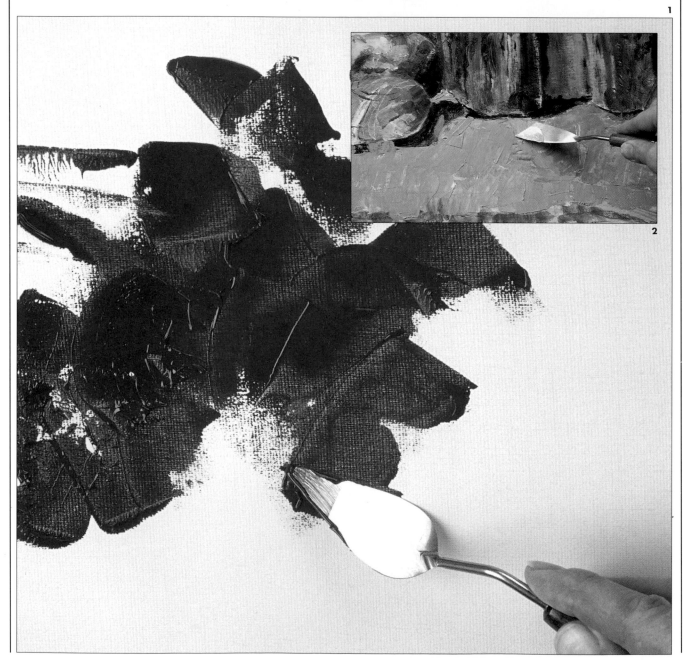

1

2

USING A PALETTE KNIFE

Although commonly called a palette knife, the trowel shaped knife is actually known as painting knife. A palette knife has a long blade similar to a butter knife but more flexible and is used for mixing paint on the palette. The painting knife, on the other hand, comes in many shapes and sizes. It is very flexible and can be used for areas of a painting or to render a complete painting. It is a good idea to experiment with different types of knives – flat-ended ones, rounded, wedge shaped or pointed, large or small. Of course, it makes sense that if the painting is to be on a large scale, then you would use a larger painting knife.

1 A pointed, trowel shaped painting knife is used to spread ultramarine blue paint liberally on to the canvas.

2 A flat-ended palette knife is utilized to spread paint in an area of stone in a painting that has been rendered with brushes as well as knives.

ACRYLICS

411

SCUMBLING

A scumble is a semi-opaque layer of light colour applied over a dry layer of a darker colour, usually opaque. A scumble resembles a light-coloured veil, partially obscuring the underlying colour. When scrubbing with light paint over dark it is a good idea to use a brush that is old as the vigorous motion may cause hairs to break off. If they do, just brush them off the canvas. For a transparent scumble, such as lace curtains blowing in the breeze against a dark background, mix colours with an acrylic medium, a lot of white and a little water and scrub on using your old brush.

Below is an example of scumbling: first, light over dark and quite opaque; second, the light scumble is fairly transparent; and the last example shows dark colour scumbled over a light background.

The small detail shows where scumbling has been used in a painting using both light and dark paint.

The sponge is a very useful tool for the artist. Commercial sponges are just as good as natural ones for this job and far cheaper. The textures that one can crate with a sponge are endless – fluffy clouds, sea surf, sand, gravel, flaking walls. Regular patterns, like concrete slabs, wooden boards and fences, can be painted with a flat-edged sponge. Shape the sponge with the scissors or pull it to pieces with your hands. For regular patterns, board etc., dab the sponge on to the canvas holding it the same way each time. To create an uneven covering, turn the sponge slightly each time you touch the picture surface.

When buying sponges, think of the colour. To see the amount of paint you are applying dark sponges are better for light paint and light ones for darker colours. Don't forget that after use they must be well rinsed out.

Here the artist, using a torn piece of sponge and ultramarine blue, creates an uneven texture by slightly turning the sponge each time it is applied to the canvas.

This demonstrates how the artist creates the textures and colour of a pebble path by using different colours, and applying them unevenly.

413

Female Figure
FURTHER TECHNIQUES

Using the female form as a subject, this painting describes how acrylic paint can be used in a mixed media composition. It is exciting to use conventional materials in unconventional ways and to experiment with different ideas. The drawing in this painting is as much a part of the completed work as the applied colour. The charcoal drawing can be identified on the finished surface along with the acrylic ground which surfaces throughout the oil glazes. To carry the unusual a little further, the artist has decided to use an unconventional canvas, the long narrow shape lending itself perfectly to the attitude of the model. High contrast is produced by using a strong, low lamp by the head of the figure which, when translated into the painting, describes the technique of lifting out dark glazes to expose the light acrylic underpainting.

A little knowledge about materials is essential to this type of painting. There are many variations of soft mixed media that can be used by the artist and which will work well together. Likewise, there are those that will not, and results can be disastrous. Oil paint can be used over many other materials – pastels, gouache, watercolour, acrylic – but very few painting mediums can be used over oil. Acrylic paint makes an ideal ground for oils. The oil paints employed in this demonstration are only of a transparent quality with the exception, of course, of white, so allowing the drawing and underpainting colours to show through and contribute to the finished work. It would be helpful to the student to spend time learning to distinguish between the transparent paints and opaque ones.

This painting technique is not as complex as it may seem at first. The composition is selected and drawn on to the canvas and the light acrylic underpainting is then applied quickly and loosely. Giving this time to dry, the artist re-establishes the drawing with charcoal and fixes it with a spray fixative. The acrylic underpainting provides the middle value of the painting. Dark oil glazes are applied all over the charcoal drawing and the acrylic ground. Areas are then wiped back to expose the acrylic middle tone; the remaining glaze represents middle-tone darks and darkest darks. All that is left is to add minimal passages of opaque to represent the highlights. This demonstration of a mixed media painting technique can provide the artist with a fast, spontaneous approach to the subject.

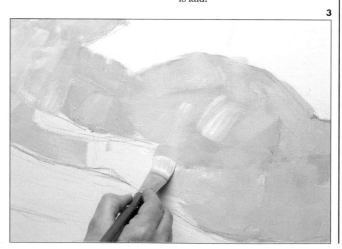

1

Materials: Canvas size 20 in × 40 in (50 cm × 100 cm); brushes – Nos. 10 and 12 flat bristle, 1 in (25 mm) wide blender or household brush; conté crayon; charcoal; putty eraser; disposable palette; rags; 3 jars of water; atomizer for water; turpentine for cleaning oil brushes.

1 For this demonstration of mixed media (oil paint over acrylic), the model is placed in a bright source of light from the left which creates strong tonal values, the highlights being emphasized by the dark cover over the couch.

2 The artist uses a black conté crayon to block in the figure which fills the length of the long narrow canvas. The cushions break up the monotony of the fairly uniform couch, echoing the curves and softness of the body.

2

3 A delicate pastel underpainting is applied to lay a foundation for the oil overpainting. For the flesh, a flat ground mixed from raw sienna, cadmium red and titanium white is laid.

3

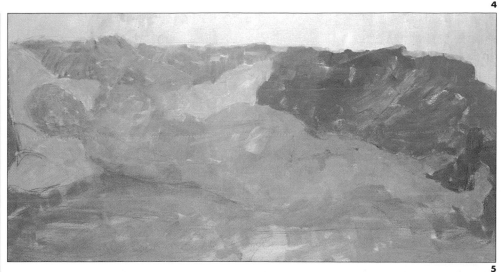

4 The underpainting is loosely completed in very pale colours – carmine, a small amount of ultramarine blue and white for the couch, raw sienna and titanium white for the background and the woman's hair, sap green and white for the large soft cushions.

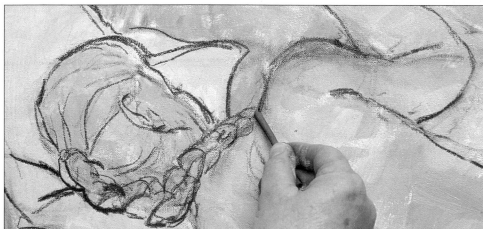

5 The artist redraws the figures with charcoal over the acrylic underpainting. Charcoal is more sympathetic to the surface than conté crayon which skids over the acrylic paint without making marks. This is sealed with a spray fixative to prevent the small particles of charcoal from polluting the oil paint.

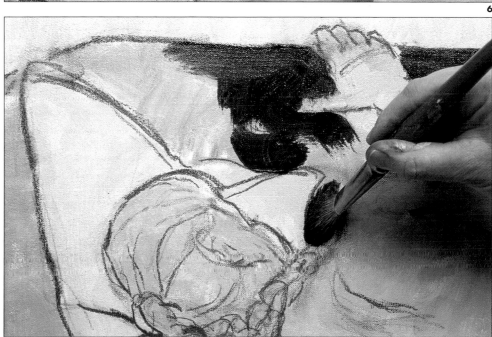

6 Using only transparent oil colours, the artist begins to add the overpainting. It is quite important for the artist using oil paints to know which colours are transparent and which opaque. A paperback book called *The Painter's Pocket Book of Methods and Materials* by Hilaire Hiler (pub. Faber) is a very useful guide. Failing that, you will find that many oil paint manufacturers state this information on the individual tubes.

ACRYLICS

7 The underpainting is painted rather dark: carmine red with a small amount of ultramarine blue for the rug over the couch, ultramarine blue and sap green for the cushions, all mixed with oil painting medium.

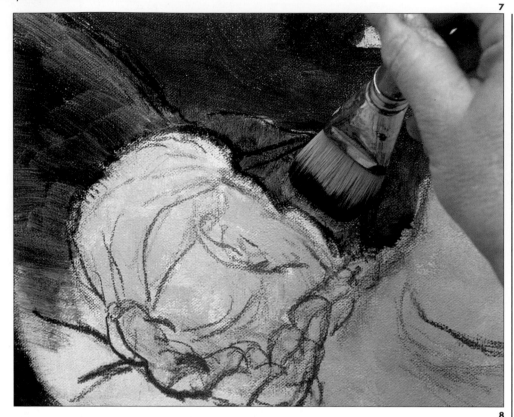

8 The underpainting is completed in no time at all, the transparent glazes being loosely applied. Raw sienna with the oil medium complete this stage with the overpainting of the hair and curtains in the background.

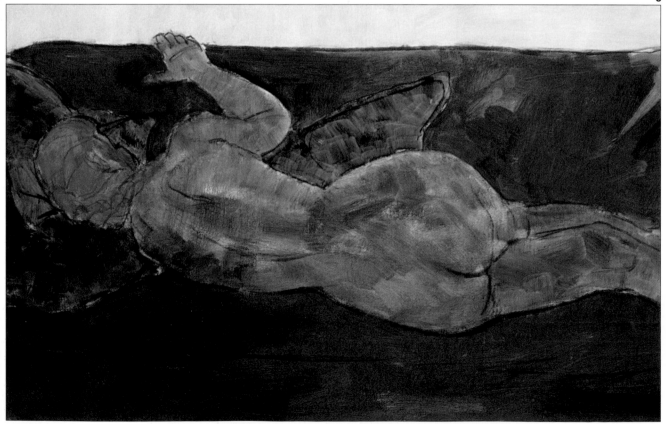

9 Using a 1 in (25 mm) blender brush, the artist goes all over the painting diffusing all of the brushstrokes and running all edges together.

10 With a clean soft rag (preferably cheesecloth), the dark glaze is lifted from the light side of the face, hair and cushions to establish a middle-tone value.

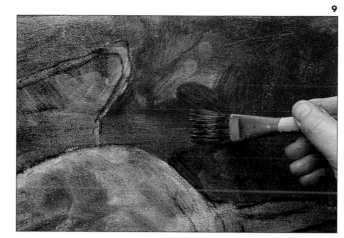

11 The rest of the body is treated in the same manner and now the couch to reveal the pastel underpainting.

12 The pattern of middle tones is completed and the artist can continue to develop the painting. If at this stage the artist feels that she has taken out too much of the glaze, it can easily be reapplied and the middle tone re-established.

FURTHER TECHNIQUES/FEMALE FIGURE

13 Here the artist demonstrates correcting mistakes. The face of the figure was wiped out too much, giving the model the appearance of having a fat face, so the glaze is painted back in.

14 Stronger darks are needed in places. Here the artist has applied them with a brush and is smoothing the brushstrokes out in an isolated area with her finger. Fingers can be a helpful tool to the artist.

15 With a No. 10 flat bristle brush, the artist tidies up around the figure, sharpening the edges and strengthening dark areas that need it: for example, the shadow under the figure and the front of the couch (the foreground of the painting).

16 Opaque passages are added to the couch by mixing white with the transparent colour. Titanium white oil colour with a touch of burnt sienna is applied only into the area of the figure reserved for the very light. Do not destroy your middle-tone values that have been established by the acrylic ground.

17 Detail in the form of dark brushstrokes has been added to the folds in the curtains of the background. Here the artist applies a light opaque to the top of those folds.

18 This painting has a spontaneous quality about it. The charcoal drawing which can be identified through the paint film lends a sketchy, instinctive look to the work. Most of the surface is transparent, with the opaques held to an absolute minimum. The total effect is fluid and translucent.

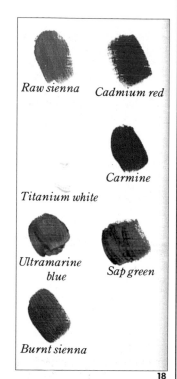

Raw sienna *Cadmium red*

Carmine

Titanium white

Ultramarine blue *Sap green*

Burnt sienna

17

18

Cat
FURTHER TECHNIQUES

The subject of animals can be very challenging and needs practice, but it doesn't take too long before it becomes quite rewarding to the artist.

Initially it is best to use pencil or charcoal and to spend time sketching. If you have a pet of your own you have a ready-made model; if not, perhaps you can visit a friend with an animal you can draw. Failing that, you can always go to the zoo or out into the country. Whatever you choose to do, persevere as at first it will be frustrating. Animals move a lot; a sleeping cat seems to be aware that you are looking at it and will flick its tail, move a paw or its head, so patience is a necessity.

When you begin, concentrate on sleeping animals. Although they tend to move a bit, it is a lot easier than sketching an animal awake. Work quickly, look for definite lines and draw them. If the animal wakes up or moves while you are drawing, and they normally do, begin again. You will learn nothing by trying to complete the drawing that you have started. When you have more experience, then you can perhaps finish the picture from memory. Careful observation and sensitively drawn lines filling a page of your sketchbook will have taught you a lot more. Block out the drawing in simple shapes: the upside down triangle of a hen, the egg shape of a bird, the squareness of a cow; and carefully develop the drawing from this. In this drawing, the whole cat can be encompassed in an oval, its head a circle within that oval, its ears and nose triangles and its tail a long cylinder. The artist

sketched out these basic shapes before she began to build up the values with cross-hatching. Remember that animals are like humans, no two look exactly alike; some look fierce or mean whereas others look soft or quiet. Animals show their moods in other expressive ways too, different to humans, a cat's pupils will be little more than slit when the animal is content, large and round when afraid. Many animals use their ears to express feelings, also tails and hair along their backs.

Acrylic was used in this drawing, like permanent ink on a brush. Ultramarine blue and burnt sienna were mixed together in a little pot with water to the right degree of fluidity, enough made to execute the whole drawing. When the cross-hatching was finished and dry a few colour washes were added to complete the picture.

1

Materials: Light green Ingres board 14 in × 21 in (35 cm × 52.5 cm); brushes – Nos. 2, 4 and 20 watercolour; 2B pencil; putty eraser; disposable palette; rags or paper towel; water atomizer; small pot; 3 jars water.

1 Animals are a demanding subject for the artist, twitching and fidgeting even when asleep. Studying their features and movements by using a sketchbook is a great asset to the painter. Here, the artist's tabby female cat, George, poses sheepishly on the kitchen counter.

2 Using a piece of pale green Ingres mounting board as a support, the artist very lightly sketches an outline with a 2B pencil. Over this she adds to and darkens the drawing with a very watery mixture of ultramarine blue and burnt sienna – these two colours being the basis of the complete drawing. The brush used is a No. 4 sable watercolour with a fine point.

2

3 Using the grey thinned paint, the artist develops the cat's face, paying special attention to the eyes as they are the most predominant feature in the whole face.

3

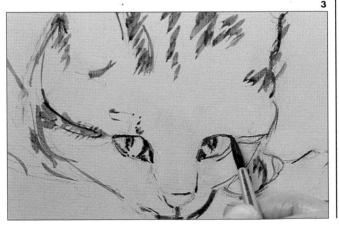

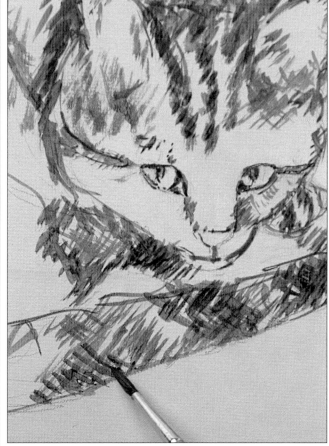

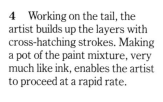

4 Working on the tail, the artist builds up the layers with cross-hatching strokes. Making a pot of the paint mixture, very much like ink, enables the artist to proceed at a rapid rate.

5 The whole of the outline of the cat is filled with the cross-hatching technique, the artist being aware of the undulating lights and darks of the tabby's fur.

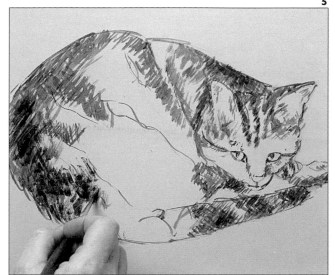

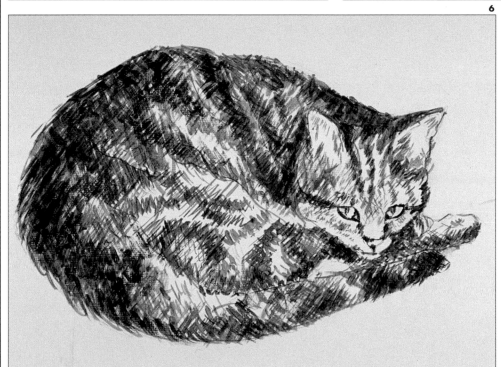

6 The cross-hatching process is completed, the artist has built up the area on the cat's back to the left of the support more than any other part. In this section the cat is actually black.

FURTHER TECHNIQUES/CAT

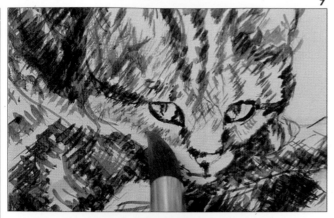

7 This detail gives the student a closer look at the cross-hatching technique employed. A gingery colour wash is mixed with raw sienna and burnt sienna and applied to the face with No. 20 synthetic watercolour brush.

8 The artist continues to apply this wash in the appropriate places. There is no worry of disturbing the drawing as acrylic paint is permanent.

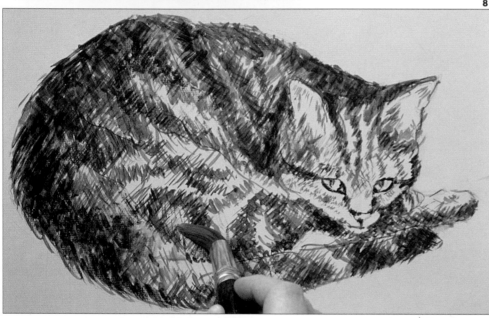

9 To strengthen the darker areas and to add to the blackness, a wash of ultramarine blue is applied over parts of the head, back and tail.

10 Carmine is mixed with a little raw sienna and watered down to produce a soft pink for the insides of the ears and the tip of the nose.

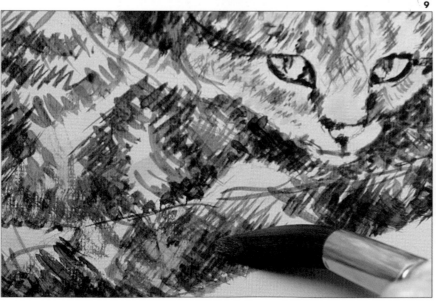

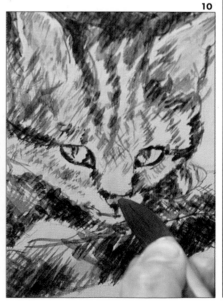

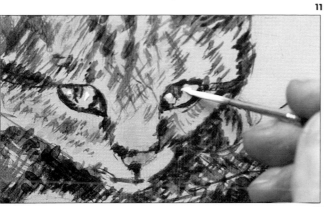

11 For the highlights in the eyes, the artist uses a No. 2 sable watercolour brush and pure titanium white. Other white areas are added around the eyes, nose and mouth.

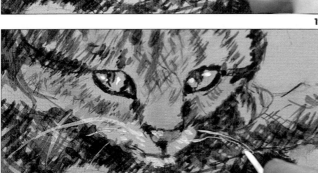

12 A No. 1 synthetic rigger brush is used with fluid white paint for the whiskers. The brush is pulled quickly in fine lines. Tiny hairs are applied in the same way to the ears.

13 To complete the delicate drawing, the artist mixes ultramarine blue and burnt sienna with a little cadmium red. With this and a No. 20 watercolour brush, she adds a shadow. This anchors the cat to the ground as previously it appeared to be floating in a vacant space.

Burnt sienna

Ultramarine blue

Raw sienna

Carmine

Titanium white

Cadmium red

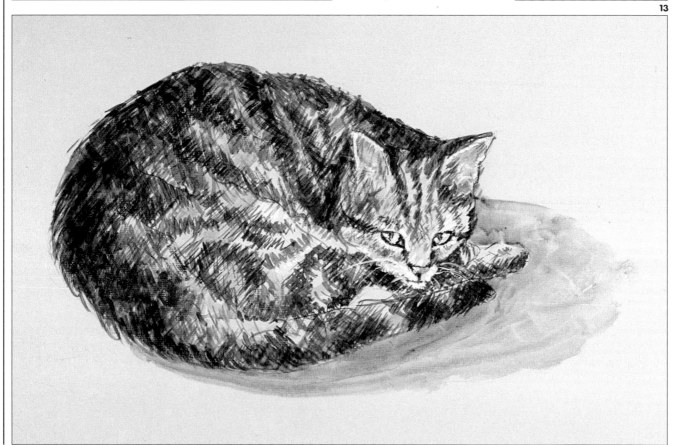

The Woodman's Garden

FURTHER TECHNIQUES

The subject of this painting could be found in most gardens. This demonstration shows that any subject matter, however simple and ordinary, when put together with imagination can make an appealing painting.

When setting up a still-life subject be careful not to make it appear contrived. The objects should look as natural as possible. Use a sketchbook and draw the subject from different angles before you begin to develop the composition on to your canvas. If you are not happy with the arrangement, rearrange it; do not begin the painting until you have arrived at the right solution to the problem – design of the composition.

In this instance, these objects were brought into the studio and displayed on a table, so the background had to be fabricated from the artist's imagination and memory bank. When you begin to paint, it is virtually impossible to draw from the memory as you will have little visual knowledge in store. The exercise of memory drawing is one way to develop this; that is, look at an object – still life, tree, house, person, whatever – and spend two minutes observing. After this time, turn away and try to remember and draw the object. Another way to develop your visual knowledge is to sketch, anywhere, anytime, anything and often.

To aid in the placing of tonal values in your still life, a light shining from a definite direction, usually from the right or the left, will make the light areas brighter and the darks stronger.

Thus, the final painting of this book exploits many of the techniques that we have learned in previous chapters – scumbling, stabbing on the paint, flicking the brush, using a sponge with unmixed colours, stippling and glazing and, in addition, the artist demonstrates the use of the palette/painting knife.

2 The artist spends some time pre-planning the composition and deciding what format she should use. To do this, she makes several rough thumbnail sketches. It is better to have some idea of the composition before working on the support as it cuts down on the confusion of many wrong lines.

Materials: Canvas board 20 in × 28 in (70 cm × 70 cm); brushes – Nos. 10 and 12 flat bristle, No. 4 flat synthetic; sketchbook; 2B pencil; eraser; charcoal; spray fixative; disposable palette; 3 jars water; water atomizer; rags or paper towels; 2 palette/painting knives; piece of sponge.

1 A selection of textured objects, all relating, is set up in the artist's studio to demonstrate in a painting how acrylic can be manipulated to produce many textures. A bright light is directed on to the objects to produce a strong tonal value.

3 The drawing is established on to a canvas board support with a piece of willow charcoal. When satisfied with the outline, the artist flicks off any excess charcoal dust with a soft rag and then fixes the drawing with a concentrated spray fixative. The background of hedge and shed is added to the studio still life to add interest and to give the illusion of the objects being outdoors in a natural setting. Working from the top of the painting to the bottom, the

artist lays in thin washes of local colour pertaining to each individual object or area. Using a large brush, No. 12 bristle, a wash of sap green and ultramarine blue are used for the shed and bark of the log. The stones are painted with various mixes of ultramarine blue, burnt sienna and carmine: likewise the axe head. The handle is painted in burnt sienna, and the grass sap green.

4 The artist, working very quickly and loosely, has applied local colour to the whole canvas. She now establishes the source of light by adding the darks.

5 An imaginary touch is added to the painting in the form of plant pots and a rake. This group of objects balances the composition and relates the background to the foreground.

6 The darkest tone of the hedge is painted in roughly in a cross-hatching brushstroke, allowing the paint to vary in thickness. This gives the impression of light coming through the thinner parts of the hedge.

7 Light in the hedge is added by stabbing the brush on to the support, using a No. 12 bristle brush and sap green, lemon yellow, and titanium white.

ACRYLICS

8 With a mixture of raw sienna and ultramarine blue, the artist, using horizontal brushstrokes, scumbles paint on to the shed. Dark lines are then applied to give the appearance of overlapping boards and the doorway. The same mixture, ultramarine blue and burnt sienna, is used to darken the glass in the windows and the shadow of the rake handle.

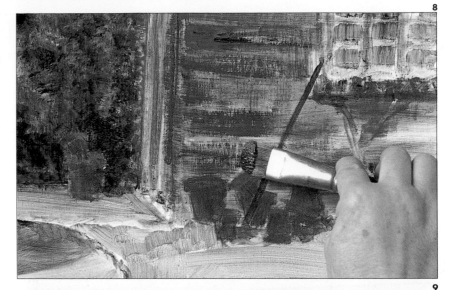

9 Painting the pots is the next step. Being careful not to overstate them, the artist uses a No. 4 flat synthetic brush and a mixture of cadmium red, burnt sienna and white. The rake is then painted in two tones, dark and light.

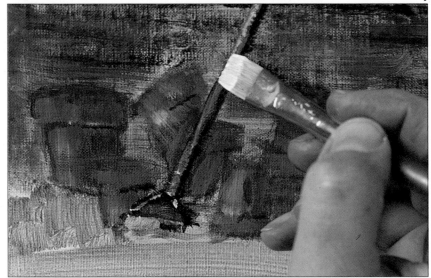

10 Small amounts of burnt sienna, lemon yellow, raw sienna, ultramarine blue and titanium white are put very closely together on the palette, but not mixed. The artist takes a damp sponge, dips it into the paints, picking up each colour individually and dabs it on the painting along the path. All of these colours together create the illusion of pebbles.

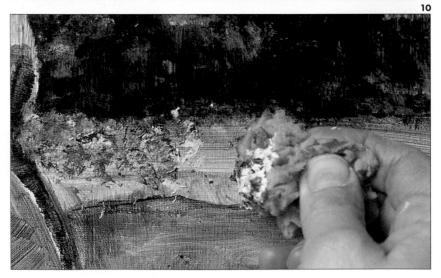

11 Trying to avoid uniformity, the artist paints the grass with a pulling down, bouncing motion of the brush. To do this she uses a No. 12 flat bristle brush containing sap green, lemon yellow, a little burnt sienna and titanium white not overmixed. It is important to keep dipping into the paint to vary the colour and texture.

12 The artist paints the three stones on the left. The top one is stippled with ultramarine blue and burnt sienna, after a mixture of raw sienna and white is sponged on. On to the middle stone a thin glaze of cadmium red and ultramarine blue is followed by darker detail and to the bottom stone the artist applies a mixture of ultramarine blue, burnt sienna and titanium white. The handle of the brush is used to scrape in light veins.

13 To paint the stone on the right, the artist uses a mixture of raw sienna and violet (ultramarine blue and carmine) with titanium white. For the dark side she uses ultramarine blue and burnt sienna. A thin glaze of white is scumbled over the lighter side and finally the cracks are added.

14 Texture is built up in the log; darks are applied first, then lighter greys are dragged down to create the bark. Darker paint is scumbled in a circular motion over the light colour of the 'slice' of wood to add the rings.

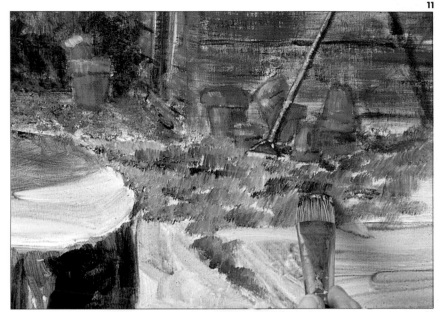

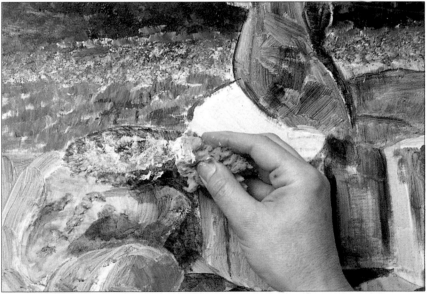

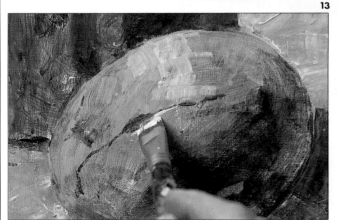

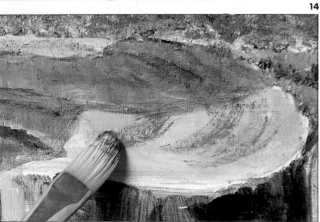

427

15 Both the axe handle and the head are simply painted in two tones: the light surface and the dark top edge. A little highlight is applied along parts of the edge of the axe with white.

16 Using a palette knife, the artist spreads the general colour of the stone slabs in the foreground which is raw sienna, titanium white and violet, the violet being made from ultramarine blue and cadmium red.

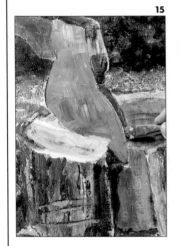

15

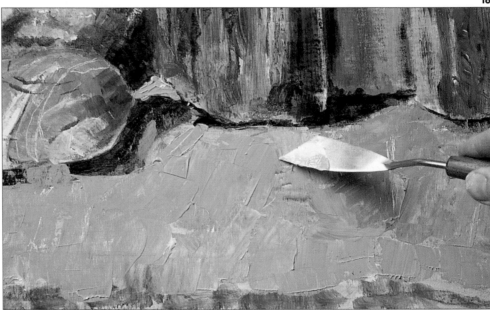

16

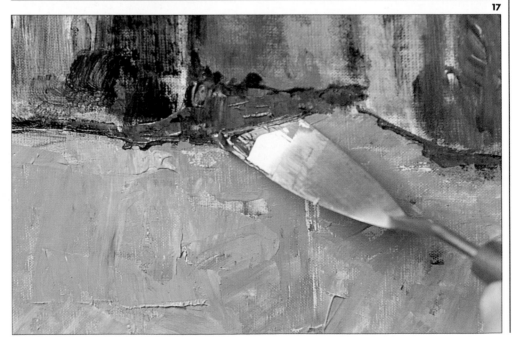

17

17 Still using the palette knife, the artist adds the shadows under the log and stones. Using a palette knife is not difficult; in fact, it could be compared to spreading butter on to bread. Using it in this area of the painting produces the right effect – layered sharp-edged rock-like slabs.

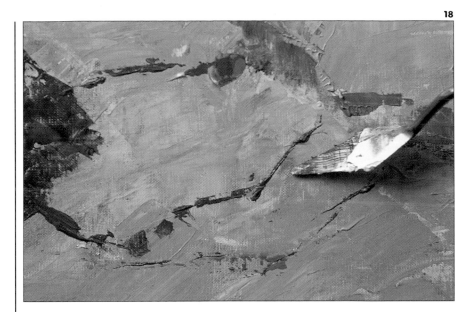

18

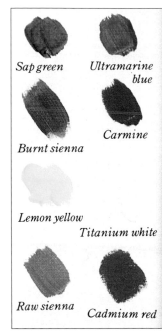

Sap green

Ultramarine blue

Burnt sienna

Carmine

Lemon yellow

Titanium white

Raw sienna

Cadmium red

18 Finally, using the edge of a long pointed trowel-shaped palette knife the artist applies the cracks on and in between the stones.

19 Many textures and techniques have been used to develop this painting but still the composition holds together. This was achieved by the use of a limited palette, seven colours plus white, and the design of the work. The handle of the rake, the line of the grass in the crack on the right and the axe handle all carry the eye to the focal point, the axe head in the log. Here the eye is held by the brightest area in the painting, the yellow sliced log.

19

Index

Acknowledgements

Watercolour
The author would like to thank all those who have helped in the preparation of this section. Special thanks to Ronald Maddox for his expert and helpful advice, and for the use of his studio; to Winsor & Newton for advice and for providing material and equipment; and to the staff of the Winsor & Newton shop in Rathbone Place, London

Contributing artists Ronald Maddox: pp 34-35, 41, 46-51, 52-55, 66-71, 72, 75, 80-85, 92-97, 98-103, 104-107, 108-113, 124-127. Ronald Maddox is vice president of the Royal Institute of Painters in Water Colours and exhibits both in Britain and abroad. He has had several one man shows and his paintings have been purchased for public and private collections in Britain, Germany, the United States and Canada. He trained at art colleges in Hertfordshire and London and practises as a freelance artist, illustrator and designer. He has been commissioned by many national and multinational corporations and his work varies from postage stamp design to illustrations for books, calendars, cards, prints and murals.

Sue Shorvon: pp 136-139.
Sue Shorvon studied fine art at Camberwell School of Art and Crafts, London. Her work has been shown in numerous mixed and one woman exhibitions.

Ian Sidaway: pp 10-11, 14, 36-37, 38-39, 40, 42-43, 45, 58-49, 60-61, 62-63, 64-65, 76-79, 88-89, 116-119, 120-123, 130-135, 140-145.
Ian Sidaway studied at Nuneaton School of Art and at Richmond college. He worked as a graphic designer but in 1971 left advertising to become a professional portrait painter. His commissioned portraits are in collections throughout the world and he has also shown in several mixed and one man exhibitions.

Photography 35mm by Ian Howes
Studio photography by Mac Campeanu

Layout and Artwork
Giorgio Moltoni

Oils
The author would like to thank all those who have helped in the preparation of this section. Special thanks to the artists Ian Sidaway and Lincoln Seligman for their work on the techniques and Step by Step demonstrations and to Winsor & Newton for their advice and prompt supply of all materials.

Photography Studio and Step by Step photography by John Melville

Other Photographs pp 148/149 Business Art Galleries, London

Acrylics
The author would like to thank all those who have helped in the preparation of this section. Special thanks to Ian Sidaway for his work on some of the technique demonstrations and to Viv Arthur at Frisk Products for her advice and prompt supply of all materials from the Talens range.

Photography Studio and Step by Step photography by John Melville

Other Photographs pp 286/87 Detail from *Guadalupe Island* by Frank Stella, The Tate Gallery, London
pp 290/291 The Tate Gallery, London
pp 292/293 Nos 1, 3, 4, 5 & 6 Business Art Galleries, London
pp 292 No. 2 The Tate Gallery, London